European
Miniatures
in
The Metropolitan
Museum
of Art

European
Miniatures
in
The Metropolitan
Museum
of Art

Graham Reynolds
with the assistance
of
Katharine Baetjer

The Metropolitan Museum of Art
NEW YORK

Distributed by Harry N. Abrams, Inc.
NEW YORK

This publication is issued in conjunction with the exhibition
"European Miniatures in The Metropolitan Museum of Art,"
held at The Metropolitan Museum of Art, New York,
from November 5, 1996, to January 5, 1997.

The exhibition is made possible in part
by The Christian Humann Foundation.

This publication has been supported, in part, by
The Drue E. Heinz Fund, the Samuel I. Newhouse
Foundation, The Christian Humann Foundation,
and the National Endowment for the Arts.

Published by The Metropolitan Museum of Art, New York

John P. O'Neill, *Editor in Chief*
Kathleen Howard, *Editor*
Greer Allen, *Designer*
Jay Reingold, *Production Manager*
Barbara Cavaliere, *Production Editor*
Robert Weisberg, *Computer Specialist*

Photography by Joseph Coscia Jr., Oi-Cheong Lee, and Bruce Schwarz,
The Photograph Studio, The Metropolitan Museum of Art

Type set by U.S. Lithograph, typographers, New York
Printed and bound by CS Graphics, Singapore

JACKET ILLUSTRATIONS
Above left: Hans Holbein the Younger, *William Roper* (no. 4);
above right: Hans Holbein the Younger, *Margaret More,
Wife of William Roper* (no. 5); lower center: Nicholas Hilliard,
Portrait of a Woman (no. 9)

Library of Congress Cataloging-in-Publication Data

Metropolitan Museum of Art (New York, N.Y.)
 European miniatures in the Metropolitan Museum of Art/Graham
Reynolds with the assistance of Katharine Baetjer
 p. cm.
 Includes bibliographical references and index.
 ISBN 0-87099-808-0 (hardcover). – ISBN 0-8109-6503-8 (Abrams)
 1. Portrait miniatures, European – Catalogs. 2. Portrait
miniatures – New York (State) – New York (N.Y.) – Catalogs.
3. Metropolitan Museum of Art (New York, N.Y.) – Catalogs.
I. Reynolds, Graham. II. Baetjer, Katharine. III. Title.
ND1337.E9M48 1996
757'.7'0940747471–dc20 96-22153
 CIP

Contents

Director's Foreword

A new catalogue dedicated to works of art in the permanent collection, although issued without the fanfare attendant upon the opening of a loan exhibition, is equally important to our roles as scholars and educators, and there can be no question but that in the field of European miniature painting Graham Reynolds is the leading authority. Mr. Reynolds's career at the Victoria and Albert Museum in London encompassed responsibility for paintings, drawings, prints, and illustrated books, as well as for the national collection of portrait miniatures. He has published widely on the last subject. He worked previously with the Department of European Paintings at the Metropolitan Museum as guest curator for our 1983 exhibition "Constable's England" and he is also the winner of the Mitchell Prize for his work on Constable. He has been most ably assisted in preparing this catalogue of miniatures by Katharine Baetjer, curator in the Department of European Paintings, who is also responsible for the accompanying exhibition.

Graham Reynolds's research has been underwritten by Drue Heinz, trustee of the Museum and chairman of the visiting committee to the Department of European Paintings, who has lent her interest and vital support to this project since its inception. The publication of the book has been supported, in part, by The Drue E. Heinz Fund, the Samuel I. Newhouse Foundation, the National Endowment for the Arts, and The Christian Humann Foundation, which has contributed also to the installation of the exhibition. I should like therefore to express my appreciation not only to Drue Heinz, but also to Faith Humann, trustee of the Humann Foundation, and to Claus Virch, chairman and president.

Philippe de Montebello
Director

Preface

The first steps toward this publication were taken in 1978, when Sir John Pope-Hennessy, then Consultative Chairman of the Department of European Paintings, invited me to make a preliminary survey of the collection of miniatures. I was able to undertake this with the assiduous help of Dean Walker, now McIlhenny Senior Curator of European Decorative Arts and Sculpture at the Philadelphia Museum. My examination then was necessarily a rapid one, and off-the-cuff comments were recorded on the comprehensive card index maintained by Elizabeth E. Gardner and Mary Ann Wurth Harris, on which were already inscribed opinions passed by other scholars of the subject, such as Leo R. Schidlof, Daphne Foskett, Hermione Waterfield, Richard Allen, and John Murdoch. The next stage was an invitation from Everett Fahy, Sir John's successor as chairman of the department, with the warm encouragement of Philippe de Montebello, Director of the Museum, to undertake a catalogue raisonné of the collection. This was made possible by the generosity of Mrs. Henry J. Heinz II, who provided the funds for my further study of the miniatures on the spot.

I was greatly helped during the period of my more detailed examination of the collection by Dorothy Kellett and all her colleagues in the department, and in particular by Jennifer Cohen who, after a short course of instruction by Jim Murrell at the Victoria and Albert Museum, was able to open all but a handful of the cases containing the miniatures. This revealed a number of interesting inscriptions and helped to solve some problems of attribution and identification. For instance, the enamel no. 111, which had been described as by C. F. Zincke, and then attributed to André Rouquet, was found to be signed on the back by the central European artist A. L. d'Argent and to be of Emperor Joseph II.

I have endeavored in each entry to acknowledge my obligation to other scholars who have expressed opinions on individual miniatures. Here I shall confine myself to a more general expression of gratitude to those forerunners and upholders of the traditions of scholarship in this fascinating but not overtilled field of research. These include the authors of articles on specific features of the collection in the *Bulletin* of The Metropolitan Museum of Art: Josephine L. Allen, Bryson Burroughs, Faith Dennis, and Harry B. Wehle. An especial debt is owed to Clare Le Corbeiller of the Department of European Sculpture and Decorative Arts. The collection of snuffboxes and *souvenirs d'amitié* under her care contains, particularly in the J. Pierpont Morgan gift, a considerable number of items set with miniatures that fall within the scope of this catalogue. She has most kindly made available her archives about these boxes. They are impressively thorough, and it is to be hoped that they will soon be published in their fullness. For the

purposes of this catalogue I have abbreviated the information about the goldsmiths' work and the date marks on the boxes to the minimum required to establish the dating of the miniatures that decorate them.

The question inevitably arises whether portraits of American sitters by European artists belong to either the Department of American Art or the Department of European Paintings. It has been decided to include the few works which fall into this category in the present catalogue, and I am grateful to John K. Howat for consenting to the transfer to European Paintings of the portraits of Elizabeth De Lancey by George Engleheart and Benjamin Franklin by a French artist, de Bréa. Dr. Alan Fern, the Director of the National Portrait Gallery, Smithsonian Institution, and his colleagues have been of great help in determining that the miniature by A. C. Loutherbourg (no. 96) is not of the fourth president.

Since I cannot be in New York to see the publication through the press, I have to thank Katharine Baetjer for supervising this operation. She joins me in expressing gratitude to the skill of John P. O'Neill, Barbara Burn, Kathleen Howard, Jay Reingold, Barbara Cavaliere, Robert Weisberg, Chris Zichello and designer Greer Allen in embodying the text in this elegantly designed and finely printed volume.

Graham Reynolds

The European miniatures had not been displayed in the twenty years prior to the exhibition with which we celebrate the publication of the present volume. Conservation work had clearly been necessary. In the absence of a staff member with the requisite skills, and with the blessing of our own conservators, we engaged Carol Aiken, who has treated some ninety objects with splendid results. An abbreviated report is supplied in the condition note for each object. Jeff Myers provided new crystals to replace harmful, degenerating early glass. I am grateful to Marjorie Shelley, conservator in charge of the Paper Conservation Department, for her advice, and to Margaret Lawson, associate conservator, who prepared the plumbagos for exhibition. Every object in this book has been newly and most skillfully photographed, for which I thank Joseph Coscia Jr., Oi-Cheong Lee, Bruce Schwarz, and manager Barbara Bridgers, of The Photograph Studio. Emma T. K. Guest has been an impeccable part-time researcher and archivist, and Jay Reingold's production work has been exemplary.

Katharine Baetjer
Curator
Department of European Paintings

Introduction

This catalogue describes the collection of portrait miniatures in the Department of European Paintings of The Metropolitan Museum of Art. It is not concerned with the American school of miniature painters, which had a vigorous life from the second half of the eighteenth century, the Museum's holdings of which are housed in the Department of American Art. A catalogue of that collection, with an account of the development of the portrait miniature in America, is in preparation.

The portrait miniatures dealt with in this publication are examples of a specialized branch of portrait painting that arose in Europe during the first quarter of the sixteenth century. Originating in France at the court of Francis I, miniature portraiture immediately took hold in England, where it had a life of strong growth and development until the end of the seventeenth century. Its cultivation on the mainland of Europe was more sporadic, but the type of portrait miniature that is executed in enamel played an important role at the court of Louis XIV. During the eighteenth century the traditional support of vellum laid on card was replaced by ivory, and the cult of the portrait miniature as a testimony of loyalty to a monarch, as a love token, and as a record of a person's features spread throughout Europe. It continued to thrive and to give employment to an increasing number of artists until the invention of photography provided a cheaper, more convenient method of fulfilling the same aims. The technique and materials of miniature painting were primarily applied to portraiture, but they were also used for religious or historical subjects, or for genre scenes. Figurative compositions in miniature are included in this catalogue.

The collection in The Metropolitan Museum of Art illustrates the progress of the art throughout the three centuries in which it was most cultivated, the changes in taste from Tudor through Baroque and Rococo to Neoclassicism and Realism, and the differences in style between its French, German, and British exponents. The collection illuminates this course of events, sometimes brilliantly, sometimes by adequate representation, and sometimes fitfully or not at all. The reason for this uneven coverage is to be sought in the history of the collection and in the manner in which it was brought together.

The core of the collection was formed by the gifts or bequests of a handful of dedicated collectors who wished the public to share in the pleasure they had derived from their possessions. The earliest of these collections to be received by the Museum was that formed by Moses Lazarus (1813–1885), cofounder of the sugar refinery Johnson & Lazarus, who had acquired a large fortune by the time he retired

in 1865. His miniatures were given to the Museum between the years 1888 and 1895 by two of his daughters, Sarah (1842–1910) and Josephine (1846–1910). In its composition, the Lazarus collection displayed a fairly even balance of eighteenth-century examples from England and France. Two enamels by Zincke (nos. 118, 119), two miniatures by William Wood (nos. 165, 166), and a richly jeweled portrait by Adam Buck (no. 227) are noteworthy among the former group; a signed portrait by P. A. Hall (no. 46) and three fine works by Joseph Bordes (nos. 196–98) among the latter.

The next major benefaction came from the estate of J. Pierpont Morgan, who had been president of the Museum from 1904 until his death in 1913. He had built up one of the finest private collections of detached portrait miniatures. These were catalogued in four sumptuous volumes by Dr. G. C. Williamson, published between 1906 and 1908, but they were sold at auction by Christie's in 1935. A few of the Museum's best purchases came from that sale, including a work by Jean Clouet (no. 1), two by Nicholas Hilliard (nos. 8, 9), and one by John Hoskins (no. 24). Morgan's gift to the Museum consisted of a magnificent collection of snuffboxes and *souvenirs d'amitié*. These are housed in the Department of European Sculpture and Decorative Arts. As is customary, many of them are embellished with portraits or other decorative paintings, and when this is the case their pictorial content has been described here. These objects greatly strengthen the representation of the French school, adding two boxes decorated with Neoclassical grisailles by J. J. de Gault (nos. 75, 76) and the only signed work by J. B. J. Augustin in the Museum (no. 169).

The bequest of Mary Clark Thompson, who died in 1923, broke new ground by increasing the representation of the earlier period. From this source came the magnificent Endymion Porter by John Hoskins (no. 22), one of his most memorable achievements, and later English works by Nicholas Dixon (no. 31) and Christian Richter (no. 38). Mrs. Thompson enriched the eighteenth-century holdings with the two intriguing enamels of nymphs attributed to Thienpondt (nos. 102, 103), with examples of Richard Cosway (no. 132) and John Smart (no. 134), and, in the nineteenth century, with three enamels by Henry Bone (nos. 221, 224, 225).

In the gift made in 1925 in memory of her husband by Mrs. Louis V. Bell, the emphasis was on late-eighteenth- and early-nineteenth-century French miniature painters. The gift included two enamels by Pierre Pasquier (nos. 42, 43), an interesting early work, *The Reader*, by J. B. Isabey (no. 176), and portraits attributed to J. A. Laurent (no. 91) and by J. M. Bouton (no. 93) and E. Bouchardy (no. 202).

The bequest made by Collis P. Huntington, who died in 1900, was not received until 1926. Unlike his nephew Henry E. Huntington, whose fine collection of miniatures by Cosway, Plimer, and late-eighteenth-century English artists is in the Huntington Art Collections, San Marino, Collis P. Huntington was not altogether fortunate as a collector of these works. The privately printed catalogue of his collection as it was in 1897 reveals an unduly high proportion of forgeries and wrong attributions. Nonetheless it is to this source that is owed the composition *The Hours* by Samuel Shelley (no. 155), which played an important role in the American miniaturist Edward Malbone's development, the only Andrew Plimer in the Museum (no. 162), and characteristic miniatures by George Engleheart (no. 148) and N. F. Dun (no. 174).

The last large benefaction before the onset of World War II was the gift in 1932 by Giulia Morosini of a part of the collection formed by her father, Giovanni P. Morosini, a sometime partner of financier Jay Gould. Morosini had assembled an immense collection of arms and armor, furniture, and decorative arts at his house in Riverdale. The Morosini gift diversified the representation of the earlier periods with the two remarkable oil portraits by the dilettante Dutch artist David Baudringhien (nos. 14, 15) and two late-seventeenth-century enamels (nos. 19, 20). The bulk of the collection, however, consisted of Continental miniatures of the late eighteenth and early nineteenth centuries.

Mrs. Catherine D. Wentworth made an extensive loan of snuffboxes to the Museum in 1945, and her bequest was received in 1948. To her belonged some of the more unusual items: the scene in a seventeenth-century artist's studio (no. 18), the box with a miniature of a whippet by J. B. Isabey (no. 178), and the exceptionally large and fine portrait of a woman by N.-H. Jacob (no. 199).

The most recent, and the largest, benefaction of note is the bequest by Mrs. Leopold Fredrick in 1962. Millie Bruhl Fredrick, who was born about 1878, was herself a painter, holding, for example, a large exhibition of portraits at the Milch Galleries, 939 Madison Avenue, New York City, in 1927. She and her mother, Henrietta Bruhl, were already collecting by 1929, and she continued to add to her collection throughout her life. A descriptive list of the collection was made in 1960 by Edward Grosvenor Paine, who as a *marchand-amateur* was one of her sources.

In the main, the Fredrick collection was characterized by a balance between late-eighteenth-century English and French miniatures similar to that found in the Lazarus collection. Among earlier pieces are a portrait by John

Hoskins, apparently of Philip, fourth baron Wharton (no. 23), and a miniature of a seventeenth-century French woman that may be one of the enamelist Jean Petitot's rare works in watercolor on vellum (no. 13). An enamel by Zincke (no. 117) and another attributed to him (no. 121) complement two of his works in the Lazarus collection. An interest in portraits of royalty is displayed by miniatures of Charles II of England (no. 27), Louis XV (no. 40) and Louis XVI (no. 58) of France, and Marie-Thérèse-Charlotte (daughter of Louis XVI), the so-called Orphan of the Temple (no. 74). The English works in the bequest include representative examples by Samuel Cotes (no. 124) and John Barry (no. 161).

The core of the present collection is formed by these larger gifts and bequests, and it has been enriched by smaller gifts of fine miniatures. The half-dozen or so miniatures bequeathed by Margaret Crane Hurlbut in 1933 are of interest because some of them had belonged to her uncle William Loring Andrews, who was a trustee of the Museum for forty years. They include the impressive figural composition *Vertumnus and Pomona* by Thomas Lefebure (no. 21). Other individual gifts include the big and faithful copy by Bernard Lens of the painting by Rubens of his family (no. 116); having given the original oil painting to the Museum, Mr. and Mrs. Charles Wrightsman complemented their gift by this early record of it. In 1951 Harry G. Friedman gave a miniature version by Anton Raphael Mengs of his acclaimed composition of Saint Anthony of Padua adoring the Christ child (no. 105). J. William Middendorf II contributed in 1968 a contemporary miniature copy of Greuze's portrait of Benjamin Franklin (no. 51). In 1962 Charlotte Guilford Muhlhofer gave a miniature by Richard Cosway that has now been established as a self-portrait (no. 130). Of the four portraits of Louis XVI that have come together from different sources in this collection, the one with the most interesting history is the miniature by Sicardi set in a jeweled box, which was given by the king himself to Colonel John Laurens when he was on a mission to France in 1781. It was bequeathed to the Museum in 1915 by Edward C. Post (no. 60).

The collection has been widened in scope and strengthened by a number of judiciously chosen purchases. The resources of the Fletcher Fund were applied to the most significant addition of all, the miniature of Charles de Cossé, count of Brissac, by Jean Clouet (no. 1), which is almost the earliest known separate portrait and is by the inventor of this type of portraiture. Two fine Hilliards (nos. 8, 9) were bought from the same source, one acquired as a work by Isaac Oliver. As already mentioned, these three early examples of the art had all been in the Pierpont Morgan collection and

were bought at the same auction in 1935. Later pieces bought through the Fletcher Fund include two notable late-eighteenth-century English miniatures: the portrait by George Engleheart (no. 147) of the loyalist Elizabeth Colden of New York, who married Peter De Lancey, and the florid portrait of an unknown woman by James Nixon (no. 128). The fund has also enabled two examples of the Austrian school to be added—that of Empress Maria Louisa by Füger (no. 112) and the large and masterly portrait of Metternich by the statesman's protégé F. J. G. Lieder (no. 210).

The Rogers Fund has been applied with equal success to strengthening the representation of earlier artists in miniature painting. Its resources are responsible for the remarkable group of three miniatures by Hans Holbein the Younger (nos. 4–6), the first great master of the art. It has also contributed the two large vellum portraits of the seventeenth century by E. Jean Saillant (nos. 11, 12), which cast some light on the obscure course of miniature painting in Continental Europe in the earlier decades. The best work by Samuel Cooper in the collection also came from these funds —the portrait of Henry Carey, second earl of Monmouth, painted in 1649 (no. 25). The purchase of a portrait by Rosalba Carriera (no. 97) signals the replacement of vellum by ivory as a support for miniatures in the early eighteenth century. The portrait of the actor Préville (no. 39) is widely known with an attribution to Fragonard. It is probably by Massé, but the ivory of a boy bought with the same fund is a fine example of Fragonard's miniature painting (no. 44). The fin-de-siècle Neoclassical and Republican styles of portraiture are typified by the miniatures of a young woman by P. E. Stroely (no. 115) and of the deputy Lameth by Jean Urbain Guérin (no. 171), both bought through the Rogers Fund.

The collection thus formed through the enthusiasm of amateurs and the purchases made by the Museum covers a commendably wide range of schools and artists. It is an especially favorable source for the understanding of the origins of the portrait miniature, since it possesses the image of Charles de Cossé, count of Brissac (no. 1) by Jean Clouet, accompanied by three examples by Hans Holbein the Younger (nos. 4–6). Since the most optimistic estimates credit Holbein with no more than twenty known miniature paintings, this is a substantial holding to find in one collection, and all three were painted in the mid-1530s, when he first took up portraiture in this technique under the tutelage of Lucas Hornebolte.

Both Jean Clouet and Lucas Hornebolte had their roots in the Low Countries, and their styles are Flemish in origin.

The Metropolitan Museum of Art possesses, though not in the Department of European Paintings, another early example of miniature painting that is one of the few such pieces produced in Flanders in the sixteenth century—the self-portrait painted in 1558 at the age of seventy-five by Simon Bening. It is in the Robert Lehman Collection (1975.1.2487) and is a second version of a work in the Victoria and Albert Museum. This portrait provides a further link between the art of illuminating manuscripts and the detached miniature. Bening's daughter Levina Teerlinc married an Englishman and was attached to the court of Elizabeth I. She painted a number of miniatures of the queen and her entourage, about which virtually nothing is known.

The tradition started in France by Clouet was only sparsely maintained by his son François Clouet; his style, although not his hand, is represented by the portrait of Henry III, king of France (no. 2). The form took far stronger hold in England, where for forty years from the 1570s Nicholas Hilliard painted sitters from many strata of society. The Museum has two fine examples of his art at its most accomplished: the head-and-shoulders portrait of a man also seen full length in Hilliard's most famous work, *A Young Man Among Roses* in the Victoria and Albert Museum, probably the queen's favorite, Robert Devereux, earl of Essex (no. 8), and a miniature of an Elizabethan court lady in the 1590s (no. 9). It is somewhat surprising to find no work here by Hilliard's chief pupil and eventual rival Isaac Oliver, although the miniature of Essex just discussed was bought as an example by the younger man.

Miniature painting was practiced only sporadically on the continent of Europe throughout the seventeenth century, and the Museum's collection parallels almost all other collections in displaying a few fine pieces without any pretense of continuity. The individually notable miniatures include the two large rectangular portraits by E. Jean Saillant (nos. 11, 12), who was born in France but produced these two works in Rome, the two oil miniatures by the Dutch artist David Baudringhien (nos. 14, 15), and the classical landscape with figures *Vertumnus and Pomona* by Thomas Lefebure, a Fleming who worked mainly in Germany (no. 21). It was very different in England, where the art was developed by an unbroken stream of accomplished painters until the end of the seventeenth century. These men were well patronized even during the period of the Civil War, and most of the leading miniaturists are represented in the Museum's collection. John Hoskins, the leader of the generation that succeeded Nicholas Hilliard, is particularly well displayed with the remarkable portrait of Endymion Porter (no. 22), a prominent member of Charles I's court, and the miniature

of the biblical scholar Dr. Brian Walton (no. 24), which once belonged to Horace Walpole. Samuel Cooper, the most eminent master of seventeenth-century miniature painting and one with a unique European reputation, is less well shown, although there is one good example, his portrait of the second earl of Monmouth (no. 25). Cooper's successor as King's Limner, Nicholas Dixon, is represented (no. 31); however, there are no examples here of his prolific contemporaries Thomas Flatman and Peter Crosse. Nor is there a single enamel miniature by Jean Petitot, although he dominated miniature painting at the court of Louis XIV and produced an uncounted number of portraits of the king and courtiers.

During the eighteenth century the art underwent a fundamental change of direction and became a popular form of portraiture throughout Europe. The change was inaugurated by the Venetian Rosalba Carriera, who painted on small sheets of ivory instead of vellum stretched over card, thus paving the way for a freer and more colorful type of expression. Her portrait of an unknown man (no. 97) embodies the new materials and the different approach that she brought to the art. She directly influenced the first important French miniaturist of the eighteenth century, Jean Baptiste Massé, to whom the portrait of the actor Préville is here attributed (no. 39). By the second half of the eighteenth century, the new methods were fully naturalized in France, and the interest felt by so many donors in this period has ensured that this phase can be appreciated in many fine examples, as in P. A. Hall's signed portrait of Louis Joseph Maurice (no. 46) and in the portraits of Louis XVI by Louis Marie Sicardi (nos. 60, 61).

The fancy painting in miniature of a boy by Jean Honoré Fragonard (no. 44) shows the extent to which the luminous surface of ivory could be used for the display of breadth of brushwork and lightness of color and the decorative effects of the Rococo style. But at the moment when this flamboyance was at its peak the Neoclassical reaction was beginning. A community of taste has brought together in the Museum's collection from different sources four examples of the grisailles of J. J. de Gault: two boxes in the Pierpont Morgan gift (nos. 75, 76), one of which includes a version of the fresco *The Sale of Cupids*, which started the Neoclassical movement; a portrait *en camaïeu* of the daughter of Louis XVI, bequeathed by Mrs. Fredrick (no. 74); and a box decorated with putti at play bequeathed by Catherine D. Wentworth (no. 77). These are complemented by decorations by the little-known Mademoiselle Duplessis on a box given by J. Pierpont Morgan (no. 70) and by a profile portrait attributed to P. J. Sauvage given by Mrs. Louis V. Bell (no. 78).

Although ivory was the most favored support for miniatures in the later eighteenth century, it did not exclude other materials. The traditions of enamel painting were continued, as in the box decorated by Mademoiselle Duplessis already mentioned and, especially notably, in the two signed portrait enamels by Pierre Pasquier given by Mrs. Louis V. Bell (nos. 42, 43). Vellum was found by the prolific Van Blarenberghes to be well adapted to the decoration of gold boxes and is the support for the scenes from the theater and of country pastimes in boxes by them given by J. Pierpont Morgan (nos. 66, 67).

Miniatures from other Continental schools are more sparsely represented but include a few interesting pieces, such as the two enamels attributed to the German artist C. F. Thienpondt (nos. 102, 103). He was taught by Ismaël Mengs, whose famous son Anton Raphael is finely represented by a miniature version on very thick ivory of one of his most successful subjects, *The Vision of Saint Anthony of Padua* (no. 105).

In England the practice of painting miniatures on ivory was begun by Bernard Lens III, who had no doubt known of Rosalba Carriera's innovation. But he continued also to paint on vellum, and the impressive large miniature by him after Rubens (no. 116) is in that medium.

Miniature painting in England in the early eighteenth century was dominated by the German-born enamelist C. F. Zincke, who is represented here by four (or perhaps five) works, two of which came in the Lazarus gift (nos. 118, 119), and two others from the Wentworth (no. 120) and Fredrick (no. 117) bequests. This rather quiet period gave way to a flourishing of talent in the second half of the century. Most of the leading artists are included in the Museum's collection. The supremely accomplished Richard Cosway is represented by a self-portrait in profile (no. 130), presenting himself as a man in the height of fashion, and by a portrait said to be of the singer Mrs. Bates, which is in exceptionally fine condition, having been set inside the lid of a box (no. 131). John Smart's more meticulous style is seen in his miniature of Sir William Hood (no. 134) and in five of his portrait sketches on paper (nos. 136–40). Other masters of the English school are George Engleheart (his miniature of Mrs. Peter De Lancey, no. 147, is of special interest), Richard Crosse (no. 133), James Nixon (no. 128), and William Wood (nos. 165, 166).

The collectors whose gifts shape the Museum's display continued their interest in French miniatures into the production of the nineteenth century. J. B. J. Augustin is less well represented than might have been expected (no. 169), but

full justice is done to his younger rival, J. B. Isabey. The ten miniatures by him in the Museum come from as many different sources. Isabey was kept fully occupied multiplying miniatures of Napoléon I and his family, and examples are included here (nos. 180–82), diversified by the portrayal of a whippet set in a gold box (no. 178). The austerity of Revolutionary portraiture is embodied in Jean Urbain Guérin's miniature of the deputy Lameth (no. 171). Guérin became a member of Isabey's studio, and that artist's influence expanded as a number of his pupils began to practice, among them Rudolphe Bel (no. 195) and Joseph Bordes (nos. 196–98). In his latest manner Isabey painted larger, romantically conceived portraits on paper stretched over metal or vellum or on card; this development is reflected in the fine, large female portrait by N.-H. Jacob (no. 199) and in the magnificent and very large miniature of Metternich by F. J. G. Lieder (no. 210). The Primitive vision cultivated in Germany by the Nazarene and Biedermeier movements recurs in the literal portrait by H. F. Schalck of Joseph and Karl August von Klein in their study, surrounded by evidence of their wide-ranging interests (no. 215).

The somewhat patchy presentation of the English school in the nineteenth century has recently been strengthened by the transfer from the Department of American Art of a miniature by Andrew Robertson (no. 231). This artist's two elder brothers, Alexander and Archibald (no. 163), came to New York in the early 1790s and belong to the American school, which they furthered by founding the Columbian Academy. Andrew Robertson settled in London and gave miniature painting a new direction by adopting a larger, often rectangular format, which made the miniature less an intimate portrait to be worn as a love token and more of a small cabinet piece to be displayed on a desk. He also abandoned the lightness of touch of Cosway and his followers, striving to give his paintings on ivory the depth of oil. The enamels by Henry Bone are well represented by six objects. This artist's main output consisted of copies of paintings by other artists, and five of his works here are of that type (nos. 221–26). The ablest and most successful miniaturist of the second quarter of the nineteenth century was Andrew Robertson's pupil and assistant, Sir William Ross. There is nothing by him in the collection, but his kindly, suave style is echoed in a self-portrait that is puzzlingly said to be by an unknown artist, Fane, on the frame, but is probably by the Scots miniaturist John Faed (no. 236).

Most collectors of miniatures, among whom may be numbered those whose gifts form the backbone of the Museum's collection, are primarily concerned with acquiring fine specimens of the best artists and are more concerned with the quality of the piece than with its subject. Nonetheless, such a collection cannot fail to be a portrait gallery. Even when the numerous mistaken or overoptimistic identifications have been eliminated, the Museum does hold images of a wide range of interesting people. Miniature painting began in the courts of Renaissance kings and has always served as a means of portraying monarchs and their immediate entourages. Hence, we can see here portraits of Charles II of England; Henry III, Louis XV, and Louis XVI of France; Frederick the Great of Prussia; Emperor Joseph II and Empress Maria Louisa of Austria; and Empress Catherine the Great of Russia. From the nineteenth century there are enamels by Bone of George IV of England and Charles X of France. The miniature of Alexander I of Russia is by Edward Miles (no. 220), an artist who after working for the English court went to Russia before settling in Philadelphia. Napoléon I had learned the importance of multiplying his image to further his absolute rule, and at least three of Isabey's immense output of these icons have been brought together here. The unmistakably exotic apparel and likeness of the Albanian tyrant Ali Pasha has been captured by the German dilettante Jacob von Hartmann (no. 214).

Although rooted in courts, miniature portraiture was soon the prerogative of less exalted members of society. Holbein started this trend right at the beginning, with his portraits of William Roper, a lawyer, and his wife, Margaret, who, although she was Thomas More's daughter, was only on the fringes of aristocratic life. While Endymion Porter was an important aide to Charles I and in high fashion, as his miniature by Hoskins shows, Sir Henry Blount was as plain a man as his portrait by Dixon reveals. The taste of our collectors has given little or no record of the court of Louis XIV, but the mid-eighteenth-century theater is evoked by the telling portrait of Préville, a leading actor of the Comédie Française. The wide-eyed features of Lola Montez (no. 211) arouse speculation about the appeal of a lowborn dancer who caused the abdication of King Ludwig I of Bavaria and died a penitent, to be buried in Greenwood Cemetery, Brooklyn. In its last phase miniature painting comes to resemble the products of the newly invented photographic processes, as in the portrait long thought to represent the eminent German scientist Alexander von Humboldt (no. 288).

Graham Reynolds

Note to the Reader

Miniatures enlarged to 150 percent are indicated by an asterisk.
All others are their true size or smaller.

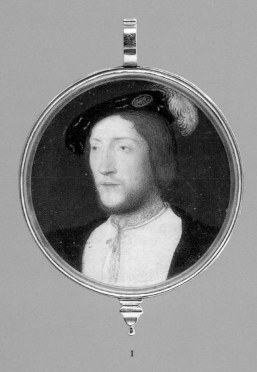

1

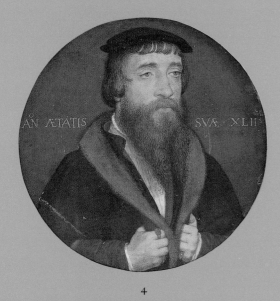

4

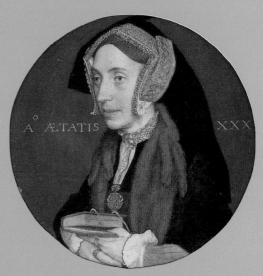

5

1. Jean Clouet, *Charles de Cossé* (1506–1563), *Count of Brissac*, about 1535*

4. Hans Holbein the Younger, *William Roper* (1493/94–1578), 1535–36*

5. Hans Holbein the Younger, *Margaret More* (1505–1544), *Wife of William Roper*, 1535–36*

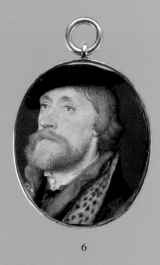

6

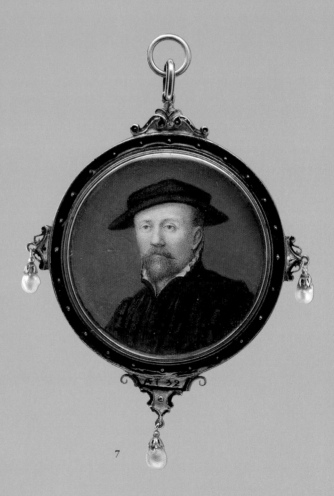

7

6. Hans Holbein the Younger, *Thomas Wriothesley (1505–1550), First Earl of Southampton*, about 1535*

7. Imitator of Hans Holbein the Younger, *Portrait of a Man, Said to Be Arnold Franz*, 17th or early 18th century

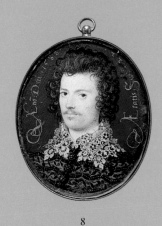

8

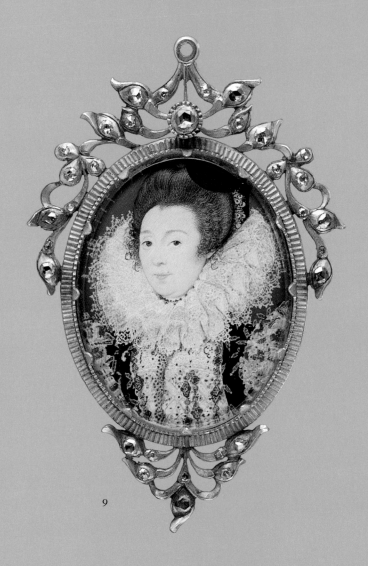

9

8. Nicholas Hilliard, *Portrait of a Young Man, Probably Robert Devereux (1566–1601), Second Earl of Essex*, dated 1588

9. Nicholas Hilliard, *Portrait of a Woman*, dated 1597*

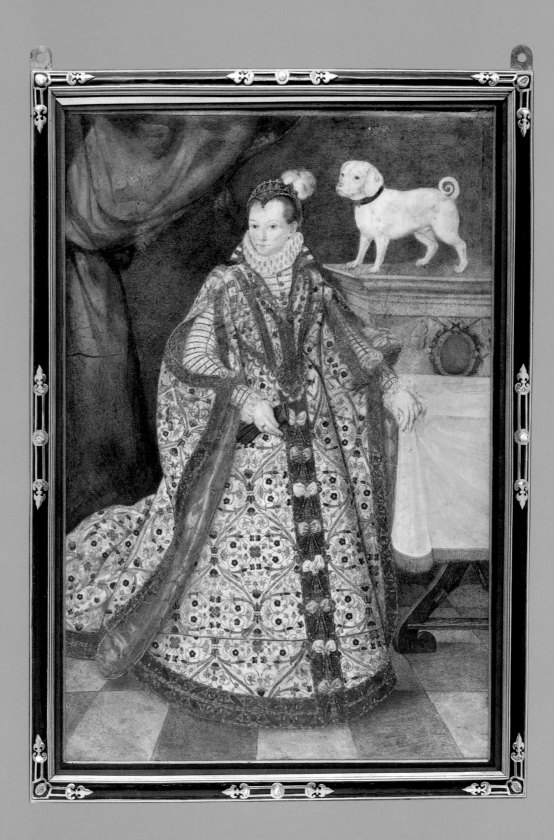

3. Attributed to Pieter Pietersz the Younger, *Portrait of a Moravian Woman*, late 16th century

238. German, *John Frederick I* (1503–1554), *Elector of Saxony*, about 1550

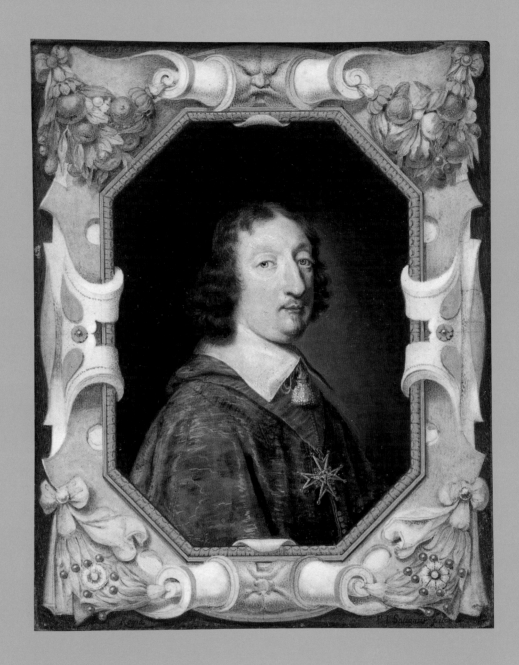

11. E. Jean Saillant, *Portrait of a Churchman*, dated 1628

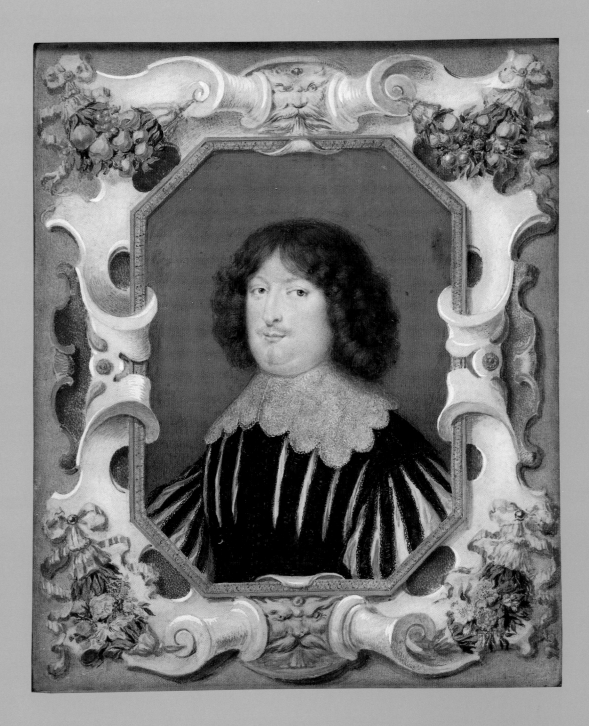

12. E. Jean Saillant, *Portrait of a Man*, about 1628

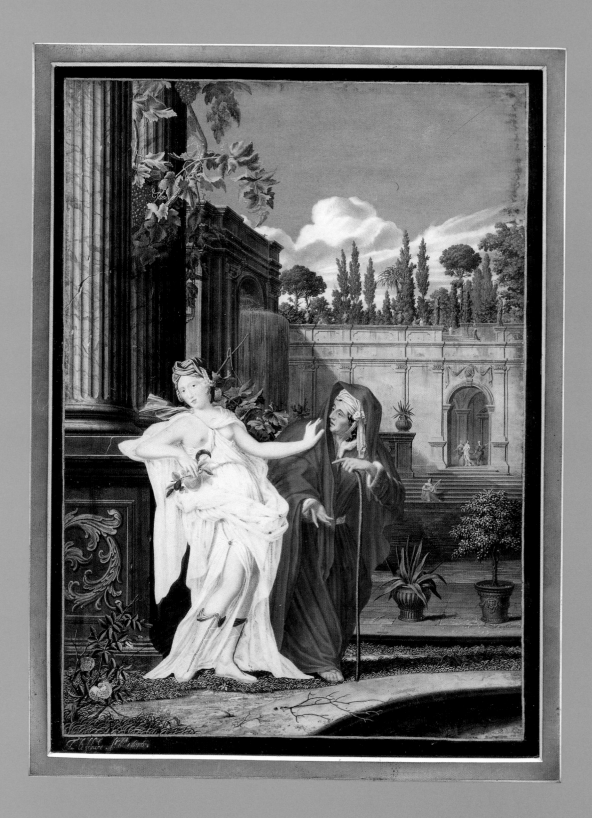

21. Thomas Lefebure, *Vertumnus and Pomona*, dated 1676

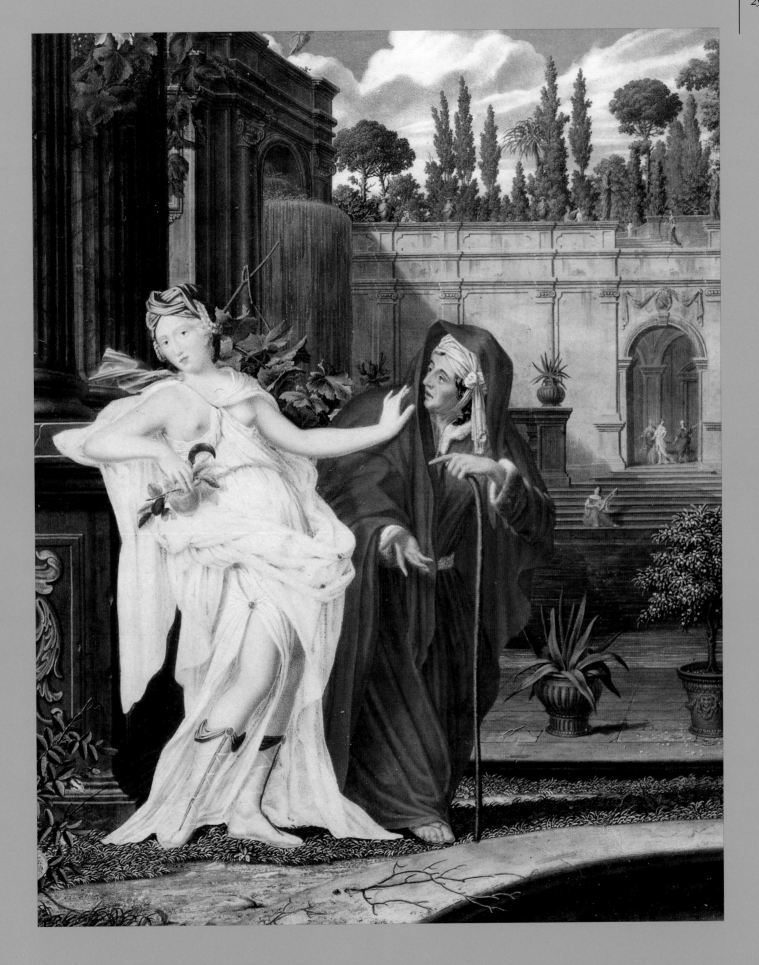

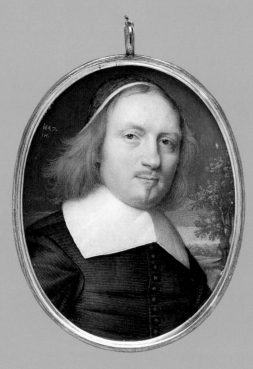

24

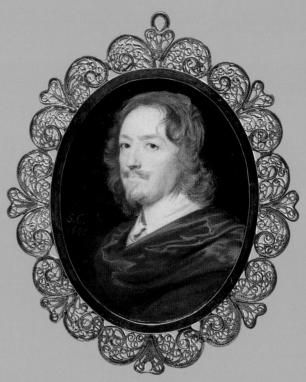

25

24. John Hoskins, *Dr. Brian Walton* (born about 1600, died 1661), dated 1657

25. Samuel Cooper, *Henry Carey* (1596–1661), *Second Earl of Monmouth*, dated 1649

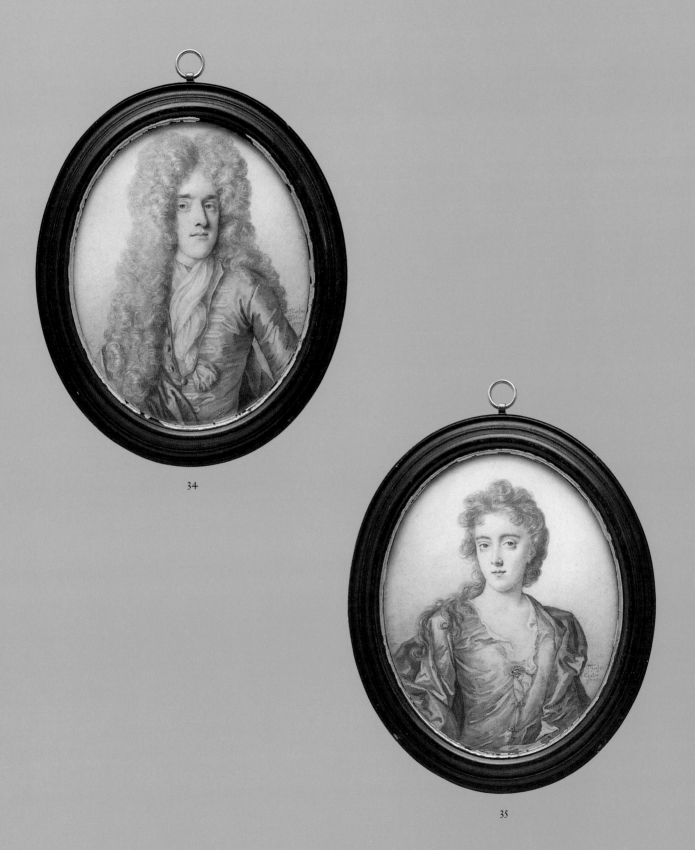

34

35

34. Thomas Forster, *Portrait of a Man*, dated 1700

35. Thomas Forster, *Portrait of a Woman*, dated 1700

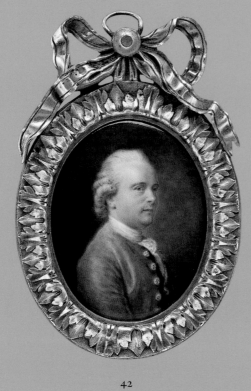

42

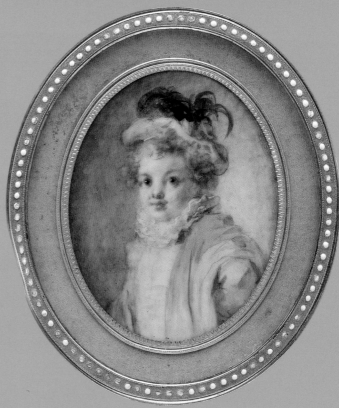

44

42. Pierre Pasquier, *Abbé Charles Bossut* (1730–1814), dated 1772

44. Jean Honoré Fragonard, *Portrait of a Boy*, about 1775

46. Peter Adolf Hall, *The Painter Louis Joseph Maurice* (1730–1820), dated 1772

51. Charles Paul Jérôme de Bréa, *Benjamin Franklin (1706–1790), after a Painting by Greuze of 1777*, dated 1777

52

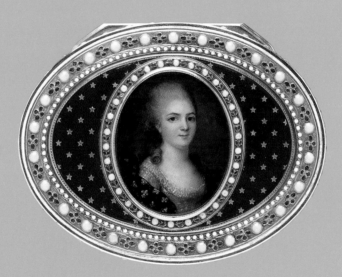

53

52. French or German, *Portrait of a Man, Probably Prince Karl of Saxony* (1733–1796), about 1778–79

53. French, *A Member of the French Royal Family, Probably a Daughter of Louis XV*, late 18th cetury

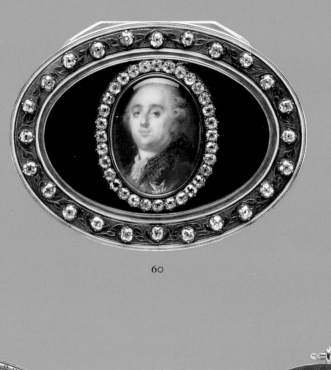

60

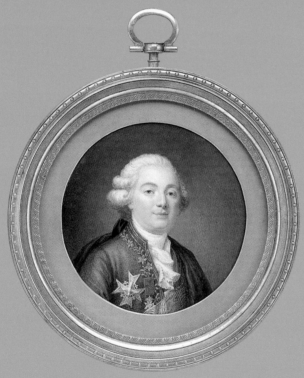

58

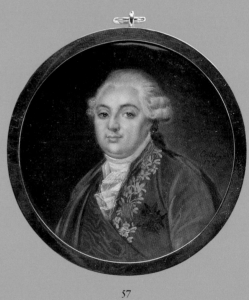

57

60. Louis Marie Sicardi, *Louis XVI* (1754–1793), *King of France*, dated 1780

58. Attributed to Jean Laurent Mosnier, *Louis XVI* (1754–1793), *King of France*, dated (?) 1790

57. Attributed to Antoine François Callet, *Louis XVI* (1754–1793), *King of France*, dated (?) 1787

71

72

71. Edmé Charles de Lioux de Savignac, *A River Landscape*, about 1766–72

72. Edmé Charles de Lioux de Savignac, *A Picnic*, about 1766–72

65. Louis Nicolas and Henri Joseph van Blarenberghe, *Views at Chanteloup (The Choiseul Box)*, dated 1767

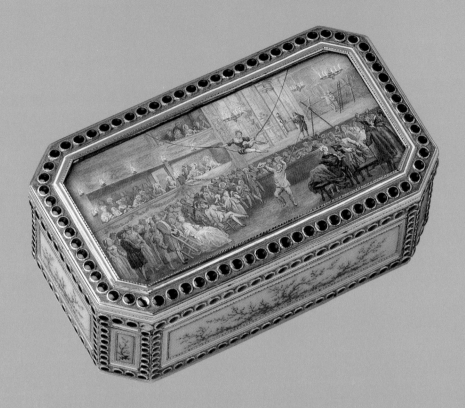

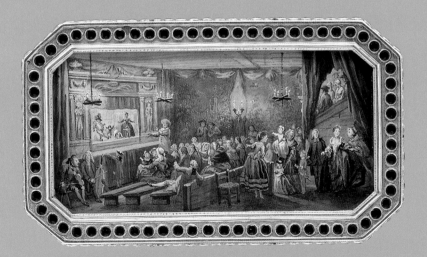

66. Louis Nicolas and Henri Joseph van Blarenberghe, *Theatrical Scenes*, about 1778–79*

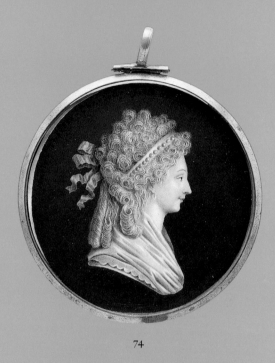

74

86

74. Jacques Joseph de Gault, *Marie-Thérèse-Charlotte (1778–1851), Daughter of Louis XVI*, dated 1795

86. Edmé Quenedey, *Portrait of a Man*, about 1780

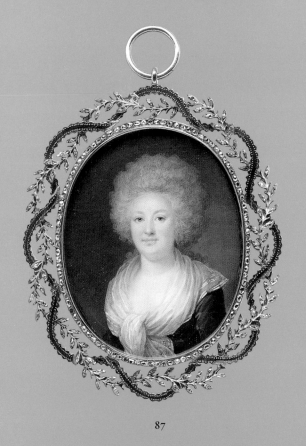

87

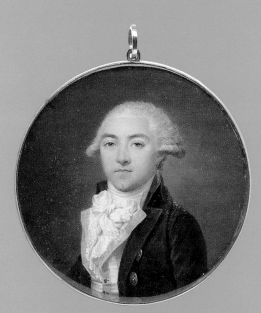

88

87. Villers, *Portrait of a Woman*, about 1790 88. Villers, *A Man with the Initials JD*, dated 1790

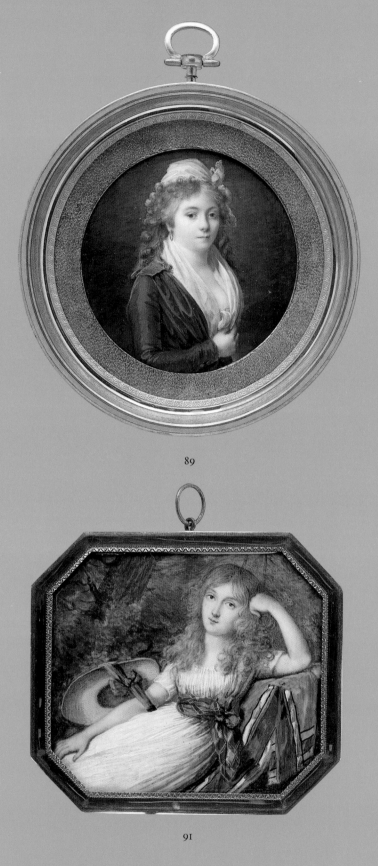

89

91

89. Frédéric Dubois, *Portrait of a Woman*, dated 1793/94

91. Attributed to Jean Antoine Laurent, *Portrait of a Young Woman*, about 1795

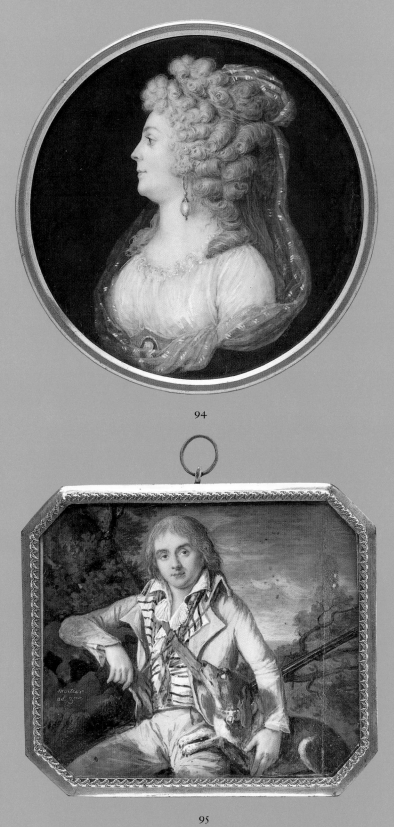

94

95

94. Vincent, *Madame Ingouf*, about 1790 95. Mortier, *A Hunter with a Dog*, dated 1794/95

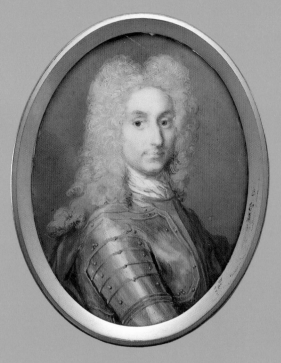

97

102

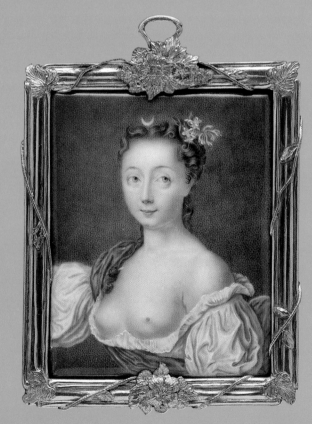

103

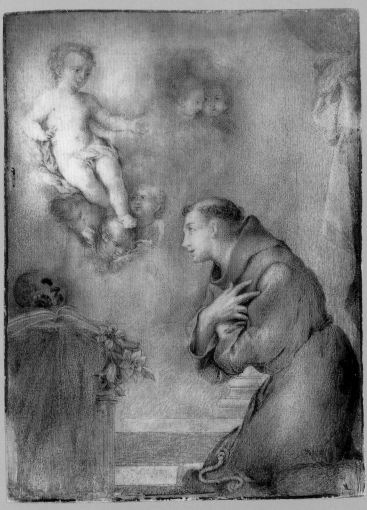

105

97. Rosalba Carriera, *Portrait of a Man*, about 1710

102. Carl Friedrich Thienpondt, *A Sea Nymph*, about 1760 103. Carl Friedrich Thienpondt, *Diana*, about 1760

105. Anton Raphael Mengs, *The Vision of Saint Anthony of Padua*, dated 1758

III

110

111. Adam Ludwig d'Argent, *Joseph II* (1741–1790), *Emperor of Austria*, about 1780

110. Johann Heinrich Hurter, *Portrait of a Woman*, about 1770–75

112

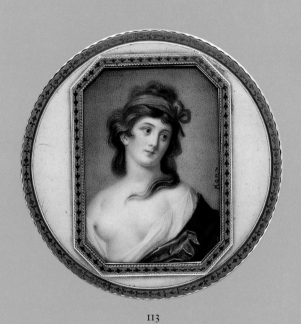

113

112. Heinrich Friedrich Füger, *Maria Louisa* (1745–1792), *Empress of Austria*, about 1790

113. Carl Christian Kanz, *Portrait of a Woman*

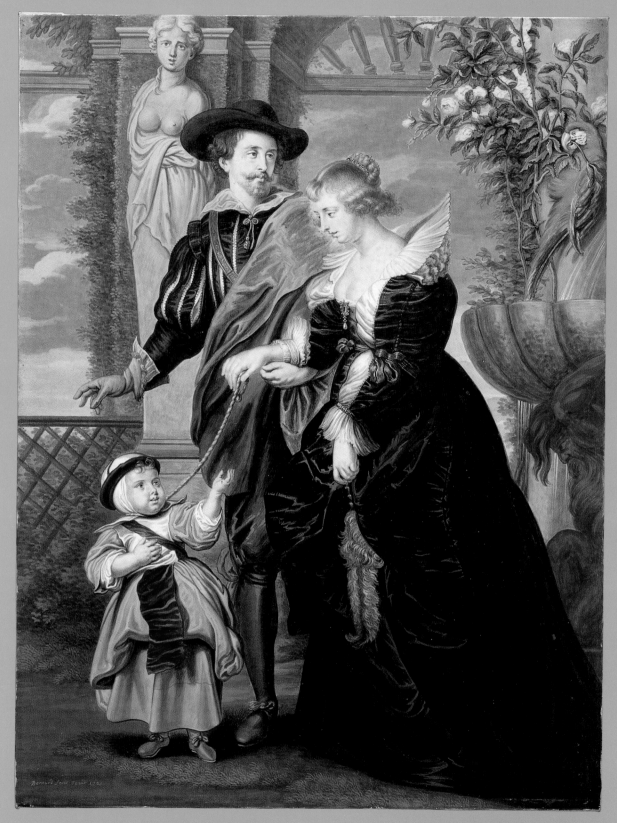

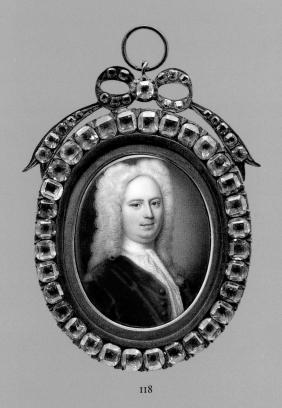

118

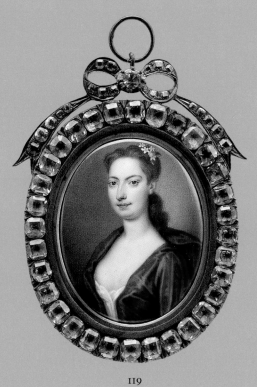

119

116. Bernard Lens, *Rubens, His Wife Helena Fourment, and Their Son Peter Paul*, dated 1721

118. Christian Friedrich Zincke, *Richard Abell*, dated 1724 119. Christian Friedrich Zincke, *Mrs. Vanderbank*, about 1730

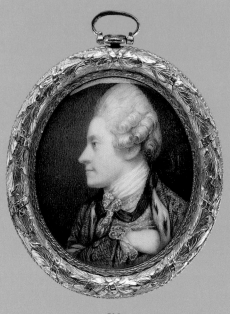

130

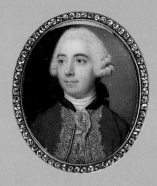

134

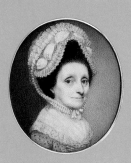

147

130. Richard Cosway, *Self-portrait*, about 1770–75

134. John Smart, *Sir William Hood*, about 1766

147. George Engleheart, *Mrs. Peter De Lancey* (Elizabeth Colden, 1720–1784), probably 1783

155. Samuel Shelley, *The Hours*, 1801

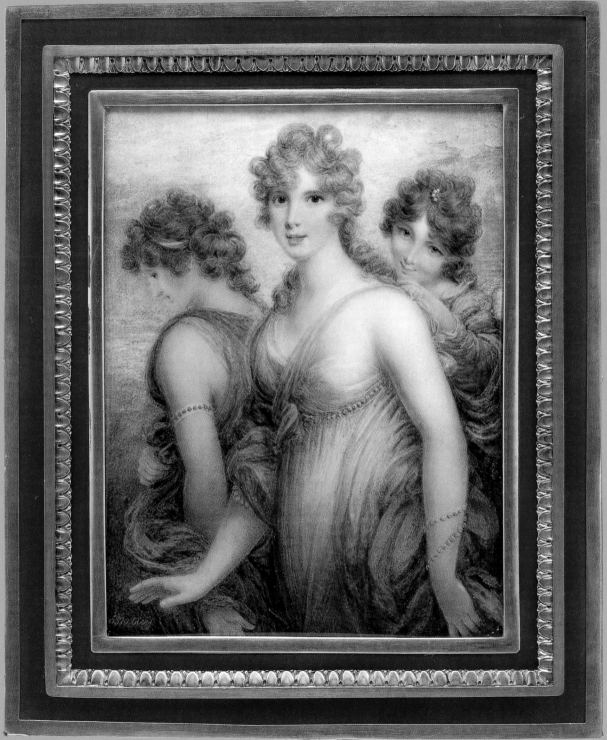

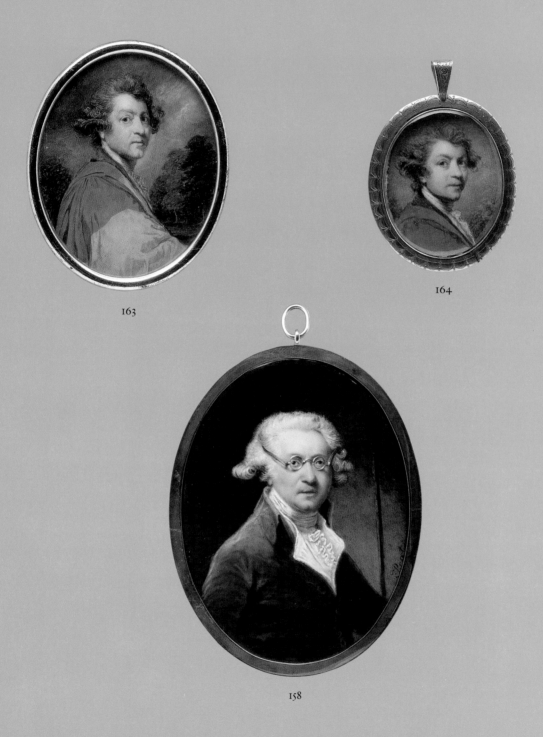

163

164

158

163. Archibald Robertson, *Sir Joshua Reynolds* (1723–1792), about 1786–91

164. Style of William Grimaldi, *Sir Joshua Reynolds* (1723–1792), 1773 or later

158. Thomas Peat, *Sir Joshua Reynolds* (1723–1792), dated 1792

165. William Wood, *An Interesting Story (Miss Ray)*, dated 1806

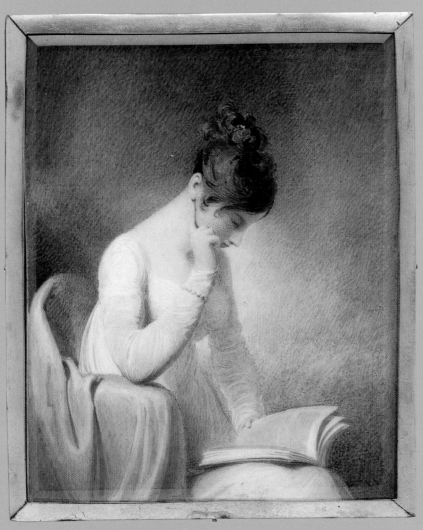

165

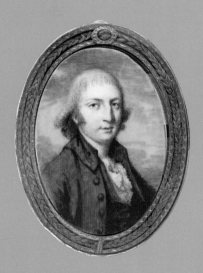

282. British, *A Man with the Initials RH*, about 1780

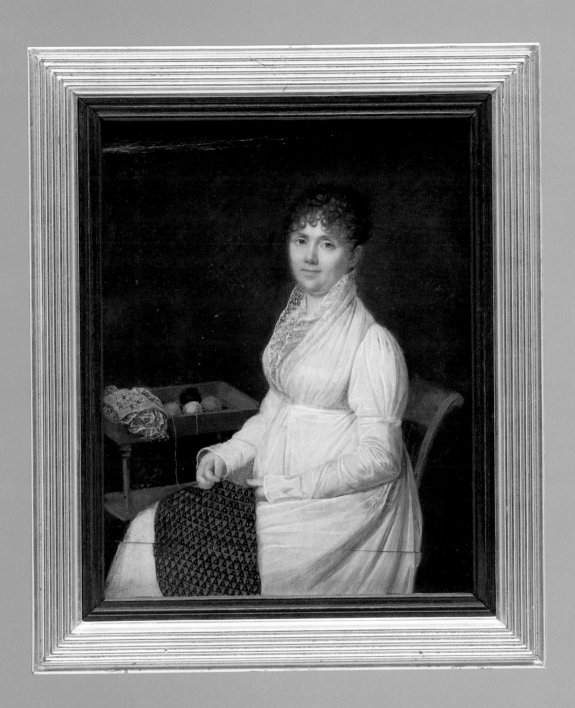

170. Style of Jean Baptiste Jacques Augustin, *Portrait of a Woman with Tapestry Work*, about 1800–1810

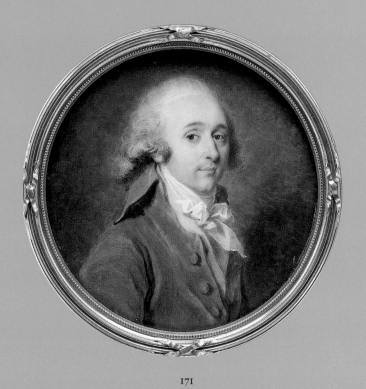

171

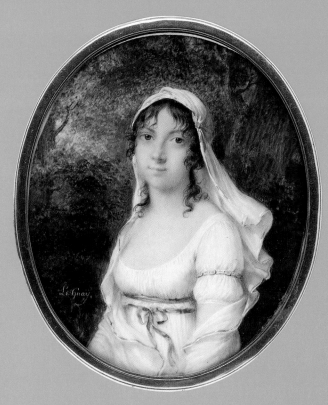

173

171. Jean Urbain Guérin, *Alexandre Théodore Victor* (1760–1829), *Comte de Lameth*, about 1789–90

173. Étienne Charles Le Guay, *Portrait of a Woman*, about 1800

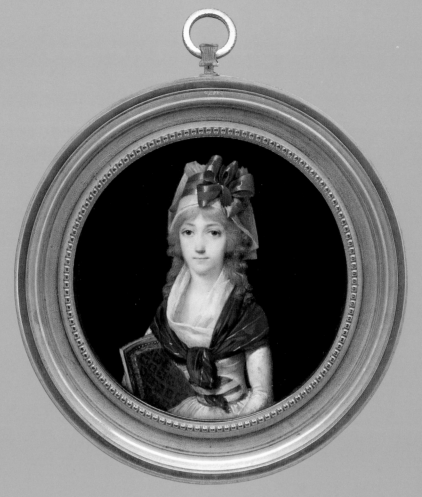

177

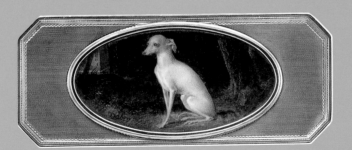

178

177. Jean Baptiste Isabey, *Portrait of a Woman*, about 1795

178. Jean Baptiste Isabey, *A Whippet*, about 1800

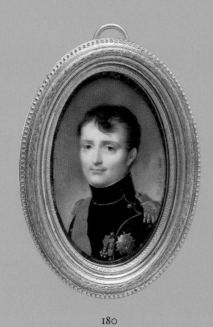

180

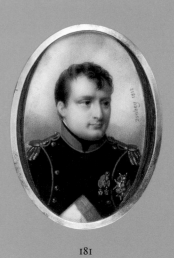

181

182

180. Jean Baptiste Isabey, *Napoléon I* (1769–1821), dated 1810 181. Jean Baptiste Isabey, *Napoléon I* (1769–1821), dated 1812

182. Jean Baptiste Isabey, *The Empress Marie-Louise*, dated 1812

183. Jean Baptiste Isabey, *Mrs. Rufus Prime* (Augusta Temple Palmer, 1807–1840), 1828

189

190

189. Vincent Bertrand, *Portrait of a Woman*, about 1810 190. Anthelme François Lagrenée, *Empress Maria Feodorovna,*

Her Son Grand Duke Michael Pavlovich, and Her Daughter-in-law Elena Pavlovna, about 1824

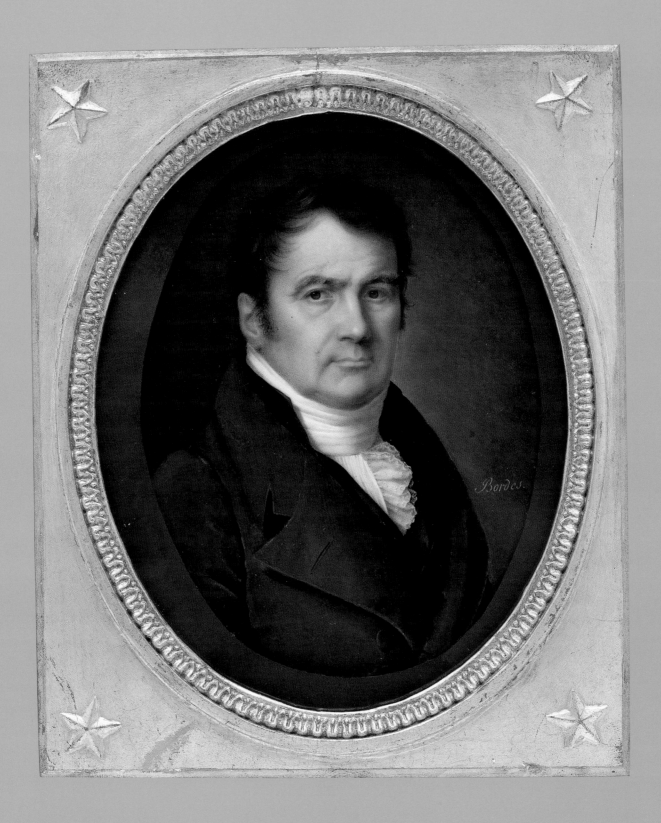

198. Joseph Bordes, *Portrait of a Man*, about 1810

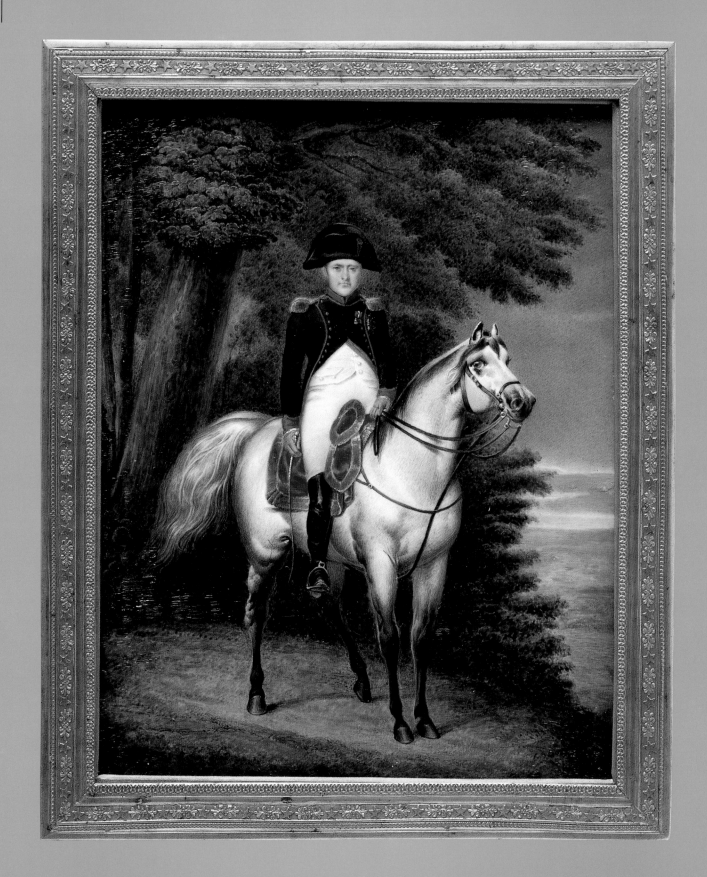

207. Luigi Marta, *Napoléon I (1769–1821) on Horseback*, dated 18[30?]

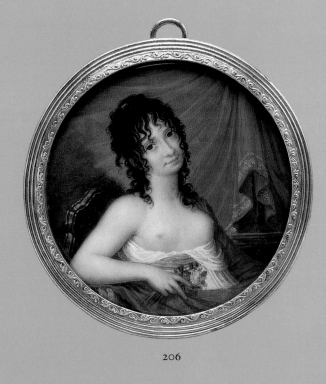

206

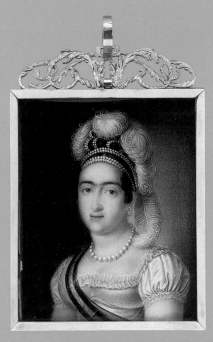

218 OBVERSE

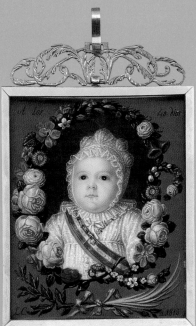

218 REVERSE

206. Giovanni Battista Gigola, *Portrait of a Woman, Said to Be Pauline Borghese* (1780–1825)

218. Luis de la Cruz y Rios, *Princess María Francisca de Asis de Borbón and Her Son Infante Carlos Luis María Fernando de Borbón*, dated 1818

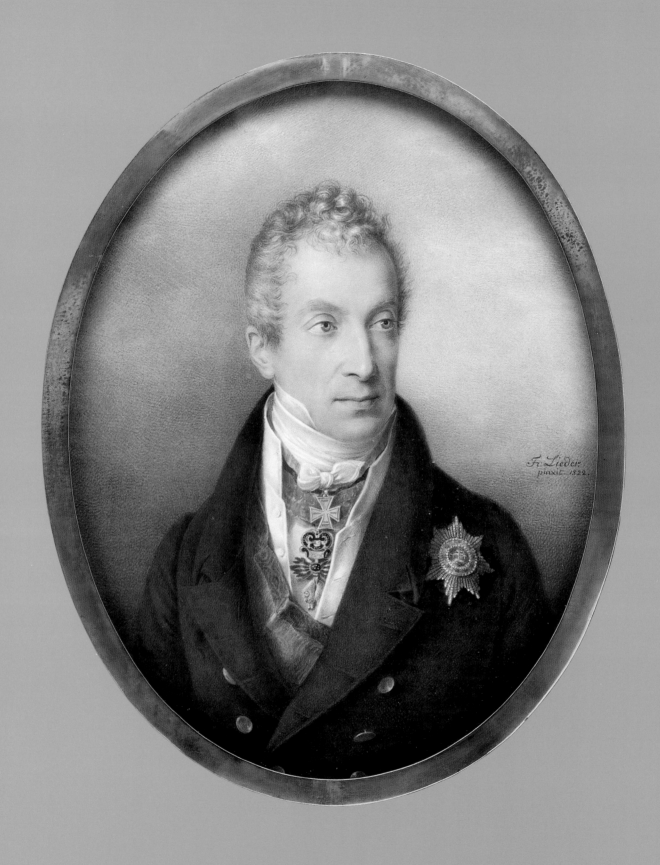

210. Friedrich Johann Gottlieb Lieder, *Prince Klemens Wenzel Lothar von Metternich (1773–1859)*, dated 1822

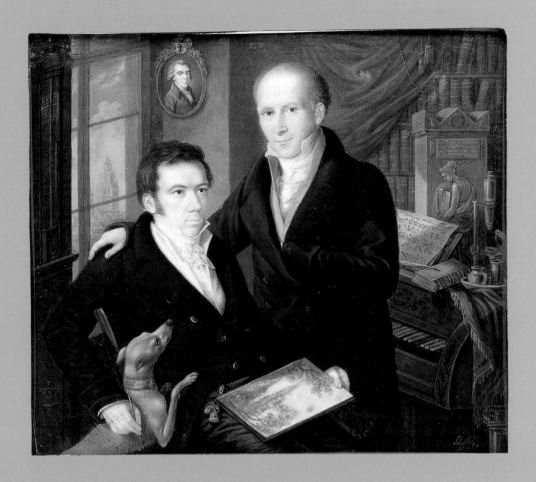

215. Heinrich Franz Schalck, *Joseph and Karl August von Klein*, about 1810–15

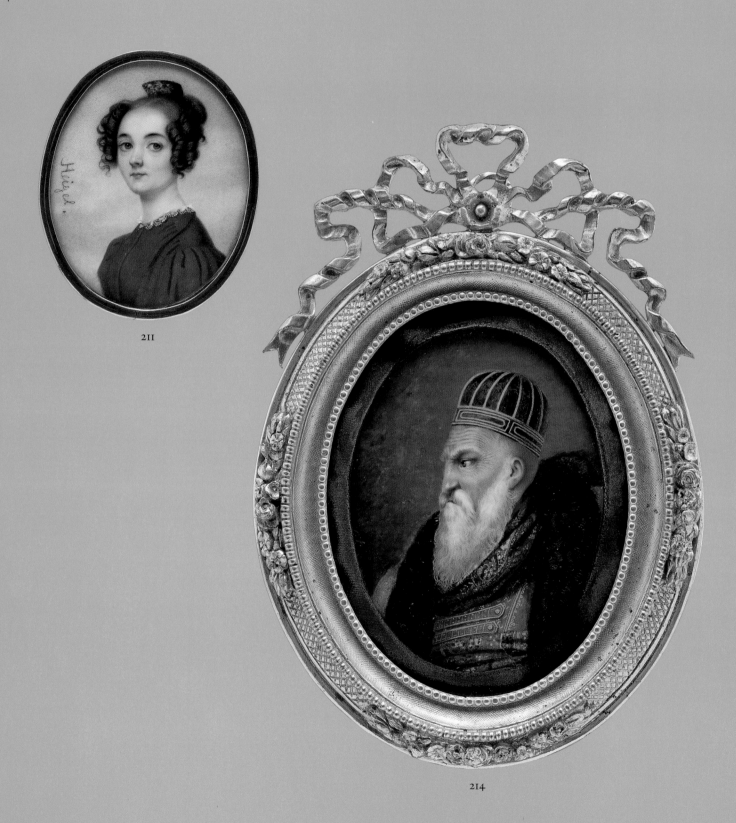

211. Attributed to Josef Heigel, *Lola Montez* (1818–1861)

214. Jacob Ritter von Hartmann, *Ali Pasha* (born about 1741, died 1822), dated 1822

225. Henry Bone, *Charles X* (1757–1836), *King of France, after Gérard*, dated 1829

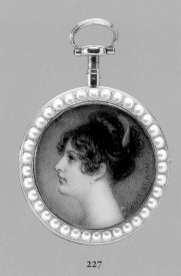

227

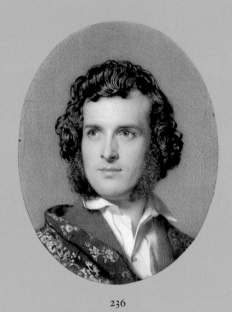

236

227. Adam Buck, *Portrait of a Woman, Said to Be Emma* (1765–1815), *Lady Hamilton*, dated 1804

236. Attributed to John Faed, *Self-portrait*, about 1850

Catalogue

Note to the Reader

The entries have been arranged in two sections. The first, nos. 1–236, comprises the more significant miniatures. The second, nos. 237–91, called the Appendix, consists of miniatures of lesser importance, including several of dubious authenticity; these have been catalogued in a more summary manner. Within each group the miniatures have been arranged chronologically by centuries and schools.

Measurements have been made in millimeters and are given in inches and millimeters, height before width. The word "signed" is used to indicate signatures and initials believed to have been written by the artist. The word "dated" is used to indicate dates believed to have been written by the artist. "Inscribed" denotes other information, and inscriptions by another hand or not certainly by the artist.

Condition is noted for every object that has been treated and whenever there is something exceptional to record. The water-color pigments used in the majority of miniatures are susceptible to fading over the years, and since most of those in the present collection have long been exposed to daylight, they are to some extent altered from their original appearance.

"Ex coll." refers to the previous history of the miniature, when known; "Exhibited" to any exhibitions in which the miniature is known to have been included; and "Literature" to published and some unpublished references to the miniature.

In accordance with the usual practice, small paintings of a miniature-like quality in enamel or oil on metal are included in the catalogue. So are the fine small portraits in graphite on vellum known as plumbagos. Silhouettes, of which the Department of Drawings and Prints has a study collection, are not included.

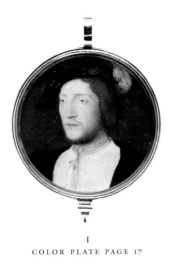

I

COLOR PLATE PAGE 17

Jean Clouet

French, active by 1516, died 1540/41

Jean Clouet, who may have been born in the Low Countries, was a painter and draftsman at the court of Francis I (1494–1547), king of France. His name first appears in the French royal accounts in 1516, the year after the accession of Francis I, and he is known to have been married and living in Tours in 1521. By 1523 he is mentioned as the second court painter, after Jean Perréal, whose name disappears from the accounts after 1527. From that date Jean Clouet was the dominant painter. In 1540 he was succeeded in the royal accounts by his son, François Clouet.

Jean Clouet was a prolific portrait draftsman, and some fifteen oil paintings are also attributed to him, including one documented portrait, that of Guillaume Budé (Metropolitan Museum). He is credited with the origination of the portrait miniature, the earliest known examples being the "Preux de Marignan," seven roundels which illustrate the second volume of *La guerre gallique*, an illuminated manuscript in the Bibliothèque Nationale, Paris (MS fr. 13429). These established the earliest norm for the portrait miniature: a three-quarter face, head-and-shoulders representation in a roundel, carried out in the limner's medium of water- and body-color on vellum. The final stage in the development of the portrait miniature was to detach the image from the manuscript page and present it as a separate work of art. Clouet did this in two known examples: one is in the British Royal Collection at Windsor Castle, and the other is no. 1 below.

I

Charles de Cossé (1506–1563), *Count of Brissac*

Vellum, diam. 1½ in. (37 mm)

Inscribed (reverse, on card): *Henri II / Roi de France*; *Henry 2ᵈ* ; *766*

Fletcher Fund, 1935 (35.89.1)

Wearing a white undershirt edged with gold decoration, a slightly darker white doublet edged and tied with gold, black cloak, black cap with white feather, gold medallion, and gold pins. Bright blue eyes; brown hair, beard, and slight mustache. Dark blue background.

The plain gold frame is glazed at the back to reveal a card on which the vellum is probably laid. A label fixed to the back is printed with the number *383* (the miniature's number in the Pierpont Morgan collection).

EX COLL.: J. Pierpont Morgan, London and New York (by 1905–13); J. P. Morgan, New York (1913–35; his sale, Christie's, London, June 24, 1935, no. 10, to Knoedler for MMA).

LITERATURE: Louis Dimier, "Une miniature . . . qu'on présume être Jean Clouet," *Bulletin de la société nationale des antiquaires de France* (Nov. 8, 1905), pp. 306–8; G. C. Williamson, *Catalogue of the Collection of Miniatures the Property of J. Pierpont Morgan*, vol. 3 (London, 1907), pp. 3–5, no. 383, pl. CXIII, no. 1, and pl. CXIII, no. 4 (the related drawing); G. C. Williamson, "Mr. J. Pierpont Morgan's Pictures: The Foreign Miniatures. VI," *Connoisseur* 18 (1907), pp. 203–4, ill. LXXXI; Étienne Moreau-Nélaton, *Chantilly: Crayons français du XVIᵉ siècle* (Paris, 1910), pp. 169, 170; Louis Dimier, *Histoire de la peinture de portrait en France au XVIᵉ siècle*, vol. 1 (Paris and Brussels, 1924), p. 25, pl. 2, and vol. 2 (Paris and Brussels, 1925), p. 38, no. 9; Étienne Moreau-Nélaton, *Les Clouets et leurs émules* (Paris, 1924), vol. 1, p. 57, fig. 13; Irene Adler, "Die Clouet: Versuch einer Stilkritik," *Jahrbuch der Kunsthistorischen Sammlungen in Wien*, N.F., 3 (1929), p. 242; Harry B. Wehle, "Four Famous Miniatures," *Metropolitan Museum Bulletin* 30 (1935), pp. 187–88, ill. (cover); Torben Holck Colding, *Aspects of Miniature Painting: Its Origins and Development* (Copenhagen, 1953), pp. 78, 87; Anthony Blunt, *Art and Architecture in France: 1500 to 1700*, 2nd ed. (Baltimore, 1970), p. 35; Peter Mellen, *Jean Clouet* (London, 1971), pp. 39, 224–25, 234, no. 134, pl. 106 (the miniature), and pp. 39, 224–25, no. 83, pl. 105 (the drawing); Katharine Baetjer, "Pleasures and Problems of Early French Painting," *Apollo* 106 (1977), p. 347, fig. 10; Graham Reynolds, *English Portrait Miniatures*, rev. ed. (Cambridge, 1988), p. 2; Graham Reynolds, *Catalogue of the Tudor and Stuart Miniatures in the Collection of H. M. the Queen* (Cambridge, 1996), no. 1.

THE HISTORY of this miniature before it entered the Pierpont Morgan collection is not known, but the inscriptions on the reverse show that it had been in both a French and an English collection. The identification of the sitter as Henry II (1519–1559) of France was abandoned when it was pointed out by Dimier (1905) that the miniature is based upon a drawing by Jean Clouet in the Musée Condé, Chantilly (no. 169), which is inscribed "brisac depuis marichal" (also transcribed "brasac"). There are copies of the drawing in various albums (e.g., Heseltine, Destailleur, Hermitage, Fontette, and Valori).

The sitter, Charles de Cossé, was descended from one of the most illustrious noble families in France. Frail as a child, he was later known as "le beau Brissac" and is said to have been the favorite of Diane de Poitiers (1499–1566), thereby incurring the jealousy of Henry II. A soldier who first distinguished himself at the

siege of Naples in 1528, Cossé-Brissac was marshal of France in 1550, governor of Picardy in 1560, and subsequently commandant of Paris and the Île-de-France.

With the sole exception of the miniature at Windsor Castle (Reynolds 1996, no. 1), this is the only known independent portrait miniature by Jean Clouet. Estimates for its date, which depends on the sitter's age, vary from 1531 (Dimier 1924) to 1540 (Moreau-Nélaton 1910). A median date of about 1535 seems plausible. The miniature at Windsor represents the dauphin Francis (1518–1536) and is datable to about 1526, rivaling Lucas Hornebolte's portraits of Henry VIII, of about 1525–27, for the distinction of being the first independent portrait miniature, outside the pages of a manuscript.

François Clouet

French, born 1520 or shortly before, died 1572

François Clouet was the son of Jean Clouet (no. 1) and succeeded him in 1540 as court painter to Francis I and his successors. He painted some portrait miniatures in a style derived from his father's. There were many followers and copyists of his drawings and other works. No. 2 is not by him but is executed in a rather mechanical version of his style of miniature painting.

Style of François Clouet

French, 1578 or later

2
Henry III (1551–1589), *King of France*

Vellum laid on wood, 2¼ x 1¾ in. (58 x 44 mm)
Inscribed (reverse, on wood): *Henry 3ᵐᵉ / Roy de / France* [?85]; *by Clouet*
Bequest of Mary Clark Thompson, 1923 (24.80.512)

Wearing a black doublet with gold buttons, white collar, blue ribbon of the Order of the Saint-Esprit, and gold earring with red jewel on right ear. Dark brown hair; black hat with gold and jeweled ornament. Blue background.

The miniature was in a champlevé enamel frame of recent date, which is no longer in use. This frame is decorated with the letter H, a shield with the lilies of France, and the dove of the Order of the Saint-Esprit (established by Henry III in 1578). The back of the frame has the H and two Greek lambdas, crowned and surrounded by the cord of the Order of the Cordelières (founded in 1498). This form of cipher was used by Louise of Lorraine (1553–1601), wife of Henry III. Around the outer edge of the

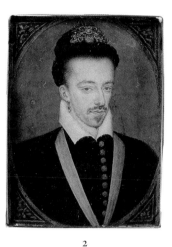

2

COLOR PLATE PAGE 20

3

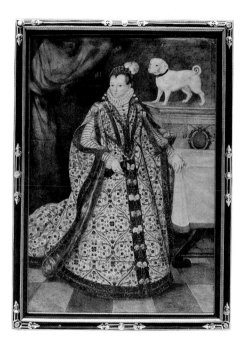

device is lettered on a band of gold CLOVET PINX AET 24 ANNO. D. 1575.

The ink inscriptions on the reverse show that the miniature was in a French collection, probably in the eighteenth century, and later in an English collection.

SOME authorities have been inclined to believe that the frame is a late-sixteenth-century one and that therefore the information on it should be given credence. However, the date 1575 given on the frame is inconsistent with the attribution of the portrait to François Clouet, who died in 1572. Furthermore, since the Order of the Saint-Esprit was not revived until 1578, its emblem on a frame dated 1575 is anachronistic. The fact that the sitter is wearing the blue ribbon of that order establishes a date of 1578 or later for this miniature, and it cannot therefore be by François Clouet. Although apparently a late-sixteenth-century production, it is carried out in a weak version of Clouet's style.

The identity of the sitter appears to be confirmed by comparison with a Clouet school drawing in the Bibliothèque Nationale (Fonds Ste.-Geneviève, no. 118), Paris (reproduced in Étienne Moreau-Nélaton, *Les Clouets et leurs émules* [Paris, 1924], vol. 2, fig. 283, and vol. 3, p. 77).

Henry III (1551–1589), the third son of Henry II (1519–1559) and Catherine de Médicis (1519–1589), succeeded his brother Charles IX as king of France in 1574. Indolent, vicious, and corrupt, he was under the influence of his mother and

before his accession had helped her organize the Massacre of Saint Bartholomew's Day. The monk Jacques Clément stabbed him in 1589 to avenge the murders of Henry, duc de Guise, and his brother. Henry III was the last of the house of Valois.

Pieter Pietersz the Younger

Netherlandish, born about 1550, died 1611

Born in Bruges, Pietersz was probably the son of an Italian painter working in that city. In 1574 he settled in northwestern Moravia at Moravská Třebová, where he later died. According to the inventory of his property made at his death, which is preserved in the local archives, he painted portraits in miniature.

Attributed to Pieter Pietersz the Younger

3
Portrait of a Moravian Woman

Vellum, 10½ x 7¼ in. (266 x 183 mm)
Bequest of Mary Clark Thompson, 1923 (24.80.529)

Wearing a richly embroidered dress in blue, red, silver, and gold on a white ground, red-lined cloak with gold embroidery, white ruff, and black cap

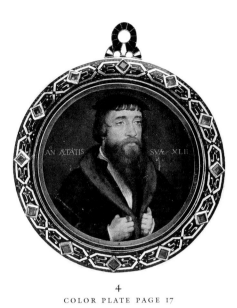

4

COLOR PLATE PAGE 17

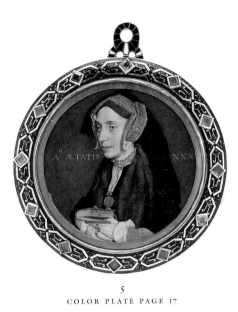

5

COLOR PLATE PAGE 17

with a white feather. Brown hair. In the background a table covered with a yellow cloth and a white dog standing on a plinth. There is a black border with an inner edge of gold around the perimeter.

CONDITION: The surface is abraded, and silver metallic paint used for details of the costume has tarnished. When released from its old mount, the cockled and creased vellum relaxed. The miniature was provided with a spacer and a backing of acid-free ragboard. The frame was repaired, and the coat of arms (see below) removed.

THIS LARGE miniature was formerly attributed to Nicholas Hilliard and was said to be a portrait of Mary Tudor (1496–1533), sister of Henry VIII of England, queen of Louis XII of France, and subsequently duchess of Suffolk. The recent frame was decorated with the arms of England at the top to accord with this identification. However, neither the attribution nor the identification is possible.

The miniature may be compared in style and presentation with one of similar size in the Victoria and Albert Museum, London (no. P.168–1910; 10⅝ x 7¾ in. [270 x 197 mm]). That full-length portrait of Anna Černohorská of Boskovice, aged eleven, is inscribed and dated 1589 and is attributed to Pieter Pietersz (Podává K. Svoboda, "Podobizna Anny Černohorské z Boskovic v Londýně," *Památky archeologické* 35 [1926], pp. 464–67, pl. 167). Unfortunately the present miniature lacks the coat of arms or inscription for which the frame attached to the plinth at right was doubtless intended.

Hans Holbein the Younger

German, 1497/98–1543

Holbein was born in Augsburg, the younger son of the painter Hans Holbein the Elder, from whom he received his first instruction in art. By 1515 he moved to Basel, where he came to know a number of leading humanists and reformers. He paid his first visit to England in 1526, with an introduction from Erasmus to Sir Thomas More. He went back to Basel in 1528 but returned to England in 1532 and, apart from short visits to the Continent, lived there until 1543 when at the age of forty-six he died of the plague. He is not known to have painted portrait miniatures until his second visit to England. He was then taught the art by one "Master Lucas," universally identified with Lucas Hornebolte, who painted the first miniatures in England at about the same time as Jean Clouet's separation of the miniature from the manuscript page. Current estimates of the number of known portrait miniatures by Holbein range from thirteen (Rowlands 1985) to twenty; nos. 4 and 5 below are accepted in the most restricted assessments.

4

William Roper (1493/94–1578)

(pendant to 50.69.2)

Vellum laid on card, diam. 1¾ in. (45 mm)

Inscribed (horizontally, in gold): A⁰ N ÆTATIS SVÆ · XLIↃ ·

Rogers Fund, 1950 (50.69.1)

Wearing a black fur-lined cloak over a black doublet lined with brown leather, white shirt, and black cap; jeweled ring on each little finger and on right index finger. Dark brown hair and beard. Blue background.

The card on which the vellum is laid is covered with a brown fabric. Partial attempts to scrape it off have revealed plain card underneath this recent covering.

The miniature is in an early-twentieth-century frame in the Renaissance style. A circular card, loosely inserted in the frame at the reverse of the miniature, is inscribed in pencil *Ernest Adolph Malschinger / 219 Gaisford St / Kentish Town / NW / London / June 3ʳᵈ 1907* (presumably the name and address of the jeweler who made this frame and that of no. 5 when both miniatures were owned by Alfred de Rothschild).

CONDITION: Although there are three or four minute areas of abrasion and slight crazing in the shirt front, the miniature is in general in very good condition.

EX COLL.: By descent in the Roper family; Alfred de Rothschild, Halton and London (by 1906–18); Almina, countess of Carnarvon, Bretby Park and London (1918–24); [Duveen Bros., London and New York, 1924–28]; Mr. and Mrs. Henry Goldman, New York (1928–37); Mrs. Henry Goldman (1937–48); [Duveen Bros., New York, 1948–50].

EXHIBITED: Metropolitan Museum of Art, 1950, *Four Centuries of Miniature Painting*, list, p. 2; Metropolitan Museum of Art, 1956, *German Drawings*, cat. supp., no. 200; National Portrait Gallery, London, 1977–78, *"The King's Good Servant": Sir Thomas More*, exh. cat. by J. B. Trapp and Hubertus Schulte Herbrüggen, no. 174; Frick Collection, New York (1978–79); Victoria and Albert Museum, London, 1983, *Artists of the Tudor Court: The Portrait Miniature Rediscovered*, exh. cat. by Roy Strong, no. 27; Pierpont Morgan Library, New York (1983).

LITERATURE: H. C. Marillier, *Christie's 1766–1925* (London, 1926), p. 225; William Roper, "The Lyfe of Sir Thomas Moore . . . ," ed. E.V. Hitchcock, *Early English Text Society*, o.s., 197 (1935), pp. xxxix–xlvii; Paul Ganz, *Die Handzeichnungen Hans Holbeins d. J.* (Berlin, 1937), p. 21; Paul Ganz, *The Paintings of Hans Holbein* (London, 1950), p. 258, no. 134, pl. 175; F. Grossmann, "Holbein Studies — II," *Burlington Magazine* 93 (1951), p. 114; Josephine L. Allen, "Some Notes on Miniatures," *Metropolitan Museum Bulletin*, n.s., 13 (1955), pp. 244–45, ill.; E. E. Reynolds, *Margaret Roper* (London, 1960), pp. 30, 142, pl. VI; Leo R. Schidlof, *The Miniature in Europe* (Graz, 1964), vol. 1, p. 368, vol. 2, p. 975, no. 569, and vol. 3, pl. 290; Daphne Foskett, *Collecting Miniatures* (Woodbridge, Suffolk, 1979), p. 47; Jane Roberts, *Holbein* (London, 1979), p. 96, fig. 93; Roy Strong, in *The English Miniature*, exh. cat. (New Haven and London, 1981), p. 36, fig. 51; Roy Strong, *The English Renaissance Miniature* (New York, 1983), p. 47, no. 5, fig. 42; John

Rowlands, *Holbein* (Oxford, 1985), pp. 90, 150, no. M.4, pl. 128; Graham Reynolds, *English Portrait Miniatures*, rev. ed. (Cambridge, 1988), pp. 6–7, ill.

WILLIAM ROPER, a Kentish landowner, lawyer, and four-time member of Parliament, was a member of Sir Thomas More's household for more than sixteen years and married his eldest daughter, Margaret, in 1521. This miniature was presumably painted at the same time as that of his wife (no. 5) and can therefore be dated to 1535–36, in which case the date of the sitter's birth, formerly recorded as between 1493 and 1498, could be more precisely given as about 1493–94. There is no other known portrait of Roper. His *Lyfe of Sir Thomas Moore*, written about 1557 and widely circulated in manuscript, gives a personal and sympathetic view of his father-in-law and the ordered calm of More's domestic life.

5
Margaret More (1505–1544), *Wife of William Roper*
(pendant to 50.69.1)

Vellum laid on playing card, diam. 1¾ in. (45 mm)
Inscribed (horizontally, in gold): Aᴼ ÆTATIS XXXᵟ
Rogers Fund, 1950 (50.69.2)

Wearing a black dress with pink sleeves and fur tippet over white shift embroidered with black at neck and cuffs; white cap embroidered with pink and gold, with black veil behind; figured gold brooch at bosom and jeweled ring on each index finger. Holding a book bound in green leather. Blue background.

The card on which the vellum is laid is covered with a brown fabric. This has been partially removed to reveal a court playing card.

The miniature is in an early-twentieth-century frame similar to that for no. 4, evidently also made by Malschinger.

CONDITION: The miniature is in very good condition except for two small losses near the bottom edge and some blackening of the white lead of the garment and headdress. Gold is used for the finger rings and the brooch, for highlights on the collar and headdress, and for the fore-edge of the book. Under magnification it can be seen that the brooch is decorated with a full-length figure.

EX COLL.: By descent in the Roper family; Alfred de Rothschild, Halton and London (by 1906–18); Almina, countess of Carnarvon, Bretby Park and London (1918–24); [Duveen Bros., London and New York, 1924–28]; Mr. and Mrs. Henry Goldman, New York (1928–37); Mrs. Henry Goldman (1937–48); [Duveen Bros., New York, 1948–50].

EXHIBITED: Metropolitan Museum of Art, 1950, *Four Centuries of Miniature Painting*, list, p. 2; Metropolitan Museum of Art, 1956, *German Drawings*, cat. supp., no. 200; National Portrait Gallery, London, 1977–78, *"The King's Good Servant": Sir Thomas More*, exh. cat. by J. B. Trapp and Hubertus

Schulte Herbrüggen, no. 174; Frick Collection, New York (1978–79); Victoria and Albert Museum, London, 1983, *Artists of the Tudor Court: The Portrait Miniature Rediscovered*, exh. cat. by Roy Strong, no. 28; Pierpont Morgan Library, New York (1983).

LITERATURE: H. C. Marillier, *Christie's 1766–1925* (London, 1926), p. 225; William Roper, "The Lyfe of Sir Thomas Moore . . . ," ed. E.V. Hitchcock, *Early English Text Society*, o.s., 197 (1935), pp. xxxix–xlvii; Paul Ganz, *Die Handzeichnungen Hans Holbeins d. J.* (Berlin, 1937), p. 21; Paul Ganz, *The Paintings of Hans Holbein* (London, 1950), p. 258, no. 135, pl. 176; F. Grossmann, "Holbein Studies — II," *Burlington Magazine* 93 (1951), p. 114; Josephine L. Allen, "Some Notes on Miniatures," *Metropolitan Museum Bulletin*, n.s., 13 (1955), pp. 244–45, ill.; E. E. Reynolds, *Margaret Roper* (London, 1960), pp. 30, 142, pl. VI; Leo R. Schidlof, *The Miniature in Europe* (Graz, 1964), vol. 1, p. 368, vol. 2, p. 975, no. 569a, and vol. 3, pl. 290; Daphne Foskett, *Collecting Miniatures* (Woodbridge, Suffolk, 1979), p. 47; Jane Roberts, *Holbein* (London, 1979), p. 96, fig. 92; Roy Strong, in *The English Miniature*, exh. cat. (New Haven and London, 1981), p. 36, fig. 52; Roy Strong, *The English Renaissance Miniature* (New York, 1983), p. 46, no. 4, fig. 43; John Rowlands, *Holbein* (Oxford, 1985), pp. 90, 150, no. M.3, pl. 128; Graham Reynolds, *English Portrait Miniatures*, rev. ed. (Cambridge, 1988), p. 6; John Rowlands with the assistance of Giulia Bartrum, *The Age of Dürer and Holbein: German Drawings 1400–1550*, exh. cat. (Cambridge, 1988), p. 234.

MARGARET (1505–1544) was the eldest child and favorite daughter of Sir Thomas More. She married William Roper (no. 4) in 1521. She was born about October 1505, and the age assigned to her in the artist's inscription indicates that this miniature was painted in 1535–36, shortly after her father's execution. She is one of the ten figures in *The Family of Sir Thomas More*, a painting on which Holbein worked from 1526 to 1528. In that representation she also reads a book, showing her dedication to learning. The painting of the family group is lost and is known only from Holbein's drawing in the Öffentliche Kunstsammlung, Basel, and from later copies by Rowland Lockey (died 1616); one of those copies was probably painted for William and Margaret Roper's son Thomas about 1593. In the eighteenth century it was still in the family house, Well Hall, Eltham, Kent (Rowlands 1985, L.10c).

6
Thomas Wriothesley (1505–1550), *First Earl of Southampton*

Vellum laid on card (irregular, cut down), 1⅛ x 1 in. (28 x 25 mm)
Rogers Fund, 1925 (25.205)

Wearing a black ermine-lined mantle over leather-lined coat, brown doublet tied with black tag, white collar, gold chain, and black cap. Bright blue

eyes; brown hair, mustache, and beard. Purplish blue background.

A label on the rough brown glass at the reverse of the frame is stamped DOUANE / · PARIS · / CENTRALE.

CONDITION: The slight light blue rim at left of the sitter's head is due to repainting. The original edge may have suffered from damp, necessitating the cutting down of the miniature.

EX COLL.: By descent to Lady Elizabeth Wriothesley, daughter of the fourth and last earl of Southampton, who in 1661 married Edward Noel, first earl of Gainsborough; by descent to Lady Susannah Noel, daughter of the third earl of Gainsborough, who in 1724 married Anthony Ashley, fourth earl of Shaftesbury; by descent to Anthony, seventh earl of Shaftesbury; bought from him by Sir Francis Cook, Richmond (about 1875–1901); Wyndham F. Cook, London (1901–5); Humphrey W. Cook, London (1905–25); his sale, Christie's, London, July 7–10, 1925, no. 307, to Agnew); [Agnew and Sabin, London, 1925].

EXHIBITED: South Kensington Museum, London, 1865, *Portrait Miniatures*, no. 2093; Burlington Fine Arts Club, London, 1889, *Portrait Miniatures*, case XXVIII, no. 8.

LITERATURE: George Scharf, *Catalogue of . . . Pictures at Woburn Abbey* (1890), p. 5, no. 5; Gerald S. Davies, *Hans Holbein the Younger* (London, 1903), p. 218; *Catalogue of the Cook Collection* (1904), pp. v, 110, 147, no. 665; George C. Williamson, *History of Portrait Miniatures* (London, 1904), vol. 1, p. 11; Dudley Heath, *Miniatures* (London, 1905), p. 96; Richard W. Goulding, "Wriothesley Portraits: Authentic and Reputed," *Walpole Society* 8 (1919–20), p. 47, pl. XIII; Bryson Burroughs, "A Miniature by Holbein," *Metropolitan Museum Bulletin* 21 (1926), pp. 98–99, ill. (cover); H. C. Marillier, *Christie's 1766–1925* (London, 1926), p. 228; Basil S. Long, *British Miniaturists* (London, 1929), pp. 214–15; Wilhelm Stein, *Holbein* (Berlin, 1929), p. 267; Clare Stuart Wortley, "The Portrait of Thomas Wriothesley, Earl of Southampton, by Holbein," *Burlington Magazine* 57 (1930), pp. 82, 85–86, ill. p. 83; Charles L. Kuhn, *German Paintings . . . in American Collections* (Cambridge, Mass., 1936), p. 84, no. 381; L. Demonts, *Musée du Louvre, Inventaire général des dessins des écoles du nord*, vol. 1 (Paris, 1937), p. 46; Paul Ganz, *Die Handzeichnungen Hans Holbeins d. J.* (Berlin, 1937), p. 20; Carl Winter, "Holbein's Miniatures," *Burlington Magazine* 83 (1943), pp. 266, 269; Paul Ganz, *The Paintings of Hans Holbein* (London, 1950), p. 259, no. 138, pl. 177; Graham Reynolds, *English Portrait Miniatures* (London, 1952), p. 4; Torben Holck Colding, *Aspects of Miniature Painting: Its Origins and Development* (Copenhagen, 1953), p. 80; Daphne Foskett, *British Portrait Miniatures: A History* (London, 1963), pp. 42–43; Arlette Calvet, in *Le XVIᵉ siècle européen*, exh. cat. (Paris, 1965), p. 29; Roseline Bacou, *Great Drawings of the Louvre Museum* (New York, 1968), under no. 26; Roberto Salvini and Hans Werner Grohn, *Holbein il Giovane* (Milan, 1971), p. 106, no. 114a, ill.; Daphne Foskett, *A Dictionary of British Miniature Painters* (London, 1972), vol. 1, p. 332; Graham Reynolds, "Portrait Miniatures from Holbein to Augustin," *Apollo* 104 (1976),

p. 275; Roy Strong, *The English Renaissance Miniature* (New York, 1983), p. 46, no. 3, fig. 38; John Rowlands, *Holbein* (Oxford, 1985), p. 239, no. R.M. 1, pl. 258; Graham Reynolds, "Hans Holbein the Younger Re-examined [review of Rowlands, *Holbein*, 1985]," *Apollo* 123 (1986), p. 216; Graham Reynolds, *English Portrait Miniatures*, rev. ed. (Cambridge, 1988), p. 6.

THIS IS a miniature version of the drawing of Thomas Wriothesley, first earl of Southampton, by Holbein in the Cabinet des Dessins, Musée du Louvre (no. RF 4651). Most unusually for a sixteenth-century work the miniature's provenance can be traced to the sitter, whose identity has not been questioned. (When lent to the exhibition of portrait miniatures at the South Kensington Museum in 1865, it was described as a portrait of a gentleman in a furred dress, and the correct name was supplied by Sir George Scharf.)

The attribution to Holbein has not passed without challenge, although it is accepted as his work in most of the literature cited above. Goulding questioned it on the ground that Wriothesley is wearing the same ermine-lined mantle as in an anonymous portrait at Woburn Abbey showing him after he received the Garter in 1545, two years after Holbein's death. However, Wortley disposes of this argument, pointing out that the Garter is not shown in the miniature, which was therefore painted before 1545 — in fact by 1543, the year of Holbein's death. More recently Rowlands (1985, no. R.M. 1) listed it among the miniatures he rejects from Holbein's oeuvre, finding in it a similarity of handling with Hilliard's self-portrait of 1577. In fact, the miniature has been cut down, and the background has probably been repainted. Its appearance is therefore initially unlike Holbein's generally accepted miniatures which are, with one exception, circular; here the features fit uncomfortably into the reduced format. But the exquisite delicacy of the brushwork, the finesse of rendering in the variations of costume, the thin brushstrokes in the hair, the slender outline of the nose, and the subtly modulated gray shadowing on the face all establish that, although it has suffered around the edges, it remains a miniature portrait in Holbein's finest style.

Thomas Wriothesley (1505–1550), first earl of Southampton, rose to power in the court of Henry VIII under the influence of Thomas Cromwell, earl of Essex, and was enriched through the dissolution of the monasteries. In 1538 he was sent as ambassador to the Netherlands to propose marriage between Henry VIII and Christina, duchess of Milan, whose portrait (National Gallery, London) Holbein had

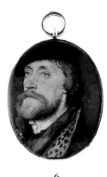

6
COLOR PLATE PAGE 18

painted for the king. The present miniature may date a year or two earlier. Wriothesley became lord chancellor in 1544, but his position was weakened by the death of Henry VIII in 1547, and he died in disgrace three years later.

Imitator of Hans Holbein the Younger

17th or early 18th century

7
Portrait of a Man, Said to Be Arnold Franz

Vellum laid on card, diam. 2⅛ in. (53 mm)
Bequest of Millie Bruhl Fredrick, 1962 (62.122.109)

Wearing a black doublet, white collar, and black cap. Brown eyes. Blue background.

The miniature is in a recent Renaissance-style frame with a black enamel rim and three pendant pearls. The frame is inscribed *ÆT 32* in the enamel at bottom and ARNOLD FRANZ HOLBEIN PINX on the back.

EX COLL.: J. Pierpont Morgan, London and New York (by 1908–13); J. P. Morgan, New York (1913–35; his sale, Christie's, London, June 24, 1935, no. 127, to Walker).

LITERATURE: G. C. Williamson, *Catalogue of the Collection of Miniatures the Property of J. Pierpont*

7
COLOR PLATE PAGE 18

Morgan, vol. 1 (London, 1906), pp. 7–8, no. 3, pl. III, no. 1, as by Hans Holbein the Younger; E. G. Paine, unpublished list of miniatures in the Fredrick collection (1960), no. 135, as by Hans Holbein the Younger.

THE MINIATURE was probably produced in the seventeenth or early eighteenth century with the intention of it being passed off as a work by Hans Holbein the Younger (1497/98–1543). A somewhat similar miniature apparently intended to show the same man — but painted on card and showing him less full face — is in the collection of H. M. the Queen, Windsor Castle (Graham Reynolds, *Catalogue of the Tudor and Stuart Miniatures in the Collection of H. M. the Queen* [Cambridge, 1996], no. 12). Two other miniatures of the same character are in the Orange-Nassau collection (Karen Schaffers-Bodenhausen and Marieke Tiethoff-Spliethoff, *The Portrait Miniatures in the Collections of the House of Orange-Nassau* [Zwolle, 1993], p. 476, nos. 692, 693, ills. in color). They are described as possibly nineteenth-century copies after Barthel Bruyn the Elder (1493–1555) or his circle.

Williamson gives an unconvincing account of the earlier history of the miniature, alleging that it came from a collection in Basel with an unbroken descent in the sitter's family since the time of Holbein and that until shortly before its purchase for the Pierpont Morgan collection the owners had a letter from Holbein to Arnold Franz in which the miniature was mentioned.

Williamson says that Franz was supposed to have been a painter in Basel but admits that nothing certain is known of him and that the family said to have owned the miniature has died out. Williamson's remarks are an attempt to validate a production which on stylistic grounds cannot be earlier than the seventeenth century.

Nicholas Hilliard

British, 1547–1619

Nicholas Hilliard, the son of Richard Hilliard, an Exeter goldsmith, was sent to Switzerland in 1557 to escape the Marian persecution of supporters of the Reformed religion. He returned to London by 1559 and made his earliest known miniatures in the following year. Hilliard served his apprenticeship as a goldsmith, beginning in 1562 with Robert Brandon, whose daughter Alice he was to marry in 1576. He became free of the Goldsmiths' Company in 1569. According to his treatise, *The Arte of Limning,* he had trained himself in miniature painting by following Holbein's technique and by copying engravings by Dürer and other masters. Hilliard enjoyed high favor with Elizabeth I (1533–1603) from 1572, but her slowness in making payments led him to work in France from 1576 to 1578/79. On his return he was much employed at the English court in miniature painting and remained the dominant figure in the art until the emergence of his pupil Isaac Oliver (1565?–1617) in the 1590s.

Hilliard was court limner to James I (1566–1625) from his accession in 1603. However, the queen, Anne of Denmark, and their son Henry Frederick, Prince of Wales, preferred the more Continental style of Isaac Oliver. In fact, most of Hilliard's work for the Jacobean court lacks the poetic distinction of his Elizabethan period. Hilliard, who seems to have been notably improvident, died in poverty in January 1619.

8
Portrait of a Young Man, Probably Robert Devereux (1566–1601), *Second Earl of Essex*

Vellum laid on card, 1⅝ x 1⅜ in. (40 x 33 mm)

Dated and inscribed (edge, in gold): *Anō · Dni · 1588 · Æatis Suæ · 22 ·*

Fletcher Fund, 1935 (35.89.4)

Wearing a slashed, dark lilac-gray doublet embroidered in black and gold and white falling collar of reticella lace. Brown eyes; brown hair and incipient mustache; very slight beard. Blue background.

CONDITION: The miniature is sealed to the convex cover glass with goldbeater's skin. There is water damage around the perimeter, where the paint layer may have adhered slightly to the glass, but otherwise the portrait head and costume are in very good state. There is some flaking and discoloration at the right edge in the background, the latter probably in the retouching of old damage, particularly in the lowest flourish of *Æ* and the bottom of *S* in the inscription; there is slight flaking at the left edge. The case in which the miniature had been framed shortly after it came to the Museum was supplied with a new and narrower gilded-copper front bezel so that the edges of the paint surface are more fully revealed.

EX COLL.: By descent in the family of the earls of Warwick at Warwick Castle; J. Pierpont Morgan, London and New York (by 1906–13); J. P. Morgan, New York (1913–35; his sale, Christie's, London, June 24, 1935, no. 173, to Knoedler for MMA).

EXHIBITED: Victoria and Albert Museum, London, 1947, *Nicholas Hilliard and Isaac Oliver,* no. 36; Metropolitan Museum of Art, 1950, *Four Centuries of Miniature Painting,* list, p. 2; Scottish Arts Council Gallery, Edinburgh, 1975, *A Kind of Gentle Painting,* no. 11.

LITERATURE: G. C. Williamson, *Catalogue of the Collection of Miniatures the Property of J. Pierpont Morgan,* vol. 1 (London, 1906), pp. 54–55, no. 48, pl. XXVII, no. 1; G. C. Williamson, "Mr. J. Pierpont Morgan's Pictures: The English Miniatures. II," *Connoisseur* 17 (January 1907), pp. 5–6, no. XXVIII, ill.; Harry B. Wehle, "Four Famous Miniatures," *Metropolitan Museum Bulletin* 30 (October 1935), pp. 187–88; Carl Winter, *Elizabethan Miniatures* (London and New York, 1943), p. 26; David Piper, "The 1590 Lumley Inventory . . . II," *Burlington Magazine* 99 (September 1957), pp. 300–303, fig. 17; Erna Auerbach, *Nicholas Hilliard* (London, 1961), pp. 104–6, 300–301, no. 79, pl. 81; Graham Reynolds, *Nicholas Hilliard and Isaac Oliver,* rev. ed. (London, 1971), no. 36 and see also nos. 37 and 38; Roy Strong, *The Cult of Elizabeth* (London, 1977), pp. 60–64, 65–83 (other portraits of Essex), fig. 36; Mary Edmond, *Hilliard and Oliver* (London, 1983), pp. 87–88.

WHEN THIS miniature was first the subject of discussion, it was regarded as a portrait of Fulke Greville (1554–1628), first baron Brooke, by Isaac Oliver; it is described in those terms by Williamson in his catalogue of the Pierpont Morgan collection (1906) and in his article of 1907. In the Pierpont Morgan sale, 1935, it was listed as a portrait of a nobleman, "said to be the 1st Lord Brooke," by Oliver. This identification may have arisen from its provenance at Warwick Castle, the home of Lord Brooke. But he was born in 1554 and was thirty-four in 1588, dates that do not tally with those inscribed on this miniature.

Winter (1943) appears to have been the first to recognize in this portrait a major work by Nicholas Hilliard. He also pointed out that the youth is represented in Hilliard's full-length *Portrait*

of a Young Man Among Roses in the Victoria and Albert Museum (no. P.163–1910 and see Auerbach 1961, no. 78, pl. 80). The sitter is also probably seen in a miniature by Hilliard in the collection of the duke of Rutland (Auerbach 1961, no. 80, pl. 82).

In 1957 Piper, who believed that the Metropolitan, Victoria and Albert, and Rutland miniatures represent the same sitter, identified him as Robert Devereux, second earl of Essex, by comparison with a painting by Sir William Segar (active late sixteenth century) in the National Gallery of Ireland, Dublin, which is dated 1590. The present miniature plays an important role in this identification, since it is the only one which bears a date and the sitter's age; these are consistent with the view that it portrays Essex, who was born in 1566. Auerbach doubted whether the three miniatures represent the same person and was cautious about the identification of the sitter as Essex. In his extensive discussion of *A Young Man Among Roses,* Strong (1977) concludes that it does represent Essex and that this work also portrays him.

To summarize, the sitter in the present miniature is almost certainly depicted in the full-length portrait in the Victoria and Albert Museum and may also be represented in the duke of Rutland's miniature. Comparison with the earliest known portraits of Essex, before he grew a beard on the expedition to Cádiz in 1596, suggests that the same man is represented in the Metropolitan miniature, and the fact that the age and date on the work agree with those of Essex supports this identification.

Robert Devereux (1566–1601), second earl of Essex, soldier and statesman, was a favorite of Elizabeth I (1533–1603), who was more than thirty years his senior. He appeared at court in 1587 and she soon grew seriously infatuated. Devereux was created master of the horse in that year. In 1590, risking the queen's ire, he secretly married Frances Walsingham. He led a successful attack on Cádiz in 1596 and was created earl marshal in 1597 and chancellor of Cambridge University in 1598. He was appointed governor-general of Ireland in 1599. On his return from this unsuccessful mission he attempted to raise a rebellion against the queen and was executed as a traitor in 1601.

9
Portrait of a Woman

Vellum, 1⅞ x 1½ in. (47 x 39 mm)

Dated (left edge, in gold): ⦂ *1597* ⦂

Fletcher Fund, 1935 (35.89.2)

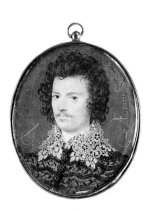

8
COLOR PLATE PAGE 19

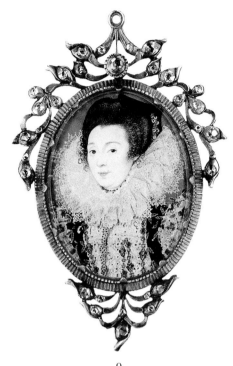

9
COLOR PLATE PAGE 19

10

Wearing a white bodice embroidered with black and green, with gold tags and chains and black-and-white sleeves, white lace-edged ruff, black necklace, and black cap trimmed with gold and pearl band. Brown eyes; brown hair. Blue background.

The miniature is in a more recent frame set with thirty-one diamonds. It has not been possible to open it to determine the support for the vellum. There are two labels numbered by hand *22* and *102;* a third, printed label with the number *25* records the number in the Morgan collection.

CONDITION: The miniature is in an unblemished state.

EX COLL.: J. Pierpont Morgan, London and New York (by 1906–13); J. P. Morgan, New York (1913–35; his sale, Christie's, London, June 24, 1935, no. 102, to Knoedler for MMA).

EXHIBITED: Victoria and Albert Museum, London, 1947, *Nicholas Hilliard and Isaac Oliver,* no. 65; Metropolitan Museum of Art, 1950, *Four Centuries of Miniature Painting,* list, p. 2; Scottish Arts Council Gallery, Edinburgh, 1975, *A Kind of Gentle Painting,* no. 22.

LITERATURE: G. C. Williamson, *Catalogue of the Collection of Miniatures the Property of J. Pierpont Morgan,* vol. 1 (London, 1906), p. 33, no. 25, pl. XVI, no. 1; G. C. Williamson, "Mr. J. Pierpont Morgan's Pictures: The Early Miniatures. I," *Connoisseur* 16 (December 1906), p. 207, no. XII, ill.; Harry B. Wehle, "Four Famous Miniatures," *Metropolitan Museum Bulletin* 30 (October 1935), pp. 187–88; Erna Auerbach, *Nicholas Hilliard* (London, 1961), pp. 133, 305, no. 103, pl. 103; Graham Reynolds, *Nicholas Hilliard and Isaac Oliver,* rev. ed. (London, 1971), no. 65.

ACCORDING TO Williamson, this miniature was once thought to be a portrait of Elizabeth I, although the sitter bears no resemblance to the queen. In his catalogue of the J. Pierpont Morgan collection he described it, on the basis of works in the Bibliothèque Nationale (Fonds Ste.-Geneviève, no. 89), Paris, and the Musée Condé, Chantilly, as a portrait of Charlotte Catherine de la Trémoïlle (born about 1565, died 1629), who in 1586 married Henry I de Bourbon (1552–1588), prince of Condé. In his article in *Connoisseur* of the same year (1906) Williamson reproduced it as a portrait of Gabrielle d'Estrées (born about 1571, died 1599), who from 1591 until her death was the favorite of Henry IV.

These hypothetical identifications are based upon the belief that the sitter's features are French in type. However, the only visit that Hilliard paid to France was from 1576 until 1578–79 (Mary Edmond, *Hilliard and Oliver* [London, 1983], pp. 59–69), and there is every reason to suppose that he was in England in 1597, the date inscribed in his characteristic calligraphy on this miniature. Although no acceptable identification has so far been proposed, this is evidently a portrait of a lady at the Elizabethan court, comparable in style with *Mrs. Holland, Aged 26 in 1593* in the Victoria and Albert Museum, London (no. P.134–1910).

10
Portrait of a Woman

Vellum laid on card, 1 x ⅞ in. (27 x 22 mm)

The Friedsam Collection, Bequest of Michael Friedsam, 1931 (32.100.311)

Wearing a white bodice embroidered in green and gold, white lace standing ruff, and white cap trimmed with jewels; gold earrings; a gold jewel hangs from pearls around her neck. Light brown hair. Blue background with gold rim.

CONDITION: Faded, discolored, and possibly restored; highlights of the pearls tarnished to black. The miniature was received in the Metropolitan Museum in an elaborate frame of polished decorative stone with gold mounts enclosing a lock of hair at the back. It is of modern manufacture and has been replaced using the existing cover glass and bezel as the basis for a simple locket case.

THIS MINIATURE was received in the Metropolitan Museum as a portrait of Elizabeth I (1533–1603) from the school of Nicholas Hilliard. The only comments on this description have been oral ones. In 1972 Erna Auerbach considered it to be of the school of Hilliard but questioned the identification of the sitter; in 1976 Roy Strong concluded that it was a nineteenth-century pastiche; and in 1977 Richard Allen called it school of Hilliard, about 1590, but not by the master himself. The identification of Elizabeth I is inadmissible, and there is as yet no clue to the sitter's name. Although

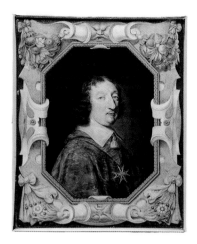

11
COLOR PLATE PAGE 22

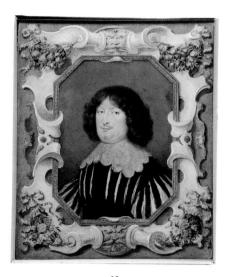

12
COLOR PLATE PAGE 23

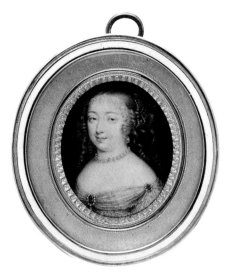

13

its present condition is far from good, it seems to be an authentic miniature by Nicholas Hilliard, painted with much refinement on the small scale he increasingly used throughout the 1590s.

E. Jean Saillant

French, active by 1620, died in or after 1638

E. Jean Saillant was born in Avignon. He joined an Augustinian order and was in Rome and Florence between 1620 and 1633, with the name of Saliano. Between May 3, 1633, and May 4, 1638, he wrote six letters from Avignon to the Roman patron of the arts Cassiano del Pozzo (1588–1657), from whom he had received several commissions while living in Rome (Giovanni Bottari and Stefano Ticozzi, *Raccolta di Lettere . . .* , vol. 1 [1822], pp. 361–71). Saillant died in Avignon in or after 1638. The two works seen here (nos. 11 and 12) provide the main evidence of his activity as a miniature painter.

11
Portrait of a Churchman

Vellum stretched over copper, 6⅛ x 4¾ in.
 (157 x 122 mm)
Signed, dated, and inscribed: (top edge, in brown) *Aetatis Sua. 25.° / Anno Dni 1628.*; (bottom edge, in brown) *Roma / E. I. Salianus. f. 16[28?]*
Rogers Fund, 1959 (59.72.1)

Wearing a gray-blue robe with coral-colored stitching and buttons, white collar and tassels, and blue ribbon and badge of the Order of the Saint-Esprit. Brown hair, incipient mustache, and slight beard. Reddish brown shaded background.

The portrait is set in a feigned gilt octagonal frame that has elaborate partially gilt strapwork decoration and swags of colored fruit and flowers.

Fixed to the backing is the trade label of P. & D. Colnaghi, Scott & Co., 13 & 14 Pall Mall East, London; also a French or Swiss customs stamp and a French or Swiss dealer's stock label.

CONDITION: The painted surface is in excellent state. The side of the copper sheeting over which the vellum is stretched is fire-gilded. The narrow molding which had previously framed the miniature was removed because the rabbet covered the signature and date. A ragboard bezel and backing and a new convex cover glass were supplied.

EX COLL.: [P. & D. Colnaghi, London]; Aimé Martinet, Geneva (by 1956–59).

EXHIBITED: Musée d'Art et d'Histoire, Geneva, 1956, *Chefs-d'oeuvre de la miniature et de la gouache*, no. 387.

LITERATURE: Leo R. Schidlof, *The Miniature in Europe* (Graz, 1964), vol. 2, p. 710, and vol. 4, pl. 507, fig. 1039.

12
Portrait of a Man

Vellum stretched over wood, 6¾ x 5⅝ in.
 (170 x 142 mm)
Rogers Fund, 1959 (59.72.2)

Wearing a black watered silk doublet slashed with white and a pale pink lace falling collar. Blue eyes; brown hair, light brown mustache and beard. Gray background.

The portrait is set in a feigned gilt octagonal frame that has elaborate strapwork decoration with a bright blue background and swags of colored fruit and flowers tied with pink ribbons.

Fixed to the backing is the trade label of P. & D. Colnaghi, Scott & Co., 13 & 14 Pall Mall East, London; also a French or Swiss customs stamp and a French or Swiss dealer's stock label.

CONDITION: The surface is in generally excellent state, though there are two small areas of overpaint, at the top center and at the right edge within the strapwork border. The panel over which the vellum is stretched is shaped at the back. As with no. 11, the framing molding was removed, and a ragboard bezel and backing and a new convex cover glass were supplied.

EX COLL.: [P. & D. Colnaghi, London]; Aimé Martinet, Geneva (by 1956–59).

EXHIBITED: Musée d'Art et d'Histoire, Geneva, 1956, *Chefs-d'oeuvre de la miniature et de la gouache*, no. 388.

LITERATURE: Leo R. Schidlof, *The Miniature in Europe* (Graz, 1964), vol. 2, p. 710, and vol. 4, pl. 507, fig. 1039A.

Jean Petitot

Swiss, 1607–1691

Born in Geneva, Petitot worked at the court of Charles I (1600–1649) of England from 1637.

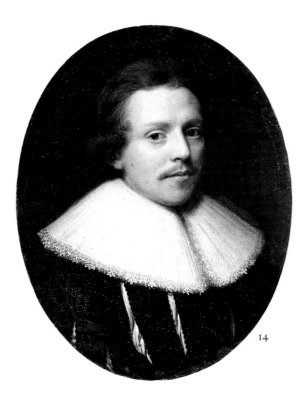

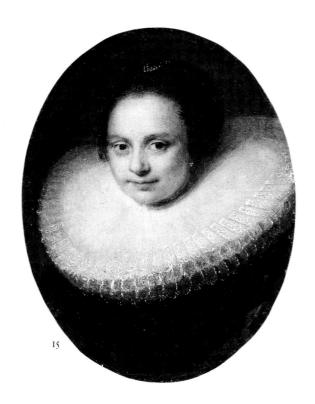

14

15

He left for France after the outbreak of the Civil War and was extensively patronized by Louis XIV (1638–1715) and his court. A devout Protestant, he fled to Geneva after the revocation of the Edict of Nantes in 1685; he arrived in 1687 and died at Vevey, still in possession of his powers, four years later. He was the greatest enamelist of the seventeenth century.

Attributed to Jean Petitot

13
Portrait of a Woman

Vellum, 1⅜ x 1⅛ in. (36 x 30 mm)
Bequest of Millie Bruhl Fredrick, 1962 (62.122.71)

Wearing a yellow gold-embroidered dress, clasped with jewels at bosom and sleeve, pearl earrings, and pearl necklace. Brown hair dressed with pearls. Dark brown background.

LITERATURE: E. G. Paine, unpublished list of miniatures in the Fredrick collection (1960), no. 131, as by Nicolas Ardin.

ALTHOUGH primarily known as an enamelist, Jean Petitot did paint some miniatures on vellum and had associations with Samuel Cooper (nos. 25–27). This may be one of his rare works in the more traditional medium; for an accepted example see the portrait in the Portland collection (Richard W. Goulding, "The Welbeck

Abbey Miniatures . . . ," *Walpole Society* 4 [1916], p. 123, no. 146, pl. XX). Two comparable enamel portraits on gold, datable about 1665, are in the Musée de l'horlogerie, Geneva (no. AD 6226).

Fabienne Sturm of the Musée de l'horlogerie, Geneva, and her colleague Hans Boeckh (in a letter, 1995) accept the attribution of this miniature to Petitot and propose to identify the sitter as the marquise de Sévigné. Marie de Rabutin-Chantal (1626–1696) married in 1644 Henri de Sévigné but was widowed in 1651. Well educated and a gifted correspondent, she is famous particularly for the letters she wrote from Paris in the 1670s to her daughter Françoise, comtesse de Grignan.

David Baudringhien

Dutch, born about 1581, died 1650

David Baudringhien is said to have been born about 1581. He was in Naples in 1629 and by 1635 lived in Amsterdam, where he died in 1650. He was a wealthy man and seems to have been an amateur who painted little; his portrait of Frederick Henry (1614–1629), count palatine of the Rhine, was in the collection of Charles I (1600–1649) (Oliver Millar, "Abraham van der Doort's Catalogue of the Collections of Charles I," *Walpole Society* 37 [1960], p. 6, no. 27; lent by Col. G. H. Anson to the exhibition *Seventeenth-Century Art in Europe,* Royal Academy, London, 1938, no. 158).

14
Portrait of a Man

(pendant to 32.75.15)

Oil on copper, 3¾ x 3 in. (95 x 76 mm)
Signed and dated (reverse): *geschildert / by bodringyn / in den iaare / 1627*
The Collection of Giovanni P. Morosini, presented by his daughter Giulia, 1932 (32.75.16)

Wearing a black doublet slashed with white and white falling collar. Brown hair and mustache. Dark gray background on right, shading to black on left.

LITERATURE: Josephine L. Allen, "Some Notes on Miniatures," *Metropolitan Museum Bulletin*, n.s., 13 (1955), pp. 245–46, ill.

THE INSCRIPTION was identified as probably the signature of David Baudringhien by Dr. H. Gerson of the National Institute of Art History, The Hague, in an August 1954 letter.

15
Portrait of a Woman

(pendant to 32.75.16)

Oil on copper, 3¾ x 3 in. (95 x 76 mm)
The Collection of Giovanni P. Morosini, presented by his daughter Giulia, 1932 (32.75.15)

Wearing a black dress with lace-edged white ruff. Dark brown hair, dressed with pearls. Dark gray-brown background.

CONDITION: Not so well preserved as no. 14; the face is worn; flaking in the dress has been restored.

LITERATURE: Josephine L. Allen, "Some Notes on Miniatures," *Metropolitan Museum Bulletin*, n.s., 13 (1955), pp. 245–46.

THE MINIATURE forms a pair with no. 14 and is by the same hand.

Monogrammist IS

Flemish, dated 1621

16
Portrait of a Man

Oil on copper, 4⅛ x 3⅝ in. (105 x 91 mm)

Signed and dated (right, above and below unidentified coat of arms): *i S / i62i*

Bequest of Mary Anna Palmer Draper, 1914 (15.43.291)

Wearing a dark lilac doublet and white lace-edged ruff; leather glove in left hand. Brown hair and beard. Red and green curtains in background.

Monogrammist JG

Northern European, about 1630

17
Traveling Players

Vellum laid on wood, 2¾ x 3½ in. (70 x 90 mm)

Signed (bottom right, in black): JG [monogram]

Bequest of Kate Read Blacque, in memory of her husband, Valentine Alexander Blacque, 1937 (38.50.333)

CONDITION: The paint surface is damaged at the upper right and along the perimeter. The vellum is mounted on a slightly larger piece of wood, and there is a coarse black line around the image. This appears to be the original treatment.

TWO ACTORS on a stage before a palatial building perform for a crowd; a third enters from behind a curtain. The artist may have intended to evoke the Piazzetta in Venice: the lower story of the most prominent building is somewhat like that of the Sansovino library, and the *rio* beyond is in the correct location, but the other buildings are imaginary. Theatrical performances, puppet shows, and other entertainments were frequently held in the Piazzetta. The costumes of the fashionable loungers point to a date of about 1630 and an origin in northern Europe.

Monogrammist FA

Northern European, dated 1664

18
An Artist Painting a Heraldic Shield in a Cabinet of Curiosities

Vellum laid on card, 4¼ x 6 in. (106 x 152 mm)

Signed (right, in front of the artist's stool, in black): FA.

Dated and inscribed (left, on the cartouche, in brown ink): *Paul Sixt / Trauthson / Comes in / Falckenstein / A.º i664*

Bequest of Catherine D. Wentworth, 1948 (48.187.740)

A paper fixed to the backing board is inscribed in a later hand: *Un comte de Falkenstein était frère / de la Reine, Marie Antoinette d'Austriche / Epouse de Louis XVI* (a count of Falkenstein was the brother of the queen, Marie Antoinette of Austria, wife of Louis XVI). In fact her brother Emperor Joseph II (1741–1790; no. 111) of Austria used the title count of Falkenstein when traveling incognito.

CONDITION: The miniature is in excellent state. The image is surrounded by a thin gold line and by a black border painted over the vellum and onto the card, which has a slight concave warp. A rag-board spacer and a new cover glass were supplied.

PAUL SIXTUS Trautson von Falkenstein lived from 1635 to 1678. In 1664 he was twenty-nine, which would accord with his presumed appearance in the portrait bust. Paul Sixtus was the grandson of the first count of Falkenstein, of the same name, who had been a minister at the court of Emperor Rudolf II.

Continental

about 1690

19
Portrait of a Man

Enamel, 1 x ⅞ in. (27 x 22 mm)

The Collection of Giovanni P. Morosini, presented by his daughter Giulia, 1932 (32.75.17)

Wearing armor with a white lace cravat and the blue ribbon of an unidentified order. Black hair. Gray background.

WHEN THIS enamel entered the Museum's collection, it was described as a portrait of Louis XIV (1638–1715), but it almost certainly does not represent him. Neither does it show Paul Scarron (1610–1660), the first husband of the purported sitter in no. 20. Richard Allen has attributed this miniature and no. 20 to the brothers Huaud (Jean Pierre, 1655–1723, and Amy, 1657–1724), Swiss artists working at the

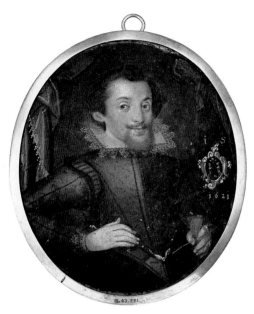

16

court of the elector of Brandenburg in Berlin from 1686 to 1700. They are painted in the rough stippling method, derived from Paul Prieur (born in Geneva about 1620, died in Copenhagen in 1684), that was adopted by some Swiss enamelists in the second half of the seventeenth century.

Fabienne Sturm of the Musée de l'horlogerie, and Hans Boeckh (in a letter, 1995) reject both the old identifications of this sitter and the following and the proposed attribution to the brothers Huaud, suggesting that the enamels may be of German origin.

20
Portrait of a Woman
(pendant to 32.75.17)

Enamel, 1 x ⅞ in. (28 x 24 mm)

The Collection of Giovanni P. Morosini, presented by his daughter Giulia, 1932 (32.75.18)

Wearing a gold brocaded dress with strings of large pearls and a jeweled brooch. Black hair. Gray background.

THIS ENAMEL is by the same hand as no. 19.

Comparison with the painting of Madame de Maintenon (1635–1719) by Pierre Mignard (Paris, Louvre, inv. 6657; see Lada Nikolenko, *Pierre Mignard, The Portrait Painter of the Grand Siècle* [Munich, 1983], pl. 29) suggests that the traditional identification of the sitter is unlikely to be correct.

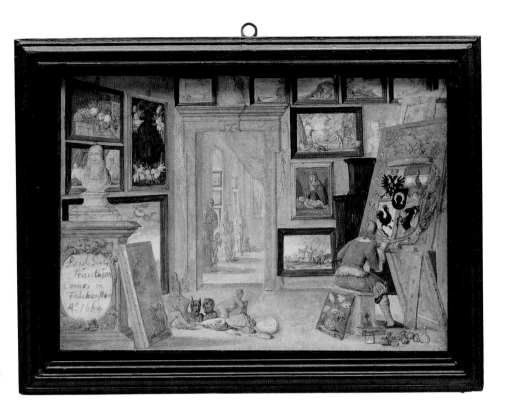

18

17

19

20

In 1652 Françoise d'Aubigné (1635–1719) married the poet Paul Scarron (1610–1660). In 1669 she became governess to Louis XIV's children by Madame de Montespan. She was secretly married to Louis XIV (1638–1715) in 1684 or shortly thereafter.

Thomas Lefebure

Flemish, born about 1636, died 1720

Lefebure (or Lefebre) was born in Brussels. By 1669 he was painter in miniature to Margrave William at Durlach in Baden. In 1674 he traveled to Italy, at the expense of Margrave Frederick IV Magnus (1617–1677), to study architecture; he practiced this art on his return, becoming Hofbaumeister in 1688 and Baurat in 1704. He died aged eighty-four in Durlach.

21

Vertumnus and Pomona

Paper, image exclusive of gold rim and dark brown border, 6¾ x 5 in. (172 x 126 mm)

Signed and dated (lower left, on surround): *T.le febure.f ͭ A⁰ 1676.*

Bequest of Margaret Crane Hurlbut, 1933 (33.136.13)

At the back of the paper on which the miniature is painted is a nineteenth-century dealer's receipt, mainly for ceramics but including a miniature of Titian's Venus.

EXHIBITED: Metropolitan Museum of Art, 1950, *Four Centuries of Miniature Painting*, list, p. 4.

LITERATURE: H. B. Wehle, "The Hurlbut Bequest," *Metropolitan Museum Bulletin* 29 (1934), p. 4.

POMONA was worshiped in Rome as the nymph who presided over gardens and fruit trees. She had taken a vow of celibacy and rejected the advances of many gods. Vertumnus, the god of spring and of orchards, tried unsuccessfully to gain her favors in the guise of a fisherman, a soldier, a peasant, and a reaper. He finally adopted the form of an old woman to plead his suit. Pomona again refused, but when Vertumnus revealed himself as a young god, she broke her vow and married him. Here Pomona is represented with her attributes of an apple and a pruning hook; Vertumnus is shown as an old woman.

Lefebure signed and dated 1674 a miniature representing Margrave Frederick IV Magnus (*Bildnisminiaturen aus Niedersächsischen Privatbesitz*, exh. cat. [Hanover, 1918], no. 45, ill.). Upon his return from Italy he completed this surprisingly distinguished work, which is exceptional in displaying his interest in architecture. He must have been back in his home country since another miniature portrait by him of a princess of Baden is also signed and dated 1676.

John Hoskins

British, active about 1615, died 1665

John Hoskins was the leading painter of portrait miniatures in England between the death of Nicholas Hilliard in 1619 and the rise to preeminence of his nephew and pupil Samuel Cooper (nos. 25–27) in the 1640s.

Hoskins began his career as a portrait painter in oils. So far only two documented paintings in this medium by him are known. They are head-and-shoulders portraits of Sir Hamon Le Strange of Hunstanton Hall, Norfolk, and his wife, Alice; her household account book records payments for them in 1617 (Prince Frederick Duleep Singh, *Portraits in Norfolk Houses* [1927], vol. 1, p. 316, no. 15 [Alice], pp. 317–18, no. 21 [Hamon]; Andrew Moore and Charlotte Crawley, *Family and Friends: A Regional Survey of British Portraiture* [1992], pp. 84–86, nos. 18 and 19, pls. 55 and 56).

It is not known who taught Hoskins the art of limning, but his earliest miniatures, seemingly from about 1615, show resemblances to those of both Nicholas Hilliard (1547–1619) and Isaac Oliver (born about 1565, died 1617). He was greatly patronized by Charles I (1600–1649) and his court; he was influenced at that time by Daniel Mytens (1590?–1648) and then by Van Dyck (1599–1641), who settled in England in 1632. The works of the 1620s and 1630s show a variety of styles, probably due to his employment of assistants, such as his nephews Alexander Cooper (1609–1660?) and Samuel Cooper (nos. 25–27) and his son John Hoskins the Younger (1620/30?–after 1692). The older Hoskins died in relative poverty in 1665. John Hoskins the Younger is known to have practiced as a limner independently from 1655, but no convincing attempts to distinguish his work from his father's have yet been made.

22

Endymion Porter (1587–1649)

Vellum, 3⅛ x 2⅝ in. (80 x 66 mm)

Signed (lower left, in gold): *H ·* [left edge trimmed; monogram probably read *iH ·*]

Bequest of Mary Clark Thompson, 1923 (24.80.505)

21

COLOR PLATE PAGE 24

Wearing a white doublet with a lace falling collar; over his left shoulder a pink-lined green cloak with rose-colored embroidery. Light brown hair, mustache, and beard. A wide landscape with clouds; trees in the foreground.

The gilt metal frame dates from the late nineteenth century. On its back is engraved *George Villiers / First / Duke of Buckingham / BY Hoskins / Shaftesbury Colln*; this is surmounted by the arms of the dukes of Buckingham of the third creation (i.e., those of Grenville, Temple, Cobham, and Nugent).

CONDITION: The surface is in fairly good state.

EX COLL.: Lady Sutton(?), 1810; earls of Shaftesbury(?).

EXHIBITED: Metropolitan Museum of Art, 1950, *Four Centuries of Miniature Painting*, list, p. 3.

THIS MINIATURE, or a replica, was engraved in 1810 in mezzotint as a portrait of Endymion Porter; the engraving is lettered *S.Cooper pinx! R. Earlom sc! pub. S. Woodburn 1810* "from a beautiful Miniature in the Possession of Lady Sutton." The engraver overlooked the miniature's signature; in fact, this portrait is a fine example of Hoskins's work of about 1630.

The inscription on the back of the frame records the erroneous identification of the sitter as George Villiers (1592–1628), first duke of Buckingham; the arms, however, are not his but those of a later creation of dukes of Buckingham. The correct identification of the sitter as

22

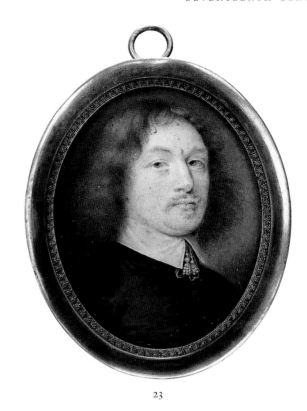

23

Endymion Porter, recorded on the engraving, was reestablished by Sir Oliver Millar (verbally, 1964, and in a letter, 1982) and is substantiated by comparison with accepted portraits of Porter, such as that by Mytens which shows him at thirty-nine in 1627 (National Portrait Gallery, London, no. 5492).

Endymion Porter (1587–1649) was a protégé of the duke of Buckingham, whose niece he married, and in 1623 was employed with Buckingham in the failed negotiations for the marriage of Charles I (1600–1649), then Prince of Wales, to the infanta of Spain. Porter took little part in politics but remained close to the young king Charles, serving as a groom of the bedchamber. He was an important patron of literature, was greatly admired as a connoisseur, and was among the first to bring knowledge of Renaissance art to England. He also brought Anthony van Dyck (1599–1641) to the king's notice and was instrumental in the acquisition of *Rinaldo and Armida* (Baltimore Museum of Art), the first Van Dyck to enter the royal collection.

23
Portrait of a Man, Said to Be Philip Wharton (1613–1696), *Fourth Baron Wharton*

Vellum on prepared card, 2¾ x 2¼ in. (69 x 56 mm)

Signed and dated (left, in black): *IH · / 1648*

Inscribed (reverse, in a later—probably nineteenth-century—hand): *Philip / L.ᵈWharton / 1643* [sic]; above this is an illegible pencil inscription.

Bequest of Millie Bruhl Fredrick, 1962 (62.122.22)

Wearing a black doublet and white collar and ties. Blue eyes; light brown hair, mustache, and beard. Gray background.

CONDITION: Discoloration in the features owing to the blackening of some white highlights.

EXHIBITED: Brooklyn Museum, 1936, *Five Centuries of Miniature Painting*, no. 26 (lent by Mrs. Leopold Fredrick).

LITERATURE: E. G. Paine, unpublished list of miniatures in the Fredrick collection (1960), no. 24, as Lord Waterford by John Hoskins.

WHEN THIS miniature entered the Metropolitan Museum, it was described as a portrait of Lord Waterford. This title did not exist in the seventeenth century, however, and the identification was no doubt based upon a misreading of the nineteenth-century inscription on the back.

The portrait of Lord Wharton by Van Dyck in the National Gallery of Art, Washington, D.C., shows him in 1632 aged nineteen and is thus too early to provide a firm basis for comparison. A second portrait, ascribed to Van Dyck or

his workshop (Norton Gallery, Palm Beach, Florida; see Erik Larsen, *The Paintings of Anthony van Dyck* [Freren, 1988], vol. 2, p. 512, no. A305, ill.), bears his name and the date 1639; it shows him at the age of twenty-six and suggests that the identification may conceivably be correct.

Philip (1613–1696), fourth baron Wharton, was the grandson of the first earl of Monmouth (and thus the nephew of the sitter in the Cooper miniature, no. 25). As the elegant young man that Van Dyck depicted, he was prominent at the court of Charles I and Henrietta Maria. He became an ardent Puritan, declaring his opposition to the crown in the Parliament of 1640 and supporting the parliamentary side during the Civil War. At the time this miniature was painted, he was an intimate of Cromwell. He deplored the execution of Charles I and lived to welcome the restoration of Charles II and the accession of William and Mary.

Wharton had a fine collection of paintings by Lely and — most notably — Van Dyck (Oliver Millar, "Philip, Lord Wharton, and His Collection of Portraits," *Burlington Magazine* 136 [August 1994], pp. 517–30). By the late 1630s he was one of Van Dyck's principal patrons and, according to Horace Walpole, owned six half-lengths and twelve full-lengths by the great Flemish artist.

John Hoskins (*continued*)

24

Dr. Brian Walton

(born about 1600, died 1661)

Vellum laid on card, 2¾ x 2¼ in. (72 x 58 mm)
Signed and dated (upper left, in gold): *1657 · i H ·*
Fletcher Fund, 1935 (35.89.3)

Wearing a ribbed black doublet, white falling collar, and black cap with white lining. Brown hair, mustache, and beard. Landscape with trees and sky background.

On the back of the vermeil case is scratched *Serjeant Maynard*.

CONDITION: The miniature is in excellent state though there are small chip losses and slight abrasion under the bezel.

EX COLL.: Sir Everard Fawkener, Wandsworth, London (until about 1735); given by him to Sir Robert Walpole (1676–1745), first earl of Oxford, Houghton Hall, Norfolk (about 1735–about 1743); given by him to Horace Walpole (1717–1797), Strawberry Hill, Twickenham (from about 1743); by descent to George Edward Waldegrave, seventh earl Waldegrave (died 1842; his sale, Robins, Strawberry Hill, fourteenth day, May 10, 1842, no. 16, to Beriah Botfield); Beriah Botfield (1842–died 1863); duke of Hamilton (Hamilton Palace sale, Christie's, July 15ff., 1882, no. 1599, to Philpot); C. H. T. Hawkins, London; J. Pierpont Morgan, London and New York (by 1906–13); J. P. Morgan, New York (1913–35; his sale, Christie's, London, June 24, 1935, no. 138, to Knoedler for MMA).

EXHIBITED: Metropolitan Museum of Art, 1950, *Four Centuries of Miniature Painting*, list, p. 3.

LITERATURE: George Vertue, "Note Books, vol. 5," *Walpole Society*, vol. 26 (1937–38), p. 20 (ca. 1743), p. 49 (1745); Horace Walpole, *Works*, vol. 2 (London, 1798), p. 473; Horace Walpole, "Anecdotes of Painting in England," *Works*, vol. 3 (London, 1798), p. 254; G. C. Williamson, *Catalogue of the Collection of Miniatures the Property of J. Pierpont Morgan*, vol. 1 (London, 1906), pp. 79–80, no. 82, pl. XXXIX, no. 2; G. C. Williamson, "Mr. J. Pierpont Morgan's Pictures: The English Miniatures. II," *Connoisseur* 17 (January 1907), pp. 6–7, no. XXIV, ill. p. 5; J. J. Foster, *Samuel Cooper and the English Miniature Painters of the Seventeenth Century* (London, 1914–16), p. 13; Harry B. Wehle, "Four Famous Miniatures," *Metropolitan Museum Bulletin* 30 (October 1935), pp. 187–89, fig. 2; Ellis Waterhouse, *The Collection of Pictures in Helmingham Hall* (Ipswich, 1958), p. 11; David Piper, *Seventeenth-Century Portraits: National Portrait Gallery* (Cambridge, 1963), p. 231; Leo R. Schidlof, *The Miniature in Europe* (Graz, 1964), vol. 1, p. 377; John Murdoch, in *The English Miniature*, exh. cat. (New Haven and London, 1981), p. 217, no. 31.

THE HISTORY of this important miniature, which has had a succession of distinguished owners, can be traced to the earlier years of the eighteenth century. Its first known owner was Sir Everard Fawkener (1684–1758), a successful merchant who became in later life a diplomat. Voltaire was a friend of his and stayed in the late 1720s at his house in Wandsworth. According to the *Dictionary of National Biography*, Fawkener spent his leisure time "in reading the classics or in collecting ancient coins and medals." As Horace Walpole (1717–1797) recorded when cataloguing his own collection, Fawkener gave the miniature to Sir Robert Walpole (1676–1745); this gift may have been made at about the time Fawkener exchanged commerce for diplomacy and was knighted, that is, about 1735. Sir Robert Walpole had passed the miniature on to his son Horace by about 1743, when George Vertue (1684–1756), the English engraver and antiquary, saw it in the latter's collection. It was recognized as an example of Hoskins's finest work in these earliest references, but the sitter's identity caused some confusion. On first seeing it Vertue described it as "so fresh & lively as if it had been done by Cooper" and commented "Qu. who it is," showing that any traditional identification had been lost. However, Walpole, who in 1757 had bought the notebook in which this reference occurs, made the annotation "Serj. Maynard" at this point. Vertue's second reference, made in 1745, shows that he had become aware of this identification; first writing "a Minister," he struck this out and wrote "Serj. Maynard," adding "near or full as well as if done by Cooper." Both in his list of miniatures in the Tribune at Strawberry Hill and in his *Anecdotes* Walpole repeated this identification, which he may have been the first to propose. He shared Vertue's admiration for the work, though with some reservations, writing in his *Anecdotes*: "Hoskins, though surpassed by his scholar, the young Cooper, was a very good painter: there is great truth and nature in his heads; but the carnations are too bricky, and want a degradation and variety of tints. I have a head of serjeant Maynard by him, boldly painted and in a manly style, though not without these faults."

This miniature is certainly one of the finest in the Hoskins canon. Murdoch lists it among twenty-two miniatures painted between 1645 and 1665 which he thinks may be by John Hoskins the Younger; this hypothesis has not gained widespread acceptance, and there is no reason for removing the work from the mature oeuvre of his father.

Piper discusses the identification of the sitter as the famous Restoration lawyer Sir John Maynard (1602–1690) and concludes that it is not convincing. He suggests that there are other possibilities, such as Sir John Maynard (1592–1658), the Royalist, or John Maynard (1600–1665), the divine. However, fresh light is thrown on the question by a somewhat enlarged nineteenth-century copy of the miniature in the Royal Collection, Windsor Castle (Cust 2/18; 3³/8 x 2³/4 in. [87 x 70 mm]; Graham Reynolds, *Catalogue of the Tudor and Stuart Miniatures in the Collection of H. M. the Queen* [Cambridge, 1996], no. 92). This was listed in an inventory of 1881 as a copy from the Hoskins in the Hamilton collection and as a portrait of Brian Walton, D.D. (born about 1600, died 1661). He edited the polyglot Bible, published in six volumes between 1654 and 1657, and in 1660 he was made bishop of Chester. The only recognized portrait of Walton is the engraving that Pierre Lombart made for the frontispiece of *Walton's Polyglot Bible*, 1657 (J. Ingamells, *The English Episcopal Portrait 1559–1835: A Catalogue* [New Haven, 1981], p. 400, pl. 296). There is so close a correspondence between that engraving and this miniature that they surely represent the same man. Ingamells (letter to the author) is inclined to agree, though he points out that Vertue accepted the identification of the sitter as Maynard even though he knew Lombart's engraving of Walton.

Sir Oliver Millar and Catherine MacLeod have drawn attention to a full-length portrait of the same sitter in the collection of Lord Tollemache. This has been published by Ellis Waterhouse (*Collection of Pictures at Helmingham Hall* [Ipswich, 1958], p. 11, no. 1) as of Sir John Maynard by Emmanuel de Critz, dated 1657.

Samuel Cooper

British, 1608?–1672

Samuel Cooper was orphaned as a child and brought up, together with his brother Alexander (1609–1660?), also a miniaturist, by his uncle John Hoskins (nos. 22–24). He was the pupil and for many years the partner of Hoskins, who is said to have been jealous of his accomplishment. He set up on his own about 1641–42. He was much patronized by Oliver Cromwell (1599–1658) and the Puritans and after the Restoration by Charles II (1630–1685) and his pleasure-loving court. He was recognized in his lifetime throughout Europe as the most accomplished miniaturist of his age. At his peak Cooper is remarkable for the breadth of his handling and the subtlety of his interpretation of character.

25
Henry Carey (1596–1661), *Second Earl of Monmouth*

Vellum on prepared card, 2½ x 2 in. (64 x 52 mm)

Signed and dated (left, in gold): *S.C.* / *1649*

Inscribed (reverse, in ink, in an old—perhaps seventeenth-century—hand): *Lord Monmouth* / *$ Mine* / M:M:

Rogers Fund, 1949 (49.33)

Wearing a brown cloak and white shirt. Dark eyes; graying light brown hair, mustache, and beard. Black background.

CONDITION: The miniature is in good state. The frame has been repaired.

EX COLL.: Leo R. Schidlof (until 1949).

EXHIBITED: Metropolitan Museum of Art, 1950, *Four Centuries of Miniature Painting*, list, p. 3.

LITERATURE: Daphne Foskett, *Samuel Cooper* (London, 1974), p. III.

THIS IS a representative example of the more restrained manner of portraiture practiced by Samuel Cooper during the Commonwealth, but it has lost some of its original force through the fading of the flesh tones.

The miniature is consistent with the engraving of Monmouth by W. Faithorne placed as the frontispiece to his translation from Boccalini, *Advertisements from Parnassus in Two Centuries; With the Political Touchstones* (1656); in fact it may be the original for that engraving, though in the print the sitter's neck is bare.

Henry Carey (1596–1661), second earl of Monmouth, had little taste for public affairs and spent most of his time in retirement translating Italian and French authors. *Burke's Peerage* quotes Horace Walpole's observation: "We have scarce anything of his own composition, and are as little acquainted with his character as with his genius." Of his nine children, seven were daughters; his second son died of smallpox in 1641 and his eldest, Lionel, fighting for the cause of Charles I at Marston Moor in 1644.

26
Portrait of a Woman, Said to Be Lucy Percy (1600?–1660), *Countess of Carlisle*

Vellum laid on prepared card, 2½ x 2 in. (65 x 50 mm)

Signed and dated (left, in light brown): *SC* [monogram] . *1653* .

Bequest of Mary Clark Thompson, 1923 (24.80.516)

Wearing a black dress edged with white, a brownish-gray scarf, and a string of pearls. Brown eyes;

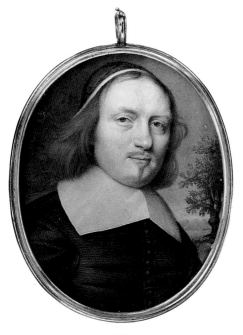
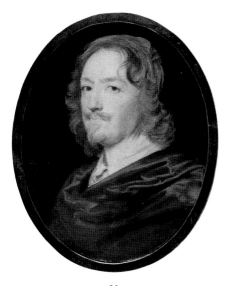

24
COLOR PLATE PAGE 26

25
COLOR PLATE PAGE 26

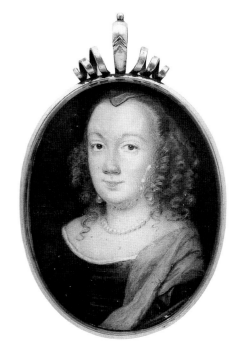

26

Samuel Cooper (*continued*)

brown hair dressed with a widow's cap. Black background.

The gessoed back on which the vellum is laid is inscribed in ink in an old hand *Countess of Carlisle*; this is repeated in pencil and on a nineteenth-century label.

CONDITION: There are several areas of flaking—the left eyebrow and, most notably, the left cheek—but the damage is in fact much more extensive. The entire forehead has been retouched, and there are smaller repaints on the bridge of the nose, the neck, and the bosom.

THE MINIATURE was once in France, since a torn blue-edged stock label fixed to the back of the frame is lettered in ink *1724 / par Cooper*. In the packing material at the back between the frame and the miniature are two green cards cut from a balcony ticket priced at two shillings and sixpence for a concert in 1856 in aid of the Organ Builders' Benevolent Institution, indicating that the miniature was then in Great Britain.

Richard Allen accepted this as an authentic work by Samuel Cooper, but Daphne Foskett and Hermione Waterfield rejected it. It is by Samuel Cooper, with an authentic signature, but it has suffered so severely as to lose most of its quality.

The identification of the sitter as Lucy Percy (1600?–1660), second daughter of Henry Percy, ninth earl of Northumberland, who became in 1617 the second wife of James Hay, later first earl of Carlisle (died 1636), is an early one but has to be regarded with suspicion. This lady's beauty, reputation, and intrigues caused her name to be attached to many otherwise unidentified seventeenth-century portraits. There is no reason to suppose that she wore a widow's cap seventeen years after her husband's death.

Style of Samuel Cooper

British, probably after 1672

27
Charles II (1630–1685), *King of England*

Vellum laid on prepared card with gessoed back,
1¼ x 1⅛ in. (33 x 27 mm)
Bequest of Millie Bruhl Fredrick, 1962 (62.122.21)

Wearing armor with a white falling collar and the blue ribbon of the Order of the Garter. Black hair and mustache. Gray background.

EX COLL.: [Art Trading Co., New York, until 1938]; Mrs. Leopold Fredrick, New York (1938–62).

LITERATURE: E. G. Paine, unpublished list of miniatures in the Fredrick collection (1960), no. 13, as by Thomas Flatman.

THE MINIATURE is not by Flatman (1637–1688). It is based upon the formal state portrait of Charles II by Samuel Cooper, of which there are examples on a larger scale in the Goodwood collection (7½ x 6⅜ in. [190 x 162 mm]; Daphne Foskett, *Samuel Cooper* [London, 1974], colorpl. 9) and in the Rijksmuseum, Amsterdam. The handling is not Cooper's, and the miniature, which is of the late seventeenth century, may be one of the portraits that Nicholas Dixon (no. 31) produced as king's limner after Cooper's death.

Monogrammist FS
(Franciszek Smiadecki?)

British, active about 1650–65

A number of oil miniatures with distinctive characteristics—such as sharp lighting with a highlight on the tip of the nose and dark shadows under the eyes—were painted in the mid-seventeenth century in England and signed with the initials FS. Others have been assigned to the same artist because they share these stylistic traits. The signature has been said to be that of Franciszek Smiadecki, who is believed to have been the son of a serf of the Orlov family (who were members of the Russian nobility) and to have gone when young to Sweden, where he was taught miniature painting by Alexander Cooper (1609–1660?). This biography is, however, largely conjectural.

Attributed to the
Monogrammist FS
(Franciszek Smiadecki?)

28
Portrait of a Man

Oil on card with gessoed back, 2⅝ x 2¼ in. (67 x 56 mm)
Bequest of Millie Bruhl Fredrick, 1962 (62.122.23)

Wearing armor and a white falling collar. Hazel eyes; black hair. Dark gray background.

The gessoed back bears a recent inscription in pencil *Genl Monk*.

LITERATURE: E. G. Paine, unpublished list of miniatures in the Fredrick collection (1960), no. 51, as after a Peter Oliver, about 1640, with the note "late 19th century copy."

THE MINIATURE is certainly of mid-seventeenth-century origin and not, as Paine suggests, a nineteenth-century copy. It is close in

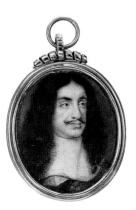

27

style to the group of oil miniatures painted in England, about 1650–65, and signed FS, as Richard Allen has also observed.

The sitter is evidently an English soldier of the Commonwealth period, about 1650. Comparison with the miniature portrait by Samuel Cooper of George Monck (1608–1670), first duke of Albemarle (John Murdoch, in *The English Miniature*, exh. cat. [New Haven and London, 1981], p. 117, fig. 131), does not support the proposed identification recently inscribed on the miniature's back.

Richard Gibson

British, born about 1615, died 1690

Richard Gibson was a dwarf who became a page to Philip Herbert (1584–1650), fourth earl of Pembroke, the lord chamberlain. He acquired a knowledge of miniature painting and was employed as a portraitist and copyist by Charles I and his court. In the 1670s he was drawing master to the daughters of the future James II (1633–1701), the princesses Mary (1662–1694) and Anne (1665–1714), both later queens of England. Gibson's style was influenced by that of his friend the painter Sir Peter Lely (1618–1680). One of Gibson's five surviving children, Susan Penelope Rosse, became a miniature painter.

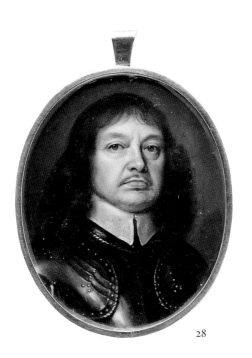

28

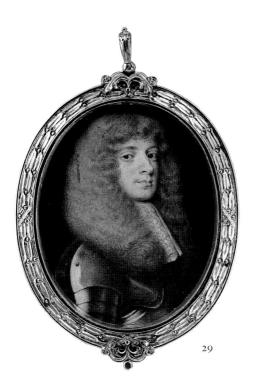

29

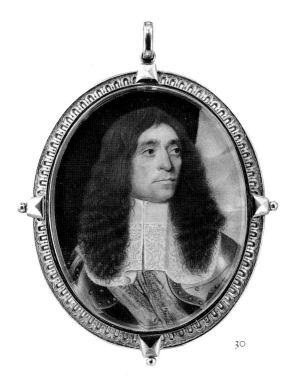

30

Attributed to Richard Gibson

29
Portrait of a Man, Said to Be
John Cecil (1628–1678),
Fourth Earl of Exeter

Vellum laid on card, 2⅞ x 2⅜ in. (72 x 59 mm)
Bequest of Mary Clark Thompson, 1923 (24.80.509)

Wearing armor and a white lace falling collar. Light brown wig. Dark brown background.

The number *27599* is written in ink on the back of the card and scratched in the bezel and on the inside of the case. The ormolu frame is engraved on the back with the inscription *Earl of Exeter / by / S. Cooper* and with the arms of the house of Cecil.

CONDITION: There are two discolored marks in the sitter's hair; otherwise the miniature is in very good condition. The vellum is slightly cockled. On the card to which it is attached are traces of gold-beater's skin. The glass has been reset.

EXHIBITED: Brooklyn Museum, 1936, *Five Centuries of Miniature Painting*, no. 8; Metropolitan Museum of Art, 1950, *Four Centuries of Miniature Painting*, list, p. 2.

THE MINIATURE was received in the Metropolitan Museum with a clearly erroneous attribution to Samuel Cooper (nos. 25–27), which

was changed in 1961 to Nicholas Dixon(?) (no. 31). Daphne Foskett in 1972 and Hermione Waterfield in 1978 suggested that the miniature might be by Richard Gibson. In a 1979 letter John Murdoch, who has reconstructed the career of Richard Gibson (John Murdoch and V. J. Murrell, "The Monogrammist DG: Dwarf Gibson and His Patrons," *Burlington Magazine* 123 [1981], pp. 282–89), expressed the opinion that the miniature is by Richard Gibson, about 1670, which is probably the case.

A photograph of this miniature is filed under Exeter's name in the archives of the National Portrait Gallery, London, and the likeness is consistent with an earlier Hoskins miniature, signed and dated 1647, at Burghley House (no. M/53) in the collection of the descendants of the earls of Exeter.

David Myers

British, active about 1659–76

A group of miniatures dating between 1659 and 1676 are signed with the monogram DM. They are now ascribed to David Myers, about whom little is known (Daphne Foskett, *A Dictionary of British Miniature Painters* [New York and Washington, D.C., 1972], vol. 1, pp. 391, 418, and vol. 2, pl. 221, no. 550, and pl. 222, no. 551, ills.).

30
Portrait of a Man

Vellum laid on prepared gessoed card, 2½ x 2 in. (62 x 51 mm)

Signed and dated (left, in gold): [D?]M. / [1]664 [the signature and date trimmed at left]

Bequest of Mary Clark Thompson, 1923 (24.80.510)

Wearing armor with a white lace-edged falling collar and the pink and gold ribbon of an unidentified order. Brown eyes; brown wig. Dark gray-brown background with sky at the right.

The back of the gilt metal frame is engraved *Lord Fairfax / DATED / 1664*. The number *28080* is written in pencil on the back of the miniature and is scratched into the inside of the case. A modern card inside the case bears remnants of printed words: *Ambass . . . / Re / de Mr. / de la Ref / le*.

CONDITION: The miniature, which is in very good state, suffers from a concave warp.

THE SIGNATURE on this miniature is a truncated version of the monogram DM found on the work assigned to David Myers. On receipt in the Metropolitan Museum, it was described as a portrait of Thomas Fairfax (1612–1671), third baron Fairfax of Cameron, following the identification engraved on the back. This appears to be inaccurate since the wound that Fairfax received at the battle of Marston Moor in 1644 remained conspicuous but is not visible here on the sitter's left cheek. The sitter also does not appear to be fifty-two, Fairfax's age in 1664.

Nicholas Dixon

British, active about 1660, died after 1708

Little is known about Nicholas Dixon before 1673 when he succeeded Samuel Cooper (nos. 25–27) as limner to Charles II (1630–1685). He was also appointed keeper of the King's Picture Closet. The 1670s were his best years as a portraitist; later he was much occupied with limned copies of old master paintings. In 1698 he offered a large collection of such copies in a lottery, but this was not a successful venture. He died in poverty.

31
Sir Henry Blount (1602–1682)

Vellum laid on card, 2⅝ x 2⅛ in. (67 x 55 mm)
Signed (left, in gold): *ND* [monogram]
Bequest of Mary Clark Thompson, 1923 (24.80.513)

Wearing a black silk cloak and white collar. Blue eyes; brown wig. Black background, with sky at right.

On the back of the gilt metal frame is engraved *William Russell / First Duke of Bedford*.

LITERATURE: Unpublished. For the version from the collection of Lord Beauchamp, Madresfield: G. C. Williamson, *History of Portrait Miniatures* (London, 1904), vol. 1, pl. LIII, fig. 5; G. C. Williamson, in *L'Exposition de la miniature à Bruxelles en 1912* (Brussels and Paris, 1913), p. 25, pl. XI, no. 44; Greta S. Heckett collection, sale, Sotheby's, London, part 4, April 24, 1978, no. 501, ill.; Graham Reynolds, *English Portrait Miniatures*, rev. ed. (Cambridge, 1988), p. 81.

THE INSCRIPTION on the frame is incorrect. The identification of the sitter as Sir Henry Blount was established from the ex-Beauchamp miniature, which was traditionally described as of him (the two miniatures are virtually identical). It is confirmed by the plumbago portrait of Blount by David Loggan (no. 32), signed and dated 1679, sold at Christie's, London, July 10, 1990, no. 9, ill. The Loggan work is a later portrait, whereas no. 31 may be dated in the 1660s.

Sir Henry Blount traveled extensively in Europe and the Levant. *Voyage to the Levant,* his account of an eleven-month journey of six thousand miles, went through eight editions in English between 1636 and 1671. Sir Henry was knighted in 1640 and sided with the Royalists in the Civil War.

David Loggan

British, 1634–1692

David Loggan belonged to an Oxfordshire family of Scots descent. Born in Gdansk, Loggan

may have studied engraving there under Willem Hondius (born about 1597, died about 1660) and in Amsterdam under Crispijn de Passe II (born about 1597, died about 1670). He was working in England by 1658 and became a citizen in 1675, the year in which he moved from Oxford to Leicester Fields (now Leicester Square) in London. Loggan was engraver to the universities of Oxford and Cambridge and was one of the earliest seventeenth-century artists to draw plumbago (graphite) portraits on vellum in England. The technique was demanding as the fine, hard line, when applied to vellum, could not be modified or erased.

32
Portrait of a Man

Plumbago on vellum, 5¼ x 4¼ in. (132 x 107 mm)
Signed and dated (right): *DL d[el] / 1680*
Rogers Fund, 1944 (44.36.3)

Wearing a gown, a lace falling collar, and a wig.

Applied to a loose backing card is the round green trade label, printed in black, of H. J. Hatfield & Sons Ltd. of Charlotte Street, London, which reads "MINIATURES ETC. / PAINTED, CLEANED, REPAIRED / AND FRAMED." This label also appears on nos. 33–37, which are uniformly framed. Here the number *19* is written on the same card in pencil.

CONDITION: The vellum was fixed to card overall, but there are now several separations at the upper right. There are a number of small holes in the vellum, three in the sitter's wig, and six in the background. The technique is tight, and the carbon is shiny where it is heavily worked. The face has a slight yellowish tone. The cover glass is a modern replacement; a spacer has been supplied.

EX COLL.: J. P. Morgan, New York (died 1943; his sale, Parke-Bernet, New York, March 24, 1944, no. 396).

EXHIBITED: Metropolitan Museum of Art, 1950, *Four Centuries of Miniature Painting,* list, p. 4.

LITERATURE: Sale catalogue, ill. p. 94.

Robert White

British, 1645–1703

Born in London, White studied there with David Loggan (no. 32). He was a prolific engraver, producing about four hundred engraved portraits, and he made many *ad vivum* portraits in plumbago (graphite) on vellum. He died in his printshop in Bloomsbury Market.

33
Portrait of a Man

Plumbago on vellum, 4¼ x 3⅜ in. (106 x 85 mm)
Signed and dated (right): *Rob*ᵗ *Whitef / 1690*
Rogers Fund, 1944 (44.36.6)

Wearing a robe, a fringed cravat, and a wig.

There is an inscription in black ink on the reverse of a card to which the cover glass is fixed with goldbeater's skin: *James 2nd Duke of / Ormond. / (dated 1690.) / died in Avignon / 1745.* Additionally there is the number *13* in pencil. See also no. 32.

CONDITION: Although the vellum is slightly stained at the edges, this is a fine and well-preserved example of White's work in plumbago. Near the signature, which is rubbed, there is some pencil work on the card backing.

EX COLL.: J. P. Morgan, New York (died 1943; his sale, Parke-Bernet, New York, March 24, 1944, no. 402).

EXHIBITED: Metropolitan Museum of Art, 1950, *Four Centuries of Miniature Painting,* list, p. 4.

DESPITE THE inscription, it is unlikely that this miniature represents James Butler (1665–1745), second duke of Ormonde, who served as lord lieutenant of Ireland. There is a 1682 plumbago by David Loggan (no. 32) purporting to represent the second duke of Ormonde (Victoria and Albert Museum, London, no. P.101–1920; see Basil S. Long, *Hand-List of Miniatures and Silhouettes* [London, 1930], p. 44, fig. 59). The sitters in the Metropolitan and the Victoria and Albert miniatures bear no resemblance to each other. The V&A miniature (by Loggan) is, however, similar to two engravings of Ormonde, also in the V&A (no. 29608.G, by S. Gribelin after Dahl, 1713, and no. 22046, by J. Smith after Kneller).

Thomas Forster

British, active about 1690–1713

Little is known about Forster except that he specialized in drawing portraits of very high quality in plumbago (graphite) on vellum at the end of the seventeenth and the beginning of the eighteenth century. A remark made by Vertue suggests that he was born as late as 1677. His drawings seem to have been made *ad vivum*; he did not engrave them.

34
Portrait of a Man

Plumbago on vellum, 4⅜ x 3⅝ in. (112 x 92 mm)
Signed and dated (right): *TForster* [initials in monogram] / *Delin* / *1700*
Rogers Fund, 1944 (44.36.2)

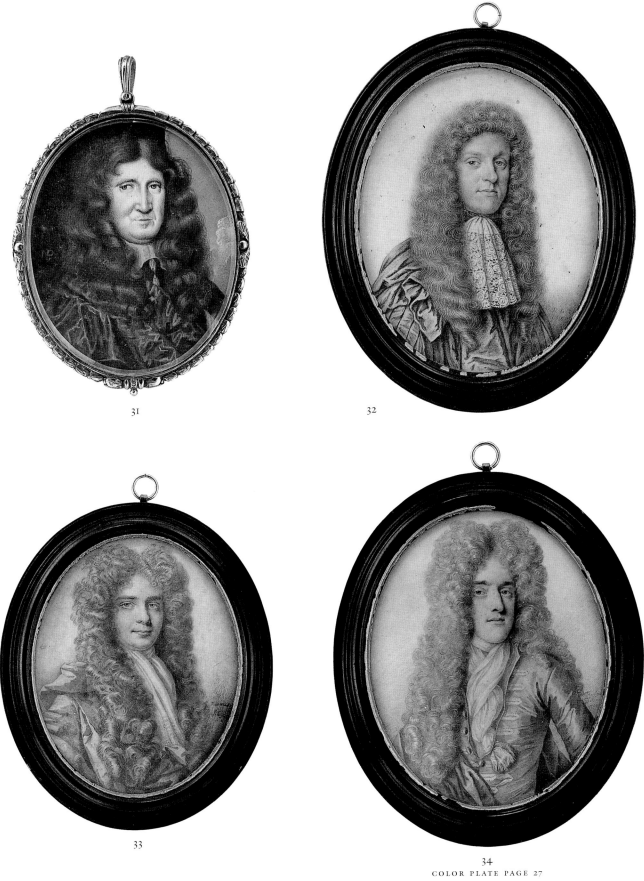

31

32

33

34

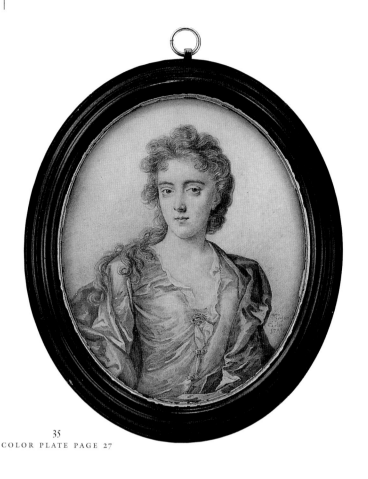

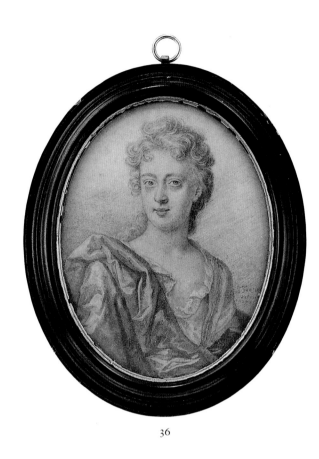

35
COLOR PLATE PAGE 27

36

Thomas Forster (*continued*)

Wearing a coat, a robe, a fringed cravat, and a wig.

CONDITION: The present miniature and no. 35 are very well preserved and characteristic of Forster's refined use of plumbago.

EX COLL.: J. P. Morgan, New York (died 1943; his sale, Parke-Bernet, New York, March 24, 1944, no. 394).

EXHIBITED: Metropolitan Museum of Art, 1950, *Four Centuries of Miniature Painting,* list, p. 5.

35
Portrait of a Woman

Plumbago on vellum, 4⅜ x 3½ in. (112 x 90 mm)
Signed and dated (right): *TForster* [initials in monogram] / *delin* / *1700*
Rogers Fund, 1944 (44.36.5)

Wearing a mantua with jeweled buckles and a shawl.

EX COLL.: J. P. Morgan, New York (died 1943; his sale, Parke-Bernet, New York, March 24, 1944, no. 398).

EXHIBITED: Metropolitan Museum of Art, 1950, *Four Centuries of Miniature Painting,* list, p. 5.

LITERATURE: Sale catalogue, ill. p. 94.

THE JEWELS indicate a sitter of wealth if not rank.

36
Portrait of a Woman

Plumbago on vellum, 4¼ x 3¼ in. (107 x 82 mm)
Signed and dated (right): *TForster* / *delin* / *1701*
Rogers Fund, 1944 (44.36.1)

Wearing a mantua and a shawl.

Inscribed on the reverse of the card to which the cover glass and vellum are fixed with goldbeater's skin: (center in pencil) *My dear mother;* (below in pencil) *12.* This inscription is repeated in ink in a later hand on the cardboard backing. See also no. 32.

CONDITION: Slight stains in the face and background.

EX COLL.: J. P. Morgan, New York (died 1943; his sale, Parke-Bernet, New York, March 24, 1944, no. 391).

EXHIBITED: Metropolitan Museum of Art, 1950, *Four Centuries of Miniature Painting,* list, p. 5.

IN THE EVENT that the inscription is correct, Forster's mother's apparent age here would support the birth date in the late 1670s suggested for the artist by Vertue.

37
Portrait of a Man

Plumbago on vellum, 5⅛ x 4 in. (130 x 102 mm)
Signed and dated (left): *Fo* / *1705*
Rogers Fund, 1944 (44.36.4)

Wearing a robe, a fringed cravat, and a wig.

CONDITION: There are four holes in the sitter's wig, two in the drapery, and several in the background; otherwise the state is good.

EX COLL.: J. P. Morgan, New York (died 1943; his sale, Parke-Bernet, New York, March 24, 1944, no. 397).

EXHIBITED: Metropolitan Museum of Art, 1950, *Four Centuries of Miniature Painting,* list, p. 5.

LITERATURE: Sale catalogue, ill. p. 94.

THE INDICATION of landscape—in the form of trees and clouds at the left—is unusual.

37

38

Christian Richter

Swedish, 1678–1732

Richter was born in Stockholm and went to England in 1702, working there for the rest of his life. His countrymen the portrait painter Michael Dahl (1656–1743) and the enamelist Charles Boit (1662–1727) were in England at the same time. Many of Richter's miniatures are copies after Samuel Cooper (nos. 25–27), Godfrey Kneller (1646–1723), Dahl, and other portraitists. He was the younger brother of David Richter the Younger (1664–1741), who became miniature painter to the Swedish court on the death of Elias Brenner (1647–1717).

38
John Churchill (1650–1722), *First Duke of Marlborough*

Vellum, 3¼ x 2⅝ in. (82 x 67 mm)
Bequest of Mary Clark Thompson, 1923 (24.80.508)

Wearing armor lined with red, a blue cloak, and a white collar. Brown wig. Dark gray shaded background.

The elaborate early-twentieth-century gilt metal frame is ornamented with military trophies. The central cartouche is engraved *John / Duke of Marlborough / By B.LENS*. Inscribed inside the frame is *Felix Jo[?uberg] / 1904* in scratched letters.

CONDITION: Vertical cuts at left and right, and a small area at bottom have been made up; the sitter's chin may have been slightly retouched. There are several scars in the blue drapery at the lower right and losses in the armor at the lower left.

LITERATURE: Unpublished. For the version in the Buccleuch collection—signed and dated on the reverse 1714—of which this is an autograph replica, see the following: H. A. Kennedy, *Early English Portrait Miniatures in the Collection of the Duke of Buccleuch* (London, 1917), pl. LXI; Wilhelm Nisser, *Michael Dahl and the Contemporary Swedish School of Painting in England* (Uppsala, 1927), cat. p. 137, no. 11; Leo R. Schidlof, *The Miniature in Europe* (Graz, 1964), vol. 2, p. 676; Daphne Foskett, *A Dictionary of British Miniature Painters* (New York and Washington, D.C., 1972), vol. 1, p. 468, vol. 2, p. 83, pl. 289, fig. 724.

THIS IS not by Bernard Lens (1682–1740; no. 116) but is instead an autograph replica of Richter's miniature of 1714 in the Buccleuch collection. Another miniature portrait of Marlborough by Richter was sold from the collection of

John Quicke, Christie's, London, July 7, 1905, no. 6 (see also Nisser [Uppsala, 1927], cat. p. 145, no. 19). Since the sitter is described in the sale catalogue as wearing the star and ribbon of the Garter, the miniature is not this version.

John Churchill (1650–1722), first duke of Marlborough, achieved a number of victories against the forces of Louis XIV during the War of the Spanish Succession. The palace designed by Sir John Vanbrugh and built for him at public expense was named Blenheim after the battle of 1704 which resulted in the most decisive of those victories. He was made a knight of the Garter in 1702.

Jean Baptiste Massé

French, 1687–1767

Born in Paris, Massé was the son of a goldsmith and jeweler. He studied with the painter Jean Jouvenet (1644–1717) and was admitted to the Académie Royale in 1717. In 1720 he met, and was influenced by, the Italian artist Rosalba Carriera (1675–1757; no. 97) when she was in Paris: he is said to have copied a bacchanal by

39

40

her and, following her example, became one of the first French miniaturists to paint on ivory. Jeanne Étienne Liotard (1702–1789) studied with him, and the Danish miniaturist Cornelius Høyer (1741–1804) became his pupil in 1764.

Massé had an immense reputation during his lifetime, but until recently few works by him were known. The recent emergence of a group of family portraits (sold Sotheby's, Geneva, November 16, 1989, nos. 8–12, and Sotheby's, Geneva, November 15, 1990, nos. 3–5 and 7 [no. 6 is of Louis XV], color ills.) gives a clearer picture of his style and suggests the attribution of the following miniature to him.

Attributed to Jean Baptiste Massé

39
Pierre Louis Dubus (1721–1799), *Called Préville, of the Comédie-Française*

Ivory laid on card, diam. 1⅝ in. (42 mm)
Rogers Fund, 1957 (57.54)

Wearing a light pink jacket, white frilled shirt, and hat. Brown eyes. Sky background.

The miniature is set in a gilt-metal mount which has been separated from the lid of a blue composition snuffbox lined with tortoiseshell. A trade card of a French firm founded in 1905 was between the miniature and the box indicating that the work was refitted in France around that time.

EX COLL.: Françoise Flameng, Paris (by 1912–19; sale, Galeries Georges Petit, Paris, May 26–27, 1919, no. 178, to Meyer); [Charles E. Slatkin, New York, until 1957].

EXHIBITED: Brussels, 1912, *L'Exposition de la miniature*, no. 758.

LITERATURE: Paul Lambotte, "Exposition de la miniature," *L'Art flamand et hollandais* 17 (1912), p. 153, ill. (reprinted in Dutch, *Onze Kunst* 21 [1912], p. 205, ill.); Jean-Jacques Olivier, *Pierre-Louis Dubus-Préville de la Comédie-Française (1721–1799)* (Paris, 1913), p. 176 and ill. following p. 72; Max Schmid, "Zur Geschichte der Miniaturmalerei," *Die Kunst für Alle* 29 (1913/14), p. 31, ill.; Max von Boehn, *Miniaturen und Silhouetten: Ein Kapitel aus Kulturgeschichte und Kunst* (Munich, 1918), pp. 69–70, fig. 67; L. De-Mauri (pseudonym of Ernestino Sarasino), *L'Amatore di miniature su avorio* (Milan, 1918), p. 218, ill.

WHEN exhibited from the Flameng collection in Brussels in 1912, the miniature was described as a portrait by Fragonard of the actor Préville; when sold from that collection in 1919, it was catalogued as a portrait of the actor Larive, French school, eighteenth century, on a box of the Louis XVI period. Olivier (1913), however, accepted it as a portrait of Préville.

In the references cited above, this miniature is treated as a representative example of Fragonard's work. Comparison with no. 44 shows that this attribution is untenable. It does, however, resemble the recently discovered family portraits by Massé in the excellence of its draftsmanship, in the treatment of the costume and

the shadows under the sitter's eyes, and in the comparative restraint of the brushwork.

Pierre Louis Dubus (1721–1799), the son of a Parisian tradesman, began his career as a traveling player and then took leading comic roles in Strasbourg, Rouen, Dijon, and Lyons. Under his stage name, Préville, he became a leading actor at the Comédie-Française. He made his Paris debut in 1753 and continued to perform with great success until his retirement in 1786. Among his many roles he created the character of Figaro in *Le Barbier de Séville* (1775) by Beaumarchais.

French

about 1750

40
Louis XV (1710–1774), *King of France*

Vellum, 2⅛ x 2⅞ in. (55 x 72 mm)
Bequest of Millie Bruhl Fredrick, 1962 (62.122.84)

Wearing armor with an ermine-lined blue cloak decorated with gold fleurs-de-lis and the blue ribbon of the Order of the Saint-Esprit. Brown eyes; powdered hair. Landscape background.

The silver frame is crested with interlaced L's surmounted by a crown; the rim and crest are set with brilliants. The back of the frame is engraved with the king's coat of arms.

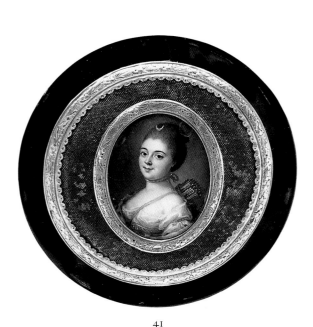

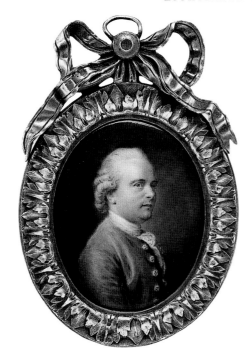

41

42
COLOR PLATE PAGE 28

A visiting card attached to the card backing of the miniature is engraved *Etienne Meynieux / Premier Président de la Cour d'Appel / Lyon.* The card is also inscribed in ink on the reverse: *Vente Meynieux / Hôtel des Ventes / de Lyon / Décembre 1931.*

CONDITION: The vellum is buckled. The sitter's mouth and chin have been retouched.

EX COLL.: Étienne Meynieux, Lyons (his sale, Lyons, December 1931).

LITERATURE: E. G. Paine, unpublished list of miniatures in the Fredrick collection (1960), no. 100, as French, about 1775.

Arnaud Vincent de Montpetit

French, 1713–1800

Born in Mâcon, Montpetit worked in Bourg-en-Bresse, and mainly in Paris. He became a member of the Académie de Saint-Luc in 1766 and was held in high regard as a painter by Louis XV (1710–1774). He made a number of inventions and evolved the process that he called eludoric painting (painting in oils on fabric under a thin film of water and fixing the miniature to the inside of a glass, thus preventing harmful exposure to the atmosphere). Ann Massing ("Arnaud Vincent de Montpetit and Eludoric Painting," *Zeitschrift für Kunsttechnologie und Konservierung* 2[1993], pp. 359–68) distinguishes this method from that of a *verre fixé*, in which a painting in oils or gouache on fabric is stuck to a glass with a translucent paste (the painting is executed in the usual way and not under water). Many of

Montpetit's miniatures in the eludoric manner have been lost. There is a miniature portrait of a boy (Massing, p. 364, fig. 4) in the Museum Boymans–van Beuningen, Rotterdam, and a signed portrait by him of Louis XV is reproduced by A. Kenneth Snowman (*Eighteenth Century Gold Boxes of Europe* [London, 1966], pl. 254).

Attributed to Arnaud Vincent de Montpetit

41
Portrait of a Woman as Diana

Verre fixé, 1⅜ x 1 in. (35 x 27 mm)

Gift of Mrs. Louis V. Bell, in memory of her husband, 1925 (25.106.31)

Wearing a white dress and gold breastplate; a quiver with a pink ribbon and with blue and red feathered arrows at her back. Leopard skin over her right shoulder. Dark eyes and eyebrows; lightly powdered hair dressed with crescent moon, the symbol of Diana. Dark gray-green background.

The miniature is set in the lid of a tortoiseshell box framed by two gold bands between which is a surround of gilt tinsel mostly discolored to green.

CONDITION: There is a scratch in the cover glass and a craze in its outer surface at the upper right edge; the *fixé* is lifting from the glass at the upper left edge. The figure nevertheless is very well preserved.

THIS MINIATURE may be associated with Montpetit's eludoric painting, though it is not close in style to the examples mentioned above, or it may be a conventional *fixé.* It dates from the 1760s and has been attributed to Montpetit by Bodo Hofstetter. Other *fixés* are numbers 53, 54, and 250.

Pierre Pasquier

French, 1731–1806

Pasquier, who painted portraits in oil, pastel, and enamel, was born at Villefranche-sur-Saône (Rhône). He became a member of the Académie Royale in 1769 upon presentation of miniature portraits representing Louis XV and the king of Denmark, both of which were exhibited that same year. He was granted a lodging in the Louvre in 1774.

42
Abbé Charles Bossut (1730–1814)

Enamel, 2⅜ x 2 in. (62 x 50 mm)

Signed and dated (reverse, in black on blue enamel): *M.ʳ l'abbé Bossut / de l'acad: R. des Sciences / Examinateur des ingénieurs / peint par Son ami Pasquier / de l'acad: R. de peinture / à paris 1772.*

Gift of Mrs. Louis V. Bell, in memory of her husband, 1925 (25.106.20)

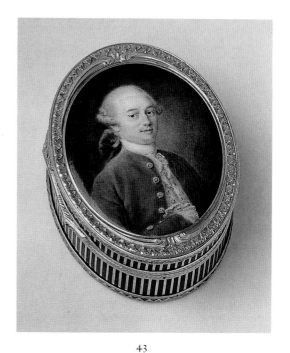

43

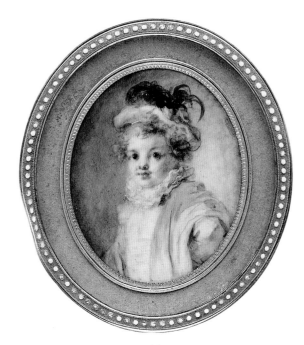

44
COLOR PLATE PAGE 28

Wearing a lilac coat with gold buttons and white frilled shirt; three-cornered hat under his left arm. Hazel eyes; powdered hair and traces of a gray beard. Gray background.

Labels on the back are inscribed in ink *4* and in print *20*.

EXHIBITED: Paris Salon, 1773, no. 132 (probably this miniature).

AMONG A number of miniatures and enamels by Pasquier which were exhibited at the Paris Salon in 1773 was number 132, "Le Portrait de M. l'Abbé Bossut, de l'Académie Royale des Sciences" (Leo R. Schidlof, *The Miniature in Europe* [Graz, 1964], vol. 2, p. 613). It seems probable the present miniature is that which was exhibited in Paris as the portrait of Bossut. Bodo Hofstetter (in a letter, 1995) has pointed out that there is an earlier enamel by the same artist and of the same sitter, signed and dated 1767. Its present whereabouts is unknown; a photograph is in the Witt Library, Courtauld Institute, London.

Charles Bossut (1730–1814), celebrated for his work in geometry, had been trained by the Jesuits and worked under d'Alembert (1717–1783) and with him on the *Encyclopédie*. He was received into the Académie des Sciences in 1768, having been appointed to a chair in hydrodynamics established by the king. He was the author of *Cours complet de mathématiques* (1795–1801) and other textbooks and treatises. Artist and sitter were contemporaries and friends.

43
Gérard de Vesme

Enamel, 2⅛ x 1¾ in. (54 x 44 mm)
Gift of Mrs. Louis V. Bell, in memory of her husband, 1925 (25.106.32)

Wearing a red coat with gold buttons, brocaded waistcoat, and white shirt; three-cornered hat under left arm. Powdered hair tied at the back with a gray ribbon. Gray background.

The enamel is mounted in the lid of a gold box made in Paris about 1770–71. The box bears the maker's mark *CB*. and the Paris marks for 1770–71. Labels on the back are inscribed in ink *3* and in print *32*. A slip of paper inside the box is inscribed *Le verso de l'émail / porte cette inscription / Gerarde de Vesme* and in another hand *peint a Paris / par Pasquier 177[3?]*.

IT WAS not thought advisable to dismantle the box to verify the transcription of the inscription on the back of the enamel. The work is characteristic of Pasquier's style in enamel painting.

Jean Honoré Fragonard

French, 1732–1806

A pupil of Boucher and Chardin, Fragonard won the Prix de Rome in 1752. After his studies in Italy, 1756 to 1761, he made his debut in the Grand Manner, presenting *Coresus and Callirhoë* (Louvre, Paris) as his reception piece to the Académie Royale in 1765. Later he abandoned this style for gallant scenes which embody the gaiety of the Rococo. A group of freely painted miniatures closely akin to his studies of children are traditionally assigned to him; no. 44 is one of this group. Some scholars attribute these works to his wife, Marie-Anne, née Gérard (1745–1823), whom he married in 1769 and who exhibited miniatures from 1779 to 1782, but the prevailing view is that they are probably by Jean Honoré Fragonard.

44
Portrait of a Boy

Ivory, 2⅞ x 2⅜ in. (73 x 59 mm)
Rogers Fund, 1960 (60.14)

Wearing a shirt with a white frilled collar, light gray jacket, and white hat with a black feather. Brown eyes; brown hair. Graduated light gray background.

Labels on the back are inscribed in print *538*, in ink *519*, and (twice) *192* and in pencil *Heine / Morgan / J.H.F.*

EX COLL.: Michel Heine, Paris (by 1888); J. Pierpont Morgan, London and New York (by 1907–13); J. P. Morgan, New York (1913–35; his sale, Christie's, London, June 24, 1935, no. 519, to Spink); [Spink & Son, London, from 1935]; [Alfred Joseph, London, until 1960].

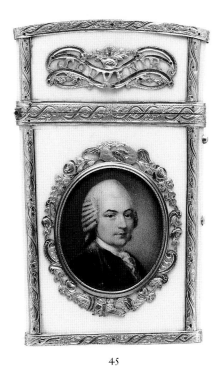

45

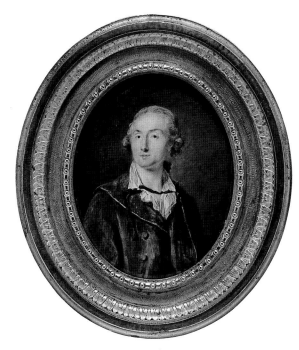

46

COLOR PLATE PAGE 29

EXHIBITED: Paris, 1888, *L'Art français sous Louis XIV et sous Louis XV*, no. 251; Galerie Georges Petit, Paris, 1907, *Chardin–Fragonard*, no. 192.

LITERATURE: Baron Roger Portalis, *Honoré Fragonard: Sa vie et son oeuvre* (Paris, 1889), vol. 1, ill. opposite p. 136, and vol. 2, p. 317; G. C. Williamson, *Catalogue of the Collection of Miniatures the Property of J. Pierpont Morgan*, vol. 3 (London, 1907), no. 538H, pl. CLXXX, no. 2 (the H suffix refers to the Heine collection bought *en bloc* by J. Pierpont Morgan); Armand Dayot and Léandre Vaillat, *L'Oeuvre de J.-B.-S. Chardin et de J.-H. Fragonard* (Paris, 1908), no. 193, ill.; Leo R. Schidlof, *The Miniature in Europe* (Graz, 1964), vol. 1, p. 266; Daniel Wildenstein and Gabriele Mandel, *L'opera completa di Fragonard* (Milan, 1972), p. 112, no. 576, ill.

THERE IS general agreement that this is one of the group of brilliantly painted miniatures by Fragonard. Torben Holck Colding has discussed this series (*Aspects of Miniature Painting: Its Origins and Development* [Copenhagen, 1953], pp. 146–48) and has concluded that considerations of date (they are from the 1770s) suggest that they are by Jean Honoré rather than his wife, Marie-Anne Gérard.

Nicolas André Courtois

French, 1734–1806

Born in Paris, Courtois painted miniatures in enamel and on ivory and vellum and full-size portraits in oil and pastel. He was made a member of the Académie in 1770, exhibited at the Paris Salon from 1771 to 1777, and was appointed painter to Louis XVI in 1782. He died in Paris.

45
Portrait of a Man

Enamel, 1¼ x 1⅛ in. (32 x 27 mm)

Signed (right edge, in black): *Courtois*

Gift of J. Pierpont Morgan, 1917 (17.190.1265) ESDA

Wearing a brown coat and white shirt. Brown eyes; powdered wig with brown ribbon. Gray background.

The miniature is set in a souvenir of ivory with gold mounts made in Paris, probably by Thomas François Merlin (master in 1773, working to about 1793) in 1775–76. It bears four marks, among them a maker's mark, possibly TFM, and the Paris mark for 1775–76.

A pierced gold plaque on the front is lettered SOUVENIR; that on the back reads D'AMITIE. A glazed gold plaque at the back reads in cipher LAMOUR. The souvenir contains a tablet of three ivory leaves and a gold-mounted pencil.

On one ivory leaf is the collection label of Bernard Franck; *2515* in pencil and *P.M.3670* in red are inscribed on another; a stock label inside is printed *78*.

EX COLL.: Bernard Franck, Paris.

LITERATURE: *Collection de 124 carnets de bal du XVIIIᵉ siècle formée par M. Bernard Franck à Paris* (Paris, about 1902), pl. 78.

Peter Adolf Hall

Swedish, 1739–1793

Born in Borås, Sweden, Hall worked in the Stockholm studio of the pastelist Gustaf Lundberg (1695–1786) from 1760 until 1766. He then settled in Paris, where he soon became the leading miniaturist and first exhibited at the Paris Salon in 1769. Hall left for Belgium in 1791 and died in Liège in 1793. In his mature work he exploited to the full the possibilities opened up by Rosalba Carriera's introduction of ivory as a ground (no. 97); his miniatures are also marked by freedom of brushwork, breadth of handling, and a subtle balance between transparent and opaque pigments. There is a fine collection of works by Hall in the Musée du Louvre.

46
The Painter Louis Joseph Maurice

(1730–1820)

Ivory, 3⅜ x 2⅝ in. (84 x 67 mm)

Signed and dated (right, in black): *hall.* / [*ft?*] *72*

The Moses Lazarus Collection, Gift of Josephine and Sarah Lazarus, in memory of their father, 1888–95 (95.14.53)

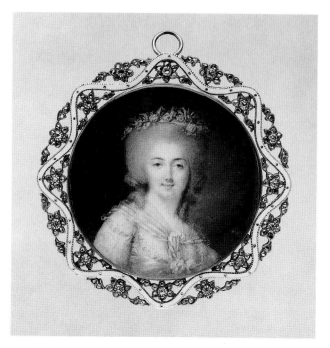

47

48

Wearing a brown coat with gold piping and an open white shirt with black ribbon ties. Brown eyes; powdered hair. Gray-brown background.

A label fixed to the brass back of the present frame is inscribed in ink in a nineteenth-century hand *Portrait / peint en 1772 par Hall, / de Louis Joseph Maurice / Né à Nancy le / Juin 1731.* To this are attached four stock labels relating to the Lazarus collection.

CONDITION: At upper left the ivory paint surface has been made up on card. The deteriorated cover glass was replaced, and a ragboard spacer was supplied.

EXHIBITED: Metropolitan Museum of Art, 1950, *Four Centuries of Miniature Painting,* list, p. 6.

MAURICE, born in Nancy, was a lawyer who gave up the bar to become a portraitist. He went to St. Petersburg in 1758 as court painter to the Empress Elizabeth (1709–1762), and he seems also to have been court painter to Catherine the Great (1729–1796). A miniature portrait by him of Empress Catherine II (about 1762) is in the Musée du Louvre, Paris (Pierrette Jean-Richard, *Miniatures sur ivoire* [Paris, 1994], no. 715, ill.). When he returned to Paris, he found favor with the queen, Marie Antoinette (1755–1793). Before the Revolution he assembled a distinguished collection of works of art.

47
Portrait of a Woman

Ivory, diam. 2 in. (52 mm)
Signed (right, in black): *hall*
Mr. and Mrs. Isaac D. Fletcher Collection, Bequest of Isaac D. Fletcher, 1917 (17.120.119)

Wearing a light blue dress with pink roses at the bosom and a white scarf. Powdered wig dressed with a blue ribbon and a chaplet of pink roses.

CONDITION: The painted surface is in fair condition; the ivory support had split into three separate pieces which had been mounted to a heavy card. The old card was removed so that the cracks could be brought together and the ivory remounted.

EXHIBITED: Metropolitan Museum of Art, 1950, *Four Centuries of Miniature Painting,* list, p. 6.

WHEN IT entered the Metropolitan Museum, this signed miniature was described as a portrait of Marie Antoinette (1755–1793), queen of Louis XVI, but that identification is incorrect. The costume suggests a date of about 1780. Opinions have differed about the status of this miniature. Despite the signature Pierrette Jean-Richard (in a letter, 1995) rejects the attribution to Hall, as does Bodo Hofstetter. The miniature may, how-

ever, be a work by Hall which has lost some of its quality through damage.

48
Portrait of a Young Woman

Ivory, 2¾ x 2⅛ in. (70 x 55 mm)
Signed (left, in black): *hall.*
Bequest of Collis P. Huntington, 1900 (26.168.45)

Wearing a blue dress with a purple belt and white sleeves; a gold chain around her neck. Hazel eyes; light brown hair bound with coral-colored ribbon and covered with a gauze veil. Gray background.

CONDITION: The well-preserved painted surface extends both above and below the ivory onto a backing card covered with vellum on the reverse. The deteriorated cover glass was replaced and a ragboard spacer was supplied.

SOME DOUBTS have been cast on the authenticity of this miniature. In 1952 Leo R. Schidlof and recently Pierrette Jean-Richard accepted it as a work by Hall. Edwin Boucher and Bodo Hofstetter have pronounced it a fake, and Hermione Waterfield thinks it a work by a pupil or a copy. However it seems to be an authentic signed work by the artist, and it has not been possible to establish clear evidence of

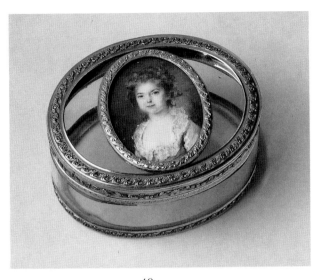

49

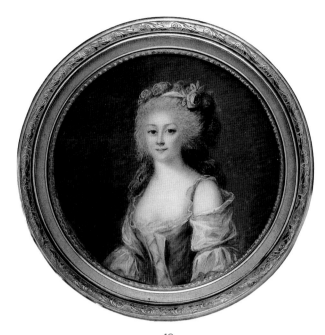

50

retouching. It was painted about 1790, late in Hall's life, when most of his output consisted of decorative portraits of beautiful women.

Attributed to Peter Adolf Hall

49
A Young Girl with the Initials DE

Ivory laid on card, 1¼ x 1 in. (33 x 26 mm)
Gift of J. Pierpont Morgan, 1917 (17.190.1135) ESDA

Wearing a pink dress with a white collar. Hazel eyes; brown hair. Gray background.

The miniature is set in a sweetmeat box of rock crystal with two-color gold mounts. It has seven marks, including an illegible maker's mark and the Paris mark for 1775–76. On the reverse of the miniature is a plaque with the monogram DE.

RICHARD ALLEN and Edwin Boucher have attributed this miniature to Hall, an attribution accepted by Bodo Hofstetter but not by Pierrette Jean-Richard.

Style of Peter Adolf Hall

about 1780

50
Portrait of a Woman

Ivory, diam. 2⅜ in. (62 mm)
Bequest of Millie Bruhl Fredrick, 1962 (62.122.137)

Wearing a purple bodice and white shift. Hazel eyes; powdered hair dressed with roses on ribbon. Brown background.

A label on the back is inscribed in ink *101*.

CONDITION: The painted surface is very well preserved; foil with copper and silver faces, the silver against the ivory, covers the back.

IN HIS unpublished list of the miniatures in the Fredrick collection (1960), no. 78, E. G. Paine described this as a work by Hall, about 1780. Though it is of fine quality and much in Hall's manner, the attribution is uncertain—the portrait is hardly spirited enough for his later style. Pierrette Jean-Richard believes it to be of the period; Bodo Hofstetter does not agree.

Charles Paul Jérôme de Bréa

French, born about 1739, died 1820

Born in Rouen, De Bréa showed at the Paris Salon from 1793. According to Leo R. Schidlof,

he may have studied with Peter Adolf Hall (1739–1793; see nos. 46–50). Bodo Hofstetter notes that C. P. J. de Bréa died in Paris on September 4, 1820, at the age of eighty-one.

51
Benjamin Franklin (1706–1790), *after a Painting by Greuze of 1777*

Ivory, 3⅜ x 2¾ in. (85 x 68 mm)
Signed and dated (right): *de Bréa / 1777*
Gift of J. William Middendorf II, 1968 (68.222.9)

Wearing a green fur-lined coat and lace jabot. Blue eyes; brown hair. Blue background.

CONDITION: The miniature has been made up at left and right edges. The painted surface extends onto a card that completes the oval support. The extension at the right was adjusted to eliminate a slight gap. A rectangular wood frame of the period with an oval opening, a gilded-copper bezel, and a convex cover glass were supplied.

EX COLL.: Michel Bernstein, Issy-les-Moulineaux (1958); [Kennedy Galleries, New York, 1960]; J. William Middendorf II (1960–68).

LITERATURE: Charles Coleman Sellers, *Benjamin Franklin in Portraiture* (New Haven and London, 1962), p. 303, no. 9, as by Louis de Broux in the Bernstein collection in 1958.

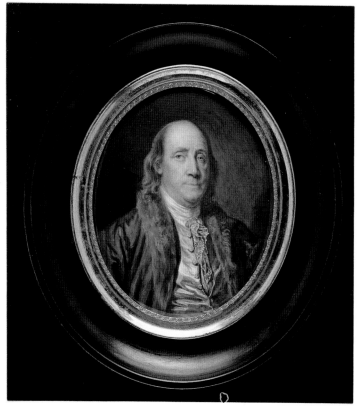

51
COLOR PLATE PAGE 30

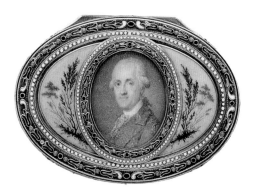

52
COLOR PLATE PAGE 31

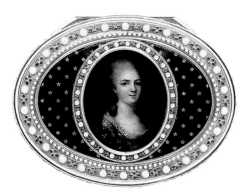

53
COLOR PLATE PAGE 31

THE MINIATURE is copied from the portrait which Jean Baptiste Greuze (1725–1805) made of Benjamin Franklin in 1777, after he arrived in France as plenipotentiary to the court of Versailles. It follows the version in oils (American Philosophical Society, Philadelphia) commissioned by Élie de Beaumont, an eminent French lawyer, in showing a green coat and lace jabot rather than the blue coat and linen jabot of the preliminary pastel sketch (U.S. Department of State, Washington, D.C.).

Perhaps owing to later retouching the signature had been misread by Sellers as *de broux*. In 1995, however, Bodo Hofstetter proposed the attribution to Charles Paul Jérôme de Bréa, pointing out a similar, signed enamel by De Bréa representing Franklin (Leo R. Schidlof, *The Miniature in Europe* [Graz, 1964], vol. 1, p. 108, vol. 3, pl. 93, fig. 165). This enamel was sold by Bohn, London, in 1885. Its present whereabouts is unknown. The resemblance between the two works is compelling.

French or German

about 1778–79

52
Portrait of a Man, Probably Prince Karl of Saxony (1733–1796)

Ivory, 1⅜ x 1⅛ in. (34 x 27 mm)
Gift of J. Pierpont Morgan, 1917 (17.190.1128) ESDA

Wearing a red uniform jacket with a green collar and a red-and-gold epaulet, white shirt, and the blue ribbon and badge of an order, either the Order of the Saint-Esprit or, more likely, the Saxon Order of the White Eagle (as proposed by Bodo Hofstetter). Blue eyes; powdered hair with black ribbon. Gray background.

The miniature is set in a gold box, fitted with panels of translucent opalescent enamel of exceptionally fine workmanship. The box was made by Jean Joseph Barrière (apprenticed 1750, master 1763, working 1793) in Paris in 1778–79. The box bears five marks, among them the maker's mark JJB and the Paris mark for 1778–79.

Inside is a label with the printed number *2360* and the number *3515* in pencil; another label is marked *p.m. 3515* in red ink.

PRINCE KARL was the fifth son of Frederick Augustus II (1696–1753), elector of Saxony and king of Poland. This identification has recently been suggested by Harald Marx, director of the Gemäldegalerie Alte Meister in Dresden.

French

late 18th century

53
A Member of the French Royal Family, Probably a Daughter of Louis XV

Verre fixé, 1½ x 1⅛ in. (37 x 30 mm)
Bequest of Catherine D. Wentworth, 1948 (48.187.454) ESDA

Wearing a gold-embroidered brown dress and blue mantle semé with fleurs-de-lis. Brown eyes; powdered hair. Gray-green background.

The miniature is set in a gold-and-enamel box made by Joseph Étienne Blerzy (master 1768, working to 1806) in Paris in 1783–84. The box bears five marks, among them the maker's mark JEB and the Paris mark for 1783–84.

CONDITION: *Fixé* is beginning to part from the inside of the glass at left and right edges.

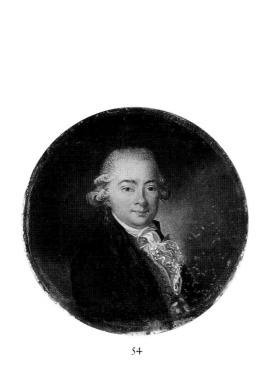

54

55

For other examples of the *verre fixé* technique, see nos. 41, 54, and 250.

THE DECORATION of fleurs-de-lis on the sitter's robe indicates that she is a member of the French royal family, probably a daughter of Louis XV. This portrait resembles those of Mme Adélaïde (1732–1800), but it may be Mme Victoire (1733–1799), since the two sisters looked alike.

French

about 1790

54
Portrait of a Man

Verre fixé, diam. 2¼ in. (60 mm)
Gift of Mrs. Louis V. Bell, in memory of her husband, 1925 (25.106.19)

Wearing a brown coat, embroidered waistcoat, and white frilled shirt. Brown eyes; powdered hair. Light brown background.

The fabric backing of the frame is inscribed in ink *A.M.B. / 60* and bears two stock labels numbered *12* (in ink) and *19* (printed).

CONDITION: Because this miniature was either painted directly on or adhered to the eighteenth-century cover glass, it cannot be treated even though the glass is weeping. The stamped and gilded bezel has been removed because it was heavily corroded from contact with the glass.

This appears to be a conventional *verre fixé*; for other examples of the technique, see nos. 41, 53, and 250.

French

about 1790

55
Self-portrait of an Unidentified Artist

Ivory, diam. 3¼ in. (82 mm)
Inscribed: (right, in gray, by the artist) *Peint par lui / meme*; (left edge, in gray, falsely) *Vestier 1786*
Bequest of Millie Bruhl Fredrick, 1962 (62.122.76)

Wearing a blue coat, open-necked white shirt with blue stripes, and plaid neckcloth; holding a palette and brushes in his left hand. Blue eyes; powdered hair. The outline of a female portrait is laid in on a canvas at right. Dark gray and roseate sky in background.

A label on the back is inscribed in ink *A Vestier / Portrait Painter / 1749–1813 / France / by himself / 1786* and *#80*.

CONDITION: The painted surface extends onto a backing card at the left; it is heavily crazed in the background. Two pieces of foil with copper and silver faces were found between the ivory and the laid backing paper. At the lower edge and under the sleeve a small area of damage that may be due to moisture has been toned. The deteriorated cover glass has been replaced. The paint has flaked in a number of places, particularly in the background, and has been retouched; there is extensive craquelure at the right and a crack and repair at the left edge.

EX COLL.: [Bensimon, Aix-les-Bains, until 1929]; Mrs. Leopold Fredrick, New York (1929–62).

LITERATURE: E. G. Paine, unpublished list of miniatures in the Fredrick collection (1960), no. 92, as by Vestier.

COMPARISON with accepted self-portraits of Antoine Vestier (1740–1824) (e.g., Anne-Marie Passez, *Antoine Vestier* [Paris, 1989], nos. 26, 41, 92, 129, 131, 160, 205, and 219, ills.) shows that this is not of or by him. The supposed signature and date along the left edge is

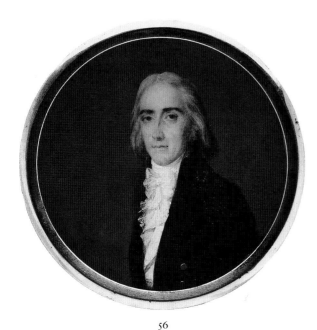

56

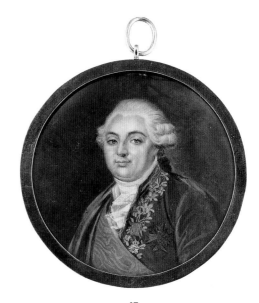

57
COLOR PLATE PAGE 32

therefore a later addition. The inscription on the easel shows, however, that it is a self-portrait, representing a young artist, as yet unidentified. From the costume it may be assumed to have been painted about 1790.

Barrois

about 1790

56
Portrait of a Man

Ivory, diam. 2¾ in. (67 mm)
Signed (left edge, in black): *Barrois*
Bequest of Ella Church Strobell, 1917 (17.134.8)

Wearing a blue coat and white waistcoat and cravat. Brown eyes. Brown background.

CONDITION: Under backing papers there was a piece of discolored foil that has been removed. An attempt was made to minimize dark stains — caused by contact with weeping glass — in the background.

WHEN THE miniature was received in the Metropolitan Museum, the signature was taken to be that of Jean-Pierre Frédéric Barrois (born 1786, died after 1841), the only miniaturist with that surname in the standard lists. It was subsequently noticed that the sitter's costume dates about 1790, when Barrois would have been four years old, and that the style does not resemble that of Barrois's self-portrait (Leo R. Schidlof,

The Miniature in Europe [Graz, 1964], vol. 3, pl. 62).

A closely similar miniature signed Barroi[s] and dating about 1790 is in the Musée des Arts Décoratifs de Bordeaux (see *L'âge d'or du petit portrait*, exh. cat. [Paris, 1995], no. B11, ill., and Jacqueline Du Pasquier, *Pierre-Edouard Dogoty 1775–1871 et la miniature bordelaise au XIXᵉ siècle* [Chartres, 1974], pp. 20–22, fig. 8).

Antoine François Callet

French, 1741–1823

Callet is recorded as a painter in large of history pieces and mythological subjects as well as portraits. He was awarded the Prix de Rome in 1764, was admitted to the Académie in 1780, and exhibited at the Salon from 1781. Callet completed his first official portrait of Louis XVI in coronation robes in 1779. He painted a number of variants, one of which was engraved by C. C. Bervic (1756–1822) and the latest of which (Musée Bargoin, Clermont-Ferrand) was exhibited at the Salon of 1789. Subsequently he entered the service of Napoléon I.

Attributed to Antoine François Callet

57
Louis XVI (1754–1793), *King of France*

Ivory, diam. 2⅝ in. (67 mm)
Signed and dated(?) (right, in black): *Callet / 1787*
The Collection of Giovanni P. Morosini, presented by his daughter Giulia, 1932 (32.75.10)

Wearing a reddish-brown coat with gold embroidery, violet cloak, white frilled shirt, blue ribbon and badge of the Order of the Saint-Esprit, and red ribbon and badge of the Order of Saint-Louis. Powdered hair. Dark gray background.

CONDITION: Silver badge of the Order of the Saint-Esprit has darkened through oxidation.

ALTHOUGH Leo R. Schidlof does not mention Callet as a miniature painter, no. 57 is presumably by him. Several bust-length portraits of the king in oil by or attributed to Callet are recorded, and in at least one of these (art market, 1979) he wears a similar costume with the same decorations.

Jean Laurent Mosnier

French, 1743/44–1808

Born in Paris, Jean Laurent Mosnier trained at the Académie de Saint-Luc and became a master there in 1766. He attracted the attention of the court and painted Marie Antoinette in 1776. He became a member of the Académie Royale in 1788 but was one of the first French artists to immigrate to England on the outbreak of the French Revolution. After exhibiting at the Royal Academy from London addresses

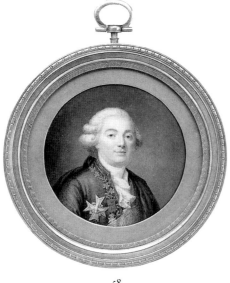

58

COLOR PLATE PAGE 32

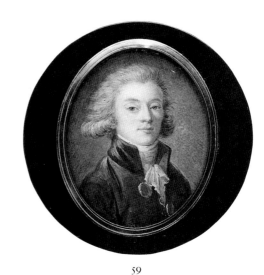

59

between 1791 and 1796, Mosnier went to Hamburg and then to Russia, where he entered the service of Alexander I (1777–1825). He died in St. Petersburg. Nine miniatures by Mosnier of which four are dated—are in the Louvre.

Attributed to Jean Laurent Mosnier

58
Louis XVI (1754–1793), *King of France*

Ivory, diam. 2¾ in. (69 mm)
Signed and dated(?) (left edge, in black): *J.L. Mosnier · 1790*
Bequest of Millie Bruhl Fredrick, 1962 (62.122.69)

Wearing a brown coat with gold embroidery, violet cloak, white frilled shirt, blue ribbon and badge of the Order of the Saint-Esprit, and red ribbon and badge of the Order of Saint-Louis. Powdered hair. Pinkish gray background.

CONDITION: Some repainting on the background near the top.

LITERATURE: E. G. Paine, unpublished list of miniatures in the Fredrick collection (1960), no. 84, as by T. L. Molnick or Molnier (both forms are misreadings of the signature).

LEO R. SCHIDLOF records that Mosnier was called the Roslin of miniature painting (after Alexandre Roslin [1718–1793]) because of his skill in rendering silk, a feature apparent in

this portrait. The costume here is identical to that worn by Louis XVI in no. 57.

In spite of the supposed signature, some doubts have been expressed about the authorship of this miniature. Pierrette Jean-Richard does not think it is in Mosnier's style.

Joseph Boze

French, 1745–1825/26

Joseph Boze was born at Martigues (Bouches-du-Rhône) in 1745 (some authorities give the date as 1744). He worked in pastel and oils as well as in miniature and was favored by Louis XVI (1754–1793), who appointed him his official war painter. Boze sought refuge in England from the Revolution; returning to Paris, he supported Marie Antoinette at her trial and was imprisoned for eleven months. Louis XVIII (1755–1824) restored him to the post of painter to the royal family. Boze died in Paris in 1825 or possibly 1826.

Attributed to Joseph Boze

59
Portrait of a Man

Ivory, 1⅞ x 1½ in. (47 x 38 mm)
Bequest of Mary Clark Thompson, 1923 (24.80.533)

Wearing a blue coat with darker blue collar and

white frilled shirt. Powdered hair. Blue background.

The miniature is set with a gold rim in the lid of a tortoiseshell box.

Among the stock labels fixed inside the box is a blue-edged one inscribed in ink *2196 / Gorzas / couvert* [?] */ dec. / BOZE*; another is numbered in ink *108* with the further inscription *M.C. Th. . .*

THE STATUS of this miniature is dubious. In 1977 Richard Allen considered it to be a fake of about 1880, after Augustin Ritt (1765–1799). However, it seems to be a work of about 1790, and the label inside the box naming Boze might be a clue for a correct attribution. The miniature displays Boze's palette as described by Leo R. Schidlof: "a not very pure yellowish colouring, with brown shadows and bluish half-tints" (*The Miniature in Europe* [Graz, 1964], vol. 1, p. 106).

The name Gorzas was perhaps intended to refer to Antoine Joseph Gorsas, a writer and political figure born in Limoges on September 21, 1751, and guillotined in Paris on October 7, 1793.

Louis Marie Sicardi

French, 1743–1825

Born in Avignon, Sicardi, who studied with his father, was admitted to the Académie in Bordeaux in 1771. He worked in Paris, where he was favored by Louis XVI (1754–1793) for miniature presentation portraits, many of which were set in gold boxes. Sicardi was also successful during the Revolution, the Empire, and the

Restoration. His exhibits at the Salon between 1791 and 1819 included oils and drawings.

60
Louis XVI (1754–1793), *King of France*

Ivory, 1¼ x 1 in. (32 x 25 mm)
Signed and dated (left, in black): *Sicardy/1780*
Bequest of Edward C. Post, 1915 (30.58.3) ESDA

Wearing a blue coat with gold and floral embroidery and the red ribbon and badge of the Order of Saint-Louis. Blue eyes; powdered hair with a black bow. Gray-brown background.

The miniature is set in a gold box decorated with enamel and diamonds made by Joseph Étienne Blerzy (master 1768, working to 1806) in Paris in 1779–80. The box bears five marks, among them the maker's mark JEB and Paris marks for 1779–81. The inside of the gold lid is engraved *PRESENTED / TO / Col.John Laurens. / by / LOUIS THE 16ᵗʰ / A.D. 1780.*

EX COLL.: Col. John Laurens (1781–82); by descent to John Laurens, his nephew(?); his widow(?), Mrs. Laurens (sold on her behalf by William Brown & Son, Baltimore, Maryland, December 4, 1866); Edward C. Post, New York and Newport, Rhode Island (until 1915).

LITERATURE: "The Bequest of Edward C. Post," *Metropolitan Museum Bulletin* 25 (1930), pp. 163, 164, fig. 2.

COLONEL JOHN LAURENS (1754–1782) of South Carolina, the first owner of this box, was an aide-de-camp to George Washington. In 1780 he was named envoy extraordinary to France to negotiate a loan from the French government. Laurens arrived in France in March 1781; the date 1780 engraved on the box as the year of Louis XVI's gift is therefore erroneous.

This is one of many autograph repetitions of a popular portrait of Louis XVI by Sicardi. An earlier version, dated 1779, was sold at Sotheby's, Geneva, November 15, 1995, no. 319; one is no. 61; and another, dated 1782, is in the Wallace Collection, London (Graham Reynolds, *Wallace Collection: Catalogue of Miniatures* [London, 1980], no. 127, ill.).

61
Louis XVI (1754–1793), *King of France*

Ivory, 1¼ x 1 in. (33 x 27 mm)
Signed and dated (left, in black): *Sicardij / 1780*
Gift of J. Pierpont Morgan, 1917 (17.190.1156) ESDA

Wearing a blue coat with gold and floral embroidery and the red ribbon and badge of the Order of Saint-Louis. Blue eyes; powdered hair with a black bow. Gray-brown background.

This miniature is set in a rectangular gold box with chamfered corners decorated with enamel. The box is of uncertain, possibly Viennese, manufacture. It bears five marks, among them an unidentified maker's mark PM/C and three nineteenth-century Russian marks.

THIS WORK is one of the numerous autograph repetitions of a popular miniature portrait of Louis XVI by Sicardi of which no. 60 is another example. The date has been read as 1790, but it is evidently 1780.

62
Portrait of a Man

Ivory, 1⅜ x 1¼ in. (36 x 32 mm)
Gift of Mrs. Louis V. Bell, in memory of her husband, 1925 (25.106.13)

Wearing a red uniform jacket with blue edging and a white-and-gold epaulet and frilled white shirt. Dark brown eyes; powdered hair tied with a black ribbon. Gray-brown background.

The miniature is in a silver frame with an inner gold border set with brilliants. A blue-edged half stock label fixed to the back is inscribed in ink *126 / medaillen / officier.*

THE MINIATURE was described on receipt in the Metropolitan Museum as French school, eighteenth century. The attribution to Sicardi was made by Leo R. Schidlof in 1952 and is apparently correct. The miniature is datable about 1780.

Attributed to Louis Marie Sicardi

63
Portrait of a Man

Ivory, set in a souvenir, 1 x ¾ in. (25 x 20 mm)
Gift of J. Pierpont Morgan, 1917 (17.190.1303) ESDA

Wearing a red coat with a pink waistcoat and white shirt. Blue-gray eyes; powdered hair. Brown background.

The miniature is set in a gold-and-enamel souvenir of nineteenth-century date with the monogram GBP in diamonds on the reverse. *Souvenir* is lettered on the front and *d'amitié* on the back. The ivory leaves inside the souvenir are inscribed twice *2457* and *21*; there is the label of the Bernard Franck collection, and a stock label printed *21* has been corrected to *20* and is inscribed in red ink *P.M. 3612.*

EX COLL.: Bernard Franck.

LITERATURE: *Collection de 124 carnets de bal du XVIIIᵉ siècle formée par M. Bernard Franck à Paris* (Paris, about 1902), pl. 20.

THE ATTRIBUTION of this late-eighteenth-century miniature to Sicardi, suggested by Richard Allen and Edwin Boucher in 1977, is not accepted by Pierrette Jean-Richard.

Pierre Rouvier
French, born after 1742, died after 1791

Born in Aix-en-Provence, Rouvier was a student from 1770 at the Académie in Paris (where his name is also recorded as Rouvière). He exhibited at the Salon de la Correspondance in 1779 and 1782, and signed and dated works by him are known from 1780 until 1791.

64
Portrait of a Woman, Said to Be Madame Bailly

Ivory, set in a horn box, diam. 2¼ in. (57 mm)
Signed and dated (right, in black): *Rouvier / 1780*
Bequest of Kate Read Blacque, in memory of her husband, Valentine Alexander Blacque, 1937 (38.50.7) ESDA

Wearing a pink muslin dress with a fichu and blue bows. Blue-gray eyes; powdered hair. Gray background.

The miniature is set in a horn box with gold mounts. A slip of paper formerly in the box read *Mme Bailly.*

The last numeral in the date is uncertain; it has been read variously as *9* or *0*. On grounds of costume the latter seems more likely.

Louis Nicolas van Blarenberghe
French, 1716–1794
and
Henri Joseph van Blarenberghe
French, 1741–1826

The work of Louis Nicolas van Blarenberghe is indistinguishable from that of his son Henri Joseph van Blarenberghe, except in the rare cases when the elder signs with his initials or the younger adds *le fils* after his name. They wanted their miniatures, usually genre scenes of daily life in Paris or the countryside animated with figures, to be regarded as the work of a communal studio. Henri Joseph's daughter Hélène continued her career in the same manner into the mid-nineteenth century.

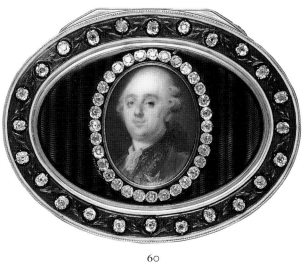

60

COLOR PLATE PAGE 32

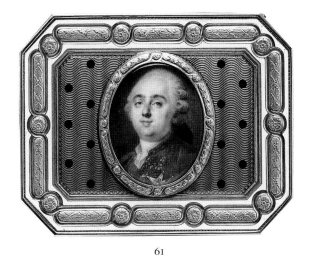

61

62

63

64

65 TOP
COLOR PLATE PAGE 34

66 BOTTOM
COLOR PLATE PAGE 35

65

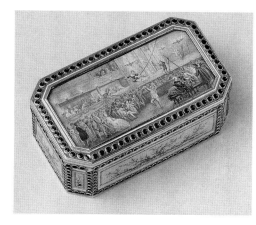

66 TOP
COLOR PLATE PAGE 35

Louis Nicolas van Blarenberghe and
Henri Joseph van Blarenbergh (*continued*)

65
Six Views at Chanteloup (The Choiseul Box)

Vellum, set in a gold box

Top: *View of the Château de Chanteloup from the Entrance Screen*; 2¼ x 3⅛ in. (57 x 80 mm); signed and dated (bottom left): *Van Blarenberghe 1767.*

Bottom: *View from the Château to the South Looking toward the Ornamental Semicircle of Water and across the Forest of Amboise*; 2¼ x 3⅛ in. (57 x 80 mm).

Front: *View of the Château from the South Looking up the Cascade from the Semicircular Basin of Water*; 1¾ x 3⅛ in. (45 x 80 mm).

Back: *View of the Château from the West across the Formal Gardens*; 1¾ x 3⅛ in. (45 x 80 mm).

Left side: *View across the Formal Gardens from the Southwest*; 1¾ x 2¼ in. (45 x 57 mm).

Right side: *View across the Forest of Amboise from the Ornamental Semicircle of Water*; 1¾ x 2¼ in. (45 x 57 mm).

Gift of Mr. and Mrs. Charles Wrightsman, 1976 (1976.155.22) ESDA

The miniatures, which are all by the Van Blarenberghes, are set in a gold box made in Paris in 1748–49, possibly by Pierre François Delafons (master 1732, working to 1787).

EX COLL.: Étienne François de Choiseul-Stainville, duc de Choiseul; his widow; Mrs. David Birnbaum.

EXHIBITED: Parke-Bernet, New York, 1955, *Art Treasures Exhibition*, no. 237; Institute of Fine Arts, New York University, 1962, *Tabatières*, no. 13; Royal Academy of Arts, London, 1968, *France in the Eighteenth Century*, no. 860; Victoria and Albert Museum, London, 1968.

LITERATURE: F. J. B. Watson, in *The Wrightsman Collection* (New York, 1970), vol. 3, pp. 133–39, no. 8, with ills. and full earlier bibliography.

THE MINIATURES are some eighteen years later than the box, suggesting that they replaced earlier miniatures which were removed. In 1770 the duc de Choiseul commissioned a similar box decorated with miniatures by the Van Blarenberghes of the interiors of the Hôtel de Choiseul in the rue de Richelieu, Paris (F. J. B. Watson, *The Choiseul Box: A Microcosm of Eighteenth-Century Taste* [London, 1963], as in the collection of Baron Élie de Rothschild).

Étienne François de Choiseul-Stainville (1719–1785), duc de Choiseul, was Louis XV's principal minister from 1760 to 1770, when he was abruptly dismissed from office. He spent the remaining years of his life in exile at the Château de Chanteloup. He had bought his property in 1761 and added greatly to the house and gardens. The château was demolished in the nineteenth century.

66
Theatrical Scenes: A Rope Dancer; A Puppet Show

Vellum, set in a gold box, each 1⅛ x 2⅜ in. (30 x 60 mm)

Gift of J. Pierpont Morgan, 1917 (17.190.1130) ESDA

The miniatures are set in a gold box made by Joseph Étienne Blerzy (master 1768, working to

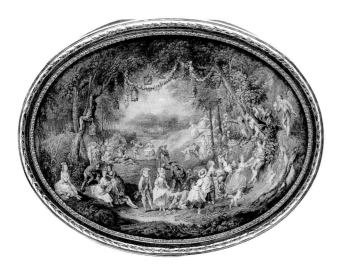

67 TOP

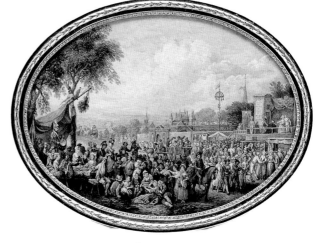

67 BOTTOM

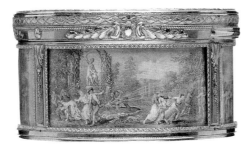

67 LEFT SIDE

1806) in Paris in 1778–79. The box bears four marks, among them the Paris mark for 1778–79, and the maker's mark of Blerzy.

Inside the box are a printed label *2348* marked in pencil *3503* and a stock label inscribed in red ink *P.M.3503*.

On the top of the box a female acrobat, urged on by a clown, swings on a rope above the audience; there is a tightrope on the stage behind her. On the bottom a puppet show, including a Punchinello, is presented by a clown. The sides of the box, in translucent enamel that resembles moss agate, are decorated with tree silhouette motifs.

AN OVAL box in the Huntington Art Collections, San Marino (no. 27.17), has on the top a miniature similar to that on the top of this box. It shows the stage over the heads of the orchestra, with the acrobat above the trestles supporting the tightrope. The miniature is signed *v Blarenberghe,* and the box is inscribed on the bezel "donné le 3 aoust 1781 par Joseph II empereur roy des Romains à M. Laurent de Lionne directeur des canaux de Picardie" (given on August 3, 1781, by Joseph II, Holy Roman

Emperor, to M. Laurent de Lionne, director of the Picardy canals) (Robert R. Wark, *The Huntington Art Collection* [San Marino, California, 1970], no. 15, fig. 179).

The resemblance of the scene on the top of this box to the signed work in the Huntington Art Collections confirms the traditional attribution of the miniatures to the Van Blarenberghes. They were all made at approximately the same time, since these two are set in a box of 1778–79 and the box at San Marino was a gift in 1781.

67
Six Scenes of Country Pastimes

Vellum, set in a gold box

Top: *Fête champêtre*; 2⅛ x 3 in. (53 x 74 mm); signed and dated (bottom, in brown): *van Blarenberghe / 1774.* The revelers, attended by a fiddler and a piper, give away flowers; the overarching trees are hung with garlands and birdcages.

Bottom: *A Festival near a Château*; 2⅛ x 3 in. (53 x 74 mm). At left countryfolk feast; at right a theatrical performance is held on a stage with a maypole to left.

Front: *Archery Match*; ¾ x 1⅞ in. (21 x 48 mm). Participants shoot at a heart-shaped target.

Back: *A Round Dance Outside a Village*; ¾ x 1⅞ in. (21 x 48 mm). At right a drunken soldier approaches a shepherd and shepherdess.

Left side: *A Youth Spurting Water from a Fountain*; ¾ x 1⅞ in. (21 x 48 mm)

Right side: *Country Scene with Two Couples on a Seesaw*; ¾ x 1⅞ in. (21 x 48 mm)

Gift of J. Pierpont Morgan, 1917 (17.190.1152) ESDA

The miniatures, which are all by the Van Blarenberghes, are set in an oval gold box with six marks, which include the Paris mark for 1774–75 and the maker's mark of Pierre François Drais (master 1763, working 1788).

Inside the box are a printed label *2365* marked in pencil *3520* and a stock label inscribed in red ink *P.M.3520.*

LITERATURE: Henry and Sidney Berry-Hill, *Antique Gold Boxes* (New York, 1953), p. 68, no. 45, ill.

Style of the Van Blarenberghes

French; sides: late 18th century; top: about 1800

68

Four Maritime Scenes; Louis XIV Crossing the Rhine in 1672

Vellum, set in a gold box

Front: *A Harbor by Moonlight*; ⅝ x 2⅜ in. (16 x 60 mm). At left countryfolk cook a meal in a pot.

Back: *A Naval Battle*; ⅝ x 2⅜ in. (16 x 60 mm)

Left side: *River Scene with Boats*; ⅝ x 1⅝ in. (16 x 41 mm). The boats are moored near a palace entrance

Right side: *A Sailing Vessel Shipwrecked and Another Driven by a Violent Storm*; ⅝ x 1⅝ in. (16 x 41 mm)

Top: *Louis XIV Crossing the Rhine in 1672*; 1⅝ x 2⅜ in. (41 x 60 mm); inscribed (lower right, in brown, falsely): BLARENBE[RGHE]

Gift of J. Pierpont Morgan, 1917 (17.190.1178) ESDA

The miniatures are set in a gold box made by Adrien Jean Maximilien Vachette (1753–1839) in Paris probably about 1800. The box is inscribed *Vachette, Bijoutier, à Paris.* and bears his maker's mark and post-Revolution and later Paris marks.

THE MARITIME scenes on four sides of this box are of fair quality and were probably made in the later years of the eighteenth century in the style of, and possibly in the workshop of, the Van Blarenberghes. The miniature of Louis XIV on the top is far inferior in quality and was presumably produced about 1800 to complete the decoration of the box. The composition derives from a painting by Adam François van der Meulen (1632–1690); an engraving of Meulen's picture, made by Charles Simonneau (P.-J. Angoulvent, *La Chalcographie du Louvre* [Paris, 1926], no. 715, ill.), was the source for the miniature.

A box made up by Vachette after 1798, also with scenes in the manner of the Van Blarenberghes, is in the Wallace Collection, London (Graham Reynolds, *Wallace Collection: Catalogue of Miniatures* [London, 1980], no. 90, ills.).

Style of the Van Blarenberghes

Continental; possibly about 1820

69

Country Scene: Harvesting Fruit

Vellum, diam. 2¾ in. (70 mm)
Inscribed (right, in black, falsely): *vanBlarenberghe*
Gift of J. Pierpont Morgan, 1917 (17.190.1183) ESDA

At left a youth hauls water from a well; at center a girl throws a bucket of water at a man who is fighting. Among the spectators at right is a woman with a spinning wheel; in the right background two countryfolk pick fruit.

This miniature is set in a gold box made by Johann Wilhelm Keibel (master 1812, died 1862) in St. Petersburg about 1820. The box has the mark of a St. Petersburg assayer, Alexander Jaschinkov (working 1795–1826).

Inside the box are a label printed *2321* and a stock label inscribed in pencil *3475*.

CONDITION: In 1940 the miniature was treated for fungus, and the decomposed glass was replaced; the surface has suffered, especially at top left edge.

EX COLL.: Marquis de Thuisy (sale, Hôtel Drouot, Paris, May 30–31, 1901, no. 134, ill.).

LITERATURE: A. Kenneth Snowman, *Eighteenth Century Gold Boxes of Europe* (London, 1966), pl. 656, the box attributed to Otto Samuel Keibel and the miniature tentatively to Henri Joseph van Blarenberghe.

THE MINIATURE is set in a circular box in varicolored gold. The box is signed KEIBEL and has a maker's mark which was apparently used by both Otto Samuel Keibel (master 1797, died 1809) and his son Johann Wilhelm Keibel (master 1812, died 1862). It was originally attributed to Otto Samuel Keibel, but in 1976 Clare Le Corbeiller dated the box about 1820 and attributed it to Johann Wilhelm Keibel.

Given the miniature's coarse workmanship, it must be accepted that the inscription *van Blarenberghe* is not genuine and that this is a pastiche executed in imitation of the Blarenberghe style.

Mademoiselle Duplessis

French; active about 1753–60

Mademoiselle Duplessis was listed among the fashionable enamelists in Paris in the *Almanach des beaux-arts* for 1753 and 1754. She may have been related to Joseph Siffred Duplessis (1725–1802), the distinguished portraitist, who arrived in Paris in 1752. The earliest gold box decorated with enamels that bears her signature (Musée du Louvre, Paris) was made by Jean George in Paris in 1755/56. A slightly later box is catalogued below.

70

Six Scenes of Putti at Play

Grisaille enamel, set in a gold box

Top: *Putto Riding a Goat with Many Companions*; 1¾ x 2½ in. (43 x 65 mm); signed (lower left,

in brown): *M^lle Duplessis*. One of the company decorates a statue of Silenus.

Bottom: *Putti Releasing Doves from a Basket*; 1⅝ x 2½ in. (41 x 64 mm)

Front: *A Tipsy Putto with a Young Satyr*; 1 x 1⅞ in. (24 x 48 mm)

Back: *Putti Planting Flowers*; ⅞ x 1⅞ in. (22 x 48 mm). Right side has been replaced.

Left side: *Two Putti with a Dove on a Basket*; ⅞ x 1½ in. (21 x 37 mm)

Right side: *A Putto with Fruit and Another with a Hoop*; ⅞ x 1½ in. (21 x 37 mm)

Gift of J. Pierpont Morgan, 1917 (17.190.1125) ESDA

These six grisaille enamels are decorated with colored floral garlands. They are set in an oval box of carved four-color gold with six marks, among them the maker's mark of Jean George (master 1752, died 1765) and Paris marks for 1759–60 and 1761–62. The box is engraved on the rim GEORGE.A.PARIS.

Inside the box are a printed label *2395* and a label inscribed in pencil *3550*.

EXHIBITED: À la Vieille Russie, New York, 1968, *The Art of the Goldsmith and the Jeweler*, no. 74.

LITERATURE: Preston Remington, "The Galleries of European Decorative Art," *Metropolitan Museum Bulletin*, n.s., 13 (1954), p. 90, ill.; A. Kenneth Snowman, *Eighteenth Century Gold Boxes of Europe* (London, 1966), pl. 318; Clare Le Corbeiller, *European and American Snuff Boxes, 1730–1830* (New York, 1966), fig. 110; F. J. B. Watson, in *The Wrightsman Collection* (New York, 1970), vol. 3, p. 195.

Edmé Charles de Lioux de Savignac

French, active about 1766–72

Little is recorded of this artist who painted scenes of festivals, country fairs, and the like for boxes and fans in the second half of the eighteenth century. His manner is similar to that of the Van Blarenberghes.

71

A River Landscape

(pendant to 24.80.527)

Paper, diam. 3 in. (77 mm)
Signed (bottom edge, in white): *L de Savig*[*nac*]
Bequest of Mary Clark Thompson, 1923 (24.80.525)

On the near bank a gallant presents flowers to a girl and a man fishes with a pole; on the far bank two women wash clothes under a thatched shelter and another woman watches.

EXHIBITED: Metropolitan Museum of Art, 1950, *Four Centuries of Miniature Painting*, list, p. 6.

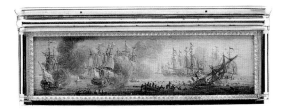

68 BACK

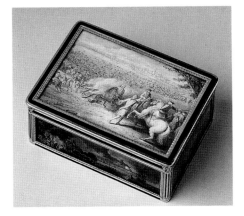

68 TOP

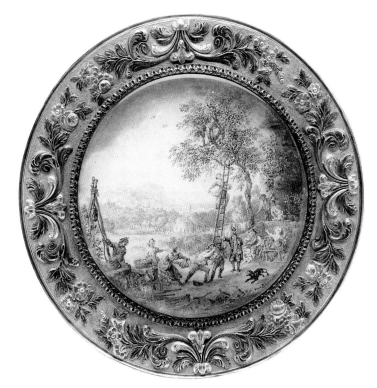

69

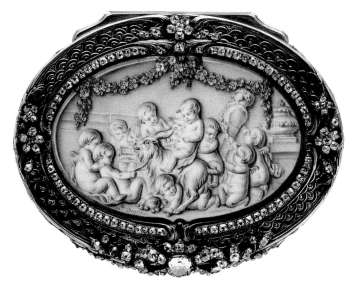

70 TOP

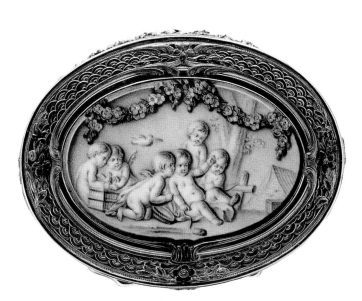

70 BOTTOM

Edmé Charles de Lioux de Savignac
(*continued*)

72
A Picnic
(pendant to 24.80.525)

Paper, diam. 3 in. (77 mm)
Signed (bottom edge, in white): *L de Savignac*
Bequest of Mary Clark Thompson, 1923 (24.80.527)

Six elegantly dressed people, waited on by two
servants, are having a *fête champêtre* in front of a
thatched pavilion; one cuts a meat pie, while a
servant gets wine from a hamper.

EXHIBITED: Metropolitan Museum of Art, 1950,
Four Centuries of Miniature Painting, list, p. 6.

Attributed to Edmé Charles de Lioux de Savignac

73
Peasants Picnicking on a Riverbank near a Village

Paper, 2 x 2¾ in. (50 x 70 mm)
Gift of J. Pierpont Morgan, 1917 (17.190.1162) ESDA

The miniature is set in the top of a late-eighteenth-
century gold box of Swiss manufacture bearing
pseudo-French marks.

Inside the box are a printed label *2366* and a stock
label inscribed in red ink *P.M.3521.*

COMPARISON with nos. 71 and 72 suggests
that the miniature is by Savignac.

Jacques Joseph de Gault

French, born 1738, died after 1812

Jacques Joseph de Gault worked for two years at
Sèvres from 1760 and was received into the
Académie de Saint-Luc in 1774; he exhibited
there until 1787. He was the first artist to paint
imitations of antique gems in grisaille for the
decoration of snuffboxes. He also painted many
portraits in miniature from the life. Some of
these are listed by Carlo Jeannerat ("De Gault et
Gault de Saint-Germain," *Bulletin de la Société de
l'Histoire de l'Art Français*, 1935, pp. 221–35).
From 1831 J. J. de Gault was confounded in the
dictionaries with Pierre Marie de Gault de Saint

Germain (1754–1842). This confusion was fueled
by the belief that his signature JJDeGault, with
two Js either separate or interlaced, should be
read as PMDeGault. In 1935 Jeannerat rectified
this error (which had been followed by Thieme-
Becker) and restored J. J. de Gault to his rightful
place in the history of the miniature. This reha-
bilitation did not become widely known, as wit-
nessed by Leo S. Schidlof (*The Miniature in
Europe* [Graz, 1964], vol. 1, p. 284).

74
Marie-Thérèse-Charlotte (1778–1851), *Daughter of Louis XVI*

Ivory, diam. 2⅜ in. (60 mm)
Signed, dated, and inscribed (in black): (bottom)
JJDegault 1795; (edge) *Marie-Thérèse-Charlotte. fille
de Louis XVI. née le 19 Decembre 1778.*
Bequest of Millie Bruhl Fredrick, 1962 (62.122.67)

Grisaille *en camaïeu*, in profile, with a gold earring
and with a fillet of pearls in her hair. Blue-gray
background.

LITERATURE: E. G. Paine, unpublished list of
miniatures in the Fredrick collection (1960), no. 72,
as by J. V. de Gault (working 1779–95).

LEO R. SCHIDLOF (*The Miniature in
Europe* [Graz, 1964], vol. 1, p. 284) lists the artist
as Pierre Marie de Gault de Saint Germain and
states that he signed *M.Degault* in such a way
that it can be read *JVJ Degault*. However, there
is no doubt that the initials on this miniature
are *JJ.*

A similar miniature in grisaille *en camaïeu* on a
blue ground, signed *Sauvage* (Piat Joseph
Sauvage, 1744–1818; nos. 78–80), was sold
recently at Christie's, London (October 17, 1995,
no. 28, ill.; see also nos. 27 and 29, ills.). In this
work Marie-Thérèse-Charlotte is shown with
her younger brother, the dauphin.

Marie-Thérèse-Charlotte, born at Versailles, was
imprisoned with other members of the royal
family in the Temple in 1791. After the executions
of her parents, Louis XVI and Marie Antoinette,
in 1793, she came to be known as the Orphan
of the Temple, where she remained until—on
December 26, 1795—she was exchanged for sev-
eral French political prisoners held in Austria
by her uncle Francis II. She was then permitted
to travel to Vienna. In 1799 she married her first
cousin Louis Antoine (1775–1844), duke of
Angoulême, son of the future Charles X.

75
Six Allegories of Love

Grisaille *en camaïeu* on ivory, set in a gold-and-
enamel box
Top: *Nymphs Setting up on a Plinth a Statue of Cupid
with a Flaming Torch*; 1⅛ x 1⅝ in. (28 x 43 mm);
signed (bottom, in scratched letters): *JJDeGault*
Bottom: *The Sale of Cupids*; 1⅛ x 1⅝ in. (28 x
43 mm)
Front: *Four Cupids Gathering Fruit from a Tree*; ½ x
1⅛ in. (11 x 30 mm)
Back: *Four Cupids Reclining Under Trees*; ½ x
1⅛ in. (11 x 30 mm)
Left side: *Three Cupids, One of Whom Has Fallen*;
½ x 1⅛ in. (11 x 30 mm)
Right side: *Three Cupids Under Trees*; ½ x 1⅛ in.
(11 x 30 mm)

Gift of J. Pierpont Morgan, 1917 (17.190.1169) ESDA

The miniatures are set in a box made in Paris in
1775–76 by Pierre François Drais.

The box bears four marks, among them the Paris
mark for 1775–76 and the maker's mark PD for
Pierre François Drais (master 1763, working 1788).
The mark, always difficult to read, was earlier con-
fused with that of Jean Ducrollay (master 1734,
retired about 1764). The correct identification, first
suggested by Henry Nocq (*Le poinçon de Paris*
[Paris, 1927], vol. 2, pp. 97–98), is confirmed by its
appearance on boxes made well after Ducrollay's
presumed retirement about 1764.

Inside the box are a printed label *2355* and a stock
label inscribed in red ink *P.M./3510.*

THE SCENE on the top of the box resembles
that, by the same artist, on the top of no. 76.
The scene on the bottom is based on a fresco
which was discovered at Stabiae in 1759 and
engraved in 1762 (*Le pitture antiche d'Ercolano e
contorni* [1778], vol. 3, pl. 7) and was imitated by
many Neoclassical artists including Joseph
Marie Vien (1716–1809) and Jacques Louis
David (1748–1825). The Victoria and Albert
Museum has a painting of the subject in oils on
marble by Piat Joseph Sauvage (C. M. Kauff-
mann, *Victoria and Albert Museum: Catalogue of
Foreign Paintings Before 1800* [London, 1973],
vol. 1, pp. 258–59, no. 320, with reference to fur-
ther literature). The composition was originally
interpreted as Indigence Selling Three Cupids
to Venus, behind whom stands Persuasion.

The signature on the top was formerly read as
M De Gault and the miniatures attributed
in error to Pierre Marie de Gault de Saint
Germain.

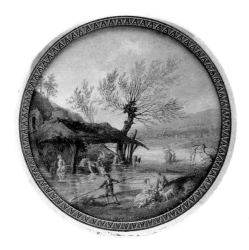

71

COLOR PLATE PAGE 33

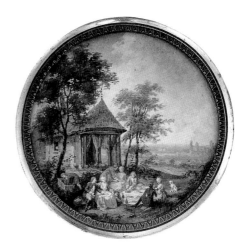

72

COLOR PLATE PAGE 33

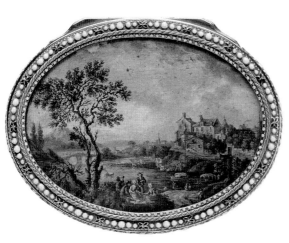

73

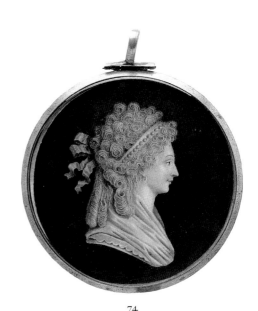

74

COLOR PLATE PAGE 36

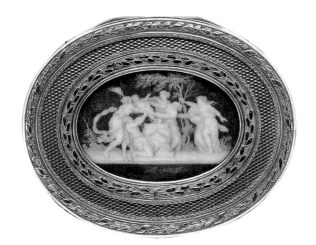

75 TOP

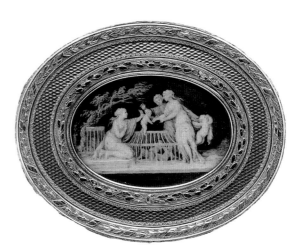

75 BOTTOM

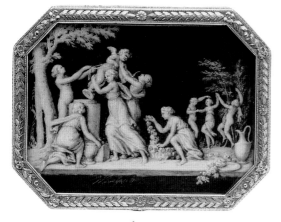

76 TOP

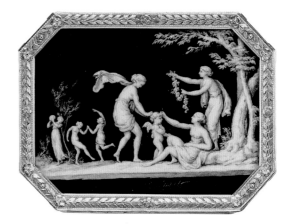

76 BOTTOM

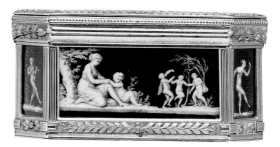

76 BACK

76

Six Miniatures Representing the Diversions of Love; Four Figures Dancing

Grisaille on enamel, set in a gold box

Top: *Nymphs Setting up on a Plinth a Statue of Cupid*; 1¾ x 2⅜ in. (44 x 61 mm); signed (bottom, in scratched letters): *JJDeGault*

Bottom: *Nymphs Presenting a Garland to Cupid*; 1¾ x 2⅜ in. (44 x 61 mm); signed (bottom, in scratched letters): *JJDeGault*

Front: *Nymphs Dancing to a Tambourine*; 1¾ x ¾ in. (43 x 18 mm)

Back: *A Nymph Comforting a Putto*; 1¾ x ¾ in. (43 x 18 mm)

Left side: *Cupid Striking a Nymph with a Dart*; ¾ x 1 in. (18 x 26 mm)

Right side: *Cupid Embracing a Nymph*; ¾ x 1 in. (18 x 26 mm)

Four chamfered corners: *Figure Dancing*; each, ¾ x ¼ in. (18 x 7 mm)

Gift of J. Pierpont Morgan, 1917 (17.190.1175) ESDA

The miniatures, which are in grisaille, are set in a carved four-color gold box which bears an illegible maker's mark and the Paris restricted warranty mark for 1838–47.

Inside the box are a printed label *2378* and a stock label inscribed in red ink *P.M./3533*.

LITERATURE: Henry and Sidney Berry-Hill, *Antique Gold Boxes* (New York, 1953), p. 68, no. 46, ill.

WHEN IT entered the Metropolitan Museum, the box was described as of French make, late eighteenth century, an opinion supported by Henry and Sidney Berry-Hill. On the evidence of style a date of 1820–30 is suggested.

The scene on the top of the box resembles that, by the same artist, on the top of no. 75. It may be assumed that the miniatures on the two boxes are of roughly the same date.

The signatures were formerly read as M De Gault and the miniatures attributed in error to Pierre Marie de Gault de Saint Germain.

Attributed to Jacques Joseph de Gault

77

Six Scenes of Putti at Play

Grisaille *en camaïeu* on ivory, set in a gold box

Top: *A Seated Putto Being Decorated with a Garland*; diam. 1⅜ in. (36 mm)

Bottom: *Putti Playing Piggyback amid Festooned Garlands*; diam. 1¼ in. (32 mm)

Front: *A Seated Putto*; ½ x 1⅛ in. (14 x 28 mm)

Back: *A Putto Being Given Flowers and a Crown*; ½ x 1⅛ in. (14 x 28 mm)

Left side: *A Recumbent Putto Being Given a Drink from a Flagon*; ½ x 1⅛ in. (14 x 28 mm)

Right side: *A Putto Playing with a Lion*; ½ x 1⅛ in. (14 x 28 mm)

Bequest of Catherine D. Wentworth, 1948 (48.187.473) ESDA

The miniatures are set in a gold box made by Pierre François Drais in Paris in 1770–71. It is decorated with green enamel and is inscribed on the rim *Drais a Paris*. It bears four marks, among them the maker's mark PD and the Paris mark for 1770–71.

ALTHOUGH unsigned these miniatures may safely be ascribed to Jacques Joseph de Gault. Similar boxes in the Louvre by Pierre François Drais (master 1763, working in 1788) have miniatures in grisaille *en camaïeu* by or attributed to de Gault. (Henry Nocq and Carle Dreyfus, *Tabatières . . . des collections du Musée du Louvre* [Paris, 1930], nos. 97, 100–102, 104; no. 101 is by him, and the others are attributed to him on grounds of style. See also Pierrette Jean-Richard, *Miniatures sur ivoire* [Paris, 1994], nos. 244 bis, 244 ter, ills.)

Piat Joseph Sauvage

French, 1744–1818

Born in Tournai, Sauvage studied painting in Tournai and Antwerp and became court painter

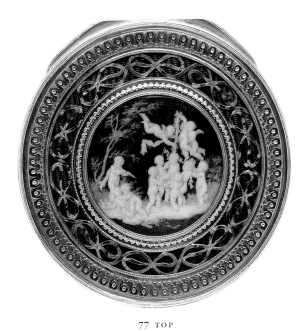

77 TOP

77 BOTTOM

in the Netherlands in 1774. Later that year he went to Paris and entered the service of Louis XVI and the prince de Condé, becoming a member of the Académie Royale in 1783. Much later, from 1804 to 1809, he worked as a porcelain painter at Sèvres. He was prominent in revolutionary activities but told the prince de Condé in 1814 that he had always been a royalist. He died in Tournai. Sauvage painted decorative grisailles imitating classical themes as well as miniatures *en camaïeu*.

Attributed to Piat Joseph Sauvage

78
Portrait of a Young Woman

Ivory, diam. 2⅛ in. (54 mm)
Gift of Mrs. Louis V. Bell, in memory of her
 husband, 1925 (25.106.6)

Grisaille *en camaïeu*; in profile, with light blue ribbons in her hair. The contours of the hair, the flowers and leaves, and the costume are tinted pale blue. Black background.

CONDITION: The miniature is very faded. The glass is weeping.

78

79

80

THE ATTRIBUTION to Sauvage was made by Leo R. Schidlof in 1952 and was accepted by Richard Allen in 1977. Pierrette Jean-Richard (in a letter, 1995), however, does not agree. The miniature must date from about 1790–95.

79
Two Allegories of Love; Two Scenes with Putti

Grisaille *en camaïeu* on ivory, set in a souvenir

Front, top: *A Putto Bearing a Pennant in a Chariot Drawn by Butterflies*; ³⁄₄ x 1³⁄₄ in. (21 x 45 mm); inscribed on pennant: *Souvenir*

Front, bottom: *A Nymph Amused by Cupid*; 2 x 1³⁄₄ in. (52 x 43 mm)

Back, top: *A Putto Bearing a Pennant in a Chariot Drawn by Doves*; ³⁄₄ x 1³⁄₄ in. (20 x 44 mm); inscribed on pennant: *d'amitié*

Back, bottom: *Cupid Leaning on His Bow*; 2 x 1³⁄₄ in. (53 x 44 mm)

Gift of J. Pierpont Morgan, 1917 (17.190.1365)
ESDA

The souvenir in which these grisaille miniatures are set is of nineteenth-century date, struck with pseudo-French marks.

Inside is a three-leafed ivory tablet; there are also a gold mount for a pencil, the label of the Bernard Franck collection, and a label inscribed *9*. One ivory leaf is inscribed in pencil *2446* and *P.M.3601*.

EX COLL.: Bernard Franck.

LITERATURE: *Collection de 124 carnets de bal du XVIIIᵉ siècle formée par M. Bernard Franck à Paris* (Paris, about 1902), pl. 9 (miniatures attributed to de Gault).

THE FORMER attribution to de Gault (nos. 74–77) was changed before 1938 to style of Piat Joseph Sauvage, late eighteenth century.

Style of Piat Joseph Sauvage

French, late 18th century

80
Putti Harvesting Wheat

Oil on wood, painted surface diam. 3 in. (76 mm)
Bequest of Millie Bruhl Fredrick, 1962 (62.122.74)

In grisaille; the putto at left wields a flail, and that at right gathers sheaves.

The surface is varnished. The reverse is painted black except for a narrow exposed rim 1 mm wide. A number that could be read 61 or more probably 19 is scratched in. There are traces of the name [Sau]vage in white paint.

IN HIS unpublished list of miniatures in the Fredrick collection (1960), no. 89, E. G. Paine lists this with an attribution to P. J. Sauvage about 1780.

81 TOP

81 BOTTOM

81 FRONT

French

about 1768–69

81
Six Hawking Scenes

Paper, set in a gold box

Top: *Departure of a Hawking Party*; 2 x 2⅞ in.
 (51 x 73 mm)

Bottom: *Watching the Kill*; 2 x 2⅞ in. (51 x 73 mm)

Front: *Watering the Horses*; 1 x 2¾ in. (25 x 71 mm)

Back: *A Gallant Interlude*; 1 x 2¾ in. (25 x 71 mm)

Left side: *Hooding the Birds at a Fountain*; 1 x 2 in.
 (25 x 50 mm)

Right side: *Hunters with Two Dogs and Hooded
 Birds*; 1 x 2 in. (25 x 50 mm)

Gift of J. Pierpont Morgan, 1917 (17.190.1142)
 ESDA

These miniatures are set in a rectangular gold box
with five marks, among them the Paris mark for
1768–69 and the maker's mark JD.

Inside the box are a printed label *2325* and a stock
label inscribed in red ink *P.M./3480*.

At one time the maker was identified as Jean
Ducrollay (master 1734, retired about 1764). But in
1967 Clare Le Corbeiller pointed out that the mark
does not resemble his, and the box was attributed
to an unidentified maker with the initials JD.

THE MINIATURES are in the manner of the
Venetian painter Francesco Casanova (1727–
1802).

French

about 1770–71

82

Six Maritime Scenes, after Claude Joseph Vernet (1714–1789)

Paper, set in a gold box

Top: *A Ship Wrecked on a Rocky Coast*; chamfered corners, 1½ x 2⅝ in. (37 x 68 mm). After a painting by Vernet engraved by J. B. Poly (engraving: Florence Ingersoll-Smouse, *Joseph Vernet* [Paris, 1926], vol. 1, pl. LXXVII, no. 723)

Bottom: *A Ship Being Driven onto a Beach*; chamfered corners, 1½ x 2⅝ in. (37 x 68 mm)

Front: *A Harbor at Evening with an Anchored Sailing Vessel*; 2⅛ x ¾ in. (53 x 19 mm). After a painting by Vernet engraved by Yves Marie Le Gouaz (engraving: Florence Ingersoll-Smouse [Paris, 1926], vol. 2, pl. CXXXIV, no. 1295)

Back: *A Boat with a Sail Approaching a Harbor*; 2⅛ x ¾ in. (53 x 19 mm). After a painting by Vernet engraved by Catherine Elisabeth Cousinet (engraving: Florence Ingersoll-Smouse [Paris, 1926], vol. 1, pl. L, no. 530)

Left side: *A Vessel with Two Sails Approaching a Harbor*; ⅞ x ¾ in. (22 x 19 mm)

Right side: *A Sailing Ship Anchored in a Harbor*; ⅞ x ¾ in. (22 x 19 mm)

Bequest of Catherine D. Wentworth, 1948 (48.187.428) ESDA

The miniatures are set in a gold box made by Dominique François Poitreau (apprenticed 1741, master 1757, retired 1781) in Paris in 1770–71.

The box bears five marks, among them the Paris mark of 1770–71 and the maker's mark of Poitreau. Its chamfered edges are decorated with small cutouts of harbor scenes, each ¾ x ¼ in. (20 x 6 mm).

LITERATURE: Faith Dennis, "French Snuffboxes in the Wentworth Collection," *Metropolitan Museum Bulletin*, n.s., 3 (1945), ill. p. 247.

THREE of the scenes are based upon identified engravings after paintings by Claude Joseph Vernet, and the others, which are in the same manner, evidently come from works by him.

François Dumont

French, 1751–1831

Dumont was born at Lunéville. His first master was the painter Jean Girardet (1709–1778) at Nancy who also taught Jean Baptiste Jacques Augustin (nos. 169 and 170) and Jean Baptiste Isabey (nos. 176–85). He went to Paris in 1768 and soon achieved great success, becoming the leading miniaturist between the era of the domi-

nance of Peter Adolf Hall (nos. 46–50) and the rise of Augustin. Dumont was received into the Académie Royale in 1788. He married Marie Nicole, daughter of Antoine Vestier (1740–1824) in 1789. He exhibited at the Salon from 1789 until 1827 and thereafter died in Paris. Dumont's best work can be found among the fifty miniatures by him at the Louvre.

83

Portrait of a Woman

Ivory, 1⅝ x 1¼ in. (41 x 32 mm)

Gift of J. Pierpont Morgan, 1917 (17.190.1138) ESDA

Wearing a white dress. Powdered hair with a white lace cap. Gray background.

The miniature is set in a gold-and-enamel box made by Joseph Étienne Blerzy (master 1768, working to 1806) in Paris in 1773–74. The box bears four marks, among them the maker's mark JEB and the Paris mark for 1773–74.

Inside the box are a printed label *2361* and a stock label inscribed in red ink *P.M.3516*.

CONDITION: The miniature is rather faded.

THIS MINIATURE is an early work. Bodo Hofstetter (*Le miniaturiste François Dumont [1751–1831]*, doctoral thesis [Paris, 1994], p. 102, no. 34) dates it 1778–80 noting that it is characteristic of Dumont in its unflattering portrayal of the sitter and accurate description of contemporary fashion. The overall bluish tone is also typical.

84

Portrait of a Woman

Ivory, 1⅜ x 1⅛ in. (36 x 28 mm)

Gift of J. Pierpont Morgan, 1917 (17.190.1300) ESDA

Wearing a blue dress with white sleeves trimmed with pink roses. Brown eyes; powdered hair dressed with a blue ribbon and pink roses. Gray background.

The miniature is set in a souvenir of ivory-colored enamel with gold mounts made in Paris in 1776–77. A gold plaque on the front is inscribed SOUVENIR, and that on the back reads D AMITIE. The monogram BDC over brown hair is on the back. The souvenir bears five marks, among them an undeciphered maker's mark and the Paris mark for 1776–77. Inside are a three-leafed ivory tablet and a gold-mounted pencil.

Inside the box there are three labels. One is that of the Bernard Franck collection; a stock label is printed *80*, and another is inscribed in red ink *P.M.3672*. An ivory tablet is inscribed *2517* in pencil and *80* in blue crayon.

EX COLL.: Bernard Franck.

LITERATURE: *Collection de 124 carnets de bal du XVIIIᵉ siècle formée par M. Bernard Franck à Paris* (Paris, about 1902), pl. 80, as by Sicardi.

THE MINIATURE is an excellent one. In 1977 Richard Allen and Edwin Boucher suggested that it is probably by François Dumont, and this attribution has been confirmed by Bodo Hofstetter (*Le miniaturiste François Dumont [1751–1831]*, doctoral thesis [Paris, 1994], p. 96, no. 28), who dates it to the late 1770s.

French

about 1795

85

Portrait of a Woman

Ivory, diam. 2½ in. (63 mm)

Bequest of Millie Bruhl Fredrick, 1962 (62.122.70)

Wearing a light blue dress, trimmed and tied with ribbons of red, white, and darker blue, and white fichu. Powdered hair. Seated in a mauve-backed chair resting her left arm on a table on which two turtledoves are billing. Brown and gray wall background. The gilt metal frame is glazed at back to reveal a sheet of ivory decorated with a scene in which a man offers a woman a flaming heart. At his knee is a scroll inscribed IL EST A TOI POUR LA VIE (He is yours for life), and behind him is a column inscribed on the base AIME SANS CESSE (Never stop loving).

CONDITION: The ivory is cracked from top to bottom (the crack passes through the doves at right). The area adjacent to the crack is overpainted, but the surface is otherwise in good condition, as is the scene in grisaille painted on a separate ivory tablet and mounted in the back of the case. The crack was cleaned and brought together, and the void was filled with colored wax. The overpaint was removed where possible, and the areas adjacent to the crack were toned. The miniature was remounted on ragboard.

LITERATURE: E. G. Paine, unpublished list of miniatures in the Fredrick collection (1960), no. 86, as by Louis Lié Périn, about 1795.

E.G. Paine's attribution of this miniature to Louis Lié Périn-Salbreux (1753–1817) has not found support. Judging from a photograph, Pierrette Jean-Richard (in a letter, 1995) admires the work but questions its authorship. Bodo Hofstetter joins her in rejecting the proposed attribution.

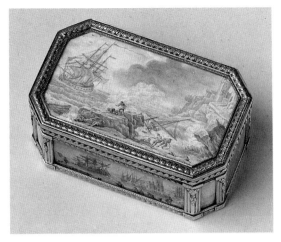

82 TOP

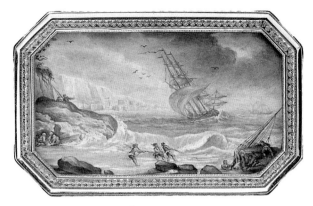

82 BOTTOM

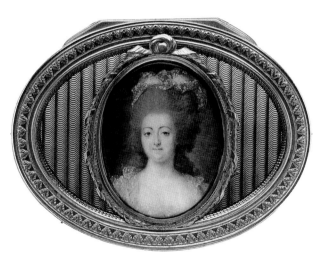

83

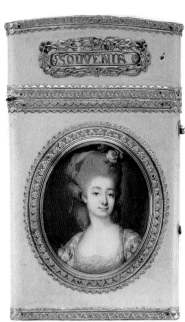

84

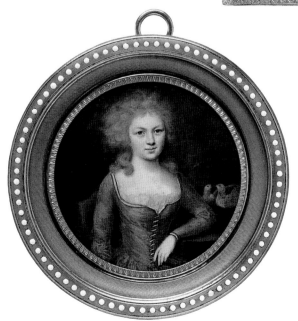

85

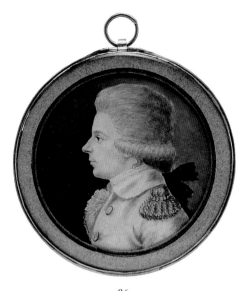

86
COLOR PLATE PAGE 36

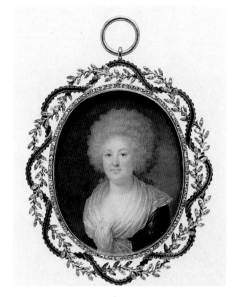

87
COLOR PLATE PAGE 37

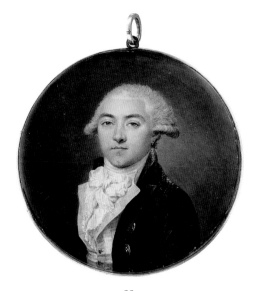

88
COLOR PLATE PAGE 37

Edmé Quenedey

French, 1756–1830

Quenedey, a pupil of François Devosge III (1732–1811), was born in Riceys-le-Haut (Aube). He worked in Brussels, Ghent, Paris, and Hamburg. He collaborated with Gilles Louis Chrétien (1754–1811), who invented the *physionotrace*, a mechanical device for making profile portraits, and made improvements on it. Quenedey was extremely prolific, and there is a collection of twelve thousand portraits by him in the Biblio-thèque Nationale, Paris. He died in Paris.

86
Portrait of a Man

Ivory, diam. 2 in. (49 mm)
Bequest of Millie Bruhl Fredrick, 1962 (62.122.73)

In profile. Wearing a white uniform jacket with gold epaulets. Brown eyes; powdered hair tied with a black bow. Gray background.

The back of the frame is glazed to reveal the recent inscription on blue-gray card *Edme.Quenedey / 1756–1830 / Peintre en miniature / Les portraits que sortent / de cet Artiste ne puevent* [sic] *être / comparés qu'a ceux qui / son* [sic] *moulés sur nature.* (Painter in miniature / The portraits by this artist can be compared only to those that are cast from nature.)

CONDITION: The deteriorated cover glasses at front and back were replaced. The discolored metal foil behind the face was also replaced.

IN HIS unpublished list of the miniatures in the Fredrick collection (1960), no. 87, E. G. Paine dates the work about 1790. By comparison with other examples, it appears to be at least ten years earlier, about 1780.

Villers

French, active about 1781–93

A number of miniatures are known which bear the signature *Villers,* with no initial, and dates between 1781 and 1793. Thieme-Becker lists *L.(?) Villers* as a miniature painter who exhibited at the Paris Salon between 1793 and 1804 and suggests that he may be identical with Nicolas de Villers, who was born about 1753. Pierrette Jean-Richard has suggested that he may instead be identifiable with Maximilien Villiers, who was born in Paris about 1760 and studied with the painter Jean Baptiste Regnault (1754–1829).

87
Portrait of a Woman

Ivory, 2⅜ x 1⅞ in. (60 x 48 mm)
Bequest of Collis P. Huntington, 1900 (26.168.55)

Wearing a dark blue dress and white fichu. Hazel eyes; powdered hair. Gray background.

The miniature is set in a decorative silver surround, which is set with brilliants and has a gold back.

CONDITION: The painted surface is in good condition, although there is some retouching along the right edge. The miniature is mounted on a slightly larger backing paper with a black border.

LITERATURE: *A Catalogue of Miniatures in the Collection of Collis P. Huntington* (New York, 1897), ill.

THE MINIATURE is reproduced in the Huntington catalogue (1897) as a work by Jean Petitot (no. 13). This eccentric attribution was altered on receipt in the Metropolitan Museum to German school, eighteenth century. In 1952

Leo R. Schidlof recognized it as a good example of the work of Villers, datable about 1790.

88
A Man with the Initials JD

Ivory, diam. 2½ in. (62 mm)
Signed and dated (lower left, in black): *Villers / 1790*
Gift of Mrs. Louis V. Bell, in memory of her husband, 1925 (25.106.21)

Wearing a dark lilac-blue coat, waistcoat striped with turquoise blue, white cravat and collar, and gold earring. Blue eyes; powdered hair. Blue-gray background.

The ivory on which the miniature is painted is sealed to a playing card. The gilt frame is glazed at back to reveal the monogram JD in seed pearls on plaited hair, surrounded by a decorative border painted with chains of pansies. This support resembles ivory but is possibly synthetic. A copper plate separates the front and back of the miniature.

CONDITION: The miniature is in excellent state.

EXHIBITED: Metropolitan Museum of Art, 1950, *Four Centuries of Miniature Painting,* list, p. 7.

THE LAST figure in the date is difficult to decipher; it has been variously read as 1790 and 1792. In 1952 Leo R. Schidlof accepted the identification of the artist as *L.(?) Villers.*

Frédéric Dubois

French, active about 1780–1819

Dubois is first recorded as an exhibitor at the Salon de la Correspondance in 1780. He worked

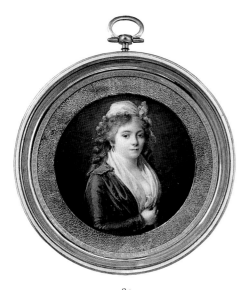

89
COLOR PLATE PAGE 38

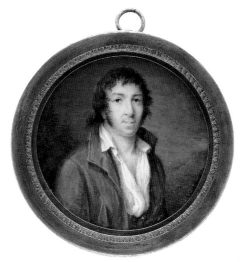

90

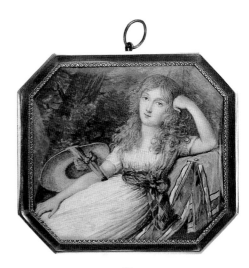

91
COLOR PLATE PAGE 38

at first in oils but later specialized in miniatures, showing at the Paris Salon between 1795 and 1804. He then went to Russia, working in St. Petersburg from 1804 until 1818. After moving to London, Dubois exhibited at the Royal Academy in 1818 and 1819.

89
Portrait of a Woman

Ivory, diam. 2⅝ in. (66 mm)
Signed and dated (right, in pencil): *Dubois. / L'an 2* [1793/94]
Bequest of Millie Bruhl Fredrick, 1962 (62.122.66)

Wearing a blue dress, white bodice, scarf, and cap, and gold earring. Blue eyes. Dark blue landscape background.

CONDITION: The surface is generally in good condition, but the ivory had cracked from top to bottom (through the signature at right). The crack was cleaned and brought together. Overpaint adjacent to the crack was removed where possible, and these areas were toned. The miniature was remounted on ragboard. The mat was replaced.

LITERATURE: E. G. Paine, unpublished list of miniatures in the Fredrick collection (1960), no. 73, as possibly by Frédéric Dubois.

THIS PORTRAIT was painted in the second year of the French revolutionary calendar, which ran from September 22, 1793, to September 21, 1794. The loosely painted background contributes to the fresh vivid effect.

Jean Baptiste Sambat

French, born about 1760, died 1827

Sambat was born in Lyons. Greatly interested in politics, he accompanied the marquis de Mirabeau (1715–1789), the French political economist, to Germany and England about 1784. Despite his radical views, he was imprisoned during the Revolution. He exhibited at the Salon of 1793.

Attributed to
Jean Baptiste Sambat

90
Portrait of a Man

Ivory, diam. 2⅝ in. (70 mm)
Bequest of Millie Bruhl Fredrick, 1962 (62.122.80)

Wearing a brown jacket and white open-necked shirt. Black hair. Landscape and evening sky in background.

CONDITION: A small loss in the ivory at lower right appears to be original: it is filled with a paper patch and painted in what appears to be the original pigments. Flaking paint in the foliage along left and right edges was consolidated, and a discolored tinned copper foil was replaced with new metal foil.

LITERATURE: E. G. Paine, unpublished list of miniatures in the Fredrick collection (1960), no. 104, as French, about 1800.

THIS PORTRAIT gives expression to the liberated feelings of the revolutionary epoch. Bodo Hofstetter has proposed the attribution to Sambat. He sees the present miniature as a typical work by this artist. Its clear-sighted

ruggedness is, however, not altogether consistent with the signed or apparently signed works by him in the Wallace Collection (Graham Reynolds, *The Wallace Collection: Catalogue of Miniatures* [London, 1980], no. 132, ill.) and in the Musée du Louvre (Pierrette Jean-Richard, *Miniatures sur ivoire* [Paris, 1994], no. 569, ill.).

Jean Antoine Laurent

French, 1763–1832

Born in Baccarat, Laurent became a pupil of Jean François Durand (born 1731) and of Jean Baptiste Charles Claudot (1733–1805) in Nancy. He began to exhibit from Paris at the Salon of 1791, and was subsequently patronized by Empress Joséphine, Queen Hortense, Louis XVIII, and the duchess of Berry. He died of apoplexy brought on by the announcement that he had been made a chevalier of the Légion d'Honneur in 1832.

Attributed to
Jean Antoine Laurent

91
Portrait of a Young Woman

Ivory, 2⅜ x 2⅞ in. (63 x 73 mm)
Gift of Mrs. Louis V. Bell, in memory of her husband, 1925 (25.106.16)

Wearing a white dress with a red-and-green plaid sash; straw hat attached to her right arm by a blue ribbon. Fair hair. Leaning against a blue shawl with green-and-white stripes; a woodland landscape of dense foliage in background.

The gilt metal frame is glazed at back to reveal an ivory backing decorated with pansies, leaves, and a bowknot, all fashioned from two types of hair, one brown and one fair.

CONDITION: The miniature has been extended at the far right edge, apparently by the artist. The handling is characterized by the extensive use of blue for the shading of flesh tones. Mounted at the back is a floral design worked in flat hair on ivory which has a pink tone because the reverse was painted with a strong pink. Both front and back are in excellent condition.

THE MINIATURE entered the Metropolitan Museum with an attribution to Mortier, the painter of no. 95. In 1952 Leo R. Schidlof thought it a fine and typical though unsigned work of Jean Antoine Laurent, but Bodo Hofstetter (in a letter, 1995) does not agree with this attribution. However, the attribution seems to be borne out by comparing this miniature with that of a young man carving his initials on a tree, signed with Laurent's initial and dated 1791 (Leo R. Schidlof, *The Miniature in Europe* [Graz, 1964], vol. 1, p. 471, and vol. 4, pl. 338, fig. 688, from the Bléhaut collection, Bourg-Argental). While the present example demonstrates Laurent's skill with landscape backgrounds, it does not support Schidlof's claim (1964, vol. 1, p. 470) that this artist's miniatures are "faultless in drawing and in expression with an exceptional sense of colour."

Jeanne Philiberte Ledoux

French, 1767–1840

Born in Paris, Ledoux became a pupil of Jean Baptiste Greuze (1725–1805). She painted portraits in oils, as well as miniatures, and exhibited at the Paris Salon from 1793 until 1819. A miniature portrait of her by Peter Adolf Hall (nos. 46–50) is in the Wallace Collection, London (Graham Reynolds, *Wallace Collection: Catalogue of Miniatures* [London, 1980], no. 111, ill.). It shows her making a copy of a seventeenth-century portrait.

92
Portrait of a Man

Ivory, diam. 2¼ in. (57 mm)
Signed (right, in black): *Ledoux*
Gift of Humanities Fund Inc., 1972 (1972.145.11)

Wearing a black coat, beige waistcoat, and white cravat. Brown eyes; lightly powdered hair. Reddish brown background.

CONDITION: The face, cravat, and waistcoat, freely painted, are quite well preserved. There is, however, damage to the peripheral areas. The presence of bloom and some paint loss around the perimeter may be attributed to moisture. Damage to the jacket of the sitter is possibly due to the severe deterioration of the original cover glass. Retouching is present in the coarse brown paint above the sitter's head. The bloom has been reduced and the retouching burnished to blend into the surrounding surface. The cover glass has been replaced.

EX COLL.: Boris Bakhmeteff, New York (until 1972).

THE MINIATURE, of about 1790, shows that the artist had been influenced by Peter Adolf Hall (nos. 46–50), the master who painted her portrait at about this time.

Joseph Marie Bouton

French(?), 1768–1823

Born in Cádiz, Bouton became painter in miniature to Charles IV (1748–1819) of Spain. He worked in Paris from 1790 until 1803 and exhibited at the Royal Academy from London addresses from 1816 until 1819. He died in Chartres.

93
A Woman Playing a Harp

Ivory, diam. 3½ in. (90 mm)
Signed (right edge, in black): *Bouton*
Gift of Mrs. Louis V. Bell, in memory of her husband, 1925 (25.106.17)

Wearing a white dress with red-and-white striped sash and black lace at the wrists. Brown eyes; powdered hair dressed with a red ribbon. The harp strings are varicolored, and the frame of the instrument is decorated with flowers. Gray background.

The miniature is in a chased gilt mount and may have been fitted into the lid of a box.

THE COSTUME is from about 1790. The artist was working in Paris from 1790 until 1803, and the sitter may therefore be French rather than Spanish. In 1952 Leo R. Schidlof considered this an exceptionally good early work by Bouton.

Vincent

French, active about 1790

Leo R. Schidlof (1952) assigns a number of miniatures signed *Vincent* without initials to Antoine Paul Vincent who exhibited from addresses in Paris at the Salon between 1800 and 1812.

94
Madame Ingouf

Ivory, diam. 4⅛ in. (105 mm)
Signed (lower right, in scratched letters): *Vincent*
Bequest of Mary Anna Palmer Draper, 1914 (15.43.298)

En camaïeu, in profile; wearing a white dress, a transparent blue-and-white veil, red-brown belt set with cameo of a man, and pearl earring. Brown eyes; light blue ribbon in powdered hair. Dark blue background.

The brown card backing is inscribed in ink *Madame Ingouf / par Vincent*.

LITERATURE: "A Bequest from Mrs. Mary Anna Palmer Draper," *Metropolitan Museum Bulletin* 10 (1915), pp. 95–96; Thieme-Becker, vol. 34 (1940), p. 379.

THE MINIATURE dates about 1790. The sitter may be a relative of the engraver François Robert Ingouf (1747–1812) or of his brother, also an engraver, Pierre Charles Ingouf (born 1746, died before 1800). P. A. Wille, a contemporary genre painter and engraver, reported that Pierre Charles Ingouf *l'aîné* had married a baker's daughter who was very pretty.

Mortier

French, active about 1790–1800

The following miniature appears to be the only recorded work by this French artist of the last decade of the eighteenth century.

95
A Hunter with a Dog

Ivory, 2¾ x 3¼ in. (70 x 83 mm)
Signed and dated (left, in white): *Mortier / an 3ᵐᵉ* [1794/95]
Gift of Mrs. Louis V. Bell, in memory of her husband, 1925 (25.106.15)

Wearing a beige jacket, white waistcoat with blue stripes, green and white scarf, and open-necked white shirt; holding leather glove; his gun suspended from leather belt. Brown eyes; light brown hair. A brown-and-white dog seated at right. Landscape and sky background.

The back of the gilt metal frame is glazed to reveal a pink-toned ivory backing decorated with a painted

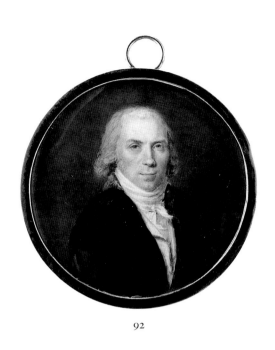

92

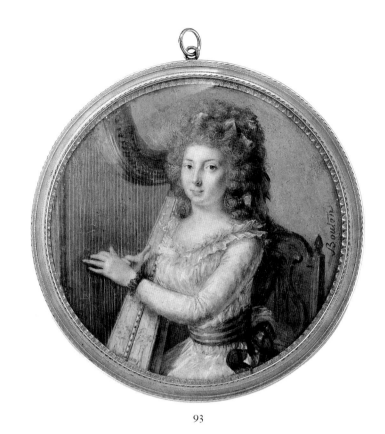

93

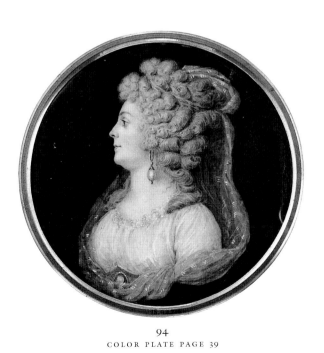

94
COLOR PLATE PAGE 39

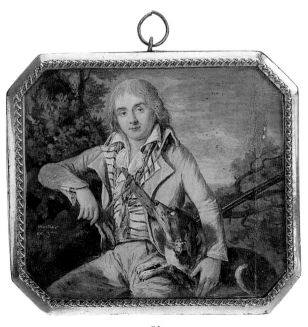

95
COLOR PLATE PAGE 39

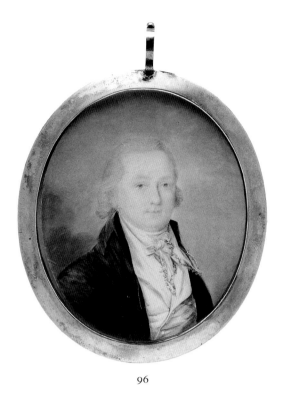

96

97

COLOR PLATE PAGE 40

Mortier (*continued*)

scroll pattern and with locks of brown and blond hair. The hair ornament is signed in pencil *Challain e[t] CNair*.

CONDITION: An open vertical crack from top to bottom about ¼ in. (6.4 mm) from the right edge, a join in the original ivory, had been repaired and retouched several times. The edges were cleaned, the pieces rejoined and glued to ragboard, and the voids sealed with beeswax. Flaking was set down and losses in the foliage at right were toned. Some of the damage may have been caused by a deteriorated cover glass which has been replaced, as has the glass covering the hair ornament on the reverse.

LITERATURE: Leo R. Schidlof, *The Miniature in Europe* (Graz, 1964), vol. 2, p. 573, and vol. 4, pl. 416, fig. 848.

THE THIRD year of the French revolutionary calendar, during which this was painted, ran from September 22, 1794, to September 21, 1795.

Annibal Christian Loutherbourg

French, born 1765, died after 1795

Loutherbourg, the son of the notable painter Philippe Jacques de Loutherbourg (1740–1812), was baptized in Paris in 1765. He studied with

Antoine Vestier (1740–1824) and at the École des Beaux-Arts in Paris. Daniel Chodowiecki (1726–1801) reported from Berlin in 1792 that he was winning applause from the court which he did not quite deserve.

96
Portrait of a Man, Said to Be James Madison (1751–1836)

Ivory, 2½ x 2¼ in. (65 x 56 mm)

Signed and dated (lower right, in scratched letters): *Loutherbourg / 1795*

The Moses Lazarus Collection, Gift of Josephine and Sarah Lazarus, in memory of their father, 1888–95 (95.14.94)

Wearing a blue coat, white waistcoat, and white tie edged with black lace. Brown eyes; powdered hair. Gray sky background.

The back of the gold frame, of blue translucent glass over tinsel, reveals, in an oval of rose diamonds and on plaited brown hair, a gold plaque with the initials JM (monogram).

CONDITION: Pink pigment was painted on the back of the ivory to warm up the flesh tones in the face; the miniature is nonetheless pale and faded.

ALAN FERN, director of the National Portrait Gallery, Smithsonian Institution, has

advised that despite the initials JM on the back, he and his colleagues believe that this is most likely not a portrait of James Madison, fourth president (1808–16) of the United States.

Rosalba Carriera

Italian (Venetian), 1675–1757

Rosalba was a pastelist as well as a painter of miniatures. In about 1700, influenced by the vogue for painting on the bottom of ivory boxes (*fondelli*), she began to work on an ivory ground; through her example this surface became that most commonly used for miniatures throughout the eighteenth century. Rosalba presented a miniature on ivory entitled *L'Innocenza*, representing a young girl with a dove (Bernardina Sani, *Rosalba Carriera* [Turin, 1988], pp. 14, 27, pl. 1), to the Accademia di San Luca in Rome in 1705. She enjoyed an international reputation, and her visit to France in 1720–21 had a decisive effect on miniature painting in that country. The ivory ground, combined with greater freedom in brushwork and the use of impasto, contributes to the brilliant effect of her miniatures.

98 LID

98 INTERIOR

97
Portrait of a Man

Ivory, 3 x 2¼ in. (76 x 59 mm)

Rogers Fund, 1949 (49.122.2)

Wearing armor with a bronze-colored cloak and a white cravat. Details of the armor are gilt. Hazel eyes; lightly powdered blond wig. Blue-gray background.

The ivory is laid on plain paper with no inscription. A black paper fixed to the frame's wooden backing is inscribed in pencil *Earl* [...] / *Middlesex*.

CONDITION: The miniature is in excellent state of preservation.

EX COLL.: Leo R. Schidlof (until 1949).

EXHIBITED: Metropolitan Museum of Art, 1950, *Four Centuries of Miniature Painting*, list, p. 5.

THE MINIATURE was painted about 1710. The attribution to Rosalba (under which it was bought) appears to be correct and has been confirmed by Bernardina Sani. The bluing of the armor is handled with characteristic technical finesse.

Charles Sackville (1711–1769), son of Lionel Cranfield Sackville (1688–1765), earl of Dorset and Middlesex, was styled earl of Middlesex from 1720 to 1765, but the miniature does not portray him or his father.

Italian (Venetian)

1730 or later

98
A Patrician and His Wife

Ivory, inside lid and bottom of ivory box, 3 x 2¼ in. (77 x 55 mm), and 2⅞ x 2⅛ in. (73 x 53 mm)

Victor Wilbour Memorial Fund, 1968 (68.156)

Man: wearing a white robe and gray-lined red cloak; powdered wig; holding leather-bound book; seated in green upholstered chair. Woman: wearing a gold-embroidered blue dress, brown stomacher, and pink scarf; powdered hair dressed with a black feather. Gray-brown backgrounds with two unidentified heraldic shields in top right corners.

The carved outer lid of the box represents a gallant scene, showing Cupid with a flaming torch leading two pilgrims (the man holds a wine flask and the young woman a staff).

EX COLL.: [N. H. Alvise Barozzi, Venice, until 1968].

THE PRACTICE of painting inside ivory boxes (*fondelli*), which led to the replacement of vellum by ivory as the support for miniatures, was inaugurated in Venice in the early years of the eighteenth century. Rosalba Carriera

(no. 97) became the first major exponent of the new technique. The present miniatures, which date about 1730 or later, differ from hers in being painted in oils rather than in gouache and in being varnished; they also adhere more closely to traditions of normal-scale portrait painting.

In 1969 Terisio Pignatti suggested that these miniatures were in the manner of Pietro Longhi (1702–1785) but also proposed comparison with the work of Bartolomeo Nazari (1699–1758) and Giuseppe Nogari (1699–1763). The costumes are not typically Venetian, and the sitters may be from elsewhere in the Veneto.

Benjamin Arlaud

Swiss, active about 1701–17

Arlaud is believed to have been born in Geneva about 1670. He painted William III (1650–1702) in 1701, though it is not certain that this was in England; he was definitely there no later than 1709. His elder brother Jacques Antoine Arlaud (1668–1746), who spent much of his working life in Paris, had a more flamboyant style.

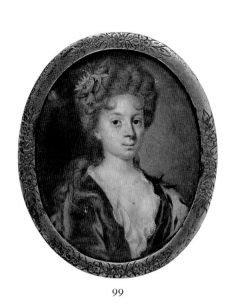

99

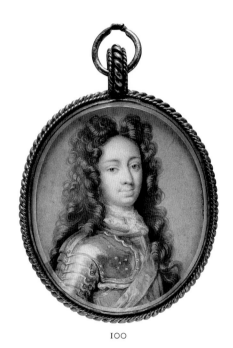

100

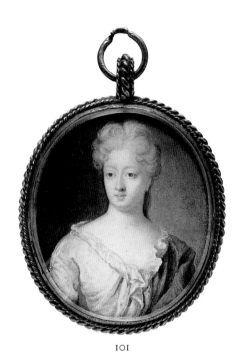

101

Attributed to Benjamin Arlaud

99
Caroline of Ansbach (1683–1737), *Consort of George II of Great Britain and Ireland*

Ivory, 2⅝ x 2¼ in. (68 x 57 mm)
Gift of Estate of Isaac A. Josephi, 1955 (55.107.1)

Wearing a blue dress, white shift, and ermine stole. Brown hair dressed with flowers. Gray background.

CONDITION: Split from top to bottom; damage from damp at top left edge and near bottom.

The paper backing of the miniature is inscribed in pencil in a nineteenth-century hand *120/ Prinzessin Wilhelmin[e]* / followed by an illegible second line and *bg.* A paper label fixed to the fabric back of the frame is inscribed in ink in a nineteenth-century hand: *Prinzessin / Wilhelmine / v. Sachsen / 8960 bg. / 80. / Gotha.*

THERE IS no record of a Princess Wilhelmine of Saxe-Gotha in the first years of the eighteenth century, the period to which this miniature belongs.

Comparison with a miniature by Benjamin Arlaud of Caroline of Ansbach in the Royal Collection, Windsor Castle, which is believed to have been painted about 1714, suggests that this may be by the same artist and of the same sitter (Richard Walker, *The Eighteenth and Early Nine-*

teenth Century Miniatures in the Collection of Her Majesty the Queen [Cambridge, 1992], no. 131, ill.). The princess's full name was Wilhelmina Carolina, and the inscription on the back may preserve a traditional identification of her as the sitter. Against the attribution of the present work to Benjamin Arlaud must be held the fact that it is on ivory; the artist is only known to have used vellum as a support, although ivory was coming into use at about this time.

In 1705 Caroline of Brandenburg-Ansbach married George Augustus (1683–1760), elector-prince of Hanover and later George II (1727–60) of Great Britain and Ireland. She was remarkable for her intellectual powers and was a friend of Leibnitz and of Newton; Alexander Pope, John Gay, and Lord Chesterfield were among the distinguished members of her circle.

Style of Benjamin Arlaud

Continental, about 1706

100
A Young Knight of the Garter, possibly George Augustus (1683–1760), *Later George II of Great Britain and Ireland*

(pendant to 62.122.104)

Vellum, 2 x 1¾ in. (52 x 45 mm)
Bequest of Millie Bruhl Fredrick, 1962 (62.122.103)

Wearing gilt-edged armor, white cravat, and the blue ribbon of the Order of the Garter. Blue eyes; gray-brown wig. Gray background.

The miniature is set in a silver corded mount. The frame is glazed at back to reveal a playing card.

LITERATURE: Unpublished list of miniatures in the Fredrick collection (1943), no. 68, as by Bernard Lens; E. G. Paine, unpublished list of miniatures in the Fredrick collection (1960), no. 16, attributed to Werner Hassel, about 1680.

NEITHER NO. 100 or 101 was received in the Museum with a traditional identification, but they appear to have remained together as a pair of related portraits. The sitter in this miniature wears the Garter ribbon. Among the persons invested with that order in the early years of the eighteenth century was George Augustus, the son of George Louis (later elector of Hanover and George I of Great Britain and Ireland) by his wife Sophia Dorothea of Celle. The future George II received the Garter in 1706. Although this is somewhat earlier in date than the standard Kneller portrait of 1716 (Oliver Millar, *The Tudor, Stuart and Early Georgian Pictures in the Collection of Her Majesty the Queen* [London, 1963], no. 343, pl. 147), the comparison suggests that he may be portrayed here. The possibility would be strengthened if, as has been surmised, no. 101 is of a princess of Hanover.

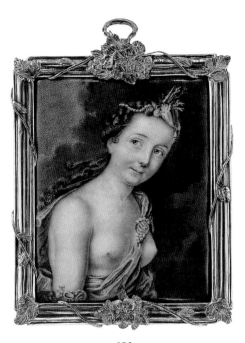

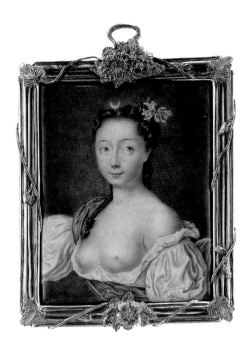

102
COLOR PLATE PAGE 40

103
COLOR PLATE PAGE 40

101

A Woman, Possibly Sophia Dorothea
(1687–1757), *Later Queen of Prussia*

(pendant to 62.122.103)

Vellum, 2 x 1¾ in. (52 x 45 mm)
Bequest of Millie Bruhl Fredrick, 1962 (62.122.104)

Wearing a pink dress, white shift, and blue robe. Blue eyes; lightly powdered fair hair. Brown background.

The miniature is set in a silver corded mount with beveled glass. The frame is glazed at back to reveal a playing card.

LITERATURE: Unpublished list of miniatures in the Fredrick collection (1943), no. 70, as by Bernard Lens; E.G. Paine, unpublished list of miniatures in the Fredrick collection (1960), no. 17, attributed to Werner Hassel, about 1680.

No. 101 has had the same history as no. 100. It has been suggested by Hans Boeck and also by Bodo Hofstetter that the sitter may be Sophia Dorothea (1687–1757), daughter of George I and sister of George II. If no. 100 does represent the future George II, it would be appropriate that no. 101 should represent his sister. The identification is to some extent borne out by comparison with portraits of Sophia Dorothea. The present work is particularly close to a portrait in the collection of the duke of Marlborough (John Kerslake, *Early Georgian Portraits* [London,

1977], vol. 1, pl. 754), but it does not seem certain that this represents the same person as Kerslake's pls. 752, 753, and 755. Another possibility which should perhaps be considered is that it might represent George II's wife, Caroline of Ansbach (1683–1737), though again it would have to be earlier than Kneller's standard portrait of 1716 (Oliver Millar, *The Tudor, Stuart and Early Georgian Pictures in the Collection of Her Majesty the Queen* [London, 1963], no. 345, pl. 148). George and Caroline were married in 1705.

Carl Friedrich Thienpondt

German, 1730–1796

Born in Berlin, Thienpondt was a pupil of Antoine Pesne (1683–1757) from 1745, and he took up miniature painting in 1751. In 1753 he went to Dresden to study with Ismaël Mengs (1688–1764). He later settled in Warsaw, where he was much sought after as a miniaturist in enamel, and he died there. Three of his portrait miniatures are in Berlin (Irene Geismeier and Bernd Burock, *Staatliche Museen zu Berlin: Miniaturen 16.–19. Jahrhundert*, vol. 2 [Berlin, 1986], nos. m619–21, ills.).

102
A Sea Nymph

(pendant to 24.80.519)

Enamel, 2⅞ x 2¼ in. (74 x 59 mm)
Bequest of Mary Clark Thompson, 1923 (24.80.520)

Wearing a blue-gray cloak clasped with pearls and a shell; a coral and shell clasp on her right arm. Brown eyes; brown hair elaborately dressed with pearls, coral, and shells. Pointillé cloud and sky background.

The ormolu frame is decorated with flowers, leaves, and winding tendrils. The miniature's back is of uninscribed white enamel, to which five stock labels have been stuck. The backing card is inscribed in ink *J* (or *S*) *P*.

CONDITION: The plaque is rounded at the edges. The enamel is in very good state despite a few shallow scratches.

THE MINIATURE is a companion piece to no. 103 and was painted by the same hand, perhaps about 1760. The attribution to C. F. Thienpondt was made by Hermione Waterfield.

These enamels are characterized by an elaborate pointillé technique, in which the smallest dots model the flesh tones and the largest give an overall texture to the background. A very bright pink is used for emphatic highlights. They are fine examples of German Rococo style and taste.

103
Diana

(pendant to 24.80.520)

Enamel, 2⅞ x 2¼ in. (74 x 59 mm)
Bequest of Mary Clark Thompson, 1923 (24.80.519)

Wearing a white shift and gray-green and pink sash. Brown eyes; brown hair dressed with honeysuckle and with crescent moon (emblem of Diana). Pointillé gray background.

The ormolu frame is decorated with flowers, leaves, and winding tendrils. The miniature's back is of uninscribed white enamel, to which five stock labels have been stuck.

CONDITION: The plaque is rounded at the edges. A deep abrasion on the model's arm, exposing a white underlayer, was toned.

THE MINIATURE is a companion piece to no. 102 and is by the same hand.

Johann Esaias Nilson

German, 1721–1788

Of Swedish descent, Nilson was born in Augsburg and began painting miniatures as early as 1742. He became painter to the elector palatine in 1761. He was director of the Augsburg Academy from 1769. Nilson was among the most prolific designers and publishers of Rococo ornamental prints in Germany at that time.

104
Portrait of a Man

Ivory, 1⅞ x 1½ in. (49 x 37 mm)
The Moses Lazarus Collection, Gift of Josephine and Sarah Lazarus, in memory of their father, 1888–95 (95.14.66)

Wearing a gray coat and waistcoat and white frilled shirt. Gray eyes; powdered hair. Brownish-gray background.

The back of the ivory, which is not laid on card, is inscribed in a recent hand in pencil *L'abbé Dubois / XVIII / Siecle.*

WHEN THIS miniature was received in the Metropolitan Museum, it was described as a portrait of Abbé Guillaume Dubois (1656–1723) by a French artist. The sitter is wearing a costume of about 1740–60, and therefore the traditional identification of the sitter cannot be sustained.

The attribution to Nilson is due to Bodo Hofstetter. It is supported by comparison with, for instance, several miniatures reproduced by Marianne Schuster (*Johann Esaias Nilson: Ein Kupferstecher des Süddeutschen Rokoko* [Munich, 1936], pp. 216–20, pls. 1–3), who catalogues forty miniatures in all.

Anton Raphael Mengs

German, 1728–1779

Anton Raphael Mengs was born in Dresden. His father, Ismaël Mengs (1688–1764), painted in miniature, and part of the rigorous training he gave his son was a grounding in that art. From 1741 to 1761 the younger Mengs lived mostly in Rome; thereafter he divided his time between Rome and Spain. He won renown as a painter in oils and in fresco, becoming one of the leading exponents of Neoclassicism.

105
The Vision of Saint Anthony of Padua

Ivory, 5⅛ x 3¾ in. (130 x 96 mm)
Signed and dated (reverse, in ink): *AR. Mengs. fe. 1758*
Gift of Harry G. Friedman, 1951 (51.160)

Wearing a brown habit; kneeling before Christ child. The altar hanging is blue.

CONDITION: The paint surface is in very good condition. The ivory support, one-eighth of an inch thick, is slightly irregular in shape. The back was coarsely planed and the signature written on this irregular surface. The frame, which fit too snugly, was replaced; a ragboard spacer and mount and a cover glass were supplied. The number *1049* is written in pencil on the reverse.

SAINT ANTHONY of Padua (1195–1231) was born in Lisbon. He became a member of the Franciscan order in 1220, and he spent the last years of his life in Padua.

The legend of the appearance of the Christ child to Anthony derives from the fourteenth-century *Liber miraculorum.* The theme was popular in Counter-Reformation art. An oil painting by Mengs of the same subject, but with a different composition, is in the Wellington Museum, Apsley House, London (C. M. Kauffmann, *Catalogue of Paintings in the Wellington Museum* [London, 1982], no. 106, ill.). This miniature is earlier than the work at Apsley House, which was reportedly painted for Charles III of Spain about 1765. Another painting of the subject which is ascribed to Mengs and is rather closer in composition belongs to the Bergen Billedgalleri, Norway.

The only miniatures by A. R. Mengs known to Leo R. Schidlof (*The Miniature in Europe* [Graz, 1964], vol. 2, pp. 550–51, and vol. 4, pl. 398, fig. 810) were portraits executed with a pointillist technique. The present work is exceptional in being a version in miniature of a religious theme which he later repeated in oil.

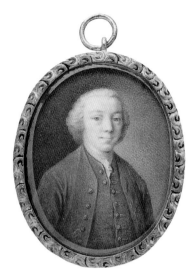

104

Theodor Friedrich Stein

German, active about 1750–88

Born in Hamburg, where he worked from 1750 to 1770, Stein executed pastels and miniatures which have been said to show the influence of Karl Gustav Klingstedt (1657–1734). Stein died in Lübeck. Many of his works are in private collections in Germany.

Attributed to Theodor Friedrich Stein

106
Portrait of a Man

Ivory, 1⅝ x 2¼ in. (41 x 62 mm)
Bequest of Millie Bruhl Fredrick, 1962 (62.122.154)

Wearing a silver-embroidered blue jacket, brocaded waistcoat, and white shirt with black necktie; holding three-cornered hat under his left arm. Blue eyes; powdered hair. Tree and sky background.

IN HIS unpublished list of the miniatures in the Fredrick collection (1960), no. 98, E. G. Paine describes this as a work of the French school, about 1765. The rectangular format was frequently used in mid-eighteenth-century Continental miniatures (see also no. 270). Torben Holck Colding recently suggested the attribution to Stein.

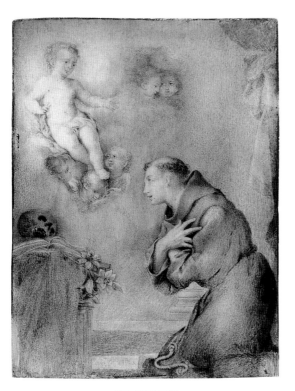

105 OBVERSE
COLOR PLATE PAGE 41

105 REVERSE

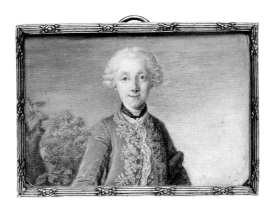

106

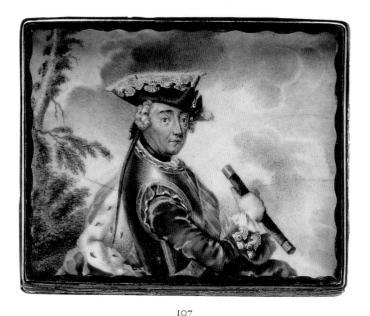

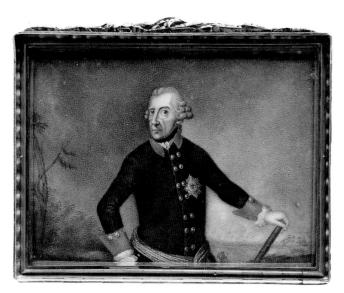

107

108

German

about 1760

107
Frederick the Great (1712–1786), *King of Prussia*

Enamel, 2¾ x 3½ in. (70 x 90 mm)

Gift of Eduard and Helen Naumann, 1963 (63.77)
ESDA

Wearing armor with a pink ermine-lined cloak and the orange ribbon of the Order of the Black Eagle; holding a marshal's baton. Landscape and sky background.

The miniature is the inside lid of an enameled box. The box has not survived.

CONDITION: Enamel is cracked horizontally at left and right center.

THE COMPOSITION, showing Frederick the Great in half armor in a landscape, has been attributed to Daniel Chodowiecki (1726–1801), a prolific engraver active in Berlin from 1743. No. 107 is one of a group of closely similar works. The most important of these is perhaps the enameled box belonging to the Stichting Huis Doorn near Utrecht, the Netherlands (Hermann Schadt and Ina Schneider, *Kaiserliches Gold und Silber: Schätze der Hohenzollern aus dem Schloss Huis Doorn*, exh. cat. [Berlin, 1985], no. 152, ills.). The outside of the lid and the bottom of the

Huis Doorn box are inscribed respectively *Lissa 5.XII.1757* and *Rosbach 5. Octbr. 1758.*, providing a terminus post quem for the entire group. Another such box was published by Arnold Hildebrand (*Das Bildnis Friedrichs des Grossen: Zeitgenössische Darstellung* [Berlin, 1940], p. 109, pl. 27). A miniature of the same subject on ivory belongs to the Swedish national portrait collection (Gripsholm Castle, no. 1797; see Eva-Lena Karlsson, in *Europeiskt Miniatyrmåleri i Nationalmusei samlingar* [Stockholm, 1994], p. 132, fig. 107). There are slight differences of detail, and only the present box and the one published by Hildebrand show the tree in the left background.

Frederick the Great (1712–1786) succeeded as king of Prussia in 1740; under him, and from the successful conclusion in 1763 of the Seven Years' War, Prussia became the most powerful of the German states. Frederick is also known for his admiration of French culture, his friendship with Voltaire, and his love of music and patronage of the visual arts.

German

about 1765

108
Frederick the Great (1712–1786), *King of Prussia*

Ivory, 2⅜ x 3¼ in. (60 x 83 mm)

Gift of J. Pierpont Morgan, 1917 (17.190.1242)
ESDA

Wearing the dark blue uniform with red lapels of the Prussian Life Guards, a white sash, and the badge of the Order of the Black Eagle; holding a marshal's baton. Powdered wig. Landscape and sky background with the smoke of battle, foot soldiers, and cavalry on the horizon at right.

The miniature is set in the lid of a gold snuffbox with scenes of Venus, Cupid, and Mercury after Boucher in painted opaque enamel on an engraved ground. The rim of the box is inscribed (front edge) *Baudeson*. The maker is probably Daniel Baudesson (1716–1785), who worked in Berlin, and the enameling is attributed to Daniel Chodowiecki (1726–1801). The box dates about 1765.

EXHIBITED: Kunsthalle der Hypo-Kulturstiftung, Munich, 1992, *Friedrich der Grosse: Sammler und Mäzen*, no. 108.

LITERATURE: Henry and Sidney Berry-Hill, *Antique Gold Boxes: Their Lore and Their Lure* (New York, 1953), pp. 138, 141, ill. 121; A. Kenneth Snowman, *Eighteenth Century Gold Boxes of Europe* (London, 1966), pp. 102–3, pls. 569–70.

THIS MINIATURE of Frederick the Great as a field marshal was perhaps based on a portrait in large. A bust-length portrait in an oval by Anton Graff (1736–1813) has been cited in this connection: it can be dated 1781–86 and belongs

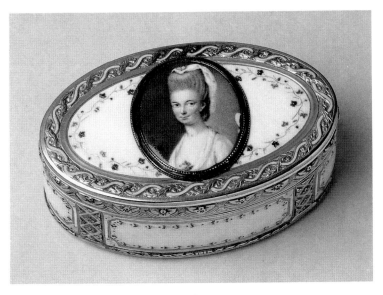

109

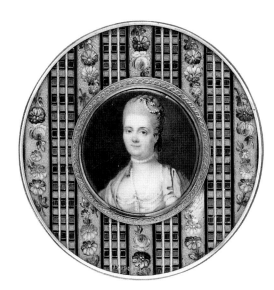

110
COLOR PLATE PAGE 42

to Schloss Sanssouci, Potsdam (Winfried Baer, in *Friedrich der Grosse: Sammler und Mäzen*, exh. cat. [Munich, 1992], no. 108, and see also p. 383, fig. 2). A more likely source might be the knee-length portrait of 1764 by Johann Heinrich Christian Franke (1738–1792) at Schloss Charlottenburg, Berlin (see *Friedrich der Grosse: Sammler und Mäzen*, p. 383, fig. 1). In either case only Frederick's head would have been copied, while the pose and the background were invented.

Comparisons with works illustrated by Arnold Hildebrand (*Das Bildnis Friedrichs des Grossen: Zeitgenössische Darstellung* [Berlin, 1940]) — for example the miniature by A. F. König of 1769 (Hildebrand 1940, pl. 36) — support a date in the 1760s.

Johann Heinrich Hurter

Swiss, 1734–1799

Hurter was born in Schaffhausen. About 1777, after working in Bern, for the French court (on the advice of Jean Étienne Liotard [1702–1789]), and at The Hague, he went to London where he exhibited at the Royal Academy from 1779 to 1781. He had much success there with miniatures

in enamel and made pastel portraits. From 1785 he traveled on the continent, but returned to London in 1787. In later life Hurter worked in Germany. He died in Düsseldorf.

109
Portrait of a Woman

Enamel, 1⅛ x 1 in. (29 x 25 mm)

Signed (left): *iH.f.* [*IH* in monogram]

The Collection of Giovanni P. Morosini, presented by his daughter Giulia, 1932 (32.75.46) ESDA

Wearing a white dress with pink rose at the bosom. Powdered hair with white veil and pink roses. Gray eyes; brown and gray-brown background.

The miniature is set in the lid of a gold-and-enamel box made by Nicolas Marguerit (master 1763, working to about 1790) in Paris in 1775–76. The box bears five marks, among them the maker's mark NM and the Paris mark for 1775–76. Although the miniature is contemporaneous with the box, it does not appear to be original to it.

CONDITION: A chip on the right edge, near center, reveals the white enamel ground.

THE PORTRAIT is probably of the same date as the box; thus it was painted, presumably in

France, a year or two before Hurter settled in London.

110
Portrait of a Woman

Enamel, diam. 1½ in. (37 mm)

Gift of J. Pierpont Morgan, 1917 (17.190.1134) ESDA

Wearing a light green dress, yellow robe, and strands of pearls. Brown eyes; powdered hair dressed with pearls. Brown background.

The miniature is set in the lid of a gold-and-enamel box made in Denmark about 1770–75. The box bears two marks, one an unidentified maker's mark and the other a Copenhagen month mark. Inside the box is a label printed *2341* and inscribed in pencil *3440*.

EX COLL.: Bernard Franck (in 1900).

EXHIBITED: Petit Palais, Paris, 1900, *Exposition rétrospective de l'art français des origines à 1800*, pl. 38.

THE ATTRIBUTION to Hurter was suggested in 1977 by Edwin Boucher. Although the enamel is unsigned, comparison with no. 109 appears to justify the attribution (there is, however, no record of a visit by Hurter to Denmark).

Adam Ludwig d'Argent

German, 1748–1829

D'Argent worked as an enamelist and engraver, first in Stuttgart, his birthplace, and later in Paris and elsewhere in Germany.

III

Joseph II (1741–1790), *Emperor of Austria*

Enamel, 1¼ x 1 in. (32 x 26 mm)

Signed (reverse, in brown on blue enamel): *A: L: d'Argent. / pxt:*

The Moses Lazarus Collection, Gift of Josephine and Sarah Lazarus, in memory of their father, 1888–95 (95.14.68)

Wearing a red uniform jacket with green facings, the red ribbon and badge of the Order of the Golden Fleece, the badge of the Order of Saint Stephen, white shirt, and black neckband. Blue eyes; powdered hair. Gray background.

THE SIGNATURE on this enamel's reverse was not discovered until the miniature was unframed for the preparation of this catalogue. It had previously been described as a portrait of the duke of Cumberland by Christian Friedrich Zincke (nos. 117–21) and subsequently as the portrait of an officer in the style of André Rouquet (1701–1758). Comparison with engraved portraits by Anton Tischler (1721–1780) and miniatures by Heinrich Friedrich Füger (no. 112) confirms that the present work depicts Joseph II (see also the sale catalogue with miniatures from the Robert D. Brewster collection, Sotheby's, Geneva, November 15, 1995, nos. 269 and 270, color ills.). It may date to about 1780.

Leo R. Schidlof (*The Miniature in Europe* [Graz, 1964], vol. 1, p. 47) records an enamel by d'Argent of Joseph II in the Lenoir sale, Paris, 1874, but there is no evidence that it was this example.

Heinrich Friedrich Füger

German, 1751–1818

Born in Heilbronn, Swabia, Füger made extended visits to Dresden, Vienna, and Rome (1776–83) before settling permanently in Vienna, where he became the most eminent miniaturist of the Austrian school. He made numerous portraits of members of the imperial family and the Viennese aristocracy. He was appointed assistant director of the Academy in 1783 and director of the Imperial Gallery in 1806. Füger was also a distinguished and successful painter in oils and pastels.

III
COLOR PLATE PAGE 42

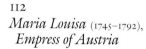

112
COLOR PLATE PAGE 43

112

Maria Louisa (1745–1792), *Empress of Austria*

Ivory, 1¼ x ⅞ in. (31 x 22 mm)

Fletcher Fund, 1941 (41.68)

Wearing a white ruff collar, blue sleeves slashed with white, diamond necklace, and pearl eardrops. Dark eyes; tiara on fair hair. Gray background.

A paper fixed to the back of the ivory is inscribed in brown ink *Heinr. / Fried. / Füger.*

EX COLL.: Therese Mayr (1907); [Walter Ephron, New York, until 1941].

EXHIBITED: Metropolitan Museum of Art, 1950, *Four Centuries of Miniature Painting*, list, p. 5.

LITERATURE: Eduard Leisching, *Die Bildnis-Miniatur in Oesterreich von 1750 bis 1850* (Vienna, 1907), no. 60, ill.

THE MINIATURE has been mistakenly described as a portrait of the empress Maria Ludovika (1787–1816), who married Franz II (1768–1835) of Austria in 1808. It is instead a reduced version of the portrait of the empress Maria Louisa by Füger of which the prime version shows her holding a miniature of her husband, Leopold II (Ernst Lemberger, *Portrait Miniatures of Five Centuries* [London, 1913], colorpl. 9). In that miniature the empress wears an ermine-lined cloak. There is another miniature ascribed to Füger in which she wears the same slashed sleeves and her husband's portrait pinned to her breast (Ferdinand Laban, "Heinrich Friedrich Füger, der Porträtminiaturist," in *Jahrbuch der Königlich Preuszischen Kunstsammlungen* 26 [1905], fig. 19).

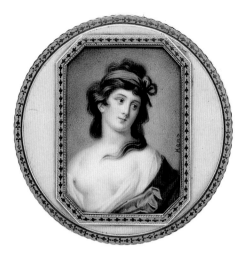

113
COLOR PLATE PAGE 43

Maria Louisa of Spain (1745–1792), daughter of Charles III, king of Spain and of Naples and Sicily, married in 1765 Leopold (1747–1792), grand duke of Tuscany, becoming archduchess of Austria and in 1790—the approximate date of this miniature—Holy Roman Empress.

Carl Christian Kanz

German, born 1758, died after 1818

Born in Plauen, Saxony, Kanz became a pupil at the Paris Académie in 1778 and exhibited miniatures at the Salon de la Correspondance in 1780 and enamels at the Paris Salon in 1808. He seems to have worked in Russia. His son C. Kanz worked in enamel from 1835 until 1839, but the date of the box in which no. 113 is set indicates that the enamel is by the elder artist.

113

Portrait of a Woman

Enamel, 2 x 1½ in. (51 x 38 mm)

Signed (right edge, in black): *Kanz*

Gift of J. Pierpont Morgan, 1917 (17.190.1127)
ESDA

Wearing a white shift and blue robe draped around her shoulders. Brown hair with a pink fillet. Gray background.

The miniature is set in the lid of a circular gold-and-enamel box made in St. Petersburg about 1820. The box bears four marks, among them an uniden-

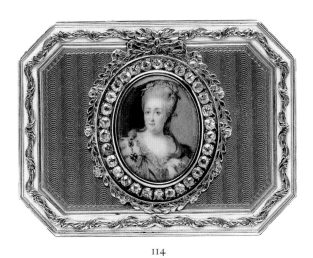

114

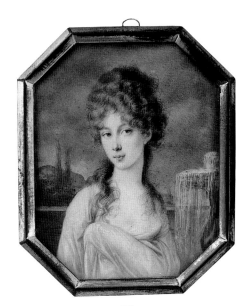

115

tified maker's mark and the St. Petersburg mark for 1818–61.

A label inside the box is printed *2307*; a stock label is inscribed *P.M./3461*.

Nicolas Soret

Swiss, 1759–1830

Soret, born in Geneva, took part in a rising in the town and was forced to flee in 1783. He went to London and subsequently to Ireland, returning to his native city in 1785. Thereafter he was in St. Petersburg, working for Catherine II (1729–1796) until her death. He returned to Geneva in 1799. He painted miniatures, but is known primarily for his fine work in enamel.

114
Catherine II (1729–1796), *Empress of Russia*

Enamel, 1⅛ x ⅞ in. (27 x 22 mm)
Bequest of Catherine D. Wentworth, 1948
 (48.187.427) ESDA

Wearing a pale green dress, ermine robe, black and gold ribbon of the Order of Saint George, and collar of the Order of Saint Andrew. Powdered hair dressed with leaves. Greenish gray and brown background.

The miniature is set in the lid of a gold-and-enamel box, circled with diamonds, made in Paris, probably by Joseph Étienne Blerzy, in 1774–75. The box bears six marks, among them an indistinct maker's mark which has been read as J.E.B., and the Paris mark for 1774–75.

IN STYLE this miniature is very like a larger oval enamel on copper representing Catherine the Great in a similar pose and costume, but with the badge of an additional order. The larger enamel (1⅝ x 1⅜ in. [41 x 35 mm]), which is signed and dated by Soret in 1786, is in the Musée de l'horlogerie, Geneva (no. AD 2364; *Meesterwerken uit Geneve*, exh. cat. [Ghent, 1979], pp. 43–44, no. 65, ill.). Fabienne Sturm and Hans Boeckh endorse the attribution of no. 114 to Soret. His miniatures bring to mind state portraits of the empress by both Feodor Rokotov and Giovanni Battista Lampi.

Born Princess Sophie of Anhalt–Zerbst, Catherine married in 1745 Prince Peter (1728–1762), nephew and successor of Empress Elizabeth I of Russia. Peter III, who reigned for only six months, was murdered in July 1762, having been deposed in favor of his wife, who was crowned Catherine II on October 3 of the same year.

Peter Edward Stroely

German, born 1768, died after 1826

Stroely (or Stroehling) was born in Düsseldorf. He worked elsewhere in Germany and in Paris, Rome, Naples, and Vienna. In 1796 he attended the coronation of Czar Paul I claiming to be an English nobleman, with a conspicuous train of attendants, and received much patronage in St. Petersburg. He worked in London from 1803 until 1807 and from 1819 until 1826. He painted portraits and subject pictures in oil as well as miniatures.

115
Portrait of a Woman

Ivory, 3⅜ x 2⅝ in. (87 x 67 mm)
Signed (lower left, in gray, on parapet): *Stroely*
Rogers Fund, 1950 (50.57)

Wearing a white dress. Brown eyes; brown hair. Landscape background in shades of gray: pines and hills on the left and a fountain on the right.

EX COLL.: Baron Max von Goldschmidt-Rothschild, Frankfurt (his sale, Parke-Bernet, New York, March 10, 1950, no. 138).

THE MINIATURE may date from about 1800.

Bernard Lens

British, 1682–1740

Bernard Lens is known as Bernard Lens III to distinguish him from his grandfather, who is thought to have been an enamel painter, and his father, who was a mezzotint engraver and drawing master. He was born in London. Following the example of Rosalba Carriera (no. 97), he led the movement in England for using ivory rather than vellum as the support for miniatures. The most prominent native-born miniaturist of the early eighteenth century in England, Lens made

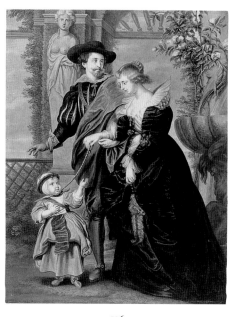

116
COLOR PLATE PAGE 44

117

many miniature copies of old master paintings as well as miniature portraits *ad vivum*. From 1723 he served as miniature painter to George I (1660–1727) and George II (1683–1760) and was a fashionable drawing master who numbered Horace Walpole (1717–1797) among his pupils.

116
Rubens, His Wife Helena Fourment, and Their Son Peter Paul

Vellum, 15½ x 11⅞ in. (394 x 302 mm)

Signed and dated (lower left, in gold): *Bernard Lens Fecit 1721.*

Purchase, Mr. and Mrs. Charles Wrightsman Gift, 1984 (1984.442)

Copied from the oil painting by Peter Paul Rubens (1577–1640) now in the Metropolitan Museum (1981.238).

EX COLL.: [Morton Morris & Co., London, until 1984].

LITERATURE: Unpublished. On the painting by Rubens, see: Walter A. Liedtke, *Flemish Paintings*

in *The Metropolitan Museum of Art* (New York, 1984), vol. 1, pp. 176–87, and vol. 2, colorpl. XIII, pls. 66–72.

RUBENS'S celebrated self-portrait with his second wife and their young child, which was painted about 1639, was reportedly given by the city of Brussels to John Churchill (1650–1722), first duke of Marlborough, after his victory at Blenheim in 1704 (for his portrait, see no. 38). It hung at Blenheim Palace, Woodstock, until 1884. The copy by Lens was painted in 1721, the year before the first duke's death. In contrast with Rubens's original, Lens centered the figure group, opening up the landscape toward the left and introducing slightly more space at the top and bottom. Certain passages in the painting which have darkened over the course of time— the folds of Helena Fourment's black skirt, for example—may be read more clearly in the miniature.

Christian Friedrich Zincke
German, 1683/85–1767

Born in Dresden, Zincke was the son of a goldsmith. He studied with the Dresden painter Heinrich Christoph Fehling (1657–1725) and then settled in England about 1704–6, becoming the pupil of Charles Boit (1662–1727) in enamel painting. When Boit left for France in 1714, Zincke became the leading painter in miniature in England; he was patronized by George II (1683–1760) and Frederick, Prince of Wales (1707–1751), and had an enormous practice. His eyes began to trouble him by 1725, and Zincke undertook less work in his later years. To a large extent his enamels are painted *ad vivum* rather than being copies of existing portraits. His work is copiously represented in the British Royal Collection.

117
Portrait of a Man

Enamel, 1⅞ x 1½ in. (47 x 38 mm)
Bequest of Millie Bruhl Fredrick, 1962 (62.122.115)

Wearing a light gray-brown coat and white shirt. Brown eyes; powdered wig. Dark brown background.

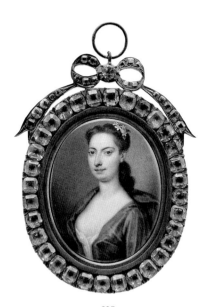

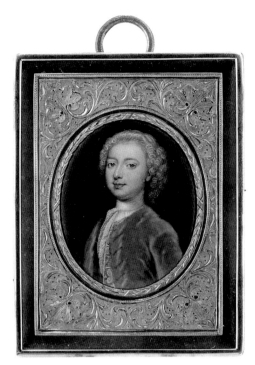

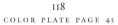

118
COLOR PLATE PAGE 45

119
COLOR PLATE PAGE 45

120

The back, which is white enamel with light blue edging, is uninscribed.

EX COLL.: Giovanni Morosini, New York; Giulia P. Morosini, New York (died 1932; her estate sale, American Art Association–Anderson Galleries, New York, October 14, 1932, no. 1260).

IN HIS unpublished list of miniatures in the Fredrick collection (1960), no. 37, E. G. Paine attributes this enamel to Zincke and dates it about 1740. Although unsigned, it is a characteristic example of his earlier work, about 1720.

118
Richard Abell

Enamel, 1¾ x 1⅜ in. (45 x 35 mm)

Signed, dated, and inscribed (reverse, in the enamel): *Richard Abell* / CF [monogram] . *Zincke.Fecit* / 1724

The Moses Lazarus Collection, Gift of Josephine and Sarah Lazarus, in memory of their father, 1888–95 (95.14.61)

Wearing a blue coat and white linen. Powdered wig. Brown background.

EXHIBITED: Metropolitan Museum of Art, 1950, *Four Centuries of Miniature Painting*, list, p. 7.

THE MINIATURE was framed in England about 1770–80 as a pair to no. 119.

119
Mrs. Vanderbank

Enamel, 1⅜ x 1½ in. (35 x 38 mm)

The Moses Lazarus Collection, Gift of Josephine and Sarah Lazarus, in memory of their father, 1888–95 (95.14.99)

Wearing a blue dress and white shift. Brown hair dressed with flowers. Gray background.

EXHIBITED: Metropolitan Museum of Art, 1950, *Four Centuries of Miniature Painting*, list, p. 7.

THE SITTER'S name, a traditional identification, may indicate that she was a relative of the painter John Vanderbank (1694?–1739), who founded the St. Martin's Lane Academy. George Vertue records ("Note Books, vol. 3," *Walpole Society*, vol. 22, 1934, pp. 57–58) that about 1732 Vanderbank painted his wife half-length in a costume resembling that of Rubens's wife (no. 116).

The miniature was framed in England about 1770–80 as a pair to no. 118, although it is

slightly later than 1724.

120
Portrait of a Young Man

Enamel, 1¾ x 1⅜ in. (45 x 36 mm)

Bequest of Catherine D. Wentworth, 1948 (48.187.495)

Wearing a bright blue coat, brown waistcoat embroidered with gold, and white shirt. Brown eyes; powdered hair. Dark brown background.

The miniature's enamel back is white and light greenish blue. A piece of tracing paper fixed to the back covers an ink inscription which has been partly transferred to this covering. It appears to be a dealer's note and price.

THE MINIATURE entered the collection of the Metropolitan Museum with an attribution to William Prewett (active 1735–50); this was changed for an attribution to Christian Friedrich Zincke on the advice of the Victoria and Albert Museum (1949). Although Daphne Foskett in 1965 accepted the attribution to Prewett, the style is fully in line with the signed and accepted late works of Zincke, from about 1745. The frame is contemporary.

Attributed to Christian Friedrich Zincke

121
Portrait of a Woman

Enamel, 1⅞ x 1½ in. (46 x 38 mm)
Bequest of Millie Bruhl Fredrick, 1962 (62.122.114)

Wearing a white satin dress with a blue bow at waist. Brown hair dressed with pearls and a blue bow. Brown background.

IN HIS unpublished list of miniatures in the Fredrick collection (1960), no. 38, E. G. Paine lists this enamel as a work by Christian Friedrich Zincke, about 1735. This attribution was accepted by Daphne Foskett in 1965 but was questioned in 1978 by Hermione Waterfield, who suggested that it may be by William Prewett (active 1735–50). Other enamelists working at about this time whose claims have to be considered include Jean André Rouquet (1701–1758) and Gervase Spencer (active by 1740, died 1763). However, the crisp, decisive modeling is more akin to the style of Zincke, though if it is by him it is a work of his later years, about 1745, when he was accepting fewer commissions because of failing sight.

Nathaniel Hone
Irish, 1718–1784

Born in Dublin, Hone was a traveling artist in England as a young man. He settled in London where he worked as a miniaturist both on ivory and in enamel; the earliest known miniature by him is dated 1747. He also painted in oils and after 1770 gave up miniature painting for that medium. In 1768 Hone was a founding member of the Royal Academy, but he quarreled with that body in 1775 when he submitted *The Conjuror*, a painting satirizing Sir Joshua Reynolds and Angelica Kauffmann. He died in London.

Horace Hone (no. 151) was his son.

Attributed to Nathaniel Hone

122
Portrait of a Man

Enamel, 1⅛ x 1 in. (30 x 25 mm)
Bequest of Millie Bruhl Fredrick, 1962 (62.122.27)

Wearing an imitation mid-seventeenth-century brown costume with a lace-edged falling collar and slashed sleeves. Brown eyes; brown hair. High color.

The miniature is set in an elaborately decorated silver frame with a coronet, apparently that of a viscount.

IN HIS unpublished list of miniatures in the Fredrick collection (1960), no. 22, E. G. Paine attributes this enamel to Nathaniel Hone, about 1760. The attribution is plausible, though if it is by Hone, it is not one of his better works.

William Pether
British, 1731/38–1821

William Pether was a cousin of Abraham Pether (1756–1812), a landscape painter known for his moonlight scenes. William Pether studied under Thomas Frye (1710–1762) and exhibited from 1761 until 1794. He is credited with the production of a quantity of eye miniatures (no. 291), but there is little stylistic resemblance between those works and the few miniatures attributed to him.

Attributed to William Pether

123
A Man with the Initials FM

Ivory, 3 x 2¼ in. (75 x 56 mm)
Signed (right, in black): *W. P.*
Gift of Lilliana Teruzzi, 1968 (68.213)

Wearing a gray-brown coat and white frilled shirt. Brown eyes; powdered hair. Sky background.

The original gilt frame is set with brilliants. Decorative borders are etched on the gilt back, and in the center an oval glass covers the gold initials FM surmounted by a crest.

In the backing is a trade card for an inn at Lyncombe near Bath.

THE INITIALS W. P. of the signature have been interpreted as those of William Pether. The powdered hair and shading of eyes and chin have a bluish tone.

Samuel Cotes
British, 1734–1818

Born in London, Samuel Cotes was the younger brother of Francis Cotes (1726–1770), a well-regarded painter and pastelist in the 1760s. Samuel Cotes exhibited from 1760 until 1789. His signature has been confused with those of Samuel Collins (no. 126) and Sarah Coote (active 1777–84). He died in London.

124
Portrait of a Woman

Ivory, 1½ x 1⅛ in. (38 x 30 mm)
Signed and dated (right, in black): *SC / 1767*
Bequest of Millie Bruhl Fredrick, 1962 (62.122.33)

Wearing a black lace-edged dress with pink inset edged with white and pearl necklace with pink ribbon at back; white lace cap. Brown eyes; dark brown hair. Gray-blue background.

LITERATURE: E. G. Paine, unpublished list of miniatures in the Fredrick collection (1960), no. 10, as by Samuel Cotes.

Jeremiah Meyer
German, 1735–1789

Born in Tübingen, Meyer was the son of the portrait painter to the duke of Württemburg; his father took him to England in 1749. He had lessons in enamel painting from the elderly Christian Friedrich Zincke (nos. 117–21), but painted more frequently on ivory. Appointed miniature painter to Queen Charlotte and painter in enamel to George III in 1764, he was a founding member of the Royal Academy in 1768. Meyer's elegant style made him the leader of the flowering of British miniature painting in the second half of the eighteenth century. He died in Kew.

125
Hannah Mahady

Ivory, ⅞ x ⅝ in. (22 x 16 mm)
The Moses Lazarus Collection, Gift of Josephine and Sarah Lazarus, in memory of their father, 1888–95 (95.14.78)

Wearing a pink dress and pearl necklace. Brown hair. Gray background.

The miniature is set as a brooch.

THE IDENTIFICATION of the sitter is traditional. The miniature was described on receipt in the Metropolitan Museum as the work of an unknown British artist, nineteenth century. In 1952 Leo R. Schidlof attributed it to either

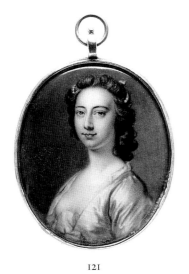

121

122

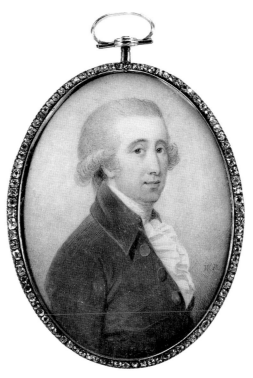

123

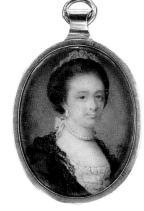

124

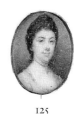

125

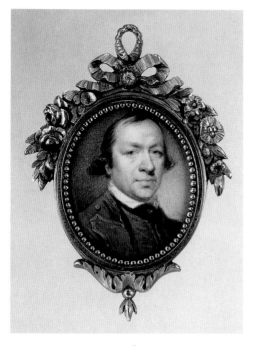

126

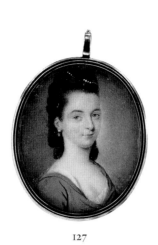

127

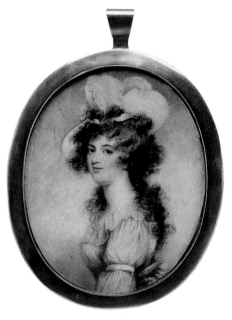

128

Jeremiah Meyer (*continued*)

Jeremiah Meyer or Penelope Cotes (a hypothetical sister of Francis and Samuel Cotes; now considered to be a figment of the imagination). E. G. Paine, Richard Allen, Edwin Boucher, and Hermione Waterfield have since agreed in assigning it to Jeremiah Meyer. It is certainly by him and, though faded, is a fine example of his work on a small scale, about 1760.

Samuel Collins

British, 1735?–1768

Born in Bristol, Collins began his career as a miniature painter in Bath, then becoming a center for fashion and for portrait painters. In 1762, to escape his creditors, he left hurriedly for Dublin, where he worked until his death. Ozias Humphry (1742–1810) was his pupil and succeeded to his practice in Bath. Some confusion has arisen in the attempt to determine whether miniatures signed S.C. are by him or by Samuel Cotes (no. 124).

126
Portrait of a Man

Ivory, 1⅝ x 1¼ in. (40 x 32 mm)
Signed (right, in brown): *Collins*

The Moses Lazarus Collection, Gift of Josephine and Sarah Lazarus, in memory of their father, 1888–95 (95.14.69)

Wearing a red coat with gold-edged lapels, red waistcoat, white shirt, and black tie. Brown hair. Gray background.

THE MINIATURE is signed in the same way as the portrait of a man called Captain Bury, 1763, in the Victoria and Albert Museum, London (P.59–1927; Graham Reynolds, *English Portrait Miniatures*, rev. ed. [Cambridge, 1988], p. 109, fig. 65). Both are important for the study of this artist, whose work is less well known than its merits deserve.

James Jennings

British, active about 1763–93

A number of miniatures painted in the 1760s and later and signed JJ are assigned to James Jennings, who exhibited in London at the Society of Artists from 1763 until 1783 and at the Royal Academy in 1793. The form of his signature and similarities of style have led to some of his work being attributed to John Smart (nos. 134–40).

127
Portrait of a Woman

Ivory, 1⅝ x 1¼ in. (40 x 34 mm)
Signed (right, in dark gray): *J* [*J*?] / [illegible, perhaps a date]
Bequest of Millie Bruhl Fredrick, 1962 (62.122.35)

Wearing a gray-blue dress with white bodice; pearl earrings. Bright blue eyes; brown hair dressed with pearls. Light gray background.

IN HIS unpublished list of miniatures in the Fredrick collection (1960), no. 15, E. G. Paine read the signature as *J.G. 1791* and attributed the miniature to James Green (1771/72–1834). In 1978 Hermione Waterfield read the signature as JJ and attributed the miniature to James Jennings.

The initials seem originally to have been JJ. An attempt was perhaps made to change the second initial to S to suggest that the miniature was by John Smart. The style of the miniature, however, is consistent with others unquestionably signed JJ and assigned to Jennings (for instance, a woman of the Hunter Blair family of 1774 in Daphne Foskett, *A Dictionary of British Miniature Painters* [New York and Washington, D.C., 1972], vol. 2, pl. 188, no. 479).

The sitter wears the rising hairstyle of the early 1770s.

James Nixon

British, born about 1741, died 1812

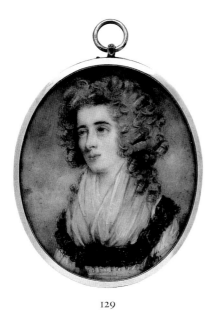

129

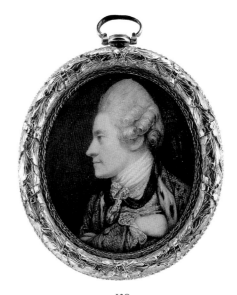

130

COLOR PLATE PAGE 46

Nixon began to exhibit in 1765 and was active until 1807. He became an associate of the Royal Academy in 1778; he was not successful financially and had to seek a pension from the academy in his later years. Miniatures assigned to Nixon bear a signature in the form of a cursive initial N.

128
Portrait of a Young Woman

Ivory, 3¾ x 3 in. (97 x 75 mm)
Signed (left, in brown): *N*
Fletcher Fund, 1939 (39.122)

Wearing a pink dress and hat with a white feather. Brown eyes; brown hair. Bluish background.

CONDITION: The pink tone especially noticeable in the background is probably due to the discoloration of a pigment which was originally blue. The surface is in generally good condition, with two minor losses in the upper right background, which have been toned. The miniature was reframed in a metal locket-style case.

EX COLL.: Mrs. William P. Derby, Framingham, Mass. (until 1939).

EXHIBITED: Metropolitan Museum of Art, 1950, *Four Centuries of Miniature Painting*, list, p. 6.

LITERATURE: Leo R. Schidlof, *The Miniature in Europe* (Graz, 1964), vol. 2, pp. 592, 1015, and vol. 4, pl. 428, no. 876.

THE SOFT, rosy flesh tones, abundant curls,

and stylish feathered hat contribute to an effect of overwhelming femininity. This miniature was much admired by Leo R. Schidlof. It dates from about 1780–85.

129
Portrait of a Woman

Ivory, 2¼ x 1⅞ in. (56 x 47 mm)
Signed (right, in black): *N*
Bequest of Millie Bruhl Fredrick, 1962 (62.122.42)

Wearing a white dress trimmed with black lace and a pink sash. Brown eyes; powdered hair. Sky background.

LITERATURE: E. G. Paine, unpublished list of miniatures in the Fredrick collection (1960), no. 28, as by Nixon, about 1785.

AS E.G. PAINE observed, the miniature is an authentically signed work by James Nixon, but it is not of such good quality as no. 128. It is datable to about 1790.

Richard Cosway

British, 1742–1821

Cosway, who was born in Devonshire, was exceptionally precocious, winning first prize at the age of twelve in a competition held by the Society of Arts in 1755 (Stephen Lloyd, *Richard and Maria Cosway: Regency Artists of Taste and*

Fashion, exh. cat. [Edinburgh, 1995], p. 20). He had ambitions to be a portrait painter in oils, but was so successful with miniatures that he concentrated on that scale. Cosway became an academician in 1771 and miniature painter to the Prince of Wales (later George IV) about 1786. He was the most notable miniature painter in England in the last quarter of the eighteenth century and had a remarkably large and fashionable following. Cosway, with his wife Maria, led a conspicuous and scandalous social life, entertaining at Schomberg House in Pall Mall where he was Thomas Gainsborough's neighbor. He died in London.

130
Self-portrait

Ivory, 2 x 1⅝ in. (50 x 42 mm)
Gift of Charlotte Guilford Muhlhofer, 1962 (62.49)

Wearing an ermine-lined brocaded blue coat, pink waistcoat, black ribbon, and white cravat. Powdered wig tied with a black bow. Gray-brown background.

LITERATURE: Stephen Lloyd, *Richard and Maria Cosway: Regency Artists of Taste and Fashion*, exh. cat. (Edinburgh, 1995), pp. 30, 101, 114, no. 18, colorpl. 17.

THE MINIATURE is established as a self-portrait by comparison with such works as the engravings after the artist's profile by I. Clarke and R. Scriven. Stephen Lloyd confirms the

identification. The artist has presented himself, with his usual flamboyance, as a macaroni, one of the young men of extreme fashion who flourished in England from about 1760. The high-dressed wig indicates that the miniature was painted about 1770–75, when the artist was about thirty years old. The ormolu frame is similar to those supplied by H. J. Hatfield & Co. for Queen Victoria's miniatures at Windsor Castle.

131
Portrait of a Woman, Said to Be Mrs. Bates (1755–1811), *as Flora*

Ivory, diam. 1¾ in. (45 mm)
The Moses Lazarus Collection, Gift of Josephine and Sarah Lazarus, in memory of their father, 1888–95 (95.14.9) ESDA

Wearing a pink and white fancy dress, holding a garland of pink and white flowers. Blue eyes; brown hair dressed with a black bow and jewels. Sky background.

The miniature is set under the lid of a circular gold-and-enamel box made by A. J. Strachan in London in 1811–12. The box bears six marks, among them the maker's mark AJS and the London mark for 1811–12. It is a *boîte à secret* in which the inner section of the gold lid is hinged and lifts up to reveal the miniature framed in a circle of rose diamonds and blue enamel.

IN A LIST compiled by Sarah Lazarus the miniature is described as a portrait of Mrs. Bates by Cosway. It is a fine example of Cosway's middle manner, about 1775, and is in notably good condition, having been protected from fading by the cover. It was set in the present box about thirty-five years after it was painted.

Sarah Harrop Bates (1755–1811) was a concert singer. In 1780 she married the musician and civil servant Joah Bates (1740/41–1799). There is a pastel of her by Ozias Humphry at Knole.

132
Ensign Lionel Robert Tollemache
(1774–1793)

Ivory, 3⅛ x 2½ in. (81 x 65 mm)
Bequest of Mary Clark Thompson, 1923 (24.80.499)

Wearing a red uniform jacket, blue waistcoat, white cravat, and black neckband. Blue eyes; powdered hair. Sky background.

A backing paper inside the case is inscribed in ink over pencil *Cap.ᵗ Tollemache / 21*. The gold back of the frame is engraved *General Tollemache / by / Cosway*.

CONDITION: The ivory is laid on a card which is glued in turn to a copper backing. The attach-

ment is loose on one side; there does not seem to be an inscription on the reverse. The miniature is well preserved. The costume lacks finish and was perhaps left incomplete.

THIS IS a replica, almost certainly by Cosway, of the miniature of Ensign Tollemache at Ham House, Petersham, England (no. HH 414-1948). The latter, which is the same size, is signed on the back by Cosway and dated 1793, the year of the sitter's death in action (reproduced in G. C. Williamson, *History of Portrait Miniatures* [London, 1904], vol. 1, pl. LVI, and in G. C. Williamson, *Richard Cosway* [London, 1905], ill. opp. p. 54). The miniature at Ham House descended through the Tollemache family.

Lionel Robert Tollemache, grandson of Lionel, fourth earl of Dysart, was an ensign in the Coldstream Guard. He was killed by a shell before Valenciennes on July 14, 1793. If the sitter is correctly identified, he was an ensign at his early death, and the inscriptions on the backing card and the frame are incorrect in describing him as a captain or a general.

Richard Crosse

British, 1742–1810

Born in Devonshire, Crosse was of the landed gentry and a deaf-mute from birth. He began to exhibit in London in 1760 and built up an extensive practice. His register of the miniatures he painted in 1775–98 (Victoria and Albert Museum, London) records in the early years up to one hundred miniatures annually. One of the more eminent miniature painters of the late eighteenth century in England, Crosse seems to have given up working in 1798. He died at his family home at Knowle, Devonshire.

133
Portrait of a Woman

Ivory, 2¼ x 1⅞ in. (58 x 48 mm)
Bequest of Margaret Crane Hurlbut, 1933 (33.136.14)

Wearing a light blue dress and white fichu. Brown eyes; powdered hair. Gray-blue background.

The contemporary frame is glazed at the back to reveal plaited hair. It was mounted as a brooch, the pin of which is missing.

CONDITION: Despite local damage from water at the left edge, the miniature is very well preserved.

ON RECEIPT in the Metropolitan Museum, this miniature was described as British school, late eighteenth century. Leo R. Schidlof (in a

letter, 1950) was the first to recognize Crosse's characteristic style here, and it is certainly by him. The miniature may date about 1780.

John Smart

British, 1741/43–1811

Smart is thought to have been born near Norwich. In his youth he finished second to Richard Cosway (nos. 130–32) in a competition held by the Society of Arts in 1755, and he has held that place ever since. Smart's miniatures bear dates from 1760, and he had an extensive clientele. He arrived in India in 1785 and worked there until 1795. He had been a director of the Society of Artists, which had continued in opposition to the Royal Academy. By the time of his return to England, the society was defunct, and Smart exhibited at the Royal Academy until his death in London in 1811. The scope of Smart's art can be studied in a remarkable collection of fifty-one miniatures, one signed and dated for each year from 1760 until 1810, which was given to the Nelson-Atkins Museum of Art, Kansas City, by Mr. and Mrs. John W. Starr (*John Smart—Miniaturist*, exh. cat. [Kansas City, 1965]).

134
Sir William Hood

Ivory, 1½ x 1¼ in. (37 x 32 mm)
Bequest of Mary Clark Thompson, 1923 (24.80.493)

Wearing a gold-embroidered dark reddish brown coat and waistcoat and white frilled shirt. Brown eyes; powdered wig tied with a black ribbon. Black and gray-brown background.

The gold frame is set with brilliants. Its back is engraved *Portrait of / Sir Wᵐ. Hood / by Smart*.

EXHIBITED: Metropolitan Museum of Art, 1950, *Four Centuries of Miniature Painting*, list, p. 7; Nelson-Atkins Museum, Kansas City, 1965–66, *John Smart—Miniaturist*, no. 4.

LITERATURE: Unpublished. Daphne Foskett (*John Smart: The Man and His Miniatures* [London, 1964], p. 68) lists a miniature of Sir William Hood, dated 1766. This must refer to another work since the present portrait is not signed or dated, though it is an authentic example of about that time.

135
Mrs. Charlotte Lennox

Pencil and watercolor on card, 2½ x 2 in. (62 x 51 mm)
Signed and dated (left, in pencil): *J.S.·/ 1777*
Rogers Fund, 1949 (49.122.1)

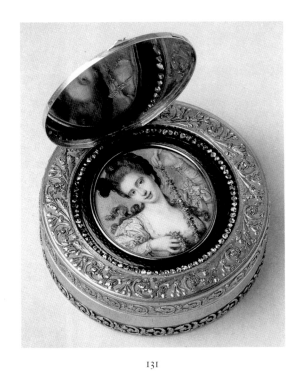

131

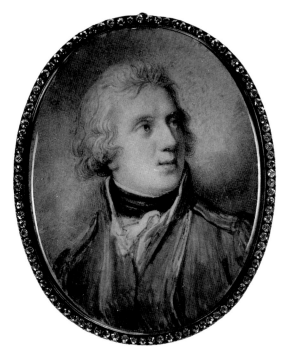

132

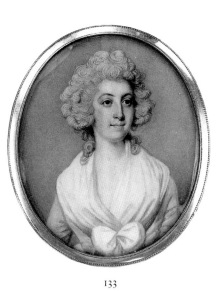

133

134

COLOR PLATE PAGE 46

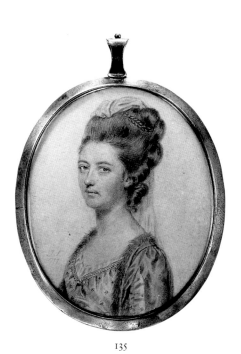

135

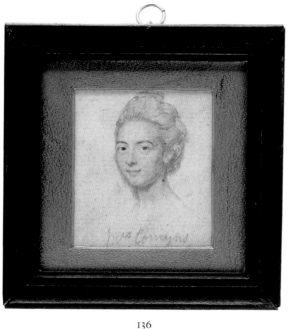

136

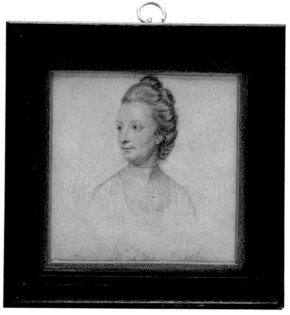

137

John Smart (*continued*)

Wearing a sprigged white dress with blue trim and fur-edged light brown jacket. Beige veil over brown hair. Brown eyes.

The frame is glazed at the back to reveal fabric, fixed to which is a recent paper label inscribed *Mrs Charlotte Lennox*.

CONDITION: The card is somewhat discolored.

EX COLL.: Sir St. Clair Thompson (until 1944; his sale, Sotheby's, London, November 9, 1944, no. 81, to Nyburg); Leo R. Schidlof (until 1949).

EXHIBITED: Metropolitan Museum of Art, 1950, *Four Centuries of Miniature Painting*, list, p. 7.

LITERATURE: Daphne Foskett (*John Smart: The Man and His Miniatures* [London, 1964], p. 70) lists a portrait of Mrs. Charlotte Lennox dated 1777; there is no evidence to show whether it is the object here catalogued.

THIS MINIATURE is framed as a finished work of art despite the fact that the background was never colored.

136
Mrs. Comyns

Pencil and some watercolor on paper, 1¾ x 1⅝ in. (46 x 42 mm)
Inscribed (bottom, in pencil): *Mʳˢ Comyns*
Bequest of Alexandrine Sinsheimer, 1958 (59.23.76)

The face is lightly tinted. Dark brown eyes; gray-washed hair.

CONDITION: The portrait is lightly sketched in pencil and completed in watercolor on medium-weight laid paper which is discolored (though the least so of the five related drawings) and slightly worn and cockled. It has been supplied with a frame, a ragboard spacer and mat, and a cover glass.

EX COLL.: English private collection (until 1914; sale, Christie's, London, May 28, 1914, no. 35 [with nos. 137–40 in one frame]; F. A. Holman, London; Alexandrine Sinsheimer, New York.

LITERATURE: Daphne Foskett (*John Smart: The Man and His Miniatures* [London, 1964], p. 64) lists Mrs. Comyns as a sitter to Smart.

THIS IS a portrait sketch made in preparation for a miniature, about 1760.

137
Mrs. Caroline Deas

Pencil and watercolor on paper, 2¼ x 2¼ in. (56 x 55 mm)
Inscribed (bottom, in pencil): *Mʳˢ Deas - Caroline*
Bequest of Alexandrine Sinsheimer, 1958 (59.23.79)

The face and neck are lightly tinted. Green eyes; brown-washed hair.

CONDITION: The portrait is lightly sketched in pencil and completed in watercolor on medium-weight laid paper which is discolored and slightly worn and cockled. It has been supplied with a frame, a ragboard spacer and mat, and a cover glass.

EX COLL.: As for no. 136.

LITERATURE: Daphne Foskett (*John Smart: The Man and His Miniatures* [London, 1964], p. 65)

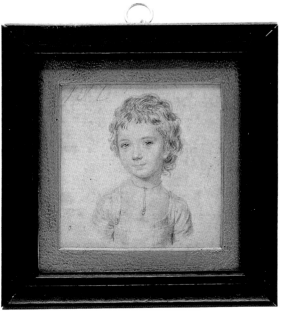

138

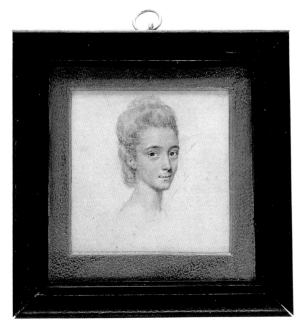

139

lists as sitters to Smart a Mrs. John Deas, of 1773, her husband, and a Miss Caroline Deas.

THIS IS a portrait sketch made in preparation for a miniature, about 1760.

138
Sir George Armytage (1761–1836), *Fourth Baronet*

Pencil and watercolor on paper, 2⅛ x 2 in. (54 x 49 mm)
Inscribed (upper left, in pencil): *182*
Bequest of Alexandrine Sinsheimer, 1958 (59.23.77)

Wearing a dress and a heart-shaped locket suspended from a string. Blue eyes.

CONDITION: The portrait is lightly sketched in pencil and completed in watercolor on medium-weight laid paper which is slightly worn and cock-

led; of the five related drawings this has the most discolored paper. It has been supplied with a frame, a ragboard spacer and mat, and a cover glass.

EX COLL.: As for no. 136.

LITERATURE: Daphne Foskett (*John Smart: The Man and His Miniatures* [London, 1964], p. 61) lists this individual as having sat to Smart as a child.

THIS IS a portrait sketch made in preparation for a miniature. The sitter was identified as Sir G. Armytage in Christie's sale catalogue of 1914, and further details were suggested by Elizabeth E. Gardner. If correct, this sketch dates from about 1763.

Foskett lists two portraits of Sir George Armytage, one as a child and the other later. She gives no locations, and it is not clear whether her listing of the portrait as a child is the present version or a finished miniature made from it.

139
Miss Ramus

Pencil and watercolor on paper, 2¼ x 2 in. (57 x 51 mm)
Inscribed (upper left, in pencil): [?] / *lne*
Bequest of Alexandrine Sinsheimer, 1958 (59.23.75)

The face is lightly tinted. Dark brown eyes; gray-washed hair.

CONDITION: The portrait is lightly sketched in pencil and watercolor on medium-weight laid paper which is slightly worn and cockled; of the five related drawings this has the lightest color paper. It has been supplied with a frame, a ragboard spacer and mat, and a cover glass.

EX COLL.: As for no. 136.

LITERATURE: Daphne Foskett (*John Smart: The Man and His Miniatures* [London, 1964], p. 72) lists Miss Ramus as a sitter to Smart.

THIS IS a portrait sketch made in preparation for a miniature, about 1770. The sitter was identified as Miss Ramus in the Christie's sale catalogue of 1914.

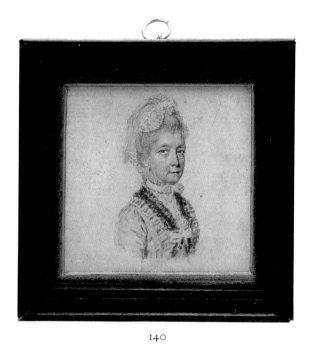

140

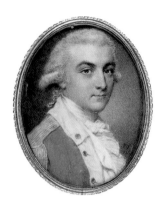

141

John Smart (*continued*)

140
Portrait of a Woman, Said to Be Lady Dering

Pencil and watercolor on paper, 2¼ x 2⅛ in.
 (56 x 54 mm)
Inscribed (upper right, in pencil): *(?)144*
Bequest of Alexandrine Sinsheimer, 1958
 (59.23.78)

Wearing a blue dress trimmed with black lace,
white fichu, and white cap trimmed with blue.
Brown eyes.

CONDITION: The portrait is lightly sketched in
pencil and completed in watercolor on medium-
weight laid paper which is discolored and slightly
worn and cockled. It has been supplied with a
frame, a ragboard spacer and mat, and a cover glass.

Ex COLL.: As for no. 136.

LITERATURE: Daphne Foskett (*John Smart: The
Man and His Miniatures* [London, 1964], p. 66)
lists Lady Dering (née Deborah Winchester), sec-
ond wife of Sir Edward Dering, sixth baronet, as a
sitter to Smart.

THE SITTER was identified as Lady Dering
in the Christie's sale catalogue of 1914. Deborah
Winchester (1745–1818) married Sir Edward
Dering, sixth baronet, as his second wife in 1765.
No. 140, showing an older woman in the cos-
tume of about 1775, almost certainly does not
represent her. A miniature portrait by George
Engleheart (nos. 146–50), said to represent her
when young, was sold at Christie's, June 26,
1980, no. 63 (ill.). There is no resemblance.

Imitator of John Smart

1784 or later(?)

141
Portrait of an Officer

Ivory, 1¾ x 1¼ in. (45 x 32 mm)
Inscribed (right, in black): J · S · / *178[?4]*
Gift of Mrs. Thomas Hunt, 1941 (41.191.2)

Wearing a red uniform jacket with white facings
and epaulet, white waistcoat, and frilled shirt.

Brown eyes; powdered hair. Gray background.

EXHIBITED: Nelson-Atkins Museum, Kansas
City, 1965–66, *John Smart—Miniaturist*, no. 17, as
by Smart.

IN A 1953 letter Arthur Jaffé suggested that the
sitter is probably an officer of the 65th Foot.

When the miniature was received in the Metro-
politan Museum, it was attributed to John
Smart. In 1972 Daphne Foskett said that in her
opinion this work is not by Smart but is a copy
from a miniature by him. Although other
authorities have thought more favorably of it, it
seems to be either a copy by another hand or so
extensively retouched on the face as to be unrep-
resentative of Smart's style.

John Bogle

Scottish, 1746?–1803

Bogle studied at the Drawing School, Glasgow,
and practiced as a miniature painter in Edin-
burgh and London. He sent works to the Royal
Academy from 1772 until 1794. The austerity of

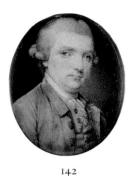

142

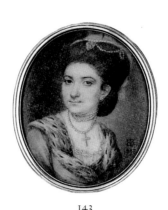

143

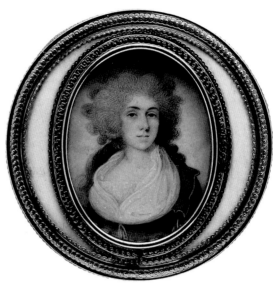

144

his portraits epitomizes the difference between the Scottish and the English style of miniature painting in the late eighteenth century.

142
A Man with the Initials AC

Ivory, 1⅜ x 1⅛ in. (36 x 30 mm)
Signed and dated (right): *I B / 1774*
Gift of Mrs. S. M. Breckenridge Long, 1940 (40.186.1)

Wearing a pink coat and waistcoat and white cravat. Powdered wig. Gray-brown background.

The gold frame is curved at the back and has apertures for the slides of a bracelet attachment; it has been converted to a brooch by the addition of a pin. The back is engraved AC.

CONDITION: There is a residue of glue at the upper left edge.

143
A Woman with the Initials MCC

Ivory, 1⅝ x 1⅜ in. (41 x 34 mm)
Signed and dated (right, in brown): *I · B / 1773*

Gift of Mrs. S. M. Breckenridge Long, 1940 (40.186.2)

Wearing a peach-colored ermine-trimmed dress, white shift, pearl necklace with pendent cross, pearl earrings, and white cap. Brown eyes; brown hair dressed with pearls. Gray-brown background.

The miniature is in a gilt metal frame which has been made into a brooch by the addition of a pin. The back of the frame is engraved MCC.

CONDITION: The crystal is slightly crizzled.

THIS MINIATURE and the preceding one (no. 142) are not a pair, since they are of different sizes and were painted at different times. But both sitters have a final initial C in their names, suggesting that they may represent two members of the same family, perhaps husband and wife.

Thomas H. Hull

British, active about 1775–1827

Hull is one of the many talented miniature painters who emerged in England in the 1770s. Little is known about him except that he worked

from London and exhibited at the Royal Academy from 1775 until 1827.

Attributed to Thomas H. Hull

144
Portrait of a Woman

Ivory, 2 x 1½ in. (50 x 39 mm)
Gift of J. Pierpont Morgan, 1917 (17.190.1137) ESDA

Wearing a gray dress with pale green edging and white fichu. Brown eyes; powdered hair. Sky background.

The miniature is set in the lid of an ivory circular box with gold mounts and lining, made by Guillaume Denis Delamotte (born 1725, master 1756, working 1793) in Paris in 1775. The box bears the Paris charge and discharge marks for 1775–81. Inside the box is a stock label printed *P.M./3524.*

WHEN THE miniature was received in the Metropolitan, it was described as the work of an unknown British artist. In 1978 Hermione Waterfield attributed it to Hull. The method of execution is in accord with other signed miniatures by him. This one may date to about 1790.

Isabella Beetham

British, born 1750, died after 1809

Isabella Robinson married Edward Beetham (1744–1809) in the early 1770s. She became known as a painter of profiles.

145
Miss Chambers

Ivory, 2¼ x 1⅞ in. (59 x 48 mm)
The Glenn Tilley Morse Collection, Bequest of Glenn Tilley Morse, 1950 (50.187.44)

Wearing a white dress. Brown eyes; powdered hair. Sky background.

The gold frame is glazed at the back to reveal a cut engraved trade label *Miniature, / BY / Mrs Beetham / No. 27.* with calligraphic flourishes. A label attached to the loop of the frame is inscribed in ink (front) *Portrait of Miss / Chambers daughter / of Dr. Chambers Surgeon / at London Hospital* and (back) *Bought at sale of Miss / Chambers' effects / 12 Sept 1929 / Auctioneers Ambrose / Houghton Essex.*

The miniature is in its original red morocco leather case with traces of an illegible printed label inside the lid.

CONDITION: The miniature, in a double-sided locket-style case, is fresh and unfaded. An unbroken curve is visible under the hairline, indicating that the artist completed the face first. The trade notice at the back of the case is printed on thin paper rather than card and is pasted to what had originally been the reverse of an ivory oval. Adhesive residues on what had been the obverse of this piece of ivory indicate that it once supported an elaborate hair design of which no trace now remains.

EX COLL.: Miss Chambers (her estate sale, Ambrose, Houghton, Essex, September 12, 1929, to Mrs. Jackson); Mrs. E. Nevill Jackson (1929–38); Glenn Tilley Morse.

LITERATURE: E. Nevill Jackson, *Silhouettes* (London, 1938), pp. 80–81, pl. 32, no. 16.

IN HER DESCRIPTION of this miniature when it was in her collection, Mrs. E. Nevill Jackson stated that it is the only known colored work by the artist, who customarily painted her profiles in monochrome. The trade card on the reverse indicates that it dates from after 1782, when Edward Beetham bought the lease of 27 Fleet Street, London.

George Engleheart

British, 1750/53–1829

Engleheart, the son of a German plaster modeler who had settled in England, was born in Kew. As a youth, he worked in the studio of Sir

Joshua Reynolds, teaching himself portraiture by making miniature copies of his master's works. He was miniature painter to George III from 1789. Engleheart was extremely prolific. His fee books, still in the collection of his descendants, show that he painted 4,853 miniatures in the almost forty years from 1775 until 1813. He maintained a high standard of quality throughout this strenuous practice.

146
Portrait of a Man

Ivory, 1¼ x 1⅛ in. (32 x 29 mm)
The Moses Lazarus Collection, Gift of Josephine and Sarah Lazarus, in memory of their father, 1888–95 (95.14.55)

Wearing a red uniform jacket, white waistcoat, and embroidered and frilled shirt. Blue eyes; powdered hair tied with a black ribbon. Light blue background.

CONDITION: The miniature is well preserved, although there has been some slight flaking in the red pigment along the lower edge.

THIS MINIATURE was described as British school, eighteenth century, until in 1952 Leo R. Schidlof recognized in it the style of George Engleheart. It is a work of about 1780.

147
Mrs. Peter De Lancey (Elizabeth Colden, 1720–1784)

Ivory, 1⅜ x 1⅛ in. (34 x 28 mm)
Fletcher Fund, 1938 (38.146.16)

Wearing a sprigged blue dress and frilled white bonnet over high-dressed dark brown hair. Brown eyes. Gray background.

The miniature is in a gold frame that may be attached by two slides to a woven hair bracelet.

EX COLL.: By family descent(?) to Mrs. Charles Byrd, Bedford City, Virginia; Erskine Hewitt, Ringwood Manor, Passaic, New Jersey (until 1938; his sale, Parke-Bernet, New York, October 22, 1938, no. 1001).

LITERATURE: Albert Ten Eyck Gardner, "Portrait of a Bronx Aristocrat," *Metropolitan Museum Bulletin,* n.s., 15 (April 1959), p. 208.

WHEN THIS miniature was sold from the Hewitt collection in 1938, the sale catalogue stated that it had been attributed to John Ramage. It was accordingly described upon acquisition by the Metropolitan Museum as American school, about 1780. It was subsequently recognized as the work of George Engleheart. A Mr. or Mrs. De Lancey was

painted by Engleheart on December 23, 1783, and Mrs. De Lancey paid seven guineas for the miniature on December 29. Presumably it was of her and is identifiable with the present work. A Col. De Lancey—one of her five surviving sons (Stephen, John, Oliver, Warren, or James) —also sat to Engleheart on May 13, 1784, but there is no record of payment.

Elizabeth (1720–1784) was the daughter of Cadwallader Colden, a lieutenant governor of New York (1761–76) who upheld British policy. She married Peter De Lancey (1705–1770), brother of James De Lancey, a loyalist lieutenant governor of New York (1753–55 and 1757–60). He served as member of the assembly for Westchester. Their daughter Alice married Ralph Izard, a revolutionary leader who later served as senator from South Carolina (1789–95). In the Hewitt sale catalogue it was stated that the miniature had been bought from a descendant of the Izard family, presumably Mrs. Charles Byrd.

There is an oil portrait of the sitter, painted about 1770–72 by Matthew Pratt, in the Metropolitan Museum (57.38; *American Paintings in The Metropolitan Museum of Art* [New York, 1994], vol. 1, p. 61, ill.).

148
Colonel Woodford

Ivory, 2⅛ x 1¾ in. (55 x 44 mm)
Bequest of Collis P. Huntington, 1900 (26.168.14)

Wearing a blue coat and white waistcoat, shirt, and cravat. Blue eyes; powdered hair. Sky background.

A card at the miniature's back is inscribed in ink in a recent hand *Sir / Ralph Woodford / By / R.Cosway / 1741–1821. / 214.*

CONDITION: The miniature is well preserved. Where the goldbeater's skin has separated from the cover glass, it can be seen that the reverse is not inscribed.

LITERATURE: *A Catalogue of Miniatures in the Collection of Collis P. Huntington* (New York, 1897), ill., as portrait of Joseph Woodford by Richard Cosway.

ALTHOUGH once attributed to Richard Cosway (nos. 130–32) this miniature has long been recognized as a portrait by George Engleheart. An entry in his fee book records a portrait of Col. Woodford dating from 1788 (George C. Williamson and Henry L. D. Engleheart, *George Engleheart* [London, 1902], p. 118). It was painted on August 14, and the sitter paid ten guineas for it on August 26 as a large miniature. This may refer to the present miniature.

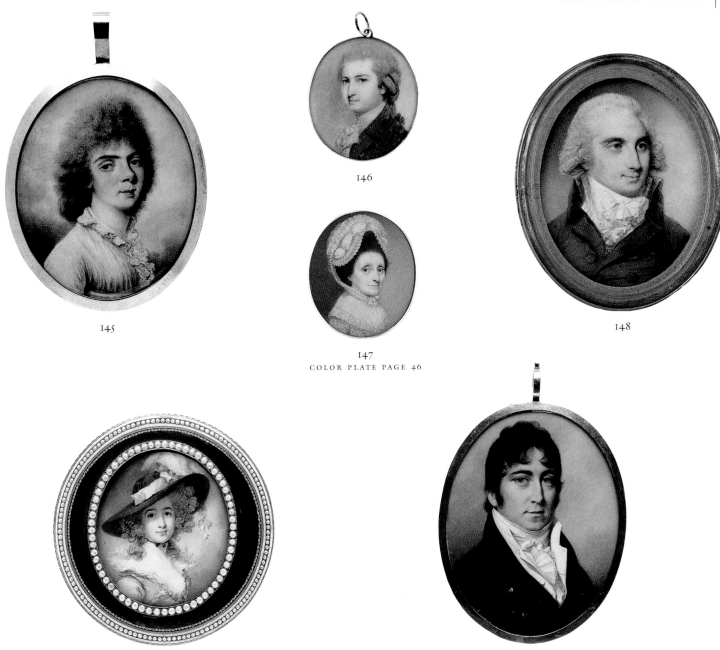

145

146

147
COLOR PLATE PAGE 46

148

149

150

The full name of the sitter is not yet known. The Joseph Woodford of Collis P. Huntington's catalogue has not been further identified. Sir Ralph Woodford, governor of Trinidad, whose name has been inscribed on the back, lived from 1784 to 1828 and cannot be the man portrayed here.

149
Portrait of a Woman

Ivory, 2⅛ x 1⅞ in. (54 x 47 mm)
The Lesley and Emma Sheafer Collection, Bequest
of Emma A. Sheafer, 1973 (1974.356.663) ESDA

Wearing a white fancy dress faced with light blue and a large black hat tied under the chin with a black ribbon and with a white ribbon and ostrich feather. Brown eyes; powdered hair.

The miniature is set in the lid of a circular gold-and-enamel box. The box bears the mark of an unidentified maker GRC; it is believed to be of Swiss make, about 1790.

THIS IS a fine and very well preserved example of Engleheart's style of about 1790, when he frequently portrayed his female sitters in flamboyant hats.

150
Portrait of a Man, Said to Be Mr. De Wolf

Ivory, 3¼ x 2½ in. (81 x 62 mm)
Signed (right, in black): *E.*
Gift of Alfred Ram, 1911 (11.218)

Wearing a blue coat and white waistcoat, frilled shirt, and cravat. Blue eyes; black hair. Sky background.

CONDITION: This miniature is generally in very good condition. The rich blue medium of

151

152

George Engleheart (*continued*)

the jacket, which was flaking in the more thickly painted areas, has been consolidated and the losses toned. At the back of the double-sided locket case there is a lock of hair against a white translucent glass backed by a piece of patterned copper foil.

THE NAME De Wolf is not recorded in the fee book which George Engleheart kept from 1775 until 1813. This is a fine example of his later style, about 1805.

Horace Hone

British, 1754–1825

Horace Hone was born in London, the son of Nathaniel Hone (no. 122), by whom he was taught. He exhibited at the Royal Academy from 1772 and was made an associate of the academy in 1779. Hone worked in Dublin, his father's birthplace, from 1782 until 1804, when he returned to England. He exhibited at the Royal Academy until 1822. He died in London.

151
Portrait of a Woman, Said to Be Lady Agnes Anne Wrothesley

Ivory, 2 x 1⅝ in. (52 x 41 mm)

Signed and dated (right): *HH* [monogram] / *1791*

Bequest of Millie Bruhl Fredrick, 1962 (62.122.28)

Wearing a black dress with white fichu and pink cap. Blue eyes; powdered hair. Gray sky background.

The back of the frame is glazed to reveal a braided plait of hair.

CONDITION: The painted surface is in good condition despite a small loss at the top right edge that may have been caused by moisture. The ivory was mounted on a slightly cockled laid paper backing which has been replaced. Under the paper, painted reinforcement is present behind the lips and cheeks of the sitter. The broken bezel has been repaired, and two convex cover glasses have been supplied.

EX COLL.: Miss Sneyd (until 1920?); Dr. Samuel W. Woodhouse Jr., Philadelphia (1943); Donald de Matalba, New York (1953); E. G. Paine, New York (1954); Mrs. Leopold Fredrick, New York.

LITERATURE: E. G. Paine, unpublished list of miniatures in the Fredrick collection (1960), no. 21, supplies the provenance.

THE IDENTIFICATION of the sitter as Lady Wrothesley, recorded by Paine, is apparently traditional. Given the date, she is likely to have been painted in Ireland.

Philip Jean

British, 1755–1802

Born at St. Ouen in Jersey, Channel Islands, Jean served in the British navy before devoting himself to miniature painting. He exhibited at the Royal Academy from 1787 until 1802, the year of his death. He also painted full-scale portraits and was patronized by members of the royal family.

Attributed to Philip Jean

152
Admiral Adam Duncan (1731–1804)

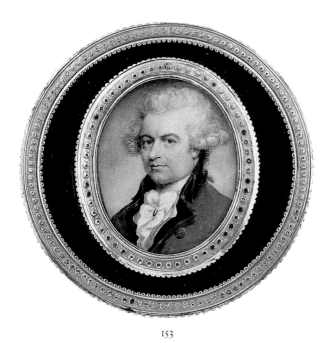

153

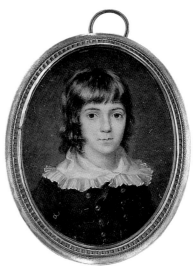

154

Ivory, 2 x 1½ in. (50 x 40 mm)

Bequest of Mary Clark Thompson, 1923 (24.80.524)

Wearing a red uniform jacket with blue lapels decorated with gold and gold epaulets. Powdered hair. Sky background.

A card backing the miniature is inscribed in pencil in a recent hand *Admiral / Duncan / by R. Cosway RA*. The wooden frame has gilt metal mounts.

THE ATTRIBUTION to Richard Cosway (nos. 130–32) is incorrect. The work is probably by Philip Jean, who made many miniatures of naval commanders, no doubt a result of his early service in the navy.

The identification as Admiral Duncan, viscount Duncan, the victor over the Dutch at the battle of Camperdown (1797), is supported by comparison with the portrait by John Singleton Copley in the National Maritime Museum, Greenwich (BHC 2670).

153
Portrait of a Man

Ivory, 1¾ x 1½ in. (46 x 37 mm)

Gift of Mrs. Louis V. Bell, in memory of her husband, 1925 (25.106.29)

Wearing a red uniform jacket with black lapels edged with gold and white cravat with jeweled pin. Brown eyes; powdered hair. Sky background.

The miniature is set in the lid of a black composition box set with gold mounts and lined with tortoiseshell.

A stock label inside the box is inscribed in ink *114 / Mre Cosway / Sf* [?] *boite*.

ON RECEIPT in the Metropolitan Museum the miniature was described as a work by Richard Cosway (nos. 130–32), following the French dealer's label inside the box. It is not, however, by him. Attributions to Charles Shirreff (born about 1750, died after 1831) by Daphne Foskett and Richard Allen and to Peter Paillou (born after 1757, died after 1831) by Hermione Waterfield do not carry conviction. It seems to be by Philip Jean (compare no. 152).

Richard Collins

British, 1755–1831

Born in Gosport, Collins began to exhibit at the Royal Academy in 1777. He was a pupil of Ozias Humphry (1742–1810), who left a memoir of his friend, in which he records that in 1789 George III was so moved by Collins's grief at the death of his wife that he appointed him portrait painter in enamel, overriding court officials who had appointed Richard Crosse (no. 133) to the post. He died in London.

154
George Howard (1773–1848), *Lord Morpeth*

Ivory, 2 x 1⅝ in. (52 x 41 mm)

Signed (right edge, in black): *R. Collins.*

Bequest of Millie Bruhl Fredrick, 1962 (62.122.36)

Wearing a blue jacket and white collar. Brown eyes; light brown hair. Gray background.

The back of the gilt frame is engraved *Lord Morpeth.*

IN HIS unpublished list of miniatures in the Fredrick collection (1960), no. 7, E. G. Paine lists this as a portrait of Lord Morpeth by Richard Collins and dates it about 1775. It is an authentic, slightly faded work by Collins, but if the sitter is correctly identified, then the date would be five years or so later.

George Howard (1773–1848), Lord Morpeth, succeeded his father in 1825 as sixth earl of Carlisle. He was long a member of Parliament, and he served as commissioner for affairs in India in 1806 and as Lord Privy Seal in 1827–28 and 1835.

Samuel Shelley

British, 1756–1808

Born in Whitechapel, London, Shelley began to exhibit in 1773. His ambitions extended beyond portrait miniature painting to imaginative figure subjects. His feeling that the latter works were not sufficiently appreciated by the Royal Academy led him to become one of the founders of the Old Water-Colour Society in 1804. In his day he was considered a near rival to Richard Cosway (nos. 130–32) for miniature portraits.

155
The Hours

Ivory, 5½ x 4¼ in. (140 x 109 mm)
Signed (lower left, in scratched letters): *S.Shelley*
Bequest of Collis P. Huntington, 1900 (26.168.71)

At left Eunomia, the Past, in a green dress; at center Dice, the Present, in a white dress with yellow, green, and brown cloak; at right Irene, the Future, in a pink and blue dress. All have brown eyes; light brown hair. Sky background.

The back of the original gilt bronze and red enamel frame is glazed to reveal the artist's inscription in ink on parchment: [D]*esigned & Painted by / Samuel Shelley / Nº 6 George Stree*[t] */ Hanover Squ*[are].

CONDITION: The painted surface is in superb condition, fresh and unfaded, but there are two cracks (one from the upper right corner, descending into the hair of the figure at right, and the other from the lower left edge, rising into the dress of the central figure). The cracks were filled with adhesive; wax was placed over the voids. No retouching was necessary. A new convex glass for the front of the miniature and a flat glass for the reverse were supplied.

EXHIBITED: Royal Academy, London, 1801, no. 793.

LITERATURE: *A Catalogue of Miniatures in the Collection of Collis P. Huntington* (New York, 1897), ill.; Ruel P. Tolman, "Malbone's 'Hours,'" *Antiques* 18 (1930), pp. 508–9, fig. 2 (reproducing also as fig. 1, Malbone's miniature; as fig. 3, Nutter's

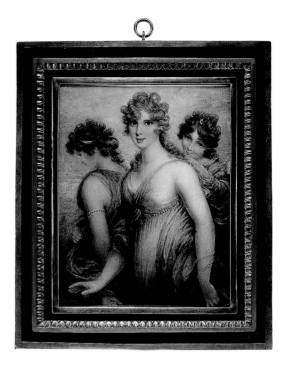

155
COLOR PLATE PAGE 47

engraving; and as fig. 4, Shelley's drawing); Ruel Pardee Tolman, *The Life and Works of Edward Greene Malbone, 1777–1807* (New York, 1958), pp. 27, 188.

SHELLEY filled many sketchbooks with designs for historical and literary subjects of this kind, and a study of *The Hours* in pen and brown ink is in the Metropolitan Museum (30.124; 7¾ x 6 in. [197 x 152 mm]). At the top the artist inscribed the drawing "past," "present," and "to come"; at the upper right he wrote a page number that reads either 103 or 107; and at the lower right he commented "either in oil or / compⁿ to Diana in min!." He apparently contemplated making either an oil painting or a miniature and if the latter, with a companion piece representing Diana.

Shelley first used the subject in a miniature shown at the Royal Academy in 1788 as number 285, *The Hours (after Gray)*. It seems likely that this exhibit should be identified with an oval miniature belonging from 1899 to Henry Walters and now in the Walters Art Gallery, Baltimore (38.75; 4⅛ x 3⅜ in. [106 x 85 mm]). The design was engraved by Nutter (in the same format, but more tightly cropped) as the frontispiece to Thomas Gray's "Ode to Spring" in Charles Taylor's *The Cabinet of Genius* (London, 1788). The rubric beneath reads "The HOURS. Fair Venus' Train."

Shelley returned to the theme in 1801, showing the present miniature at the Royal Academy as number 793. He titled it *The Horae, Eunomia,*

Dice and Irene; or the past, the present, and the coming hour. Its companion piece was number 804 — *The Parcae; or, the Fates drawing the thread of human life* — whose present whereabouts is unknown. Shelley's work, particularly the present miniature, played a significant role in the development of the style of Edward Greene Malbone (1777–1807), the distinguished American miniature painter. In 1801 he wrote to Charles Fraser of Charleston, South Carolina, from London that he thought Cosway and Shelley the best English miniaturists to copy and continued, "I am painting one now which I shall bring with me. It is 'The Hours: the past, present, and the coming.'" The American artist's enlarged copy (6⅝ x 5⅝ in. [168 x 142 mm]), signed and dated *Edwᵈ G. Malbone / August 1801*, has belonged since 1854 to the Providence Atheneum, Rhode Island. When in the Huntington collection, Shelley's miniature was thought to be a copy of Malbone's rather than the reverse.

156
Portrait of a Man

Ivory, 3 x 2⅜ in. (75 x 60 mm)
Bequest of Millie Bruhl Fredrick, 1962 (62.122.39)

Wearing a blue coat and white waistcoat and frilled shirt. Brown eyes; powdered hair. Gray-green background.

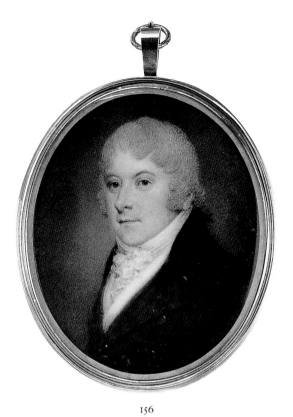

156

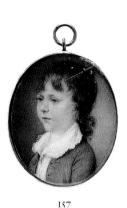

157

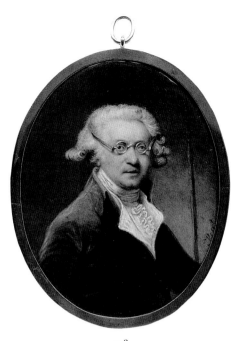

158

COLOR PLATE PAGE 48

The back of the frame is glazed to reveal tresses of fair hair bound with gold thread and seed pearls on dark blue glass.

A card between the silver foil and blue glass at the back of the frame is inscribed in ink by the artist *S.Shelley. / no / 6 g¹ George Street / Hanover Sq^ᵉ*.

LITERATURE: E. G. Paine, unpublished list of miniatures in the Fredrick collection (1960), no. 32, as by Shelley, about 1790.

PAINE'S dating is perhaps slightly too early for this typical signed portrait by Shelley, which probably dates about 1800.

Style of Samuel Shelley

late 18th century

157
Portrait of a Boy

Ivory, 1¼ x 1 in. (33 x 27 mm)
Bequest of Millie Bruhl Fredrick, 1962 (62.122.32)

Wearing a green coat, beige waistcoat, and white shirt. Brown eyes; brown hair. Gray-blue background.

The miniature is set in a curved gilt frame. Originally the frame had an opening that was intended for a slide to fix it onto a bracelet.

THE MINIATURE was once attributed to John Smart (nos. 134–41). In his unpublished list of miniatures in the Fredrick collection

(1960), no. 54, E. G. Paine correctly rejected this attribution. He suggested that it was in the style of Richard Crosse (no. 133) or Ozias Humphry (1742–1810). In 1972 Daphne Foskett suggested that it was by Samuel Shelley. In 1977 Richard Allen and Edwin Boucher suggested that it was in the manner of Samuel Collins (no. 126), about 1770. Of all these suggestions an attribution to Samuel Shelley is the most plausible.

Thomas Peat

British, active about 1791–1831

Peat worked in London and subsequently in the provincial centers of Bath, Leamington, and Bristol. He is mainly known as an enamelist but is said to have painted portraits in oil in imitation of Sir Joshua Reynolds.

158
Sir Joshua Reynolds (1723–1792)

Enamel, 4 x 3⅛ in. (101 x 80 mm)
Signed (right edge, in black): *T Peat* [TP in monogram]
The Collection of Giovanni P. Morosini, presented by his daughter Giulia, 1932 (32.75.8)

Wearing a deep lilac coat, white waistcoat and shirt, and metal-rimmed glasses. Ruddy complexion.

Gray hair. Maulstick behind the sitter's extended left arm. Gray-brown background.

The copper back is partly covered with blue enamel; one area is inscribed in the enamel by the artist *Sir Joshua Reynolds 1792*.

The back of the gilt frame is engraved *Sir Joshua Reynolds P.R.A. / 1788 / Enamel after the original in / Her Majestys collection / Formerly in the Marquis Thorn [sic] / By Mr. Peate*.

THE INSCRIPTION refers to Reynolds's self-portrait of 1788 (Oliver Millar, *The Later Georgian Pictures in the Collection of Her Majesty the Queen* [London, 1969], vol. 1, no. 1008, vol. 2, pl. 105), which in 1812 was given to George IV by the artist's niece, Mary Palmer, Marchioness of Thomond. There are many repetitions, and the type was engraved by Caroline Watson (1789), S. W. Reynolds, and G. Clint (1799). In the 1788 portrait Reynolds wears a black coat and the maulstick does not appear in the background.

An enamel of 1809 by Henry Bone (nos. 221–26) after the 1788 Reynolds self-portrait also shows him in a purple coat (Richard Walker, *The Eighteenth and Early Nineteenth Century Miniatures in the Collection of Her Majesty the Queen* [Cambridge, 1992], no. 784, ill.). In Bone's enamel there is a stone wall in the background.

An earlier version by Bone, signed and dated 1792, was sold at Sotheby's, London, July 4, 1989, no. 346 (ill.). In it, Reynolds wears a brown coat.

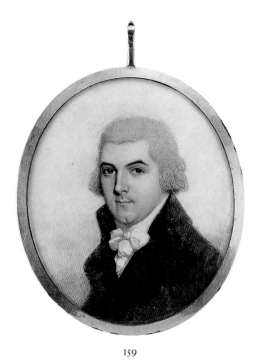

159

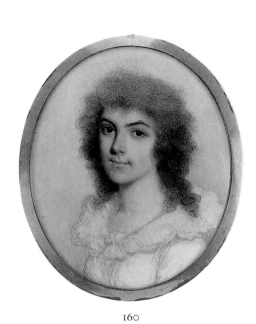

160

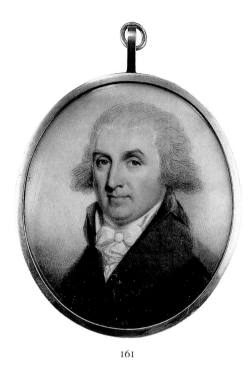

161

John Barry

British, active about 1784–1827

Little is known about this miniature painter, whose style is, however, easily recognizable. He exhibited works from London addresses at the Royal Academy between 1784 and 1827.

159
Portrait of a Man
(pendant to 30.III.2)

Ivory, 2½ x 2⅛ in. (64 x 54 mm)
Gift of Mrs. Sherwood Eddy, 1930 (30.III.1)

Wearing a gray coat and white shirt and cravat. Gray-blue eyes; powdered hair. Sky background.

The back of the frame is glazed to reveal plaited hair. This cover glass is a replacement.

ON RECEIPT in the Metropolitan Museum this miniature was described as the work of an unknown British artist of the eighteenth century. In 1952 Leo R. Schidlof recognized in it the distinctive style of John Barry. The pronounced angle of the upper contour of the eyebrow is characteristic and may also be seen in nos. 160 and 161.

The sitter is presumably the husband of the woman seen in no. 160. Both date from about 1790.

160
Portrait of a Woman
(pendant to 30.III.1)

Ivory, 2½ x 2⅛ in. (64 x 54 mm)
Gift of Mrs. Sherwood Eddy, 1930 (30.III.2)

Wearing a white dress with ruffled roller. Brown eyes; powdered hair. Sky background.

The back of the frame is glazed to reveal plaited hair.

AS WITH no. 159, in 1952 Leo R. Schidlof first recognized the characteristic hand of John Barry in this previously unattributed miniature.

The sitter is presumably the wife of the man seen in no. 159.

161
Portrait of a Man, Said to Be John Durham

Ivory, 2⅝ x 2¼ in. (67 x 56 mm)
Bequest of Millie Bruhl Fredrick, 1962 (62.122.40)

Wearing a green coat and white shirt and cravat. Hazel eyes; powdered hair. Sky background.

The back is glazed to reveal the gold initials JD in monogram over plaited brown hair inset in blue glass over tinsel.

EX COLL.: [Art Trading Co., New York, until 1939]; Mrs. Leopold Fredrick, New York (1939–62).

IN HIS unpublished list of miniatures in the Fredrick collection (1960), no. 6, E. G. Paine attributes this miniature to John Barry, about 1790. The attribution is certainly correct.

The identification as John Durham accords with the monogram on the back of the frame.

Andrew Plimer

British, 1763–1837

Plimer was the son of a clockmaker who worked at Wellington, Shropshire. He is said to have run away from home with his brother Nathaniel and joined a band of gypsies, roaming about with them for two years. He is also said to have become a servant to Richard Cosway (nos. 130–32) in 1781, learning in due course the art of miniature painting. He set up on his own and had considerable success, exhibiting from 1786 until 1830. His brother Nathaniel also practiced as a miniaturist. Andrew Plimer died in Brighton.

162
Elizabeth Bushby

Ivory, 3 x 2¼ in. (75 x 57 mm)
Bequest of Collis P. Huntington, 1900 (26.168.59)

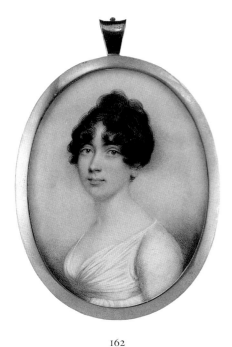

162

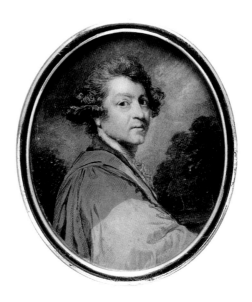

163

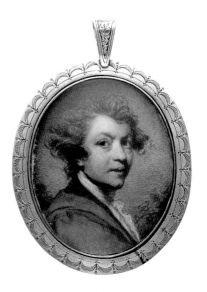

164

Wearing a white dress and lilac sash. Brown eyes; dark brown hair. Sky background.

Inside the case is a folded laid paper inscribed *Elizabeth Bushby / 1804 / by Plimer*.

LITERATURE: *A Catalogue of Miniatures in the Collection of Collis P. Huntington* (New York, 1897), ill.

THIS IS a good example of Andrew Plimer's work, which is seen in considerable strength in the Huntington Art Collections, San Marino. In Collis Huntington's catalogue the sitter was described as Jane Elizabeth Liddell, the daughter of Thomas, Lord Ravensworth, who married in 1823 William Keppel, sixth viscount Barrington. However, the recently discovered identification as a portrait of Elizabeth Bushby in 1804 is doubtless to be accepted. George C. Williamson (*Andrew and Nathaniel Plimer: Miniature Painters* [London, 1903], p. 46, ill. following p. 90) lists a portrait of Martha Bushby by Andrew Plimer from the collection of Arthur Jaffé, Hamburg. It is of a girl with features similar to those of the present sitter; she has the same hairstyle but is turned to the right, rather than the left as here. He also notes that Sir Joshua Reynolds painted portraits of the Bushby family. William Bushby (1751–1830) and his brother John were patrons of the poet Robert Burns (Robert Bayne-Powell, *Catalogue of Portrait Miniatures in the Fitzwilliam Museum, Cambridge* [Cambridge, 1985], p. 106 and see also p. 79).

Archibald Robertson

Scottish, 1765–1835

Archibald Robertson was born at Monymusk, near Aberdeen, Scotland. After studying in Edinburgh and from 1786 in London, he worked again in Aberdeen. He went to the United States in 1791 and painted a miniature of George Washington which ensured his success. With his brother Alexander Robertson, also a miniature painter, he founded the Columbian Academy of Painting in New York. Andrew Robertson (no. 231) was his younger brother.

Sir Joshua Reynolds is said to have given him advice, and the miniature catalogued below is no doubt a product of Robertson's years in England or Scotland.

163
Sir Joshua Reynolds (1723–1792)

Ivory, 3 x 2⅜ in. (75 x 60 mm)
Bequest of Geraldine Winslow Goddard, 1923 (24.21)

Wearing an academic gown over a brown coat and white shirt. Brown hair. Sky and landscape background.

CONDITION: The ivory is laid to cockled paper. The miniature is well preserved despite the presence of glue residue and a craze in the trees at the right edge.

EX COLL.: The artist, London and New York (until 1835); by descent to his daughter; by descent to her daughter, Mrs. J. Warren Goddard, New York (until 1923).

LITERATURE: Mrs. J. Warren Goddard, *Archibald Robertson* (New York, 1920), p. 1; Leo R. Schidlof, *The Miniature in Europe* (Graz, 1964), vol. 2, p. 683; Daphne Foskett, *A Dictionary of British Miniature Painters* (New York and Washington, D.C.), 1972, vol. 1, p. 472.

ARCHIBALD ROBERTSON'S miniature must date between 1786 and 1791. It is copied from the 1773 half-length self-portrait by Reynolds in the collection of Earl Spencer at Althorp. The artist's costume is accounted for by the fact that he was given an honorary Doctorate of Civil Law at the University of Oxford that same year.

Style of William Grimaldi

1773 or later

William Grimaldi (1751–1830) was born in Shoreditch and exhibited in London from 1768 to 1830. He worked in Paris from 1771 to 1783 and was miniature painter to George IV, when Prince of Wales.

164
Sir Joshua Reynolds (1723–1792)

Ivory, 1⅞ x 1½ in. (47 x 37 mm)
Bequest of Millie Bruhl Fredrick, 1962 (62.122.60)

Wearing an academic gown over a brown coat and white shirt. Brown hair. Sky and landscape background.

The back of the gold frame is engraved with a garland; in the center is a basket of flowers suspended on a ribbon.

LITERATURE: E. G. Paine, unpublished list of miniatures in the Fredrick collection (1960), no. 60, as by an unknown artist, about 1785, after Reynolds's self-portrait.

THE MINIATURE is copied from the self-portrait of 1773 in the collection of Earl Spencer (compare no. 163). It is vigorously painted by a good artist working somewhat in the manner of William Grimaldi (1751–1830).

In addition to nos. 163 and 164 there are miniature versions of the 1773 Reynolds self-portrait by George Engleheart (nos. 146–50) and attributed to James Nixon (nos. 128 and 129; see Robert Bayne-Powell, *Catalogue of Portrait Miniatures in the Fitzwilliam Museum, Cambridge* [Cambridge, 1985], p. 160, ill.).

William Wood

British, 1769–1810

Wood was born in Suffolk and entered the Royal Academy schools in 1785. His manuscript list of sitters, which is in the library of the Victoria and Albert Museum, London, shows that in the years from 1790 to 1808 he painted 1,211 miniatures. This list is of immense value for the study of the technique of late-eighteenth-century miniaturists. He gives details of the pigments and methods he used in each portrait and frequently appends a tracing which gives an outline of the sitter's features. Wood died in London.

165
An Interesting Story (Miss Ray)

Ivory, 4¾ x 3⅞ in. (119 x 97 mm)
The Moses Lazarus Collection, Gift of Josephine and Sarah Lazarus, in memory of their father, 1888–95 (95.14.95)

Wearing a white dress and a pearl bracelet; reading a book while seated in a chair covered with a pink cloth. Brown hair. Gray background with suggestions of sky and landscape.

The miniature is backed by a card with an ornamental border inscribed in ink by the artist *DJDS / By / Will: Wood / Cork Str.ᵗ / Lond. / 1806.* [and above] *No 6160.*

CONDITION: There are several small losses in the hair. The miniature is otherwise in very good state.

EXHIBITED: British Institution, 1807, no. 130 (*An Interesting Story*); Metropolitan Museum of Art, 1950, *Four Centuries of Miniature Painting*, list, p. 7.
LITERATURE: George C. Williamson, *The Miniature Collector* (London, 1921), p. 290.

THE MINIATURE is no. 6160 in the artist's ledger (Victoria and Albert Museum, London); the entry runs:

6160 *Half length of a girl reading*:

the face in shadow. about 17. — studied from Miss Ray. — Begun, 14 Decr, 1806. — On a piece of good ivory; gumm'd to white card. — Prepared with powdered pumice. — Outlin'd with common ink, & a steel pen. — Ink wash'd off next day; so as to leave only a grey stain. —

I believe all the colours are perfectly durable. — Bright reds are 520, 521 and 525. Ground is chiefly of 518. 479.white. Gum arabic.

Red drapery of 438 and 521.

Sent to British Institution, 10th January, 1807 and entitled "An Interesting Story"

Parallelogram: 4 x 5 in. Sight 3⅞ x 4⅞.

The numbers in this description are the artist's code for his pigments; there is no key to them in the ledgers. Wood exhibited three miniatures at the British Institution in 1807 from 8 Cork Street.

If Wood had intended this miniature to be read as a portrait, he would not have shown the young woman's breast bared. The anatomy is awkward and would not have been studied from the model.

166
Portrait of a Man, Said to Be Mr. Fitzgerald

Ivory, 3¼ x 2⅝ in. (81 x 66 mm)
The Moses Lazarus Collection, Gift of Josephine and Sarah Lazarus, in memory of their father, 1888–95 (95.14.97)

Wearing a gray coat with a black collar, white waistcoat and cravat. Hazel eyes; powdered hair. Sky background.

CONDITION: The surface is in good condition. The ivory support is, unusually, very thick at one end and thin at the other.

EXHIBITED: Metropolitan Museum of Art, 1950, *Four Centuries of Miniature Painting*, list, p. 7.

IN HIS ledger the artist records as no. 5589 a copy he made in 1798 "from a bad crayon pic-

ture" of Lord Edward Fitzgerald (1763–1798), brother to the duke of Leinster. He does not provide a tracing, and the size he gives (less than 72 x 57 mm) indicates that the entry does not refer to this work.

Anne Foldsone Mee

British, born about 1770, died 1851

Anne Mee is first recorded in 1790, when she was working at Windsor Castle on portraits of Queen Charlotte and the princesses. She married Joseph Mee, an Armagh barrister, before 1804. Her style is closely based on that of Richard Cosway (nos. 130–32), and her earlier works are sometimes mistaken for his. In her later, more florid style she painted the series Gallery of Beauties of George III (Richard Walker, *The Eighteenth and Early Nineteenth Century Miniatures in the Collection of Her Majesty the Queen* [Cambridge, 1992], nos. 857–74, ills.) in emulation of the earlier Windsor Beauties of Sir Peter Lely (1618–1680).

167
Portrait of a Woman, Possibly Barbara (1768–1829), *Marchioness of Donegall*

Ivory, 2⅞ x 2⅛ in. (73 x 53 mm)
Gift of J. Pierpont Morgan, 1917 (17.190.1150)

Wearing a white dress and black ribbon. Blue eyes; powdered hair. Blue background.

The miniature is set in lid of a black composition box with gold mounts and lining.

A paper kept inside the box is inscribed in ink:

Snuff box with miniature by / Richard Cosway R.A. of Anne / 1st Marchioness of Donegall - / Lady of the Bedchamber of Queen / Charlotte - eldest daughter of James / 5th Duke of Hamilton and Brandon. / This miniature, with others, was / given by the 3rd Marchioness of / Donegall, who died in 1829, / daughter of Dr Luke Godfrey D.D., / to her niece Miss Barbara Godfrey, / who gave them to her niece, / daughter of Major Godfrey and / wife of the Rev. G. Hughes, that / gentleman gave them to his wife's / friend and companion Miss Vale, / who / attended him up to the time of his / death–about 20 years ago. Miss / Vale gave them to her niece Miss / Julia Moreton from whom it was / acquired.

Inside the box are a printed label *2291*, which is also inscribed in pencil *3445*, and a stock label inscribed in red ink *P.M.3445*.

CONDITION: The state of preservation is fine.

THE MINIATURE was described on receipt in the Metropolitan Museum as a work by

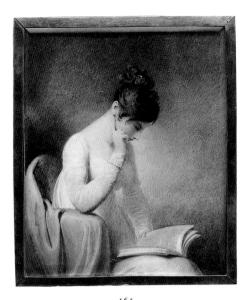

165

COLOR PLATE PAGE 49

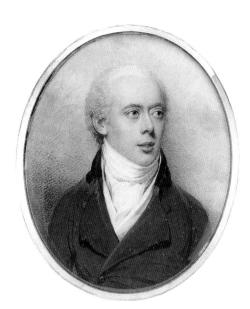

166

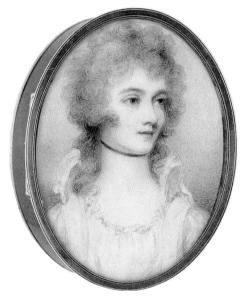

167

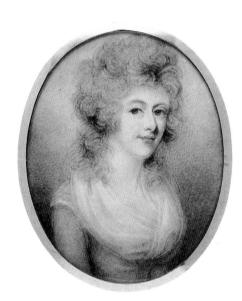

168

Richard Cosway (nos. 130–32), in accordance with the manuscript history inside the box. The style was correctly recognized as that of Anne Mee by Richard Allen in 1977 and Hermione Waterfield in 1978.

The costume dates about 1790, and thus the miniature cannot represent Anne, first wife of the first marquis of Donegall (1739–1799), who died in 1780. It may conceivably be of Barbara, née Godfrey (1768–1829), whom he married as his third wife in 1790.

168
Portrait of a Woman, Said to Be Lady Sophia Boyle

Ivory, 2⅝ x 2⅛ in. (67 x 53 mm)
The Moses Lazarus Collection, Gift of Josephine and Sarah Lazarus, in memory of their father, 1888–95 (95.14.60)

Wearing a light blue dress with a white fichu. Blue eyes; reddish brown hair. Sky background.

CONDITION: The miniature, which is in very good condition, is fixed to a piece of laid paper which is inscribed *Anna Foldstone pinx*. The case is packed with three pieces of playing card with club motifs. The tarnished foil at the back has been cleaned and the broken cover glass, also at the back, replaced.

ON RECEIPT in the Metropolitan Museum, this miniature was described as a work by Richard Cosway (nos. 130–32). The style was correctly recognized as that of Anne Mee by

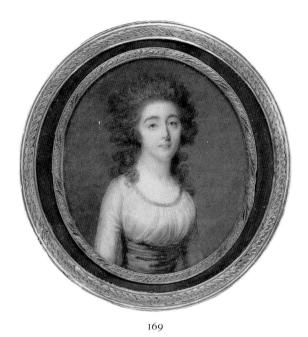

169

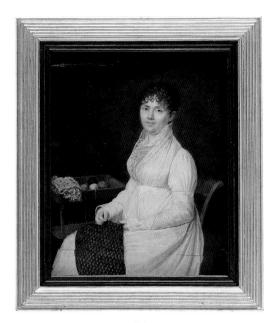

170

COLOR PLATE PAGE 51

Anne Foldsone Mee (*continued*)

Richard Allen in 1977 and Hermione Waterfield in 1978. Like no. 167, it is an early work, of about 1790.

Jean Baptiste Jacques Augustin

French, 1759–1832

Augustin was born in Saint-Dié, near Nancy, where he studied with the painter Jean Baptiste Charles Claudot (1733–1805) who also taught his younger rival Jean Baptiste Isabey (nos. 176–85). He moved to Paris in 1781, where for the next twenty years he painted highly animated miniatures. His success was diminished by the more extensive patronage given by Napoléon I to Isabey. He was made chevalier of the Légion d'Honneur in 1821 and became painter-in-ordinary to Louis XVIII in 1824. He died of cholera in Paris.

169
Portrait of a Woman

Ivory, 2¼ x 2⅛ in. (57 x 52 mm)
Signed and dated (left edge, in red): *augustin. f. 1790.*
Gift of J. Pierpont Morgan, 1917 (17.190.1120) ESDA

Wearing a white dress with a blue sash. Brown eyes; powdered hair. Gray-green background.

The miniature is set in the lid of a tortoiseshell box with gold mounts; the sides and bottom of the box are painted blue with gold stars. The box bears the Paris discharge mark for 1775–81 and the French mark for small imported work, 1838–64.

Inside the box are a printed label *2329* and a stock label inscribed in red ink *P.M./3484.*

THE DISCHARGE mark indicates that the miniature was painted at least nine years later than the completion of the box; the second mark shows that the box had been exported from France and was reimported around the middle of the nineteenth century.

A somewhat similar miniature of a woman with a tricolored belt, signed and dated 1790, is in the Musée du Louvre (Pierrette Jean-Richard, *Miniatures sur ivoire* [Paris, 1994], no. 10, ill.).

Style of Jean Baptiste Jacques Augustin

about 1800–10

170
Portrait of a Woman with Tapestry Work

Ivory extended by card, 5⅝ x 4⅝ in. (140 x 117 mm)
The Moses Lazarus Collection, Gift of Josephine and Sarah Lazarus, in memory of their father, 1888–95 (95.14.50)

Wearing a white dress. Seated at a table with black, white, and orange wools, working at tapestry on her knee. Brown eyes; dark brown hair. Gray-brown background.

CONDITION: The ivory, which is irregular in shape, was mounted on gesso-covered composition board before the miniature was painted. The model's dress, the tapestry on which she is working, and the table legs continue into the gessoed extension. The ivory is slightly cockled and has shrunk from side to side, exposing cracks through which the white gesso ground could be seen. It was determined that the original dimensions should be preserved and the frame modified to mask the cracks. A new glass was supplied, an additional painted molding was inserted into the frame, and the miniature was set between a new ragboard spacer and mount.

THE MINIATURE was received in the Metropolitan Museum without an attribution. In 1965 E. G. Paine tentatively ascribed it to J. B. J. Augustin; in 1977 Richard Allen described it as of the school of Augustin, about 1800, and in the same year Edwin Boucher suggested that it might be by a Swiss painter, remarking that it resembled the work of François Ferrière (1752–1839).

This miniature is an accomplished piece of about 1800–10, showing the influence of both Isabey and Augustin in their republican and classical manners. It is perhaps not of sufficiently high quality to justify an attribution to Augustin.

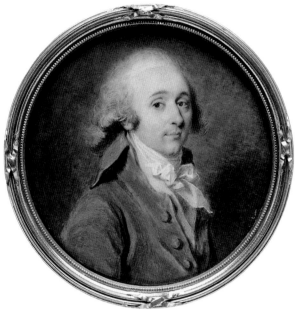

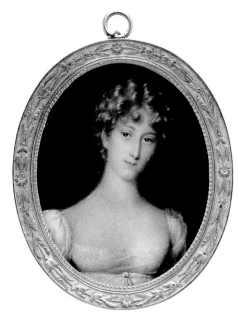

171

COLOR PLATE PAGE 52

172

Jean Urbain Guérin

French, 1761–1836

Born in Strasbourg, Guérin moved to Paris in 1785 and may have been a pupil of the pastelist Mlle Huin, who exhibited at the Salon from 1796 until 1801. In the wake of the Neoclassical revival, he painted a number of miniatures *en camaïeu*. Leaving Paris during the Revolution, he returned during the Consulate and became a member of Isabey's studio, a course that affected his later style. He exhibited at the Salon from 1798 until 1827. Guérin died in Obernay, Alsace, where he had moved in 1821.

171
Alexandre Théodore Victor (1760–1829), *Comte de Lameth*

Ivory laid on card, diam. 3 in. (75 mm)
Signed (left, in brown): *J.Guerin. f.*
Rogers Fund, 1961 (61.77)

Wearing a brown coat, yellow waistcoat, and white shirt. Blue eyes; powdered hair. Brownish gray background.

The back is glazed to reveal an inscription in ink written over an erased earlier inscription: *A^dre de Lameth - / par Guérin / député et orateur / à l'Assemblée Constituante / 1760–1829.*

Two labels are fixed to the backing; one is printed *229* and the other *1065*.

CONDITION: The state is very fine. The ivory is laid on a larger card covered at the back with brown paper.

EX COLL.: Madame Levaigneur estate (sale, Hôtel Drouot, Paris, May 2–4, 1912, no. 229); [Alfred Joseph, London, until 1961].

IN THE AUTUMN of 1789 Guérin began work on a series of miniatures of the most prominent deputies of the French National Assembly. These were engraved by Franz Gabriel Fiessinger (1752–1807). An engraving by Fiessinger of Lameth, after a drawing by Guérin dated November 20, 1790, shows the sitter in profile (Bayard Tuckerman, *Life of General Lafayette* [New York, 1901], vol. 3, ill. opp. p. 95 [facsimile]). The identification of this sitter is further confirmed by the portrait of Lameth by Jean Michel Moreau le jeune (1741–1814).

Alexandre, comte de Lameth, had a distinguished political and military career. He was deputy for Peronne at the Assemblée Nationale in 1789; he was elected president of the Assemblée Nationale in 1790. Lameth served briefly as a brigadier general under Lafayette in 1792.

172
Portrait of a Woman

Ivory, 2⅜ x 1¾ in. (59 x 46 mm)
Signed (left edge, in black): *J.Guerin.f.*
Bequest of Millie Bruhl Fredrick, 1962 (62.122.87)

Wearing a white dress. Blue eyes; light brown hair. Dark brown background.

CONDITION: The miniature had been treated previously, and heavy overpaint is present below the sitter's collarbone at the left and in the background at the right (extending slightly into the cheek). The white pigment of the dress, which was flaking, has been consolidated. The losses in the dress have been toned and some of the clumsy inpainting has been improved, though not where it encroaches on the sitter's face. Under the original paper backing, a thin shaped-foil insert follows the sitter's profile.

THE PLAIN Empire style of costume points to a date of about 1815, as E. G. Paine pointed out in his unpublished list of miniatures in the Fredrick collection (1960), no. 76. The fine gilt frame must be original.

Étienne Charles Le Guay

French, 1762–1846

Born at Sèvres, Le Guay was the son of the porcelain painter Étienne Henri Le Guay. He was a pupil of Joseph Marie Vien (1716–1809). He worked as a painter at the Sèvres porcelain factory for a considerable time and exhibited miniatures at the Paris Salon from 1795 until 1819; some of his miniatures were painted on porcelain. His three wives — Marie Sophie Giguet (died 1801), Marie Victoire Jacquotot

(1772–1855) from whom he was divorced in 1803, and Caroline de Courtin — were all pupils of his and painted miniatures; Mme Jacquotot and Caroline Le Guay also painted porcelain at Sèvres. Le Guay died in Paris.

173
Portrait of a Woman

Ivory, 3½ x 3 in. (90 x 75 mm)
Signed (left, in gray): *Le Guay*
Bequest of Collis P. Huntington, 1900 (26.168.9)

Wearing a white dress bound at the waist with gray ribbon. Brown eyes; black hair covered by a white veil with gilt edging that falls to waist. Gilt bracelet. Woodland landscape background.

Two labels are fixed to the metal back of the frame. One is printed *Collection / du / Marquis de Bailleu Nº* and in ink *69* and struck-through *6*; the other is a stock label inscribed in ink *Nº 79 / Princesse d' / Angoulemme.*

CONDITION: The surface is pristine. The reverse of the ivory is painted around the outline of the figure with a blue-green wash. A piece of irregularly shaped discolored metal foil, which was present behind the ivory, has been cleaned.

EX COLL.: Marquis de Bailleul(?).

EXHIBITED: Metropolitan Museum of Art, 1950, *Four Centuries of Miniature Painting*, list, p. 10.

LITERATURE: *A Catalogue of Miniatures in the Collection of Collis P. Huntington* (New York, 1897), ill., as the duchesse d'Angoulême.

See no. 74 for Marie-Thérèse-Charlotte (1778–1851), duchesse d'Angoulême, daughter of Louis XVI. This miniature of about 1800 cannot, as suggested by the label on the reverse of the frame, represent the same sitter.

Nicolas François Dun

French, 1764–1832

Dun was born in Lunéville, southeast of Nancy. He worked chiefly in Naples, where he died.

174
Portrait of a Woman, Said to Be Madame Récamier (1777–1849)

Ivory, 2⅜ x 1⅞ in. (60 x 48 mm)
Signed (right edge, in black): *Dun*
Bequest of Collis P. Huntington, 1900 (26.168.17)

Wearing a white dress and bonnet with pink bows. Gray eyes; brown hair. Gray background.

CONDITION: The surface is speckled with spots of discoloration, perhaps from removal of mildew.

EXHIBITED: Metropolitan Museum of Art, 1950, *Four Centuries of Miniature Painting*, list, p. 10.

LITERATURE: *A Catalogue of Miniatures in the Collection of Collis P. Huntington* (New York, 1897), ill.

THE HUNTINGTON catalogue identifies the sitter as Jeanne-Françoise-Julie Adélaïde Bernard Récamier (1777–1849) by Dun. The costume is about ten years later than that in the 1805 portrait of Madame Récamier by François Gérard (1770–1837) (Musée Carnavalet, Paris), to which it should be compared.

The miniature was at first attributed to John Dunn (active about 1801–41), but Leo R. Schidlof in 1952 correctly recognized in it the work of Nicolas François Dun, the French miniaturist who worked chiefly in Naples. Although the traditional identification of the sitter is highly uncertain, it should be noted that Madame Récamier was in Naples for some months in 1812–14, the approximate date of this miniature.

Jacques Delaplace

French, born 1767, died after 1831

Delaplace was born in Vernon, northwest of Paris. Little else is known about his life, training, or exhibition history.

175
Portrait of a Woman

Ivory extended by card, 2½ x 2¼ in. (64 x 55 mm)
Signed (right, in black): *Delaplac[e]*
Bequest of Margaret Crane Hurlbut, 1933 (33.136.8)

Wearing a white dress and sage green shawl trimmed with decorated ribbon. Brown eyes; dark brown hair dressed with a gilt ornament. Holding spray with pink rose and bud in right hand. Landscape and sky background.

CONDITION: The ivory tablet had been extended by the artist at the top right with a triangular paper wedge, so as to complete the rectangle. Losses that had occurred at the join were filled with a soft pigmented wax to make this gap less conspicuous. The surface was otherwise in excellent condition but for a spot of moisture. The reverse bears painted details emphasizing the curve of the arm, while the rose, the hair, and the landscape background are sketched in pencil.

THE MINIATURE was painted about 1805–10 and is in its original gilt-metal frame.

Jean Baptiste Isabey

French, 1767–1855

Isabey was born in Nancy, where he studied with the painter Jean Baptiste Charles Claudot (1733–1805), who also taught Augustin (no. 169) and Laurent (no. 91). He went to Paris in 1786 and received some patronage from Marie Antoinette; however, he rose to a preeminent role among the early-nineteenth-century French miniaturists through his pupil Hortense de Beauharnais (1783–1837). She introduced him to Napoléon I, who was her stepfather and brother-in-law. Isabey became his court painter and had to maintain a number of studio assistants to help him provide the great number of miniatures of the emperor which he was called on to produce. His earlier works were done on ivory, but in the second decade of the nineteenth century he adopted the new technique of painting on paper stretched over sheets of metal. This enabled him to work on a larger scale and contributed to the fluent brushwork and luminosity of his later portrait miniatures.

176
The Reader

Ivory, diam. 3⅛ in. (79 mm)
Signed and dated (foot of the pilaster, in gray): *Isabey / 1790.*
Gift of Mrs. Louis V. Bell, in memory of her husband, 1925 (25.106.7)

Wearing a gray bodice, pink skirt, and black shawl with a red ribbon around her neck. Brown eyes; brown hair bound with red ribbon. Seated by a marble-topped table on which are three books. Gray wall background.

The miniature is in a mount of red and green gold and was perhaps once set in the lid of a box.

CONDITION: The miniature is in quite good condition. There is a metal foil against the reverse of the ivory, behind the face. The deteriorated cover glass was replaced.

EXHIBITED: Metropolitan Museum of Art, 1950, *Four Centuries of Miniature Painting*, list, p. 10.

THE ATTRIBUTION to Isabey of this portrait of an unknown woman was rejected by Richard Allen in 1977. The signature appears to be authentic, however, and the date is consistent with the sitter's costume. Although a relatively early work, lacking his later flamboyance, this is a representative example of Isabey's first manner. A similar miniature, signed and dated 1787, is in the Musée du Louvre (Pierrette Jean-Richard, *Miniatures sur ivoire* [Paris, 1994], no. 347, ill.).

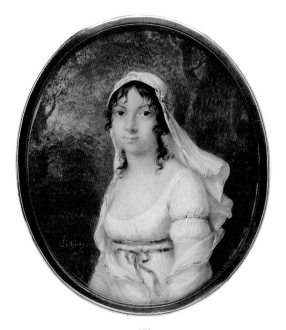

173
COLOR PLATE PAGE 52

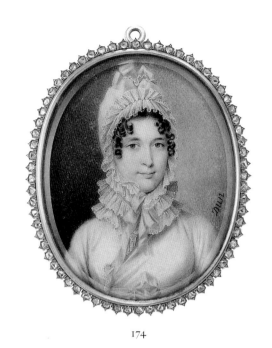

174

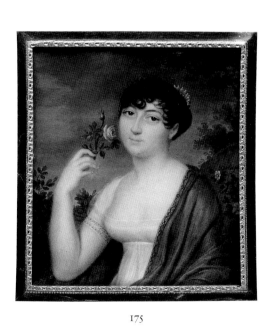

175

176

Jean Baptiste Isabey (*continued*)

177
Portrait of a Woman

Ivory, diam. 2⅞ in. (73 mm)
Signed (bottom right, in white): *Isabey*
Bequest of Millie Bruhl Fredrick, 1962 (62.122.88)

Wearing a white dress with a striped blue-and-white sash and striped brown-and-red shawl. White cap with blue ribbon. Green eyes; lightly powdered hair. Seated in a chair with blue fabric back. Black background.

CONDITION: The miniature is in fine condition. The deteriorated cover glass was replaced.

EX COLL.: [E. F. Bonaventure Inc., New York, until 1930]; Mrs. Leopold Fredrick, New York (1930–62).

LITERATURE: E. G. Paine, unpublished list of miniatures in the Fredrick collection (1960), no. 81.

THE MINIATURE is a typical example of Isabey's style at a date slightly later than no. 176 and was painted about 1795. A comparable signed but undated portrait of a woman is in the Musée du Louvre (Pierrette Jean-Richard, *Miniatures sur ivoire* [Paris, 1994], no. 356, ill.).

178
A Whippet

Ivory, 1⅛ x 2¼ in. (28 x 56 mm)
Signed (bottom edge, in black): *Isabey*
Bequest of Catherine D. Wentworth, 1948 (48.187.444) ESDA

The dog, blond with a white chest and belly, is flanked by the base of a pedestal and the trunk of a tree; the grass is sprinkled with flowers.

The miniature is set in a gold box made in Paris, possibly by Joseph Étienne Blerzy (apprenticed 1750, master 1768, working 1806), about 1800. The box bears four marks, among them the maker's mark JEB and Paris marks for 1797 and 1798–1809.

THE PORTRAYAL of a favorite dog is an unusual subject in Isabey's oeuvre.

179
Madame Jean Baptiste Isabey
(Jeanne Laurice de Salienne, died 1829)

Ivory, diam. 3⅜ in. (86 mm)
The Collection of Giovanni P. Morosini, presented by his daughter Giulia, 1932 (32.75.20)

Wearing a white dress. Blue eyes; light brown hair. Sewing a white handkerchief; worktable holds scissors and basket of white thread. Black background.

CONDITION: On receipt in the Metropolitan Museum, the miniature was badly cracked. It has been repaired, and retouching is visible in the background, especially at left and at top center.

THIS MINIATURE was received in the Museum as the portrait of an unknown woman by an unidentified artist. Bodo Hofstetter has drawn attention to a version by another hand in the Musée de l'horlogerie, Geneva, which established the present work's authorship and the identity of the sitter. The Geneva version (*L'âge d'or du petit portrait* [Paris, 1995], pp. 202, 203, color ill.) is a portrait of Mme Isabey by Henriette Rath (1773–1856). It varies in a number of details from the Metropolitan miniature: for example, the format is oval (3⅛ x 2¾ in. [80 x 69 mm]) rather than circular, the table for sewing materials is in front of the sitter rather than to her right, and a black box has replaced the open basket of cottons. There are also subtle modifications in the sitter's features, hairstyle, and costume.

The Geneva version is inscribed on the reverse by Henriette Rath: *Portrait de / Madame Isabey / première femme / la tête d'après nature / peint par H. Rath / copie d'après Isabey*. This inscription was evidently written in or after 1829, when Isabey married for the second time. It indicates that Mme Rath based her copy on the present miniature but painted Mme Isabey's features from a fresh sitting from the life. Henriette Rath was a pupil of Isabey from 1798, when she first came from Geneva to visit Paris. The Geneva miniature is ascribed to the period of her early association with Isabey.

Isabey married Jeanne Laurice de Salienne in 1791. His portrait of her in mourning, dated 1790, is in the Musée du Louvre (*L'âge d'or du petit portrait* [Paris, 1995], pp. 316, 317, color ill.). The Metropolitan and Geneva portraits appear from the costume and hairstyle to date about 1796–1800. If Henri Bouchot (*La miniature française*, 2nd ed. [Paris, 1910], p. 268) was correct in giving Mme Isabey's age as twenty-five before her marriage, she continued to look remarkably youthful in these portraits made some eight or so years later. She died in 1829, and Rose Maistre became Isabey's second wife in the same year.

180
Napoléon I (1769–1821)

Ivory, 2 x 1⅛ in. (50 x 30 mm)
Signed and dated (right edge, in black): *Isabey. 1810.*
Gift of Junius S. and Henry S. Morgan, 1947 (47.33.3)

Wearing a black uniform jacket with red piping and gold epaulets, the red ribbon and badge of the Légion d'Honneur, and badges of the Iron Crown of Lombardy and the Grand Eagle of the Légion d'Honneur. Brown eyes; brown hair. Gray sky background.

CONDITION: The miniature is in fine condition. A cloth-covered mat which covered the signature was removed. The convex cover glass was gilded to create a narrow band on the inner surface that masks the card to which the miniature is mounted but reveals the signature.

EX COLL.: J. P. Morgan, New York (until 1943); by descent to his sons.

EXHIBITED: Metropolitan Museum of Art, 1950, *Four Centuries of Miniature Painting*, list, p. 10; Metropolitan Museum of Art, 1978, *The Arts under Napoleon*, no. 32.

ISABEY and his studio produced many portrait miniatures of Napoléon I. Here the composition is less usual than that of no. 181, in which the sitter looks to his left. The emperor also looks younger in this work.

Napoléon Bonaparte (1769–1821) became emperor of France in 1804. He founded the Order of the Iron Crown of Lombardy in 1805, following his coronation as king of Italy.

181
Napoléon I (1769–1821)

Ivory, 2¼ x 1⅜ in. (56 x 36 mm)
Signed and dated (right edge, in black): *Isabey 1812*
Gift of Helen O. Brice, 1942 (42.53.5)

Wearing the black uniform jacket of the National Guard with red collar and gold epaulets, and badges of the Légion d'Honneur, the Iron Crown of Lombardy, and the Grand Eagle of the Légion d'Honneur. Brown eyes; brown hair. Sky background.

The miniature is backed by a portion of a trade card engraved on / RL AND GOLD / . . . ker / . . . nd Street, / ND. / description.

The miniature is in a simple gilt mount with hair on either side of the ivory.

EXHIBITED: Metropolitan Museum of Art, 1950, *Four Centuries of Miniature Painting*, list, p. 10.

THIS IS one of many replicas of a standard portrait of Napoléon I produced by Isabey and his assistants from 1805, when the emperor founded the Order of the Iron Crown. A closely similar version, dated 1812, is in the Wallace Collection (Graham Reynolds, *Wallace Collection: Catalogue of Miniatures* [London, 1980], no. 185, ill.). Nos. 182 and 186 in the Wallace Collection are other versions assigned to Isabey himself.

177
COLOR PLATE PAGE 53

178
COLOR PLATE PAGE 53

179

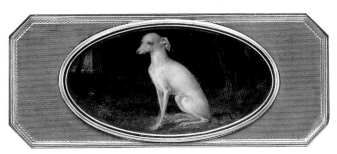

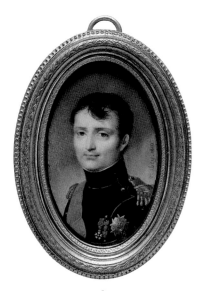

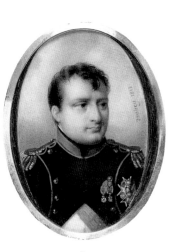

180
COLOR PLATE PAGE 54

181
COLOR PLATE PAGE 54

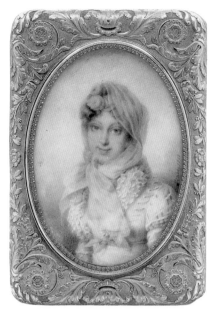

182

COLOR PLATE PAGE 54

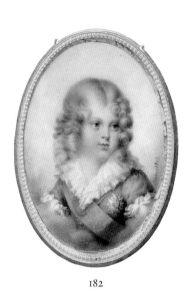

182

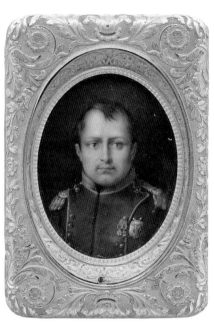

182

Jean Baptiste Isabey (*continued*)

Two further examples, both of which are signed and one of which is dated 1813, are in the Musée du Louvre (Pierrette Jean-Richard, *Miniatures sur ivoire* [Paris, 1994], nos. 375, 376, ills.). The signature on the present miniature appears to be genuine. The backing indicates that it was reframed in England or the United States.

182

The Empress Marie-Louise, the King of Rome, and Napoléon I

Ivory, set in a gold box

Empress Marie-Louise (1791–1847): 2¼ x 1⅝ in. (58 x 41 mm); signed and dated (right edge, in black): *Isabey 1812*. Wearing a white dress with peach sash and white veil with peach ribbon. Blue eyes; fair hair dressed with roses. Light sky background.

François-Charles-Joseph Bonaparte, King of Rome (1811–1832): 2¼ x 1⅝ in. (56 x 40 mm); signed and dated (right edge): *Isabey 1815*. Wearing a blue dress with white collar and cuffs and red ribbon

and badge of the Légion d'Honneur. Blue eyes; fair hair. Sky background.

Napoléon I (1769–1821): 2 x 1½ in. (49 x 38 mm). Wearing the green uniform with red facings of the *chasseurs à cheval*, the red ribbon and badge of the Légion d'Honneur, and another badge. Brown eyes; brown hair. Dark brown background.

Gift of J. Pierpont Morgan, 1917 (17.190.1114) ESDA

The portrait of the empress Marie-Louise is visible on the outer lid of the box. It lifts out; against its reverse is the portrait of the king of Rome. Bodo Hofstetter points out that both signatures have been tampered with. Underneath, set in a shallow well in the outer lid, is the portrait of Napoléon I. It is not quite the right size and seems to be a replacement for a lock of hair that has been lost.

The miniatures are set in a gold box made by Gabriel Raoul Morel in Paris about 1815. The box bears eight marks, among them the maker's mark GRM and Paris marks for 1809–19.

A piece of paper inside the box is inscribed in pencil *Two beautiful miniatures by Isabey / and one by Mad de Mirabel* [sic] and in ink *Formerly belonging to the Emperor, and afterwards / to the Maréchal Lefevre / de Nouette* [sic].

Inside the lid are a label printed *2308* and another inscribed in pencil *3462*.

EX COLL.: General Charles Lefebvre-Desnouettes.

EXHIBITED: Metropolitan Museum of Art, 1978, *The Arts under Napoleon*, no. 186.

MINIATURES by Isabey of Napoléon I, the empress Marie-Louise, and the king of Rome are mounted on other boxes, differently arrayed. For instance, they occur in a row on the top of a box formerly in the collection of Prince Victor Napoléon (Mme de Basily-Callimaki, *Isabey* [Paris, 1909], ill. p. 157).

A miniature of Marie-Louise in 1812 shows her in the same dress but without the veil (Eduard Leisching, *Die Bildnis-Miniatur in Oesterreich von 1750 bis 1850* [Vienna, 1907], ill. pl. 23, no. 3). A miniature of the king of Rome signed and dated 1815 is in the Musée du Louvre (Pierrette Jean-Richard, *Miniatures sur ivoire* [Paris, 1994], no. 379, ill.), and there are also two watercolors by or after Isabey (see Robert Bayne-Powell, *Portrait Miniatures in the Fitzwilliam Museum, Cambridge* [Cambridge, 1985], pp. 140–41 and ill.).

In the present group the smaller portrait miniature of Napoléon I is not close to Isabey's style, but it is unlikely to be by Madame de Mirbel

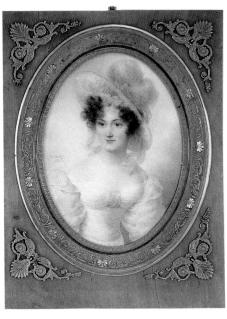

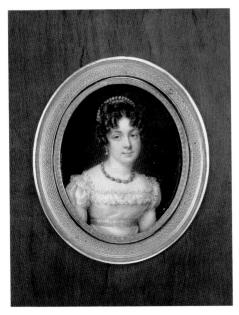

183

COLOR PLATE PAGE 55

184

(1796–1849), who made her name with portraits of Louis XVIII in 1818 and 1819.

183
Mrs. Rufus Prime
(Augusta Temple Palmer, 1807–1840)

Card, 5⅜ x 4 in. (138 x 102 mm)
Signed (left, in pencil): *J.Isabey / A Paris* —
Gift of Cornelia Prime, 1908 (08.60)

Wearing a white dress trimmed with pink on the sash, sleeves, and bosom and a pink hat with an ostrich feather. Brown eyes; dark brown hair. Rather lurid blue-and-yellow sky background.

The back of the card is inscribed in ink in a more recent hand *Madame Rufus Prime / de New York / Paris 1829.*

The miniature is in a contemporaneous wooden frame with ormolu mounts. Paper fixed to the back of the frame is inscribed in ink in a variety of hands; *Mons.* *L. Rihouet/ 7 Rue de la Paix / Paris* [struck through]; *Augusta Temple Prime / Wife of Rufus Prime / Paris 1828.* — ; *Rufus Prime / New York / December Paris 1828 ; property of CORNELIA PRIME / Huntington.1894* — / *N.Y.*

EX COLL.: By family descent.

EXHIBITED: National Academy of Design, New

York, 1894, *Portraits of Women*, 1894, no. 603 (lent by Cornelia Prime); Metropolitan Museum of Art, 1950, *Four Centuries of Miniature Painting*, list, p. 10.

IN A LETTER written to the Metropolitan Museum in 1908, the sitter's daughter, Cornelia Prime, states that this miniature is one of only four American ladies painted by Isabey, and shows her as a young bride on her wedding trip to Paris. Augusta Temple Palmer (1807–1840) married Rufus Prime in 1828. She was the daughter of William Lambe Palmer, captain Eighteenth Light Dragoons, who was acting British consul general in New York in 1798, and was the granddaughter of Sir John Temple, British consul general to the United States in 1785–98. Her maternal grandmother, Lady Elizabeth Temple, was the daughter of James Bowdoin, governor of Massachusetts.

184
Portrait of a Woman

Ivory, 3 x 2¼ in. (76 x 56 mm)
Signed (right edge, in black, indistinctly): *J.te Isabey*
Bequest of Helen Winslow Durkee Mileham, 1954 (55.III.2)

Wearing a white dress with blue sash and necklace and earrings of blue stones set in gold. Gray eyes; brown hair with diadem of blue stones set in gold. Dark brown background.

The miniature is surrounded by a chased ormolu mount set in a rectangular wooden frame, apparently the original arrangement.

The back of the frame is covered with paper which is inscribed in ink *Succession de / M Le Prince / de Wagram / 1.er projet de / . . . ement / M Georges Meusnier.*

The paper backing is also stamped *G.es MEUSNIER / EXPERT / 27 & 22 Rue S.t Augustin.* A label fixed to it is printed in blue *461.*

EX COLL.: Prince de Wagram, Paris; Paul Soubeiran de Pierres, Montpellier (his sale, Anderson Galleries, New York, December 8, 1927, no. 50).

THIS PORTRAIT was painted about 1815. Hermione Waterfield and Bodo Hofstetter have doubted the reading of the signature and the attribution, but the inscription appears to be as transcribed and the miniature to be a representative, if not remarkable, example of Isabey's work.

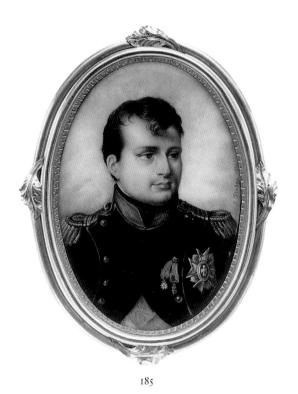

185

186

Style of Jean Baptiste Isabey

19th century

185
Napoléon I (1769–1821)

Ivory, 2¾ x 2 in. (70 x 50 mm)
Inscribed (right edge, in black, falsely): *J Isabey 1811*.
Bequest of Collis P. Huntington, 1900 (26.168.60)

Wearing the black uniform jacket of the National
Guard with red collar and gold epaulets, and badges
of the Légion d'Honneur, the Iron Crown of
Lombardy, and the Grand Eagle of the Légion
d'Honneur. Brown eyes; brown hair. Sky back-
ground.
LITERATURE: *A Catalogue of Miniatures in the
Collection of Collis P. Huntington* (New York, 1897),
ill., as by Isabey.

THIS IS a version of an Isabey portrait of
Napoléon I of which there are many replicas
(e.g., in the Wallace Collection, London, for
which see Graham Reynolds, *Wallace Collection:
Catalogue of Miniatures* [London, 1980], nos.
182, 185, and 186, ills.). The authenticity of the
alleged signature was rejected by Leo R.
Schidlof in 1952 and by Richard Allen in 1977,

and it is very doubtful. The miniature is proba-
bly an old copy after Isabey with a false signa-
ture added.

Charles Pierre Cior

French, born 1769, died after 1838

Born in Paris, Cior became the pupil of Jean
Bauzil (French, active about 1792–98). Cior
worked in many European countries, including
France, Spain, and Russia. His first exhibit at
the Paris Salon was in 1796 and his last was in
1838.

186
Portrait of an Officer

Ivory, diam. 3 in. (77 mm)
Signed (left, in white): *Cior*
Gift of Mrs. Louis V. Bell, in memory of her
husband, 1925 (25.106.26)

Wearing a blue uniform jacket with beige facings
and red collar, white waistcoat, and black hat

trimmed with gold and with yellow-crested black
feather. Hazel eyes; dark brown hair. Landscape
and sky background with a castle on left and tree
on right.

The miniature is set in the lid of a circular tortoise-
shell box. A stock label numbered *3548* in ink is
fixed to the back of the miniature, and there are two
other stock labels numbered *101* (black ink) and *26*
(painted) inside the box.

THE MINIATURE displays many of the char-
acteristics Leo R. Schidlof describes in Cior's
work from about 1815: a nearly frontal pose, sky
background in gouache, leaves on the right, and
signature ending in a spiral flourish on the left.

Augustin Dubourg

French, 1758–1800

Born at Saint-Dié (Vosges), Dubourg exhibited
from 1791 until 1800. Jean Baptiste Jacques
Augustin (no. 169) was also born at Saint-Dié,
and some of Dubourg's works were confused
with those of his cousin.

187

188

187
Portrait of a Woman

Ivory, diam. 2⅜ in. (60 mm)
Signed (right, in gray): *Dubou[rg]*
Bequest of Millie Bruhl Fredrick, 1962
 (62.122.92)

Wearing a dark blue dress with a white belt and a
black hat trimmed with white ribbon. Brown eyes;
brown hair. Seated in a chair with red leather back.
Gray background with columns.

CONDITION: The surface is abraded and marked,
and there is a loss under the rabbet and other
damage caused by dampness.

IN HIS unpublished list of miniatures in the
Fredrick collection (1960), no. 70, E. G. Paine
described this as a work by Christopher Curtius,
about 1798. Curtius is an artist not recorded in
the standard dictionaries. Paine was apparently
unaware of the signature, concealed in part by
the frame, which is that of Augustin Dubourg.
The style is consistent with that of the miniature
of a lady by Dubourg reproduced by Leo R.
Schidlof (*The Miniature in Europe* [Graz, 1964],
vol. 3, pl. 183, fig. 341).

Vincent Bertrand

French, born 1770, died after 1817

Bertrand was a pupil of Jean Baptiste Regnault
(1754–1829) and exhibited at the Paris Salon
between 1796 and 1817.

188
Portrait of a Woman

Ivory, 2⅝ x 2 in. (58 x 48 mm)
Signed (left edge, in black): *Bertrand*.
Gift of Mrs. Heyward Cutting, 1942 (42.150.15)

Wearing a white dress edged with flowered red,
green, and white ribbon, red cloak, and coral
necklace. Brown eyes; dark hair. Gray-brown
background.

CONDITION: Heavy mold was found on the
miniature and on the inner surface of the deterio-
rated convex cover glass, which has been replaced.
There is a flaw in the paint in the left background
over a blind crack in the ivory.

THE MINIATURE, painted about 1810,
shows the strong influence of Jean Baptiste

Isabey (nos. 176–85). Leo R. Schidlof (*The
Miniature in Europe* [Graz, 1964], vol. 1, p. 81)
expressed a preference for Bertrand's miniatures
on ivory over his more usual work, which he
called "*portraits aériens*" — sitters surrounded by
clouds painted on large sheets of vellum.

189
Portrait of a Woman

Ivory, 4¼ x 4 in. (110 x 100 mm)
Signed (right, in black): *Bertran[d]*
Gift of Mrs. John LaPorte Given, 1945 (45.110.1)

Wearing a white dress, reddish brown scarf with
floral decoration, and straw bonnet with white
band. Holding a basket of flowers. Gray eyes;
brown hair. Landscape background with mountains
on left and tree on right; sunset sky.

The signature is over a dark area and is now diffi-
cult to decipher but has been read as *Bertrand* since
1952.

CONDITION: The more opaque paint used for
the background has faded, as can be seen from areas
of blue that are protected by the rabbet of the frame.

Some overpaint is present in the passages of crazing or loss in the sky, especially at the upper right corner. The ivory, which had been cockled, has relaxed. The central section of the fine laid paper which had been attached to its reverse had previously been removed, exposing painted reinforcement behind the face. Rose shadows had been applied to the reverse of the cheek, neck, bosom, and hands. A remnant of silver foil remains.

THE MINIATURE is of about the same date as no. 188.

Anthelme François Lagrenée

French, 1774–1832

Born in Paris, Lagrenée studied with his father, Louis François, and then with Vincent (no. 94). He visited Russia in 1823 and had a number of commissions from Alexander I (1777–1825). He exhibited at the Paris Salon from 1799 to 1831. Lagrenée died in Paris of cholera.

190
Empress Maria Feodorovna, Her Son Grand Duke Michael Pavlovich, and Her Daughter-in-law Elena Pavlovna

Ivory, set in a box

Empress Maria Feodorovna (1759–1828): 1½ x 1⅛ in. (38 x 27 mm). Wearing a brown dress, ermine-trimmed red gown and blue ribbon and badge of the Order of Saint Andrew. Brown hair with jeweled crown. Sky background.

Grand Duke Michael Pavlovich (1798–1849): 1⅜ x 1⅛ in. (36 x 26 mm). Wearing a dark blue uniform jacket with gold epaulets and blue ribbon and badge of the Order of Saint Andrew. Fair hair. Sky background.

Grand Duchess Elena Pavlovna (1807–1873): 1⅜ x 1⅛ in. (36 x 26 mm); signed (left edge, in black): *Lagrenée*. Wearing a blue dress and red ribbon and badge of the Order of Saint Catherine. Fair hair dressed with tiara and blue flowers. Gray background.

Gift of Dr. and Mrs. John Sinclair Dye, 1950 (50.133) ESDA

These miniatures are set in a carved gold-and-silver surround in the lid of a box of gold, silver, enamel, and tortoiseshell. The box, which may be of Swiss manufacture, bears two unidentified marks.

A note found inside the box, signed by Epstein, the manager of the Antiquariat, and the expert Molodre(?), identified the sitters incorrectly as Alexandra Fedorovna, wife of Nicholas I, with one of his sons and his wife.

EX COLL.: Bought in Russia before 1940 by Dr. and Mrs. John Sinclair Dye.

MARIA FEODOROVNA was the widow of Paul I (1754–1801), and Grand Duke Michael was the youngest of their ten children. He married his cousin, who was born Frederike Charlotte of Württemburg.

The identification of the sitters has been established by comparison with engravings reproduced by D. V. Rovinsky (*Complete Dictionary of Russian Engraved Portraits*, vol. 2 [1887]: Maria Feodorovna [1817], by H. Benner, p. 1243, no. 17; Michael Pavlovich, p. 1294, no. 12; Elena Pavlovna, p. 910, no. 1).

Although only the portrait of the grand duchess is signed, the other two may also be by Lagrenée. Another, very similar miniature of the grand duchess in half length by Lagrenée was sold at Sotheby's, London, December 14, 1995, no. 91, ill. The couple married in 1824, a possible date for the miniatures.

Ferdinand Machéra

French, 1776–1843

Born at Dôle (Jura), Machéra became a pupil of Anatole Devosge (1770–1850) in Dijon and was influenced by Jean Baptiste Isabey (nos. 176–85). He died at Lyons in 1843.

191
Portrait of a Man

Ivory, 2¼ x 1⅝ in. (57 x 43 mm)

Signed and dated (right edge, in black): *Machera 1827*

Bequest of Millie Bruhl Fredrick, 1962 (62.122.108)

Wearing a black coat and white shirt and cravat. Brown eyes; dark hair. Gray background.

IN HIS unpublished list of miniatures in the Fredrick collection (1960), no. 83, E. G. Paine records that the sitter is "stated to be" Victor Hugo, but the portrait is not of him.

Jean-Baptiste-Ponce Lambert

Swiss(?), active about 1801–12

Lambert is believed to have been born in Geneva. A pupil of Jean Baptiste Jacques Augustin (no. 169), he worked in Paris painting

portraits in oil and miniatures on ivory and in enamel. He exhibited in the Salons of 1801, 1802, and 1812.

192
Portrait of a Man

Ivory, diam. 2⅜ in. (59 mm)

Signed and dated (left edge, in pencil): *Lambert p.! 1801.*

Gift of Mrs. Louis V. Bell, in memory of her husband, 1925 (25.106.27)

Wearing a blue coat, white waistcoat with green edging, and muslin cravat. Brown eyes; gray hair. Gray-brown background.

The miniature is set in the lid of a box made of figured wood lined with tortoiseshell.

MINIATURES by Lambert are rare. Leo R. Schidlof, who in 1952 pronounced this an excellent example of his work, cites only a grisaille profile by him (*The Miniature in Europe* [Graz, 1964], vol. 3, pl. 336, fig. 679).

French

1800

193
François Joseph Lefebvre (1755–1820)

Ivory, diam. 2⅛ in. (54 mm)

Signed and dated (?)(lower right edge)

Bequest of Mary Anna Palmer Draper, 1914 (15.43.288)

Wearing a blue uniform jacket with red collar decorated in gold and black cravat. Brown eyes; brown hair. Dark gray background.

A loose cardboard backing card of more recent date is inscribed in ink *G.! Lefebvre / 1800*. The miniature is in a circular metal surround, which may have been set in the lid of a box.

CONDITION: Clumsy old restorations are present on the sitter's right sleeve and in the background. Damage along the perimeter at the bottom affects the costume and renders the presumed signature and date illegible.

THE SUBJECT, François Joseph Lefebvre (1755–1820), duke of Danzig, was a marshal of France. He had an extremely successful military career under Napoléon I. On March 20, 1799, at Stockach, he was gravely wounded in a battle against the Austrians and returned to Paris, where he was named commandant of a division quartered there. He was still in Paris on April 1, 1800.

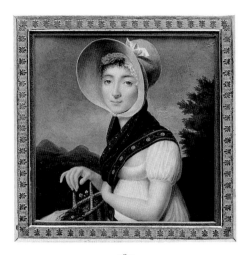

189
COLOR PLATE PAGE 56

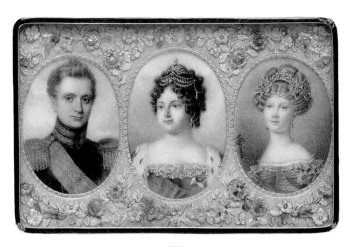

190
COLOR PLATE PAGE 56

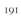

191

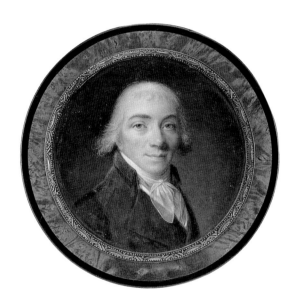

192

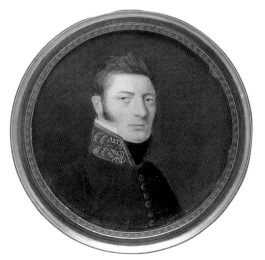

193

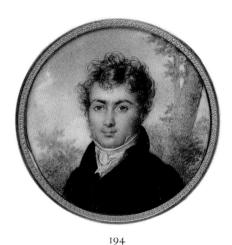

194

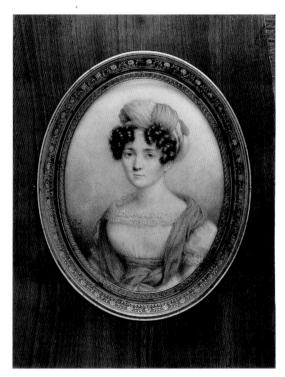

195

J. Lecourt

French, active about 1804–30

The birth and death dates of J. Lecourt are not known. He sent miniatures to the Paris Salon between 1804 and 1819 from an address in Versailles and is said by Nagler to have still been working there in 1830. Some of his Salon exhibits were painted in imitation of Petitot's enamels.

194
Portrait of a Man

Ivory, diam. 2 in. (50 mm)

Signed (left edge, in gold): *Lecourt*

Gift of Mrs. Louis V. Bell, in memory of her husband, 1925 (25.106.35)

Wearing a blue coat with black reverse, yellow waistcoat, and white cravat. Brown eyes; brown hair. Landscape and sky background.

CONDITION: The miniature, which is in very good condition, is mounted in a gold bezel in the lid of a red-painted composition box lined with tortoiseshell. As mold was present on the inner surface of the cover glass, the rim was removed so that it could be cleaned.

LEO R. SCHIDLOF (*The Miniature in Europe* [Graz, 1964], vol. 1, p. 477) remarks that this artist's miniatures are usually small and that he usually signs his work in gold (as he has done here). This miniature probably dates from about 1810.

Rudolphe Bel

Swiss, active by 1822, died 1849

Bel (or Bell) was born in Payerne, Switzerland. He became a pupil of Jean Baptiste Isabey (nos. 176–85) and followed his master's style closely. He exhibited at the Paris Salon from 1822 until 1835.

195
Portrait of a Woman

Paper stretched over metal, 5 x 3½ in. (126 x 88 mm)

Signed and dated (left, in black): *Bel / 1822*

A stock label is inscribed in ink *15* and *A.M.B.65*.

Gift of Mrs. Louis V. Bell, in memory of her husband, 1925 (25.106.1)

CONDITION: The light tones are darkened and discolored by comparison with the edge all around, which has been protected by the rabbet of the frame.

Wearing a white muslin dress, blue sash and scarf, and blue-and-white turban. Blue eyes; black hair. Sky background.

A SIGNED miniature employing a similar color scheme is in the Musée de l'horlogerie, Geneva (*L'âge d'or du petit portrait*, exh. cat. [Paris, 1995], no. G73, ill.).

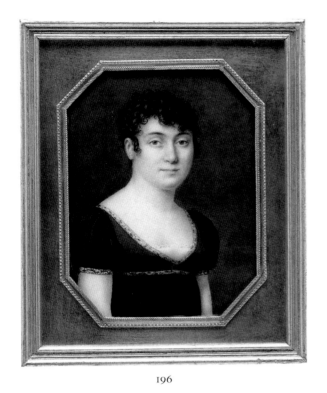

196

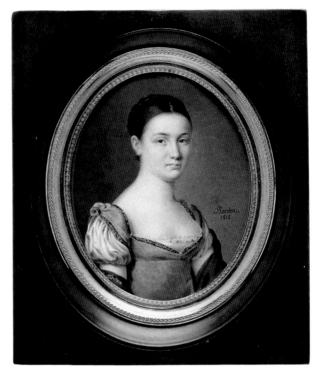

197

Joseph Bordes

French, born 1773, died after 1835

Born in Toulon, Bordes studied with Jean Baptiste Isabey (nos. 176–85). He sent works to the Paris Salon from 1808 to 1835 and also exhibited in the French provinces. He made some lithographic copies after his own miniatures.

196
Portrait of a Woman

Ivory, 4⅛ x 3⅛ in. (106 x 80 mm)

Signed and dated (lower right, in yellow): *Bordes / 1808*

The Moses Lazarus Collection, Gift of Josephine and Sarah Lazarus, in memory of their father, 1888–95 (95.14.51)

Wearing a dark blue dress trimmed with red-and-green ribbon and white fichu. Brown eyes; dark brown hair. Dark gray-brown background.

CONDITION: The very thin ivory was mounted to a heavy multi-ply paper that had a tendency to curl. This mount was therefore removed and replaced with ragboard. Metal foil, which has been cleaned, is present under the ivory, backing the arm as well as the face. There is some crazing where the blue is most heavily applied. The deteriorated glass has been replaced.

EXHIBITED: Metropolitan Museum of Art, 1950, *Four Centuries of Miniature Painting*, list, p. 9.

AS WITH no. 197, the last letter of the signature could be read as *n* rather than *s*. This, however, was the way in which Joseph Bordes wrote his signature, and the miniature is a representative work by him.

197
Portrait of a Woman

Ivory, 4 x 3⅛ in. (104 x 82 mm)

Signed and dated (right, in black): *Bordes. / 1812.*

The Moses Lazarus Collection, Gift of Josephine and Sarah Lazarus, in memory of their father, 1888–95 (95.14.86)

Wearing a gold dress trimmed with multicolored ribbon and with white sleeves and bodice, and blue shawl. Brown eyes; brown hair. Dark gray-brown background.

On the back are the inscriptions *440 / J Bordes* and *8955*; also fixed to the back are three stock labels.

CONDITION: The miniature, on very thin ivory, was mounted to heavy cockled paper which has been replaced with ragboard. A small piece of tarnished and deteriorated metal-leaf backing the face was also removed, leaving a pale stain on the reverse of the ivory. Iridescent spots in the dark background have been toned. The weeping cover glass has been replaced.

EXHIBITED: Metropolitan Museum of Art, 1950, *Four Centuries of Miniature Painting*, list, p. 9.

198
COLOR PLATE PAGE 57

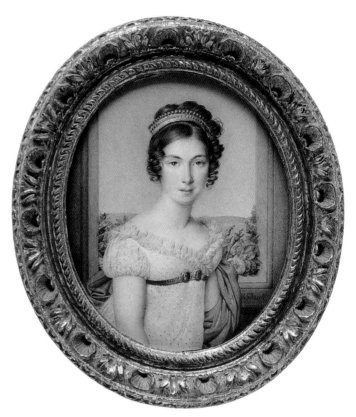

199

198
Portrait of a Man

Ivory set into card, 7⅛ x 5⅞ in. (181 x 149 mm)

Signed (right, in yellow): *Bordes.*

The Moses Lazarus Collection, Gift of Josephine
and Sarah Lazarus, in memory of their father,
1888–95 (95.14.83)

Wearing a brown jacket, black waistcoat, and white
frilled shirt. Hazel eyes; brown hair. Gray-brown
background.

On the backing is the stamp ꜱ ʟᴀᴢᴀʀᴜꜱ followed
in ink by *1891 / New York City* and the ink inscription
*J. Bordes, peintre en miniature– / Médaille a l'Exposi-
tion de la Ville de Douay 1819 & 1821 Médaille a l'Ex-
position / de la ville de Lille 1822.*

Cᴏɴᴅɪᴛɪᴏɴ: The miniature is on a prepared
support of gessoed card into which an ivory oval is
set. The support had warped in a concave curve.
The ivory had separated from it, leaving a thin
crack. Nevertheless, the painted surface is in superb
condition. The cover glass has been reverse painted
with a band (acrylic) of bluish-brown color to mask
the separation.

In 1952 Leo R. Schidlof remarked that this
was the best miniature by Bordes that he had
ever seen. It shows the extent to which the artist
had profited from his time as a pupil of Jean
Baptiste Isabey (nos. 176–85).

Nicolas-Henri Jacob

French, 1782–1871

Born in Paris, Jacob studied with Jacques
Louis David (1748–1825) and with a certain
Du Pasquier. From 1805 to 1814 he was painter
to Eugène de Beauharnais (1781–1824), viceroy
of Italy and later duke of Leuchtenberg. Jacob
exhibited at the Paris Salon from 1802 to 1865.

199
Portrait of a Woman

Card, 8¼ x 6¾ in. (208 x 171 mm)

Signed and dated (right, in black): *NhJacob / 1817*

Bequest of Catherine D. Wentworth, 1948
(48.187.742)

Wearing a white muslin dress, red belt with two
gold buckles set with red stones, and red shawl.
Brown eyes; brown hair dressed with gold diadem
set with red stones. Window in the background
opens onto a flower garden with hills beyond.

Cᴏɴᴅɪᴛɪᴏɴ: There are minor stains and some
discolored dots on the white dress. The glass was
replaced. An acid-free mat was supplied.

Lɪᴛᴇʀᴀᴛᴜʀᴇ: Leo R. Schidlof, *The Miniature
in Europe* (Graz, 1964), vol. 1, p. 398, and vol. 3,
pl. 303, fig. 609.

Pierre-Laurent Canon

French, 1787–1852

Canon was born in Caen. He painted portraits
in oil and landscapes as well as miniatures.
He exhibited at the Paris Salon in 1831 and
also showed in Lille and Douai. He died in
Paris.

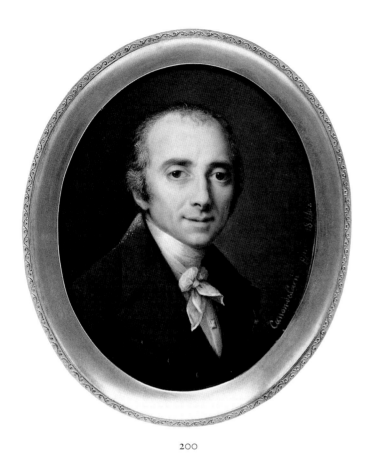

200

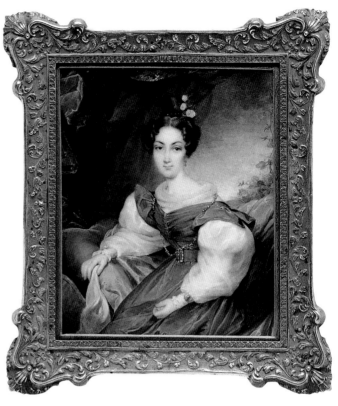

201

200
Baron Louis Dominique Louis (1755–1837)

Ivory, 4⅛ x 3⅛ in. (105 x 80 mm)

Signed and dated (right edge, in white):
Canon.de.Caen pinx 1844.·.

The Moses Lazarus Collection, Gift of Josephine
and Sarah Lazarus, in memory of their father,
1888–95 (95.14.90)

Wearing a gray coat, white shirt and cravat, cameo
stud, and red ribbon of the Légion d'Honneur in
buttonhole. Brown eyes; gray hair. Dark gray
background.

A paper fixed to the loose backing card, torn from
an index in French, is inscribed in black ink in a
later hand *Baron Louis Ministre des Finances.*

CONDITION: Except for some crazing in the
more thickly painted background and the lapels,
the surface is well preserved. Two small losses at the
right edge and several dull spots around the lapel
ribbon have been toned. The deteriorated cover
glass has been replaced.

LITERATURE: Leo R. Schidlof, *The Miniature*

in Europe (Graz, 1964), vol. 1, p. 125, and vol. 3,
pl. 104, fig. 193.

A PRIEST, a politician, and an expert on
banking, Baron Louis Dominique Louis served
as minister of finance during the Restoration. In
1815 he was awarded the Grand Cross of the
Légion d'Honneur. On his retirement in 1832 he
became a peer of France. If, as seems likely, the
identification of the sitter is correct, then the
miniature is posthumous.

Étienne Bouchardy

French, 1797–1849

Born in Paris, Bouchardy became the pupil of
Louis Marie Sicardi (nos. 60–63) and Antoine
Jean Gros (1771–1835). He exhibited at the Paris
Salon from 1819 to 1849, obtaining a third-class
medal in 1833. He died in Paris.

201
Portrait of a Woman

Ivory, 4⅞ x 4⅛ in. (125 x 104 mm)

Signed and dated (in black): (left edge)
E.BOUCHARDY.; (lower left) *1838.*

Bequest of Margaret Crane Hurlbut, 1933 (33.136.7)

Wearing a blue-gray dress with muslin sleeves.
Brown eyes; dark brown hair dressed with three
rosebuds. Seated on a brown sofa covered with lilac
cloth. Curtain and landscape background.

CONDITION: Despite flaking and some heavy
overpaint in the background, the miniature is in
generally good condition, with fresh bright colors.
The flaking was consolidated, the losses toned, and
the old repairs improved. Traces of silver leaf on the
reverse showed through and were removed. A new
ragboard mat and backing were supplied.

EXHIBITED: Metropolitan Museum of Art, 1950,
Four Centuries of Miniature Painting, list, p. 7.

LITERATURE: H. B. Wehle, "The Hurlbut
Bequest," *Metropolitan Museum Bulletin,* 29 (1934),
p. 4.

THE MINIATURE displays the facility in
painting fabrics that was one of Bouchardy's
skills (see also no. 202).

202
Portrait of a Woman

Ivory laid on card, 3¼ x 2⅝ in. (82 x 67 mm)
Signed and dated (right edge, in red):
E.Bouchardy.1832.
Gift of Mrs. Louis V. Bell, in memory of her
husband, 1925 (25.106.4)

Wearing a black velvet dress, white lace-edged
collar, and gold chain and earrings. Gray eyes;
plaited brown hair. Landscape background on left;
red curtain on right.

CONDITION: The miniature, in the back of a red
morocco case, was under a deteriorated convex
glass which has been replaced. The surface is in
excellent condition, but the face had been marred
by gray patches resulting from discolored silver leaf
applied to the back of the ivory. This was replaced
with a new leaf of metal foil.

EXHIBITED: Metropolitan Museum of Art,
1950, Four Centuries of Miniature Painting, list,
p. 9.

François Meuret

French, 1800–1887

Born in Nantes, Meuret studied in Paris with
Louis François Aubry (1767–1851). He exhibited
at the Paris Salon from 1822 to 1852, receiving a
second-class medal in 1827 and a first-class medal
in 1843. Meuret was miniature painter to Louis-
Philippe (1773–1850), king of France. He was
appointed chevalier of the Légion d'Honneur in
1864.

203
Portrait of a Woman, Said to Be Marie de Mautesson

Ivory, 2¼ x 1⅞ in. (58 x 47 mm)
Signed (right edge, in black): Meuret.
Gift of Helen O. Brice, 1942 (42.53.1)

Wearing a black dress, white fichu and ruff, and
pink bow at her neck. Gray eyes; dark brown hair
dressed with a black bow. Sky background.

CONDITION: The miniature is in excellent condi-
tion but for an area of moisture damage on the sit-
ter's left sleeve. A paper backing card was separated
from the reverse of the ivory so that a piece of
discolored metal leaf could be replaced with new
foil.

ACCORDING TO the donor, the miniature is
said to represent Marie de Mautesson of the
Académie Royale de Musique. It was painted
about 1830.

Giacomo Andreoli

Italian, active about 1808

The following miniature is clearly signed
Andreoli. The artist is not recorded under that
name in Thieme-Becker or by Leo R. Schidlof.
He is probably the miniature painter listed as
Giacomo Ardroli by John Lumsden Propert (A
History of Miniature Art with Notes on Collectors
and Collections [London, 1887], p. 167) as the
author of miniatures of Napoléon I and
Joséphine.

204
Jérôme Bonaparte (1784–1860), King of Westphalia

Ivory, 2⅜ x 1⅞ in. (60 x 48 mm)
Signed (left edge, in black): Andreoli
Gift of Helen O. Brice, 1942 (42.53.2)

Wearing the white uniform with black and gold
trimming of the Westphalian Infantry, red ribbon
and badge of the Légion d'Honneur; and badge of
the Grand Eagle of the Légion d'Honneur. Brown
eyes; black hair. Sky background.

A paper label that was fixed to the brown card
backing is inscribed in ink Le Roi Jérôme and Murat
(obliterated in pencil).

CONDITION: Despite the fact that the original
cover glass was severely deteriorated and wet, the
miniature is in pristine condition. The paint is very
glossy, with metallic gold and silver used for the
epaulets and medals. A new glass was supplied, and
corrosion caused by contact with the deteriorated
glass was removed from the original bezel.

THE MINIATURE is a rectangular copy from
the oval miniature portrait by Jean Baptiste
Jacques Augustin (no. 169) of Jérôme Bonaparte
in the Wallace Collection (Graham Reynolds,
Wallace Collection: Catalogue of Miniatures [Lon-
don, 1980], no. 171, ill.); the original is signed by
Augustin and dated 1808.

Jérôme Bonaparte, younger brother of
Napoléon I, was appointed king of Westphalia
by the Treaty of Tilsit in 1807 and reigned until
1813. He married first Elizabeth Patterson, in
Baltimore in 1803, and second Princess Cather-
ine of Württemburg (1783–1835) in 1807.

Domenico Bossi

Italian (Venetian), 1765–1853

Bossi was born in Trieste. He worked in most
of the countries of central Europe, and his
reputation rivaled that of his contemporary
Jean Baptiste Isabey (nos. 176–85). He was in
St. Petersburg from 1802, leaving for Paris in
1812. He became a member of the Vienna Acad-
emy in 1815. Bossi died in Munich.

205
Count Alexander Ivanovich Sollogoub
(1788–1844)

Ivory, 2⅜ x 1⅞ in. (60 x 47 mm)
Signed and dated (right edge, in black): Bossi 1810
Gift of Humanities Fund Inc., 1972 (1972.145.7)

Wearing a blue coat, beige embroidered waistcoat,
and white shirt and cravat. Brown hair. Gray-brown
background.

CONDITION: The condition is poor. The left side
of the sitter's face, both edges of the miniature, and
the signature have been affected by damp. The
damages have been toned to minimize them. The
glass has been replaced.

EX COLL.: Countess N. M. Sollogoub, Moscow
(1905); Boris Bakhmeteff, New York (until 1972).

LITERATURE: Grand Duke Nicolas Mikhaïlo-
witch (ed.), Portraits russes des XVIIIᵉ et XIXᵉ siècles
(St. Petersburg, 1905), vol. 1, no. 75, ill.

POLISH by origin, Count Alexander
Ivanovich Sollogoub became a complete Rus-
sian. Having inherited great wealth, he was a
brilliant figure at the court of Alexander I
(1777–1825). In 1810 he married as his second
wife Sophia Ivanovna, the daughter of I. P.
Arkharoff, and moved briefly to Moscow. He
was the arbiter of elegance in his age and intro-
duced the blue cloak bound with red velvet,
which enjoyed a great vogue. He and his family
were acquaintances of Pushkin.

Giovanni Battista Gigola

Italian (Brescian), 1769–1841

Born in Brescia, Gigola studied in Milan and
between 1791 and 1796 was in Rome, where he
frequented the Accademia di San Luca and won
a first prize in composition. He then went to
Brescia and to Paris, where he exhibited at the
Salon from 1802 to 1804. Returning to Milan,
he entered the service of the viceroy of Italy,
Eugène de Beauharnais (1781–1824), whose por-
trait he painted. He also worked in enamel and
illustrated The Corsair by Byron and other works.

206
Portrait of a Woman, Said to Be Pauline Borghese (1780–1825)

Ivory, diam. 2⅝ in. (66 mm)
Signed (right, in brown): Gigola / F
Bequest of Collis P. Huntington, 1900 (26.168.33)

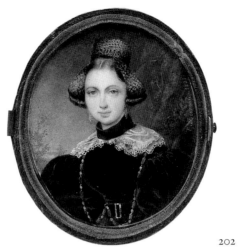

202

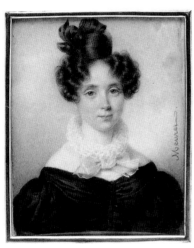

203

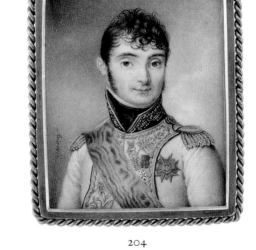

204

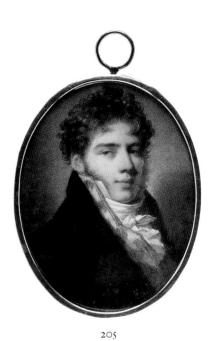

205

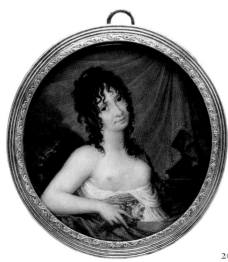

206
COLOR PLATE PAGE 59

Giovanni Battista Gigola (*continued*)

Wearing a white shift held by a gold sash and a pink shawl. Brown eyes; black hair. Seated in a green-backed chair, holding a bunch of flowers. Beige curtain in background.

A cut backing card is lettered *MR. CLARENCE W. S . . . / HAS REMOVED HIS OFFICES . . . / No. 12 EAS . . .*

CONDITION: The painted surface is fresh and undamaged. The weeping glass was replaced.

LITERATURE: *A Catalogue of Miniatures in the Collection of Collis P. Huntington* (New York, 1897), ill., as a portrait of Marie Pauline Bonaparte, Princess Borghese.

PAULINE BONAPARTE, sister of Napoléon I, married first in 1801 General V. E. Leclerc (1772–1802) and second in 1803 Prince Camillo Borghese (1775–1832). Thereafter she lived in Neuilly and in Rome. She died in Florence.

Luigi Marta

Italian (Neapolitan), 1790–1858

Marta was born in Aversa, near Naples, in 1790, and died in Milan on January 25, 1858. He worked in Naples and Milan, and from what little is known of his miniatures, he was much influenced by French practice.

207
Napoléon I (1769–1821) *on Horseback*

Ivory, 5¾ x 7½ in. (146 x 191 mm)

Signed and dated (lower left, in brown): [*Lu*]*igi Marta f: 18*[*30?*]

Gift of Gloria Zicht, 1992 (1992.104)

Wearing the green uniform with red piping of a colonel of the *chasseurs à cheval*, with, among others, the badges of the Légion d'Honneur and the Grand Eagle of the Légion d'Honneur. The gilt surround and frame with appliqués in the shape of the initial N and various imperial devices are original.

CONDITION: The ivory tablet is approximately one eighth of an inch thick. In general the colors are fresh and bright, and the figure of Napoléon and his mount are in good condition. There was extensive crazing in the heavily glazed foliage and sunset in the background, however, and some small losses at top center. The crazing has been consolidated and the losses toned. There is also slight

moisture damage at the center left edge. A ragboard spacer and mount have been supplied. The frame's velvet covering had lost its nap and has been replaced with silk moiré of a similar color. A missing ormolu mount was replaced.

LEO R. SCHIDLOF (*The Miniature in Europe* [Graz, 1964], vol. 2, p. 535) records only two portrait miniatures by Marta, one of which is similarly signed, inscribed *Napoli*, and dated 1823. It may be recalled that when Marta was young, Napoléon's sister Caroline and her husband, Joachim Murat, had briefly (1808–15) been king and queen of Naples.

Although the date is not clear, the miniature is certainly posthumous. It shows Napoléon as he looked in about 1810 and is probably a product of the revival of the cult of the emperor which gathered strength from the 1830s.

F. Carbonara

Italian, early 19th century

208
Portrait of a Woman

Ivory, diam. 2⅝ in. (66 mm)

Signed (right edge, in gray): *F⁰ Carbonara*

The Collection of Giovanni P. Morosini, presented by his daughter Giulia, 1932 (32.75.7)

Wearing a white dress with a brooch and fur-edged green gown. Brown eyes; black hair. Gray background.

The miniature is in the lid of a tortoiseshell-lined wooden box with tortoiseshell mounts.

CONDITION: The condition is good despite several small losses in the fur and gown.

NO ARTIST with the name Carbonara is recorded in Thieme-Becker or by Leo R. Schidlof.

Carl August Senff

German, 1770–1838

Senff was born near Merseburg. He studied in Leipzig and Dresden, becoming a pupil of Anton Graff (1736–1813) and Christian Leberecht Vogel (1759–1816). He taught at the university at Dorpat from 1803 and died there in 1838.

209
Portrait of a Woman

Ivory, 2⅜ x 2 in. (60 x 50 mm)

Signed and dated (right edge, in black): *C.Senff.fec.1808*

Bequest of Mary Clark Thompson, 1923 (24.80.511)

Wearing a blue dress, white shift and collar, and white bonnet with blue ribbon. Gray eyes. Gray background.

Friedrich Johann Gottlieb Lieder

German, 1780–1859

Lieder was born in Potsdam. After making his debut at the Berlin Academy he studied at the École des Beaux-Arts in Paris and became a pupil of Jacques Louis David (1748–1825). From about 1810 he worked in Vienna and was a protégé of Metternich, who sent him to Paris to learn lithography. In 1816 Lieder became a painter to the Prussian king Frederick William III (1770–1840) in Berlin. He exhibited at the Vienna Academy from 1822 until 1830, becoming a member in 1824 and later a counselor. He died in Budapest.

The portrait below and the related engravings give testimony to the strength of the relationship between Metternich and the artist.

210
Prince Klemens Wenzel Lothar von Metternich (1773–1859)

Card laid on recent support, 8¾ x 6¾ in. (224 x 172 mm)

Signed and dated (right, in black): *Fr: Lieder. / pinxit 1822.*

Fletcher Fund, 1941 (41.67)

Wearing a blue coat, white waistcoat and cravat, the ribbon and badge of the Order of the Golden Fleece, the ribbon and badge of the Order of Saint Stephen, and the ribbon and badge of the Civilian Cross of Honor of 1813–14. Blue eyes; graying brown hair. Sky background.

The miniature is in a folding case of blind-tooled green leather. The case was originally stiffened with a metal plate.

EX COLL.: Ernest H. Marso, New York (until 1941).

CONDITION: The condition is good though there is some water damage at the lower right edge.

EXHIBITED: Metropolitan Museum of Art, 1950, *Four Centuries of Miniature Painting*, list, p. 10.

207
COLOR PLATE PAGE 58

208

209

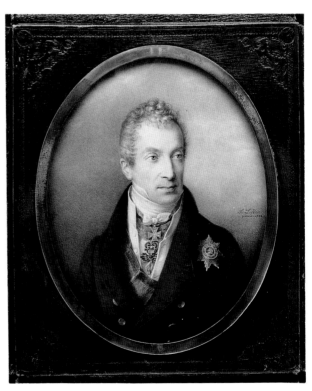

210
COLOR PLATE PAGE 60

Friedrich Johann Gottlieb Lieder
(*continued*)

A RELATED engraving in reverse is lettered *Metternich F. Lieder gez. Hugel*[?] *und F. Ströber gest. in Stahl Wien 1839. Nach dem Leben gezeichnet* (Metternich drawn by F. Lieder engraved in steel by Hugel[?] and F. Ströber Vienna 1839. Drawn from life). Lieder himself made a lithograph in reverse, but with the badge on the left shoulder, which is contemporaneous with, but independent of, this miniature.

Metternich, Austrian foreign minister, ambassador, and chancellor, was among the greatest statesmen of the nineteenth century. At the Congress of Vienna in 1815 he secured a leading role in Europe for the Hapsburg empire of Franz II (1768–1835). He fell from power during the constitutional revolutions of 1848.

Josef Heigel

German, 1780–1837

Josef Heigel was born in Munich in 1780. After studying at the Munich Academy, he went to Paris, where he exhibited miniatures at the Salon from 1817 until 1837. His son Franz Napoleon Heigel (no. 212) was also a miniaturist.

Attributed to Josef Heigel

211
Lola Montez (1818–1861)

Ivory, 2½ x 2⅛ in. (65 x 54 mm)
Signed (left edge, in black): *Heigel.*
Gift of Helen O. Brice, 1942 (42.53.3)

Wearing a purple dress with white lace collar. Gray eyes; brown hair dressed with a tortoiseshell comb. Sky background.

The backing is inscribed in ink in a recent hand *Lola Montez / Maitresse König Ludwig / v[on] Bayern.* (Lola Montez mistress of King Ludwig of Bavaria).

CONDITION: The miniature is in very good condition.

IN 1953 Leo R. Schidlof, while remarking that it is difficult to distinguish between the work of Josef Heigel and that of his son Franz Napoleon Heigel, considered this miniature the work of the elder Heigel.

Although the identity of the sitter has been questioned on grounds of costume, the miniature bears a striking resemblance to other authenticated portraits of Lola Montez. If the costume is correctly dated before 1840, the portrait was painted before she became the mistress of Ludwig I and could be by Josef Heigel. If these indications are misleading, the miniature would have been painted in Munich after Josef's death by his son Franz Napoleon.

Lola Montez (1818–1861) was born Marie Dolores Gilbert in Limerick, Ireland. She had an adventurous career as a dancer and captivated Ludwig I of Bavaria (1786–1868) on her visit to Munich in 1847. She was his mistress until he was forced to abdicate in 1848. She died in New York in 1861 and is buried in Greenwood Cemetery, Brooklyn.

Franz Napoleon Heigel

German, 1813–1888

Franz Napoleon Heigel, the son of Josef Heigel (no. 211), was born in Paris. After studying with his father and at the Munich Academy, he became the pupil of Jean Urbain Guérin (nos. 171–72) in Paris and exhibited at the Salon from 1833 to 1835. He settled in Munich about 1846 and became painter to Ludwig I (1786–1868; reigned 1825–48) and his grandson Ludwig II (1845–1886; reigned 1864–86), kings of Bavaria. He died in Munich.

212
Henriette Sontag (1806–1854)

Ivory, 2⅞ x 2⅜ in. (73 x 60 mm)
Signed (left edge, in black): *F[r] Heigel*
Gift of Mrs. Thomas Hunt, 1941 (41.191.3)

Wearing a gold-brocaded dress with brown bodice; gold and amethyst brooch and earrings. Gray eyes; brown hair. Dark gray background.

When the miniature was received in the Metropolitan Museum, the inscription was read as *Fr. Heigel 18[]s.*

The backing card has the recent inscription in pencil *Heigel / Mme Sontag.*

CONDITION: The miniature is in very good condition. Discolored silver leaf on the reverse of the ivory was removed and replaced with a piece of tinfoil.

THE GERMAN-BORN soprano Henriette Sontag (1806–1854) was, as Mlle Sontag, a renowned opera singer. She made her debut in Vienna in 1822 and in 1823 created the title role in Weber's *Euryanthe*. In the late 1820s she secretly married Count Rossi, the Sardinian ambassador to the Dutch court. She performed in Europe and America and died in Mexico City while on tour. This miniature may date about 1835.

Dupuy

German(?), active about 1801–17

A number of enamels executed between 1801 and 1817 and signed *Dupuy* are known. Leo R. Schidlof (*The Miniature in Europe* [Graz, 1964], vol. 1, p. 227) suggests that the artist may have been Nicolas Bernard Dupuy, a goldsmith from Metz who worked from 1773 and went to Geneva, but this identification is not certain.

213
Margaret Rieche Richard

Enamel, diam. 2⅛ in. (54 mm)
Bequest of Georgiana Emily Reynolds, 1918 (18.73)

Wearing a brown dress and a white shift and cap with a blue ribbon. Brown eyes. Gray background.

EX COLL.: By descent in the Richard family.

THE SITTER is Margaret Richard, née Rieche, of Geneva, the great-grandmother of the donor.

The miniature is unsigned, and the attribution to Dupuy of Geneva was made in 1952 by Schidlof. It seems plausible when this work is compared with an enamel signed by the artist and dated 1815 (Leo R. Schidlof, *The Miniature in Europe* [Graz, 1964], vol. 3, pl. 191, fig. 357).

Jacob Ritter von Hartmann

German, 1795–1873

Hartmann, a dilettante miniature painter, became a general in the Bavarian infantry. He died in Würzburg.

214
Ali Pasha (born about 1741, died 1822)

Ivory, 4⅛ x 3¼ in. (105 x 84 mm)
Signed and dated (left edge, in red): *htn. 22*
The Moses Lazarus Collection, Gift of Josephine and Sarah Lazarus, in memory of their father, 1888–95 (95.14.52)

Wearing a gold-embroidered red robe, brown embroidered sash, blue embroidered neck scarf, light brown coat with fur lapels, and brown crown with gold bars. Blue eyes; white mustache and beard. Yellow-brown background.

The ivory is irregular at the top and bottom and has been made up to an oval by being laid on a card.

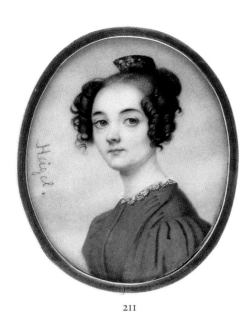

211

COLOR PLATE PAGE 62

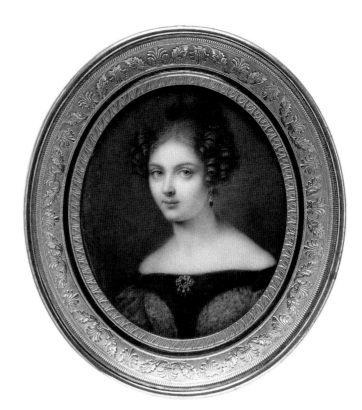

212

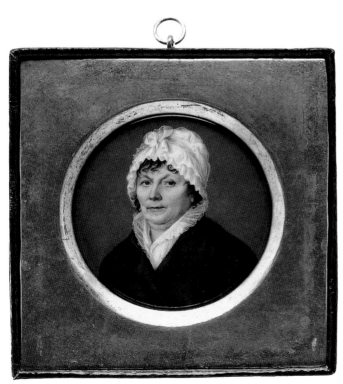

213

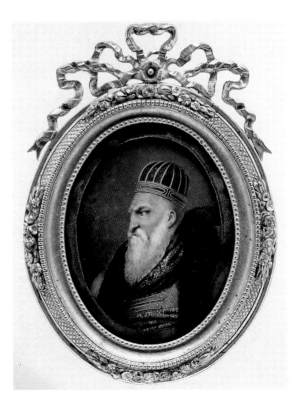

214

COLOR PLATE PAGE 62

Jacob Ritter von Hartmann (*continued*)

The back is inscribed in pencil in a recent hand *Ali Pascha / of Djuernni*[?].

THE SIGNATURE on this miniature is in the same form as that on a work by Hartmann shown at the *Miniaturen–Ausstellung*, Munich, 1912, which was signed *Htn. 9/20* (Thieme-Becker, vol. 16 [1923], p. 81).

Ali Pasha, called the Lion of Yanina, was a Turkish brigand who became the despotic ruler of much of Albania, Epirus, Macedonia, Thessaly, and the Morea, with his court at Ioannina. Byron visited him in 1809 and described their meeting in *Childe Harold's Pilgrimage*. Ali Pasha was murdered on February 5, 1822.

Heinrich Franz Schalck

German, 1791–1832

Born in Mainz, Schalck was the son of a painter. He worked chiefly in Frankfurt am Main until 1825 and then in Karlsruhe, where he died.

215
Joseph and Karl August von Klein

Ivory, 4⅝ x 5⅛ in. (117 x 131 mm)
Signed (lower right, in white): *Schalck / pinx.*
The monument is inscribed in gold *antonio a Klein / Hoc · pietat · monim- / tum · posuere fil · Carol / et frat. Josep Monati* and also *Leben / der Di*[. . .].
Book on the piano is inscribed in gold *Anton / von / Klein / Leben*, and dog's collar is inscribed *C.A.vK.* Sheet music is inscribed *Allegro mod* . . .
The Moses Lazarus Collection, Gift of Josephine and Sarah Lazarus, in memory of their father, 1888–95 (95.14.85)

Interior of a study. Joseph von Klein, the older man, stands in the center with his left arm around the shoulders of his nephew Karl August (1774–1870). Joseph was the brother and biographer, and Karl August the son, of Anton von Klein (1748–1810), to whom the monument is dedicated. The literary biography to which reference is made in the pencil inscription is displayed on the piano. A church tower is visible through the window on left. There is a Freemasonry symbol in lower left corner.

The backing removed from the reverse of the ivory is inscribed in pencil: *Mr Charles Auguste de Klein / fils unique d'Antoine de Klein avec / son oncle Joseph, auteur de la vie / littéraire d'Antoine de Klein, dont le portrait / se trouve* — - (Mr. Karl August von Klein, only son of Anton von Klein, with his uncle Joseph . . .).

CONDITION: The miniature came to the Museum in what was probably the velvet inner liner of a folding case. It was glued into the well of the liner, which is slightly warped, and was not covered with glass. The painted surface is nevertheless in good condition despite a chip near the upper left corner and a crack extending to the edge of the painted window jamb. The damage was stabilized with adhesive and small losses toned. When the miniature was removed from the liner, several laid-paper backings were found, the outermost of which is inscribed. The well was cleared to give the ivory more room, then covered with cotton blotting paper and a piece of Ethafoam, and edged with ribbon. A convex cover glass was supplied.

LITERATURE: Leo R. Schidlof, *The Miniature in Europe* (Graz, 1964), vol. 2, p. 721.

ANTON VON KLEIN, a philologist and writer, had been a professor at Mannheim.

This composition gives a comprehensive view of cultivated German city life. It illustrates the range of the interests of the family. Karl August paints a watercolor landscape; a musical composition is on the piano. The barometer at left and the microscope on the piano indicate scientific interests. The books include works by Buffon as well as by Horace, Voltaire, and Tasso. The symbol of Freemasonry also marks the sitters as enlightened German citizens. This miniature may be dated about 1810–15.

Mikail Ivanovich Terebenev

Russian, 1795–1866

Terebenev was born in St. Petersburg and was a pupil at the academy there from 1803. He became an associate academician in 1824 and a full academician in 1830. He died in St. Petersburg.

216
Portrait of a Woman

Ivory, 2⅞ x 2¼ in. (72 x 57 mm)
Signed (right edge, in black, in Russian):
 M. Terebenev
Gift of Humanities Fund Inc., 1972 (1972.145.10)

Wearing a pink dress with white puffed sleeves; gold earrings with blue jewels. Blue eyes; black hair dressed with a gold tiara set with blue jewels. Gray background.

The miniature was later laid on card, which is inscribed in pencil *M. Terebeneff / Portrait of a Lady / about 1815.*

EX COLL.: Boris Bakhmeteff, New York (until 1972).

THE DATE given in the inscription on the back is somewhat too early; it is more nearly about 1830.

Ivan Konstantinovich Aivazovsky

Russian, 1817–1900

Aivazovsky was born in the Crimea and studied at the academy in St. Petersburg, of which he later became a member. He traveled widely, visiting Italy, Asia Minor, the Greek Islands, and the United States. He was a prolific and extremely talented marine and landscape painter.

217
A Ship in a Stormy Sea

Card, 1 x 2 in. (26 x 53 mm)
Signed (lower right, in black): *A*
Inscribed (reverse, in ink): *Aivasovsky / 1892.*
Gift of Isabel F. Hapgood, 1913 (13.130)

THE DONOR'S visiting card, much larger than this seascape, is kept with the miniature. It was presumably painted as a gift in recognition of Isabel Hapgood's hospitality when the artist visited the United States. Aivazovsky's *View of New York* (1893) was sold at Christie's, London, October 5, 1989, no. 247.

Luis de la Cruz y Rios

Spanish, active by 1815, died 1850

Luis de la Cruz y Rios was born at Santa Cruz de Tenerife, Canary Islands, and sometimes signed his works Canario. He settled in Madrid in 1815 and became painter to Ferdinand VII (1784–1833). He died in Malaya.

218
Princess María Francisca de Asis de Borbón and Her Son Infante Carlos Luis María Fernando de Borbón

Ivory, obverse and reverse each 2¼ x 1¾ in. (57 x 47 mm)
Signed, dated, and inscribed (reverse, in blue): (bottom) *LC. á.1818*; (top) *Á los 40 · dias*
Gift of Mrs. John LaPorte Given, 1945 (45.110.4)
Princess María (1800–1834): wearing a white dress with the purple and white ribbon of the Order of Queen Maria Luisa and the pink ribbon of an

215

COLOR PLATE PAGE 61

216

217

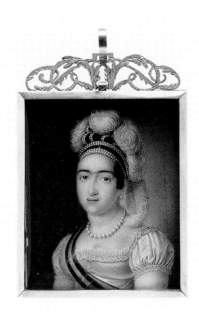

218

COLOR PLATE PAGE 59

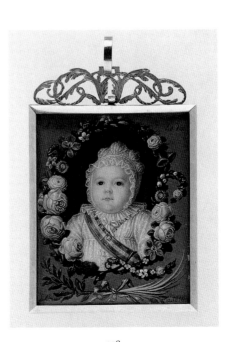

218

COLOR PLATE PAGE 59

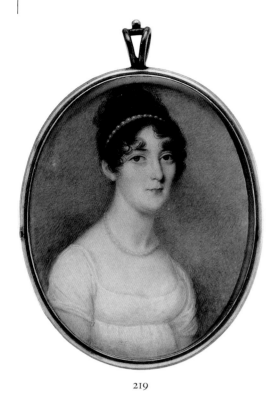

219

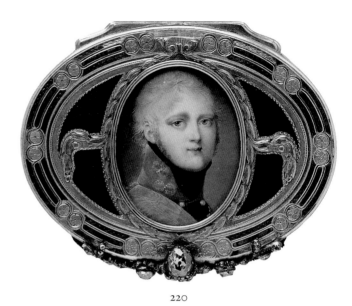

220

Luis de la Cruz y Rios (*continued*)

unidentified order. Brown eyes; black hair; white ostrich plumes; pearl earrings and necklace.

Infante Carlos Luis (1818–1861), seen in floral garland: wearing a white frock and bonnet and the collar of the Golden Fleece over the blue and white ribbon of the Order of Charles III and the orange ribbon of an unidentified order. Brown eyes.

The miniatures are framed back to back in a gilt metal mount with a decorative cresting.

EXHIBITED: Metropolitan Museum of Art, 1950, *Four Centuries of Miniature Painting,* list, pp. 9–10.

THE SITTERS are María Francisca de Asis de Borbón, princess of Portugal, and Infante Carlos Luis María Fernando de Borbón, later conde de Montemolin. The baby, elder son of Infante Carlos María Isidro de Borbón (1788–1855) and his niece, Princess María, was born in Madrid on January 31, 1818. It has been suggested that the inscription *Á los 40 dias* refers to his receipt of the Order of the Golden Fleece when forty days old. He was the nephew of Ferdinand VII (1784–1833), king of Spain; both he and his father were pretenders to the throne in 1833.

Seven miniatures by Cruz from the later 1820s representing the brother-in-law and uncle of the sitters, Infante Francisco de Paula de Borbón (1794–1865), his wife, Luisa Carlota, princess of the Two Sicilies (1804–1844), and five of their children were sold at Sotheby's, London, on May 28, 1992 (nos. 178 and 179).

Thomas Hazlehurst

British, born about 1740, died about 1821

Hazlehurst was born in Liverpool and practiced as a miniaturist in that city all his life. He exhibited at the Society for Promoting Painting and Design in Liverpool in 1787 and at the Liverpool Academy from 1810 to 1812. He made a large number of paintings of the flora of Lancashire.

219
Agnes Sewell

Ivory, 3 x 2⅜ in. (75 x 60 mm)
Signed (lower right, in brown): *T · H*
Gift of Elise Shackelford Black, 1945 (45.95)

Wearing a white dress and pearl necklace. Gray eyes; dark brown hair dressed with pearls. Sky background.

The frame is glazed at the back to reveal four locks of brown hair, with a few light strands, bound with gold wire on black fabric background.

EX COLL.: By family descent.

THE SITTER, painted perhaps about 1800, was the great-great-grandmother of the donor. She was a native of Liverpool.

Edward Miles

British, 1752–1828

Miles was born in Yarmouth and began studying at the Royal Academy in 1772. He was appointed miniature painter to Frederica, duchess of York and later, in 1794, to Queen Charlotte (1744–1818). After going to Russia in 1797, he became court painter to Alexander I (1777–1825) and worked there until about 1806. In 1807 he settled in Philadelphia, where he was a founding member of the Society of Artists of the United States. Miles died in Philadelphia.

220
Alexander I (1777–1825), *Emperor of Russia*

Ivory, 1⅝ x 1¼ in. (41 x 33 mm)
Gift of J. Pierpont Morgan, 1917 (17.190.1185) ESDA

Wearing a black uniform jacket with red collar and gold lace and black neckband and the blue ribbon and badge of the Order of Saint Andrew. Hazel eyes; fair hair. Gray background.

The miniature is set in the lid of a gold-and-enamel box made by Jean George in Paris in 1763–64. The box is inscribed on the rim GEORGE.A.PARIS and bears four marks, among them the maker's mark and the Paris mark for 1763–64.

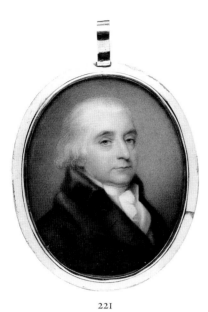

221

222

Inside the box is a label printed *2364* and inscribed in ink *3519*.

THE PORTRAIT, which is some forty years later than the box, shows the emperor at the time of his accession in 1801. Comparison with a miniature by Edward Miles (Anne Hollingsworth Wharton, *Heirlooms in Miniatures* [Philadelphia and London, 1898], ill. opp. p. 210, then in the Edward S. Miles collection, Philadelphia) indicates that the present work is also by him.

Alexander I was the grandson of Catherine the Great (no. 114).

Henry Bone

British, 1755–1834

Bone was born in Truro, Cornwall, the son of a cabinetmaker. He was apprenticed as a china-painter, but after the failure of the Bristol factory where he was working, he settled in London about 1779. The greater part of his output consisted of copies in enamel of old master and contemporary paintings, but he painted a few portraits *ad vivum*. He exhibited at the Royal Academy from 1781 until 1834 and was named a royal academician in 1811. He served as enamel painter to George III, George IV, and William IV, and he often incorporated references to these and similar appointments in the lengthy inscrip-

tions he wrote in the enamel on the back of his miniatures. He died in London.

221
Henry Hope (1735/36–1811), *after Jones*

Enamel, 2⅛ x 1¾ in. (54 x 43 mm)

Signed (right edge, in black): *HBone* [*HB* in monogram]

Inscribed (reverse, in black on blue enamel): *Henry Hope Esq.ʳ / Henry Bone pin[x] / April 1802*

Bequest of Mary Clark Thompson, 1923 (24.80.521)

Wearing a blue-gray coat with a black collar, yellow waistcoat, and white shirt and cravat. Gray eyes; white hair. Gray background.

EXHIBITED: Metropolitan Museum of Art, 1950, *Four Centuries of Miniature Painting,* list, p. 9.

AN EXTREMELY wealthy banking and trading family of Scottish origin, the Hopes had long been settled in Amsterdam but returned to England with the approach of the French army in 1794. Henry Hope is not to be confused with his cousin Henry Philip Hope (1774–1839), whose portrait in enamel by Bone was exhibited at the Royal Academy in 1803 as no. 629 and for whom the Hope diamond was named.

The miniature is apparently after a painting, whose present location is not known, by the young George Jones, R.A. (1786–1869).

The National Portrait Gallery, London, has two drawings by Bone of Henry Hope. A squared pencil drawing (vol. 3, 2f) is inscribed *Henry Hope Esq — Nov 1804.* A slightly larger version in ink on transparent paper (vol. 2, 96f) is inscribed *Mʳ Hope after Jones / for Miss Metcalf / April 1819.* (Information about these two drawings and the drawings referred to in connection with catalogue nos. 222–26 was kindly supplied by Richard Walker, whose catalogue of drawings by Henry Bone in the National Portrait Gallery is scheduled for publication in the Walpole Society's annual volume for 1996.)

222
Thomas Howard (1585–1646), *Second Earl of Arundel, after Rubens*

Enamel, 7¼ x 5¾ in. (185 x 147 mm)

Inscribed (reverse, in black on blue enamel): *The Earl of Arundel / London Janʸ 1808. / Painted by Henry Bone ARA. / Enamel Painter to his R.H. the / Prince of Wales, for Lord / Frederick Campbell, after / the Original by Rubens.*

The Moses Lazarus Collection, Gift of Josephine and Sarah Lazarus, in memory of their father, 1888–95 (95.14.82)

Wearing armor with a white falling collar and a medallion on a chain around his neck. Brown eyes; brown hair, mustache, and beard. Gray-blue background.

The original ormolu mount is stamped (lower right): *ENAMEL HBONE* [*HB* in monogram] *R.A.*

CONDITION: The enamel was covered with a superficial haze which was softened and polished off. Under a stamped ormolu mount it was in a newer black frame but with the original wooden backing to which the inscribed laid paper was attached (it has now been separated). The enamel has a pronounced convex lift and within the space were a piece of tissue paper and a lamb's wool pad. This was probably the original arrangement.

EXHIBITED: Royal Academy, London, 1808, no. 363.

A SIMILAR inscription on paper attached to the back of the frame, probably in the artist's hand, adds the information that the Rubens portrait was in the possession of Lord Frederick Campbell and that Henry Bone was enamel painter in ordinary to George III. (Rubens's oil sketch of 1629 is now in the National Portrait Gallery, London.)

Thomas Howard, earl of Arundel, was a courtier and collector, especially of antique sculpture (the Arundel marbles, now in the Ashmolean Museum, Oxford) and of works by Holbein.

The National Portrait Gallery, London, has Bone's squared pencil drawing (vol. 2, 14a). The inscription differs from those above in stating: *for Lord F. Campbell— Sep.ᵗʸ 1807* [ink line drawn through date]. *1808. / & for Lord Suffolk—1808 / The Original—Lord F. Campbell.*

223
George IV (1762–1830) *as Prince Regent, after Lawrence*

Enamel, 2½ x 2 in. (64 x 49 mm)

Signed (left, in gray): *HB* [monogram]

Inscribed (reverse, in pink on white enamel): *His R.H. the / Prince Regent— / London March . 1816 . / Painted by Henry Bone R.A. / Enamel painter in Ordinary / to His Majesty & Enamel / painter to H.R.H. the / Prince Regent after the / Original by Sir Tho: / Lawrence R.A. &c*

Bequest of Collis P. Huntington, 1900 (26.168.61)

Wearing a field marshal's red uniform jacket with black cravat, gold-embroidered black collar, white shirt, and badges of the Orders of the Golden Fleece, the Garter, the Black Eagle, and the Saint-Esprit. Blue eyes; dark hair. Gray-brown background.

CONDITION: There are firing flaws at the lower edge.

EXHIBITED: Metropolitan Museum of Art, 1950, *Four Centuries of Miniature Painting*, list, p. 9.

LITERATURE: *A Catalogue of Miniatures in the Collection of Collis P. Huntington* (New York, 1897), ill.

THE PORTRAIT by Lawrence from which this is copied is probably that painted for Lord Charles Stewart, afterward third marquis of Londonderry, and exhibited (as no. 65) at the Royal Academy in 1815 (Kenneth Garlick, *Sir Thomas Lawrence* [Oxford, 1989], no. 325[c]).

There are eight comparable enamels by Bone in the Royal Collection (Richard Walker, *The Eighteenth and Early Nineteenth Century Miniatures in the Collection of Her Majesty the Queen* [Cambridge, 1992], nos. 757–64, ills.).

The National Portrait Gallery, London, has Bone's large squared drawing (vol. 1, 81) of the complete portrait; it measures 14 by 9½ in. (356 x 241 mm) and is inscribed *Prince Regent 1816*. An enamel copy of the full composition, described as "the largest enamel portrait ever painted," was in the Bone sale (1832, no. 70); its present location is not known.

224
Matthew Baillie (1761–1823), *F.R.S., after Hoppner*

Enamel, 5⅛ x 4 in. (130 x 103 mm)

Inscribed (reverse, in pink on bluish-white enamel): *Mathew Baillie M.D. / Born October 27ᵗʰ. 1761. / London / July, 1817. / Painted by Henry Bone RA. / Enamel painter in Ordinary to / His Majesty, & Enamel painter / to His R.H. the Prince Regent, / after the Original by John Hoppner / R.A.*

Bequest of Mary Clark Thompson, 1923 (24.80.503)

Wearing a gray coat and white shirt. Brown eyes; gray hair. Seated in a green-backed chair. Red curtain in background.

The original ormolu mount is stamped (lower right): *ENAMEL HBONE* [*HB* in monogram] *RA.*

CONDITION: The enamel was covered with a superficial haze which was softened and polished off. It was in its ormolu mount, set in a paper-covered wooden sink mat. The enamel has a pronounced convex lift. A wooden frame was supplied.

MATTHEW BAILLIE was born in Lanarkshire. He was the nephew and heir of Dr. William Hunter (1718–1783), anatomist and surgeon-accoucheur, and himself made many contributions to the study of morbid anatomy. He was physician extraordinary to George III (1738–1820). He inherited William Hunter's Museum, now the Hunterian Art Gallery in Glasgow. This miniature was painted for his wife, Sophia, née Denman.

The painting by John Hoppner (1758–1810) from which it is copied is in the Hunterian Art Gallery, Glasgow.

The National Portrait Gallery, London, has Bone's squared pencil drawing (vol. 3, 13a). The inscription adds to that recorded above: *for Mʳˢ. B–Janʸ. 1810.*

225
Charles X (1757–1836), *King of France, after Gérard*

Enamel, 14¼ x 10¼ in. (364 x 260 mm)

Signed (in the enamel, at the foot of the throne): *HBone* [*HB* in monogram]

Inscribed (reverse, in enamel): *Charles Xᵗʰ King of France / The Original Picture by Gerard and / graciously given by His Most / Christian Majesty to E.M. Maᵗᶜchioness / Dowager of Salisbury by whom it was / with heartfelt gratitude received in / December 1826. / London / October 1829. / Painted by Henry Bone R.A. Enamel painter to / His Majesty and to the late King and the late / Duke of York &c &c — After the Original by - Gerard.*

Bequest of Mary Clark Thompson, 1923 (24.80.523)

Wearing blue robes with gold-embroidered fleurs-de-lis and ermine trim and lining. Holding a sceptre the end of which rests beside his crown on a purple cushion on a low stool. Gray hair. Red curtains, a throne, vaulted hall, and pedestal in the background.

CONDITION: The convex copper support is uneven with a fine firing crack across the center. The surface was covered with a cloudy white residue which was softened and polished off.

EXHIBITED: Royal Academy, London, 1832, no. 491.

LITERATURE: Janet S. Byrne, "The Best Laid Plans," *Metropolitan Museum Bulletin*, n.s., 17 (1959), p. 194, ill. p. 195; Daphne Foskett, *A Dictionary of British Miniature Painters* (New York and Washington, D.C., 1972), vol. 1, p. 172.

CHARLES X, grandson of Louis XVI, succeeded his brother Louis XVIII as king of France in 1824. He took refuge in England in 1830, abdicating in favor of Louis-Philippe.

The portrait by François Pascal Gérard (1770–1837) is in the collection of the marquis of Salisbury, Hatfield House.

The National Portrait Gallery, London, has Bone's squared pencil drawing, inscribed *Charles 10ᵗʰ — King of France* and *Gerard pinxᵗ.* An enamel version, signed and dated 1829, was in the Bone sale (1836, no. 38, bought by Henry [Pierce?] Bone for 25½ guineas).

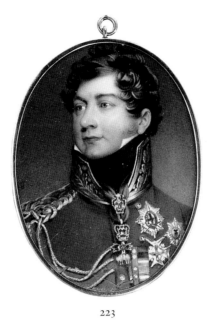

223

224

225

COLOR PLATE PAGE 63

Henry Bone (*continued*)

226
Algernon Percy (1602–1668),
Tenth Earl of Northumberland,
after Van Dyck

Enamel, 7 x 5⅜ in. (178 x 136 mm)

Inscribed (reverse, in enamel): *Algernon Percy— Earl of Northumberland. / London / May .1827. Painted by / Henry Bone R.A. Enamel-painter to His Majesty and / Enl. painter to His R.H. the late Duke of York; &c &c —After the Original by Vandyke, in the possession of the Rt. Honble the Earl of Essex / Cassiobury Park / Herts.* And in ink, apparently also by the artist and to the same effect, with the addition of the address: *No. 15, Berners Street / London*

The Moses Lazarus Collection, Gift of Josephine and Sarah Lazarus, in memory of their father, 1888–95 (95.14.47)

Wearing a breastplate, gold-colored doublet lined with pink, white shirt with falling collar, and blue sash of the Order of the Garter. With a sword and baton and leaning on an anchor. Brown eyes; light brown hair and mustache. Masonry, sea and sky background.

The original ormolu mount is stamped (lower right): *ENAMEL.HBONE.* [*HB* in monogram] *R.A.* The frame may also be original. It has a keyhole, once supported a glass, and is hinged to the mount.

EX COLL.: Lord Northwick; unidentified sale, no. 105 (label attached to enameled back).

ALGERNON PERCY, earl of Northumberland, was a collector and one of Van Dyck's most important patrons. Charles I appointed him admiral of the fleet in 1636 and lord high admiral in 1638, but he grew increasingly dissatisfied with the king's policies and in 1642 deserted the Royalist cause.

The full-length portrait by Anthony van Dyck (1599–1641) is now in the collection of the Duke of Northumberland at Alnwick. The sitter's elbow rests upon an anchor.

Bone's squared pencil drawing is in the National Portrait Gallery, London (vol. 1, 69a). It follows the Van Dyck full-length in showing clouds around the sitter's left hand, which were not carried over into the enamel. Its inscription adds to those recorded above: *Mr. Ord.* The Mr. Ord for whom this was painted may have been Craven Ord (1756–1832), an antiquary and student of sepulchral brasses.

Adam Buck

Irish, 1759–1833

Born in Cork, Buck was the son of a silversmith. He settled in London in 1795 and exhibited until 1833. As well as painting miniatures he made a number of watercolor designs for the sentimental engravings popular at the beginning of the nineteenth century. In 1811 Buck published the illustrated work *Paintings on Greek Vases.* He died in London.

227
Portrait of a Woman, Said to Be
Emma (1765–1815), *Lady Hamilton*

Ivory, diam. 1¼ in. (32 mm)
Dated (right edge, in black): *NOV 15 1804*
The Moses Lazarus Collection, Gift of Josephine and Sarah Lazarus, in memory of their father, 1888–95 (95.14.81)

In profile. Blue eyes; dark brown hair. Sky background.

The miniature is set in a richly jeweled frame of similar form to a watch case, the back of which opens to show a glazed inner back with the initials EH in seed pearls on brown hair.

THE FAMOUS Emma (1765–1815), Lady Hamilton, became in 1781 the wife of Sir William Hamilton, British envoy at Naples, and later the mistress of Lord Nelson.

The description of this work as a portrait of her is given plausibility by the initials EH in the back of the case. While the miniature was in the Lazarus collection, a photograph of it was sent to the statesman William E. Gladstone, who forwarded it to the publishers for reproduction in a life of Emma Hamilton (Hilda Gamlin, *Emma, Lady Hamilton: An Old Story Re-Told* [London, 1891], ill. p. 178). A photograph of the present work is filed without comment with portraits of Emma, Lady Hamilton, in the archives of the National Portrait Gallery, London; Richard Walker, however, does not believe that it represents her.

E. G. Paine, in 1965, proposed the correct attribution of this miniature to Adam Buck.

Sampson Towgood Roch

Irish, 1759–1847

Roch (or Roche), who was a deaf-mute, was born in Youghal, Ireland. He studied in Dublin and worked there for a time, moving in 1792 to Bath where he had a good connection. He exhibited at the Royal Academy in 1817. On

retirement he returned to County Waterford, where he died.

228
Portrait of a Girl

Ivory, 2¼ x 1⅞ in. (58 x 48 mm)
The Moses Lazarus Collection, Gift of Josephine and Sarah Lazarus, in memory of their father, 1888–95 (95.14.72)

Wearing a white dress and light pink sash. Light brown eyes; fair hair. Gray-blue background.

The back of the frame has a tress of fair plaited hair enclosing an oval of translucent white glass over tinsel set with the gold monogram MY or possibly RMY.

ON RECEIPT in the Metropolitan Museum, this miniature was described as the work of an unknown British artist of the nineteenth century. In 1952 Leo R. Schidlof attributed it to S. T. Roche. The sense of an incipient smile and the pronounced drawing under the eyes are customary features of that artist's style. The miniature may be dated about 1790.

Charles Robertson

Irish, born about 1760, died 1821

The son of a jeweler, Robertson was born in Dublin. He began his artistic career by executing designs and portraits worked in hair. He first exhibited miniatures in 1775. He worked in London from 1785 until 1792 and then returned to Dublin, where he was a leader of the Hibernian Society of Artists.

Robertson's elder brother Walter (born about 1750, died 1802) accompanied Gilbert Stuart (1755–1828) to America in 1793 and made miniatures of Washington and other prominent citizens before proceeding to India.

229
Portrait of a Man

Ivory, 2½ x 2 in. (61 x 50 mm)
Bequest of Millie Bruhl Fredrick, 1962 (62.122.61)

Wearing a blue coat and white waistcoat, shirt, and cravat. Blue eyes; fair hair. Greenish gray-brown background.

The back of the gilt metal frame is engraved *Chas Robertson / 1810.* This inscription conveys the correct authorship of this miniature.

CONDITION: The condition of the painted surface is good, with minor water damage around the perimeter.

LITERATURE: E. G. Paine, unpublished list of miniatures in the Fredrick collection (1960), no. 31.

226

227

COLOR PLATE PAGE 64

228

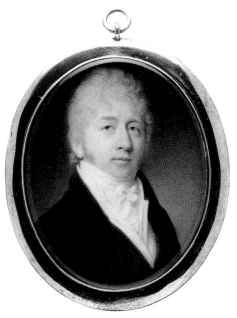

229

Charles Jagger

British, born about 1770, died 1827

Charles Jagger worked in Bath, where he died.

Attributed to Charles Jagger

230
Portrait of a Man

Ivory, 1¾ x 1⅝ in. (46 x 42 mm)

The Moses Lazarus Collection, Gift of Josephine and Sarah Lazarus, in memory of their father, 1888–95 (95.14.8) ESDA

Wearing a blue coat, light beige waistcoat, and white frilled shirt. Brown eyes; powdered hair. Sky background.

The miniature is set in a circular box of vernis Martin in blue, white, and pink stripes with gold mounts and a tortoiseshell lining. The marks on the box are indistinct; it may be French of the late eighteenth century.

THE ATTRIBUTION to Charles Jagger was suggested by Richard Allen and Edwin Boucher in 1977. It is probably correct; the hatched background and "boiling" sky are characteristic of his style. A date of about 1790 may be suggested.

Andrew Robertson

Scottish, 1777–1845

Andrew Robertson was born in Aberdeen. His elder brothers Archibald (no. 163) and Alexander (1772–1841) went to New York in the early 1790s and established the Columbian Academy of Painting there. Andrew copied some portraits by Henry Raeburn (1756–1823). On his arrival in London in 1801 he set out to counteract the influence of Richard Cosway (nos. 130–32) by giving his miniatures the appearance of painting in oil; he also favored the rectangular format rather than the oval which was then standard. He was the master of the prominent Victorian miniaturist Sir William Charles Ross (1794–1860). He died in Hampstead, North London.

231
Portrait of a Man

Ivory, 3¾ x 2⅞ in. (80 x 63 mm)

Signed and dated (right, in black): *AR* [monogram] / *1828*

Morris K. Jesup Fund, 1986 (1986.390)

Wearing a black coat and white shirt and cravat. Blue eyes; brown hair. Blue sky background.

CONDITION: The miniature (on a rectangular piece of ivory) is in excellent condition. It was removed from a modern shadow box and provided with a facsimile ormolu mat and a ragboard backing. The old glass was replaced.

EX COLL.: Christie's, New York, October 18, 1986, no. 412, as by Archibald Robertson.

THE MONOGRAM is that of Andrew Robertson and not, as catalogued by Christie's, that of his brother Archibald.

Samuel John Stump

American, 1778–1863

Stump worked in England but is believed to have been born in America. He began studies at the Royal Academy, London, in 1796. As a member of the Sketching Society from 1810 until 1849, he drew a number of historical and poetical subjects. He exhibited at the Royal Academy and elsewhere from 1802 until 1849.

232
Portrait of a Man

Ivory, 2⅝ x 2¼ in. (68 x 56 mm)

Signed (right edge, in scratched letters): *Stump pt*

Bequest of Millie Bruhl Fredrick, 1962 (62.122.44)

Wearing a black coat and white waistcoat and cravat. Brown eyes; brown hair. Gray background.

The gilt frame is glazed at back to reveal a plume of two shades of brown hair, bound with seed pearls and gold wire over translucent white glass laid on tinsel.

CONDITION: There has been slight flaking at left edge above center.

IN HIS unpublished list of miniatures in the Fredrick collection (1960), no. 34, E.G. Paine dates this portrait about 1825.

Joshua Wilson Faulkner

British, active about 1809–20

Faulkner was born in Manchester. He became a member of the Liverpool Academy and exhibited portrait miniatures there and at the Royal Academy from 1809 until 1820.

233
Portrait of a Woman

Ivory, 4 x 3⅛ in. (100 x 80 mm)

Bequest of Margaret Crane Hurlbut, 1933 (33.136.15)

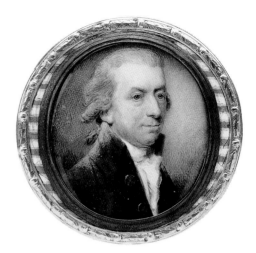

230

Wearing a green dress trimmed with pink ribbons and with brown bodice, seated in red chair and holding a gold jewel suspended from a pink ribbon. Brown eyes; black hair with white muslin veil. Gray wall in background with landscape and sky on left.

The ivory is laid on a larger sheet of paper which has trial brushstrokes on it. The miniature is in a red morocco case, the lid of which has been lost.

THE MINIATURE reflects the type of idealized portraiture found as illustrations to the keepsakes and books of beauties of the 1830s. It was received in the Metropolitan Museum together with an engraving after it inscribed *Drawn by B. R. Faulkner Engraved by H. Robinson*. The drawing after the miniature was evidently by Benjamin Rawlinson Faulkener (1787–1849), who after a brief career in trade in Gibraltar returned to England about 1813, studied with his elder brother Joshua, and exhibited portraits in large at the Royal Academy and elsewhere from 1821. The engraver was perhaps John Henry Robinson (1796–1871), who worked in London. The engraving, which is in the same sense as the miniature, differs in showing a tree in the right background.

Andrew Dunn

Irish, active about 1800–20

Born in Ireland, Dunn studied at the Dublin Society Schools. He failed to establish himself in Dublin and settled in London, exhibiting at the Royal Academy from 1809 until 1818. Nothing is known of him after 1820.

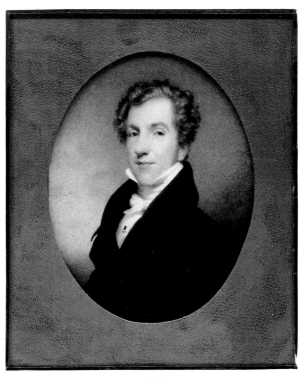

231

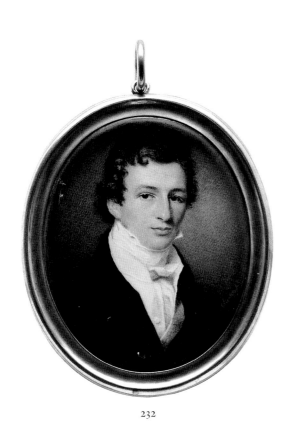

232

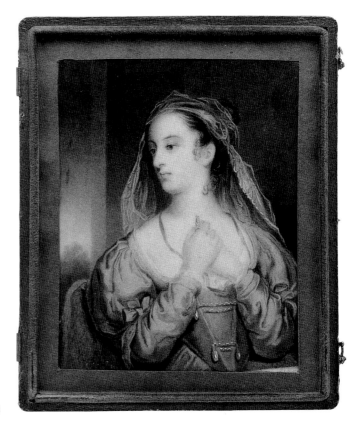

233

234

235

Andrew Dunn (*continued*)

234
Portrait of an Officer

Ivory, 2⅝ x 2⅛ in. (67 x 55 mm)
Signed (right, in black): *A. DUNN*
Bequest of Millie Bruhl Fredrick, 1962 (62.122.106)

Wearing a red uniform with beige lapels and collar
and black neckband. Brown eyes; brown hair. Sky
background.

The frame is glazed at back to reveal locks of hair
arranged as a fleur-de-lis and bound with seed
pearls and gold thread on translucent glass over
tinsel.

LITERATURE: E. G. Paine, unpublished list of
miniatures in the Fredrick collection (1960), no. 12,
as about 1810.

François-Theodore Rochard

French, 1798–1858

François-Theodore Rochard was the younger
brother of Simon-Jacques Rochard (1788–1872),
who had settled in England in 1816 and became a
successful miniature painter. François-Theodore
joined his brother in London about 1820 and
exhibited at the Royal Academy and elsewhere
from 1820 until 1855. He painted historical sub-
jects as well as miniatures. The element of

French elegance which he and his brother
brought into British miniature painting was a
welcome novelty to many fashionable patrons.
Rochard died in London.

235
Portrait of a Woman

Ivory, 3⅞ x 3¼ in. (98 x 83 mm)
Signed and dated (left edge, in scratched letters):
F.ᶜⁱˢ Rochard Pinx.ᵗ 1829
Bequest of Millie Bruhl Fredrick, 1962 (62.122.90)

Wearing a black dress, ermine-lined cloak, pink
scarf, and lace-edged white cap tied with white rib-
bon. Brown eyes; black hair dressed with two red
roses. Seated in a leather-backed chair. Dark gray-
brown background.

CONDITION: The support is somewhat cockled.
There is a curving crack (near the right edge and
extending three-quarters of the way up from the
bottom) with original paint in it, suggesting that
the ivory must have split while the artist was
working on the portrait. The lower left corner
shows more recent damage. The voids were filled
with colored wax and the smaller cracks attached
with adhesive. A ragboard spacer was supplied.

LITERATURE: E. G. Paine, unpublished list of
miniatures in the Fredrick collection (1960), no. 30.

John Faed

Scottish, 1819–1902

If the suggestion discussed in the following
entry is correct, the artist was John Faed, R.S.A.
(1819–1902), who was self-taught and as a very
young man in Galloway worked primarily as a
miniaturist. He settled in Edinburgh in 1840
and exhibited miniatures and paintings at the
Royal Scottish Academy between 1841 and 1895.
From 1864 to 1880 he lived primarily in London,
where he had begun to exhibit paintings at the
Royal Academy in 1861. His brother James Faed
(1821–1911) painted some miniatures, but no.
236 is not his. Both are better known as painters
in large.

Attributed to John Faed

236
Self-portrait

Ivory, 2⅝ x 2⅛ in. (68 x 55 mm)
Gift of Mrs. John LaPorte Given, 1945 (45.110.3)

Wearing a brown coat, open-necked white shirt,
and brocaded dressing gown. Blue eyes; black hair.
Gray background.

This miniature is in a gold locket frame set as a
brooch with a hinged cover; the glazed back reveals
locks of dark brown and fair hair bound with gold
wire and with seed pearls on white glass; the inside
of the lid (which has been separated) is engraved
The English Artist / Fane / by himself.

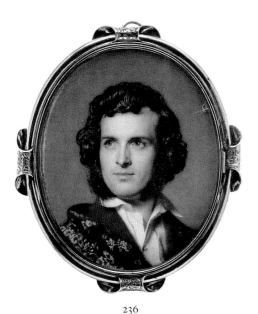

236

COLOR PLATE PAGE 64

237

238

COLOR PLATE PAGE 21

EXHIBITED: Metropolitan Museum of Art, 1950, *Four Centuries of Miniature Painting,* list, p. 10.

LITERATURE: Leo R. Schidlof, *The Miniature in Europe* (Graz, 1964), vol. 1, p. 246, and vol. 3, pl. 204, fig. 388; Daphne Foskett, *A Dictionary of British Miniature Painters* (New York and Washington, D.C., 1972), vol. 1, p. 267, and vol. 2, pl. 109, no. 291.

THE ONLY recorded miniaturist with the name Fane exhibited once, at the Royal Academy, in 1776. Since this miniature was painted about 1850 it cannot be by him. The quality of this work is so high that without the inscription on the locket it might well have been ascribed to Sir William Charles Ross (1794–1860), the leading Victorian miniaturist. Hermione Waterfield, anticipated by Hope Mathewson and Mrs. Henry W. Howell Jr., Librarian of the Frick Art Reference Library in 1954, has made the ingenious suggestion that it may be by John Faed, who exhibited miniatures at the Royal Scottish Academy in 1841–43, 1846, 1847, and 1853 (see Mary McKerrow, *The Faeds — A Biography* [Edinburgh, 1982]). The few miniatures known to be by this artist are indeed reminiscent of the style of Sir William Ross, and the attribution has a real chance of being correct if we may assume that the engraver of the inscription on the locket misheard *Faed* as *Fane*. A miniature portrait of Thomas Allen by John Faed is framed in a somewhat similar manner in a gold locket with a shutting lid (Daphne Foskett, *Collecting Miniatures* [Woodbridge, Suffolk, 1979], p. 218, pl. 51B).

Appendix

Continental

about 1550

237
Portrait of a Man

Oil on card; overall 1¾ x 1½ in. (43 x 38 mm); feigned oval portrait, 1¼ x 1⅛ in. (32 x 28 mm)

Inscribed: (around portrait, in black) EN TIBI CALVITIEM VENERANDI OSTENDO MEIONIS IVRIS QVI IGNAROS NVNC RVDIMENTA DOCET; (bottom edge, partially illegible) [?5 or Ao] 68

Gift of Cornelius Vanderbilt, 1880 (80.3.180)

Wearing a green doublet and white shirt. Dark brown hair and beard. Dark gray-brown background.

CONDITION: The pigments have darkened severely. Two pinholes in the sitter's temple have been filled with wax, and losses from top to bottom along the left edge have been toned. The miniature has been supplied with a new convex glass.

LITERATURE: Metropolitan Museum of Art, *Drawings* (1895), no. 180.

THIS IS an early example of an oil miniature.

The inscription, which indicates it represents a respected teacher, may be translated: "Behold, I display my baldness to you, venerable sir, who now teaches the ignorant the rudiments of the law of [Meionis]." The last word has yet to be explained.

Although the miniature has been classified as French, it might be from a northern European country, probably one that had adopted the reformed religion, since the austere costume is in keeping with the standards of Geneva.

German

about 1550

238
John Frederick I (1503–1554), *Elector of Saxony*

Oil on vellum, 6⅝ x 5⅜ in. (168 x 137 mm)

Inscribed (top): LE DVC DE SAXE

Bashford Dean Memorial Collection, Funds from various donors, 1929 (29.158.753) ARMS AND ARMOR

Wearing armor with mail sleeves. Dark hair and beard. Dark background.

EX COLL.: Hamilton Palace sale; Bashford Dean, New York (until 1929).

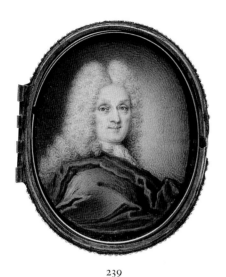

239

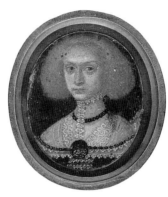

240

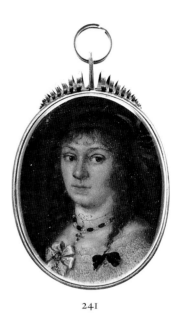

241

THE MINIATURE was acquired by the Department of Arms and Armor to document the type of equipment worn at the court of Saxony. In spite of its French inscription, the miniature is painted in the style of German mid-sixteenth-century court portraiture, ultimately derived from the example of Lucas Cranach.

John Frederick I, called the Magnanimous, was the elder son of the elector John the Steadfast. A Lutheran, he succeeded his father in 1532.

French

about 1700

239
Portrait of a Man

Vellum laid on playing card (one diamond showing), 2⅛ x 1¾ in. (54 x 43 mm)

The Moses Lazarus Collection, Gift of Josephine and Sarah Lazarus, in memory of their father, 1888–95 (95.14.92)

Wearing a blue coat and white cravat. Brown eyes; white wig. Brown background.

A piece of playing card kept at the back, with one heart showing, is inscribed in ink in an old hand *une [?s]antiens*. On a paper label fixed to the back is printed *22*.

The miniature is in a metal frame hinged for a lid and covered with shagreen.

CONDITION: Flaking slightly around the top left edge.

WHEN THIS miniature was received in the Metropolitan Museum, it was erroneously described as a portrait of a king of France, probably Louis XIV. Its attribution to the French school is perhaps strengthened by the old inscription in French, which appears to form part of the miniature's original backing.

Continental

about 1630

240
Portrait of a Woman

Oil on metal laid on card, 1⅜ x 1¼ in. (36 x 31 mm)

The Collection of Giovanni P. Morosini, presented by his daughter Giulia, 1932 (32.75.14)

Wearing a black dress trimmed with gold braid, white lace collar, black and gold necklace, chain, and jewel. Brown eyes; fair hair. Green background.

CONDITION: There are a number of losses in the hair and along the left and right edges.

THIS OIL miniature, which has a naive charm, has been assigned to the Dutch school, but there is little comparable material on which to base a judgment.

Continental

about 1630

241
Portrait of a Woman

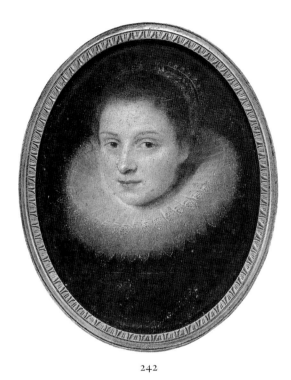

242

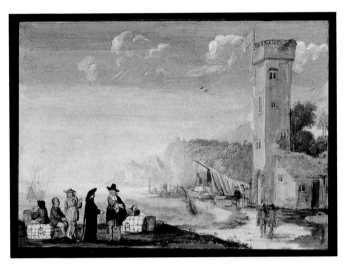

243

Oil on copper, 2 x 1½ in. (50 x 38 mm)
Bequest of Millie Bruhl Fredrick, 1962 (62.122.135)

Wearing a white lace bodice with yellow bow and brooch at bosom and necklace of black and white stones with pendant cross. Brown eyes; brown hair with yellow ribbons and lovelock tied with black ribbon. Dark brown background.

LITERATURE: E. G. Paine, unpublished list of miniatures in the Fredrick collection (1960), no. 57, as possibly Spanish.

THE MINIATURE, which was painted about 1630, has been attributed to the Spanish school. The pendant cross indicates that the sitter, who might also be Flemish, is a Roman Catholic.

Flemish

about 1625

242
Portrait of a Woman

Oil on copper, 3⅜ x 2⅝ in. (86 x 67 mm)
Bequest of Millie Bruhl Fredrick, 1962 (62.122.128)

Wearing a black dress, white ruff, and jeweled chain and pendant. Brown eyes; brown hair dressed with white frilled cap. Dark gray background.

EX COLL.: Comtesse de la Béraudière, Paris; [Julius H. Weitzner, New York, until 1931]; Mrs. Leopold Fredrick, New York (1931–62).

CONDITION: This miniature is rubbed and with many small damages.

EXHIBITED: Brooklyn Museum, 1936, *Five Centuries of Miniature Painting*, no. 144 (attributed to Rubens).

LITERATURE: E. G. Paine, unpublished list of miniatures in the Fredrick collection (1960), no. 127, as school of Rubens, about 1630.

ACCORDING to the bill submitted by Julius H. Weitzner to Mrs. Fredrick in 1931, W. R. Valentiner had attributed this oil miniature to a Flemish painter, about 1620. The miniature was not listed in the sales of works belonging

to the comtesse de la Béraudière in 1930 and 1931.

Flemish

about 1650

243
Harbor Scene

Vellum, 4⅛ x 5¾ in. (104 x 145 mm)
Bequest of Catherine D. Wentworth, 1948 (48.187.741)

The bales of merchandise bear merchants' marks.

The vellum has been applied to composition board inscribed on the reverse in pencil *boudoir de M^{me} / face fenetre / gauche bas*, indicating that the miniature was in a French collection.

THE STANDARD of execution in this maritime scene is hardly more than that of an amateur.

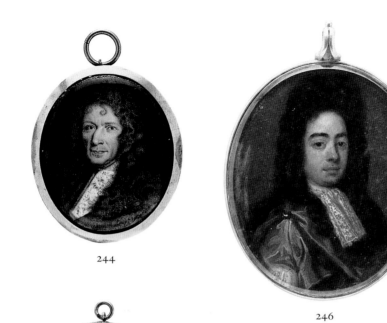

244

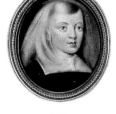

245

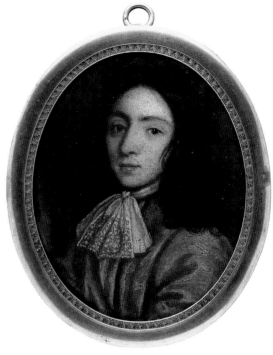

246

247

Continental

about 1670

244
Portrait of a Man

Enamel, 2 x 1⅜ in. (50 x 35 mm)
Bequest of Millie Bruhl Fredrick, 1962 (62.122.85)

Wearing a brocaded black coat and white lace jabot. Brown eyes; brown wig. Black background.

IN HIS unpublished list of miniatures in the Fredrick collection (1960), no. 41, E. G. Paine describes this as school of Charles Boit (1662–1727) or a copy after him. The costume, however, suggests an earlier date of about 1670. The marked stippling in the flesh tones is akin to that of the enamelists of the northern schools, working in the manner of Paul Prieur (1620–1684) or the Huaut brothers (Jean Pierre, 1655–1723; Amy, 1657–1724).

Fabienne Sturm of the Musée de l'horlogerie, Geneva, and Hans Boeckh (in a letter, 1995) propose a later date, about 1700, and suggest comparison with the work of the Geneva enameler Jean André (born 1646, died about 1717).

Continental

about 1650

245
Portrait of a Child

Enamel on gold, 1 x ⅞ in. (25 x 22 mm)
Bequest of Millie Bruhl Fredrick, 1962 (62.122.124)

Wearing a black dress with white collar. Fair hair. Brown background.

CONDITION: There is a crack in the hair at left.

LITERATURE: E. G. Paine, unpublished list of miniatures in the Fredrick collection (1960), no. 122, as by a Dutch artist.

DAPHNE FOSKETT has suggested that this may be a member of the Hapsburg family, about 1680. There is a certain resemblance. However, the date is likely to be closer to the mid-seventeenth century.

British

about 1690

246
Portrait of a Man

Oil on copper, 2⅜ x 2 in. (60 x 50 mm)
Bequest of Mary Anna Palmer Draper, 1914 (15.43.302)

Wearing a lilac coat with white sleeves and white lace steinkirk. Dark eyes; dark brown wig. Dark gray-brown background.

OPINIONS have differed on the origin of this miniature, which may be British, about 1690.

248

249

British

about 1690

247
Portrait of a Man

Oil on copper, 3¼ x 2⅝ in. (82 x 68 mm)
Bequest of Millie Bruhl Fredrick, 1962
 (62.122.155)

Wearing a yellow robe and white lace cravat.
Brown eyes; brown hair. Dark brown background.

CONDITION: There are several losses in the
yellow robe and some blanching in the hair.

THE STYLISTIC elements of this miniature
are hardly sufficient to determine its country of
origin; it may be British, about 1690.

French

about 1720

248
Portrait of a Man

Oil on copper, 2 x 1½ in. (49 x 39 mm)
Fletcher Fund, 1942 (42.104)

Wearing a blue robe and white frilled shirt with
black ribbon. Brown eyes; brown wig. Brown
background.

The miniature is set in the lid of a moss agate box.

EX COLL.: Alfred Tyrnauer, New York (until
1942).

THIS PORTRAIT appears to date about 1720.

Jacques Charlier

French, 1720–1790

Charlier was a prolific painter in miniature of
mythological and gallant scenes for the *menus
plaisirs* and styled himself *peintre du roi*. Many of
his subjects were closely based on paintings or

drawings by François Boucher (1703–1770), and
he is said to have been Boucher's pupil. The
Wallace Collection, London, has thirty-four
miniatures by or attributed to him.

Style of Jacques Charlier

probably 19th century

249
Leda and the Swan, after Boucher

Ivory, 2 x 2⅞ in. (50 x 72 mm)
Bequest of Millie Bruhl Fredrick, 1962 (62.122.63)

EX COLL.: [Bensimon, Aix-les-Bains, until 1929];
Mrs. Leopold Fredrick, New York (1929–62).

LITERATURE: E. G. Paine, unpublished list of
miniatures in the Fredrick collection (1960), no. 69,
as by Charlier.

THE COMPOSITION is after Boucher's *Leda
and the Swan* of 1742, now in the National-
museum, Stockholm (Alexandre Ananoff and

Daniel Wildenstein, *François Boucher* [Lausanne and Paris, 1976], no. 222). Although the present miniature has been regarded by some authorities as by Charlier, it is a good anonymous nineteenth-century copy.

A second miniature version, probably by Charlier, is in the Wallace Collection, London (Graham Reynolds, *Wallace Collection: Catalogue of Miniatures* [London, 1980], no. 77, ill.). A third miniature version, attributed to Charlier, was sold at the Mme J. Brasseur sale, Paris, April 15, 1921, no. 4. A fourth miniature version, which was ascribed to the atelier of François Boucher, was in the Giulia P. Morosini estate sale, American Art Association — Anderson Galleries, New York, October 15, 1932, no. 1583, ill.

French

about 1750

250
View of a Harbor

Verre fixé, diam. 3⅛ in. (80 mm)
Bequest of Millie Bruhl Fredrick, 1962 (62.122.75)

The card backing the miniature is inscribed in ink in a more recent hand *Claude Joseph / Vernet / I / 1756 / . . . 1777 ·*.

The miniature is painted on brown fabric; the glass to which it is fixed is convex in front but flat on the side of adhesion. Other *fixés* are nos. 41, 53, and 54.
Ex coll.: [Art Trading Co., New York, until 1936]; Mrs. Leopold Fredrick, New York (1936–62).

IN HIS unpublished list of miniatures in the Fredrick collection (1960), no. 93, E. G. Paine attributes this miniature to Claude Joseph Vernet (1714–1789) and identifies the scene as the harbor of Toulon. The subject is of a type frequently painted in oil by Vernet, but there is no evidence that he occupied himself with the specialized technique of *fixés.*

French

about 1760

251
Portrait of a Man

Ivory, 1¼ x 1 in. (31 x 25 mm)
Bequest of Millie Bruhl Fredrick, 1962 (62.122.72)

Wearing a white uniform jacket with blue trimming, gold epaulet, and the badge of the Order of Saint-Louis. Blue eyes; powdered wig tied with black bow. Gray background.
CONDITION: The miniature is in a two-sided locket hinged to open. The portrait is on a slightly cockled ivory support with part of a paper label

adhered to the reverse. The harbor(?) scene on the reverse, apparently on gessoed paper attached to silk, is damaged all around the perimeter and darkened or discolored at the center.

IN HIS unpublished list of the miniatures in the Fredrick collection (1960), no. 85, E. G. Paine attributes this miniature to Jean J. Provost, working 1762. No miniaturist of this name is recorded, but reference may have been intended to Jean Prévost (Leo R. Schidlof, *The Miniature in Europe* [Graz, 1964], vol. 2, p. 651), who was painter to Louis XV of France in 1762 and exhibited portraits and flowers in miniature at the Salon between 1774 and 1782. No miniature by him is recorded, and therefore the attribution cannot be checked. The work is by a French miniaturist working about 1760.

French

about 1770

252
Portrait of a Man

Ivory, 1⅜ x 1⅛ in. (34 x 28 mm)
Gift of Mrs. Louis V. Bell, in memory of her husband, 1925 (25.106.33)

Wearing a light green jacket with white froggings and pink waistcoat. Blue eyes; powdered wig tied with a black bow. Gray background.

The miniature is set in the lid of a green composition box lined with tortoiseshell and with gold mounts. The mounts were made in Paris between 1768 and 1774. Inside the lid is a small label printed *33.*

THE MINIATURE is of the same date as the French box, that is, about 1770. Pierrette Jean-Richard (in a letter, 1995) has suggested that the artist might instead be of northern European origin.

F.M.

French, 1774

253
Portrait of a Man, Said to Be Lieutenant d'Alézac

Ivory, 1½ x 1⅛ in. (38 x 30 mm)
Signed and dated (left, in white): *F.M. / Pinxit / 1774*
Gift of J. Pierpont Morgan, 1917 (17.190.1318) ESDA

Wearing a lilac-gray uniform jacket with red facings and silver froggings and yellow waistcoat. Brown eyes; powdered hair. Gray background.

The miniature is set in a black tortoiseshell souvenir with gold mounts made by Jean Pierre Mendouze

(or Maindouze; master 1778, died 1793) in Paris in 1780–81. The box bears three marks, among them the maker's mark J.P.M. and the Paris mark for 1780–81. It is lettered SOUVENIR on the front and D'AMITIE on the back, with the monogram TM in gold.

One of the tablets of ivory inside the souvenir is inscribed in pencil *2524* and *P.M.3679;* a stock label is printed *87.* Another ivory tablet is inscribed in ink on a stock label *Lieutenant / d'Alézac.* The label of the Bernard Franck collection is inside the souvenir.

Ex coll.: Bernard Franck.

LITERATURE: *Collection de 124 carnets de bal du XVIIIᵉ siècle formée par M. Bernard Franck à Paris* (Paris, about 1902), pl. 87.

THE INITIALS of the signature have been read as E.M. but F.M. is the more probable reading.

The name *Lieutenant d'Alézac* inside the souvenir may record a traditional identification of the sitter. It does not, however, tally with the monogram TM on the back of the case.

French

about 1778

254
Portrait of a Man

Ivory, 1⅜ x 1⅛ in. (36 x 28 mm)
Gift of Mrs. Louis V. Bell, in memory of her husband, 1925 (25.106.37)

Wearing a dark blue uniform coat with red collar and silver embroidery and epaulet, white shirt, and the badge of an order, possibly that of the White Eagle. Blue eyes; powdered hair with black ribbon. Dark gray background.

The miniature is set in the lid of an engine-turned gold box lined with ivory made in Paris in 1777–78. Inside the lid is printed *37.*

THE MINIATURE is of the same date as the box, about 1778.

French

about 1779

255
Portrait of a Man

Enamel, 1⅛ x ⅞ in. (30 x 23 mm)
Gift of J. Pierpont Morgan, 1917 (17.190.1312) ESDA

Wearing a green coat with gold trimming and white shirt. Hazel eyes; powdered hair with a black ribbon. Gray background.

The miniature is set in a gold-and-composition souvenir made in Paris in 1778–79. The souvenir bears four marks, among them the Paris mark for 1778–79.

250

251

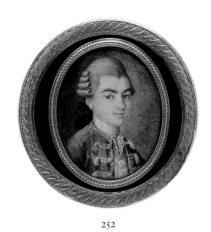

252

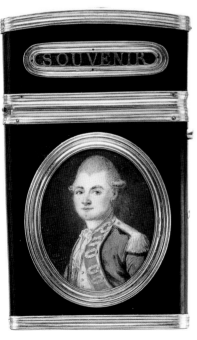

253

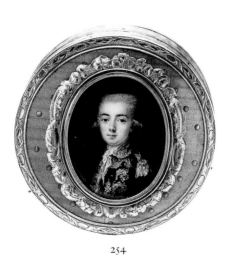

254

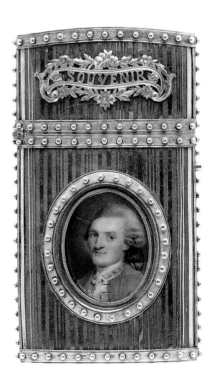

255

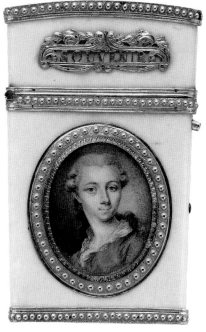

256

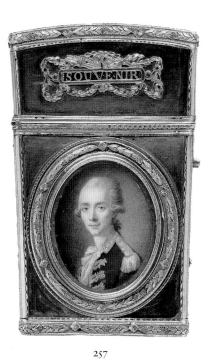

257

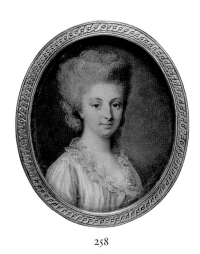

258

The souvenir is lettered SOUVENIR on a gold plaque on the front and D'AMITIE on the back. Glazed at the back to show a colored wax picture on painted card representing two doves on an altar and inscribed IMITE LES (imitate them). Inside are a three-leafed ivory tablet and gold-mounted pencil. Also inside are the label of the Bernard Franck collection and a label printed *47*. An ivory leaf is inscribed in pencil *2484* and in blue crayon *49* and *P.M.3639*.

EX COLL.: Bernard Franck.

LITERATURE: *Collection de 124 carnets de bal du XVIII^e siècle formée par M. Bernard Franck à Paris* (Paris, about 1902), pl. 47.

French

about 1780

256
Portrait of a Man

Ivory, 1⅜ x 1⅛ in. (34 x 28 mm)

Gift of J. Pierpont Morgan, 1917 (17.190.1268) ESDA

Wearing a blue coat and white shirt. Brown eyes; powdered wig with a black bow. Greenish-gray background.

The miniature is set in an ivory souvenir with gold mounts which was made by Pierre Denis Chaumont in Paris in 1780–82. The souvenir bears four

marks, among them the maker's mark PDC and the Paris marks for 1780–81.

The carnet is lettered on gold plaques SOUVENIR on the front and D'AMITIE on the back. The back is glazed to reveal a grisaille miniature on ivory of a cupid at an altar with a dolphin, the background tinted pale pink. Inside are a three-leafed ivory tablet and a gold-mounted pencil. Also inside are the label of the Bernard Franck collection inscribed in pencil *Sophie Arnould* and a stock label printed *53*. The ivory leaves are inscribed in pencil *2490 / 53*.

EX COLL.: Bernard Franck.

LITERATURE: *Collection de 124 carnets de bal du XVIII^e siècle formée par M. Bernard Franck à Paris* (Paris, about 1902), pl. 53.

IT HAS been suggested by Richard Allen and Edwin Boucher that the present miniature is from the school of Antoine Vestier (1740–1824), but this hypothesis is not convincing.

French

about 1779

257
Portrait of a Man

Ivory, 1¼ x 1 in. (33 x 26 mm)

Gift of J. Pierpont Morgan, 1917 (17.190.1369) ESDA

Wearing a blue uniform jacket with silver froggings, red collar, red and silver epaulets, and white shirt. Powdered wig. Gray background.

The miniature is set in a souvenir made in Paris, probably by Pierre André Barbier (master 1764, working 1776), in 1778–79. The souvenir bears four marks, among them the maker's mark (?) and the Paris mark for 1778–79.

The souvenir is lettered on gold plaques SOUVENIR on the front and D'AMITIE on the back. Also on the back is a monogram in gold, probably JB. Inside are a three-leafed ivory tablet and a gold-mounted pencil. Also inside are the label of the Bernard Franck collection and a stock label inscribed *83*. An ivory leaf is inscribed in pencil *2520* and *P.M.3675* and in blue crayon *83*.

EX COLL.: Bernard Franck.

LITERATURE: *Collection de 124 carnets de bal du XVIII^e siècle formée par M. Bernard Franck à Paris* (Paris, about 1902), pl. 83.

French

about 1780

258
Portrait of a Woman

Ivory, 1⅞ x 1½ in. (48 x 37 mm)

Bequest of Millie Bruhl Fredrick, 1962 (62.122.78)

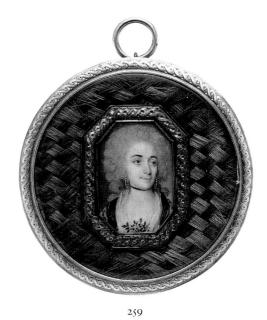

259

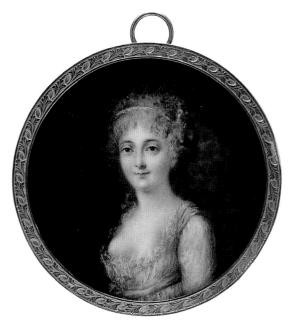

260

Wearing a white dress with pink bow at bosom. Brown eyes; powdered hair. Gray background.

A card at the back of the miniature is inscribed in a recent hand in pencil . . . *sse / P.A.Hall / French 18th*.

EX COLL.: Donald de Montalba (1953); Edward Grosvenor Paine, New York (1954).

IN HIS unpublished list of the miniatures in the Fredrick collection (1960), no. 80, E. G. Paine attributes this miniature to Peter Adolf Hall (nos. 46–50), about 1780. Although a work of sensitive quality, it does not embody the salient features of Hall's style, and this attribution has understandably been questioned by Daphne Foskett, Richard Allen, and Hermione Waterfield.

French

about 1790

259
Portrait of a Woman

Ivory, 1⅛ x ¾ in. (30 x 20 mm)
Bequest of Mary Clark Thompson, 1923 (24.80.514)

Wearing a gray dress with black scarf and white fichu; blue leaves and berries at her bosom; black ribbon around her neck; pearl-chain eardrops. Brown eyes; powdered hair. Green background.

This miniature is set in an eight-sided gilt mount which is itself set in a circular gilt mount with plaited brown hair between the two.

THE MINIATURE was probably mounted in this elaborate way as the lid of a box.

French

about 1795

260
Portrait of a Woman, Said to Be
the Comtesse de Guiche

Ivory, diam. 2½ in. (62 mm)
Bequest of Collis P. Huntington, 1900
(26.168.41)

Wearing a white dress and coral scarf. Brown eyes; powdered hair dressed with coral ribbon. Dark gray background.

The miniature is set in a circular gold mount, which was perhaps fitted in the lid of a box. One of the cards backing the miniature is inscribed in ink in a recent hand *Comtesse / de Guiche / Vestier* and in another hand *7 / 983*.

Three stock labels are fixed to the frame's silk-covered back.

CONDITION: The painted surface is well preserved. Backing paper was removed from the reverse of the ivory, a vertical crack one inch long near the left edge was mended, and a small void was filled with wax. The ivory was mounted on ragboard.

WHEN THE miniature was received in the Metropolitan Museum, it was attributed to Antoine Vestier (1740–1824). The attribution has, however, been abandoned. In 1952 Leo R. Schidlof considered the miniature a modern copy, and both Hermione Waterfield and Bodo Hofstetter have questioned its authenticity. It appears, however, to be a genuine work of about 1795, somewhat in the manner of Peter Adolf Hall (nos. 46–50), though not of sufficient quality to be ascribed to him.

The title comte de Guiche occurs in the Gramont family, but it has not been possible to identify the sitter.

261

262

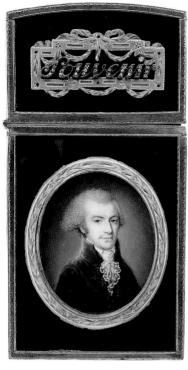

263

French

about 1790

261
Portrait of a Woman

Ivory, 2⅛ x 1¾ in. (53 x 46 mm)
Gift of J. Pierpont Morgan, 1917 (17.190.1139) ESDA

Wearing a white dress and fichu with pink sash. Hazel eyes; powdered hair. Leaning against blue chairback. Gray background.

The miniature is set in a circular box of gold and blue glass lined with tortoiseshell.

Inside the box are a label printed *2352* and a stock label inscribed in red *P.M. / 3508*.

French

about 1790

262
Marquis de Lafayette (1757–1834)

Ivory, 1¼ x ¾ in. (31 x 19 mm)

Gift of J. William Middendorf II, 1968 (68.222.24)

Wearing a gray uniform coat with light gray facings and gold epaulets, white frilled shirt, and the red ribbon and badge of the Order of Saint-Louis. Brown eyes; powdered hair with a black ribbon. Pinkish gray background.

The eight-sided miniature is set in a ring, which is stored in a green shagreen case.

EX COLL.: Erskine Hewitt, New York (by 1930–1938; his sale, Parke-Bernet, New York, October 18–22, 1938, no. 1011); [Ginsburg and Levy, New York, until 1961].

EXHIBITED: Museum of French Art, New York, 1930, *Lafayette: Tenth Official Loan Exhibition*, no. 133 (lent by Erskine Hewitt).

THE SUBJECT is Marie Jean Paul Roch Yves Gilbert Motier (1757–1834), marquis de Lafayette, the celebrated French statesman and general who supported the American cause in the War of Independence. He entered American military service in 1777 and was instrumental in the defeat of the British commander Lord Cornwallis at Yorktown (1781), which marked the end of the Revolutionary War.

French

about 1790

263
Portrait of a Man

Ivory, 1½ x 1¼ in. (39 x 31 mm)

Gift of J. Pierpont Morgan, 1917 (17.190.1390) ESDA

Wearing a black coat and white shirt and cravat. Brown eyes; powdered hair. Gray background.

The miniature is set in a tortoiseshell souvenir with gold and diamond mounts made in Paris about 1780–90.

The souvenir is lettered in diamonds SOUVENIR on the front and D'AMITIE on the back. A gold plaque at the back is lettered in cipher LAMOUR. The souvenir contains a two-leafed ivory tablet, gold-mounted pencil, and gold scissors. The scissors, which may not be original to the souvenir, bear four marks.

Inside the souvenir is the label of the Bernard Franck collection. An ivory leaf has a stock label *39* and is inscribed in pencil *2476 / P.M.3631*.

EX COLL.: Bernard Franck.

LITERATURE: *Collection de 124 carnets de bal du*

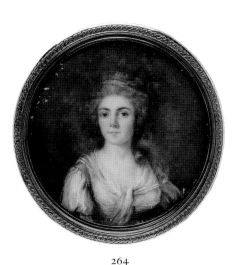

264

265

266

XVIII^e siècle formée par M. Bernard Franck à Paris (Paris, about 1902), pl. 39.

French

about 1790

264
Portrait of a Woman, Said to Be the Princesse de Ligne

Ivory, diam. 2½ in. (65 mm)

The Moses Lazarus Collection, Gift of Josephine and Sarah Lazarus, in memory of their father, 1888–95 (95.14.10) ESDA

Wearing a blue bodice with white sleeves and white muslin scarf. Brown eyes; powdered hair with blue fillet. Gray background.

The miniature is set in a tortoiseshell box with gold mounts made by Jean Baptiste Gillet (born 1709, master 1734, died 1786) in Paris in 1768–75. The box bears five marks, among them the maker's mark JBG and the Paris marks for 1768–75.

ONE OF the donors, Sarah Lazarus, listed this miniature as a portrait of the princesse de Ligne by François Dumont (1751–1831). It is not, however, in Dumont's style. It appears to be later than the box in which it is set; the costume

points to a date about 1790.

The supposed sitter may have been a relative of Charles Joseph (1735–1814), prince de Ligne.

French

about 1790

265
Portrait of a Woman
(pendant to 55.111.4)

Ivory, diam. 2⅜ in. (60 mm)

Bequest of Helen Winslow Durkee Mileham, 1954 (55.111.5)

Wearing a black figured dress, white fichu, high white cap trimmed with gray ribbon, and black ribbon around neck. Hazel eyes; brown hair. Light brown background.

The miniature is a pair with no. 266. The sitters may be husband and wife.

CONDITION: The sitter's face is underpainted with green. A cockled backing paper was released from the ivory. A new cover glass was supplied.

EX COLL.: E. G. Paine, New York (until 1954; his sale, Parke-Bernet, New York, January 9, 1954, no. 321, with pendant).

IT IS NOT difficult to imagine this *citoyenne* sitting as a *tricoteuse* at the foot of the guillotine.

French

about 1790

266
Portrait of a Man
(pendant to 55.111.5)

Ivory, diam. 2⅜ in. (60 mm)

Bequest of Helen Winslow Durkee Mileham, 1954 (55.111.4)

Wearing a brown coat, yellow waistcoat, and white cravat. Brown eyes; powdered hair. Light brown background.

The miniature is a pair with no. 265, and both are by the same artist.

CONDITION: The miniature was released from a cockled backing card. There is a warped curve and a blind crack at the left, and some staining at either side of the head. The deteriorated glasses front and back were replaced.

EX COLL.: Same as no. 265.

French

about 1790

267
Portrait of a Woman, Said to Be the Princesse de Lamballe

Ivory, 1⅜ x 1⅛ in. (34 x 28 mm)
Gift of J. Pierpont Morgan, 1917 (17.190.1197) ESDA

Wearing a white dress. Brown eyes; powdered hair. Gray background.

The miniature is set in a nineteenth-century gold-and-enamel box which imitates French eighteenth-century work.

IN 1974 Clare Le Corbeiller concluded that the box is a nineteenth-century pastiche furnished with marks intended to convey that it is an eighteenth-century work by Jean Antoine Alazard (master 1787, working 1806). The miniature, however, appears to be a genuine if rather damaged work of the French school, about 1790.

The identification of the sitter as the princesse de Lamballe is feasible, since this portrait is comparable with the painting by Joseph Siffred Duplessis (1725–1802) in the Musées de Metz, which is said to be of her (Jules Belleudy, *J.-S. Duplessis* [Chartres, 1913], pp. 124–25, ill. opp. p. 96).

Marie Thérèse Louise de Savoie-Carignan (1748–1792), princesse de Lamballe, was a tragic victim of the revolutionary terror. The intimate companion of Marie Antoinette, she returned from refuge in England to share the queen's imprisonment in the Temple. In 1792 she refused to take the oath of detestation of the king and queen and was cut down outside the courtroom.

French

about 1790

268
Louis Morau

Ivory, 1¾ x 1⅝ in. (45 x 42 mm)
Inscribed (in black ink on larger sheet of brown paper attached to back of miniature when it was received in the Metropolitan Museum): *Morau (Louis) fils de / François Morau et frère / du Capitaine. Chirurgien / dela Marine Royale. Servit / plusieurs années à Toulon / sur l'Indomptable. Il fut / fait / prisonnier à la bataille de / Trafalgar (1805). Retiré à / Lyons il y mourut sans / enfant et laissa sa fortune / à son frère le Capitaine. / Il avait epousé Mˡˡᵉ / de Guyon fille d'un Notaire / royal de Châlon S. Saône. / guillotiné pendant la Révolution. / Louis Morau était mon / Arrière-Grand Oncle. / Rey.*
Gift of Dr. Fernand Rey, 1922 (22.102)

Wearing a blue coat with pink collar and red vest with white collar. Brown eyes; powdered hair. Blue-gray background.

The miniature is in a heart-shaped locket with a small padlock and key. The locket is glazed at back to reveal a sheet of ivory tinted pink with brown hair forming the monogram LM and sprigs of foliage surrounding it.

EX COLL.: By family descent.

WHEN THE miniature was received in the Metropolitan Museum, it was attributed to Jean Baptiste Isabey (nos. 176–85). It is not by him but by a minor artist working in an unusual format, about 1790.

Continental

about 1740–50

269
Portrait of a Woman

Ivory, 1⅞ x 1½ in. (47 x 40 mm)
Bequest of Millie Bruhl Fredrick, 1962 (62.122.132)

Wearing a white dress edged with pink flowers. Brown eyes; dark brown hair dressed with white flowers. Gray background.

THIS exemplifies the early phase of Continental miniature painting in the eighteenth century after it was given a new direction by Rosalba Carriera (no. 97). It is somewhat in the manner of Rosalba's follower Felicità Sartori, later Hoffmann (died 1760), who was her pupil in Venice from 1728 and worked in Dresden from 1741. Hermione Waterfield has suggested that it might be by the Danish miniaturist Cornelius Høyer (1741–1804), but this is not accepted by Torben Holck Colding, the author of the definitive monograph on that artist. In his unpublished list of the miniatures in the Fredrick collection (1960), no. 64, E. G. Paine assigns it to the Flemish school, about 1765.

Continental

about 1750

270
Portrait of a Woman

Ivory, 1½ x 2¼ in. (37 x 60 mm)
Bequest of Millie Bruhl Fredrick, 1962 (62.122.152)

Wearing a gray dress and lilac shawl; holding a rose in right hand and a torch in left. Brown eyes; powdered hair. Sky background.

LITERATURE: E. G. Paine, unpublished list of miniatures in the Fredrick collection (1960), no. 17, as by an unknown artist about 1765.

IN THE mid-eighteenth century this form of elongated rectangular portrait was frequently adopted by Continental miniaturists but was rarely used in England.

Continental, probably Dutch

about 1760

271
Samuel Verplanck (1739–1820)

Ivory, 1¼ x 1 in. (32 x 27 mm)
Gift of James De Lancy Verplanck and John Bayard Rodgers Verplanck, 1940 (40.176.1)
AMERICAN ART

Wearing a blue coat, embroidered waistcoat, and white shirt. Powdered wig tied with a black ribbon. Gray background.

The back of the gold frame is engraved *Samuel Verplanck. / Born 19ᵗʰ Sep. 1739. / Died Janʸ 27ᵗʰ 1820.*

EX COLL.: Samuel Verplanck (died 1820); by family descent.

THE SITTER, Samuel Verplanck, was a New Yorker of Dutch descent. In 1758 or soon thereafter he went to Amsterdam, entering the employ of his uncle, Daniel Crommelin, whose daughter Judith he married. The couple returned to America in 1763 and lived at what is now 30–32 Wall Street, Manhattan, and at Fishkill, New York. It is likely that this miniature was painted by a Dutch artist in about 1760. Verplanck sat to John Singleton Copley in 1771 (*American Paintings in The Metropolitan Museum of Art* [New York, 1994], vol. 1, pp. 94–96, ill.). Like the miniature, Copley's portrait remained with the family until it was given to the Metropolitan Museum with the furnishings from Samuel and Judith Verplanck's drawing room on Wall Street (Joseph Downs, "The Verplanck Room," *Metropolitan Museum Bulletin* 36 [1941], pp. 218–24, ills.).

Continental

about 1780

272
Portrait of a Woman, Said to Be Princess Apraxine

Ivory, 2¼ x 1¾ in. (56 x 44 mm)
Bequest of Millie Bruhl Fredrick, 1962 (62.122.138)

Wearing a pink dress edged with white; a jewel suspended from a cord around her neck. Brown eyes; powdered hair dressed with blue flowers. Gray-blue background.

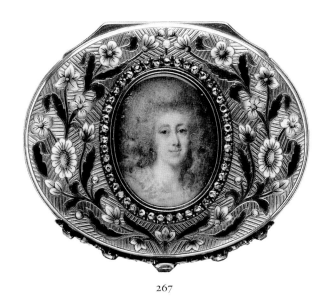

267

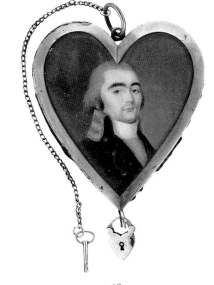

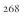

268

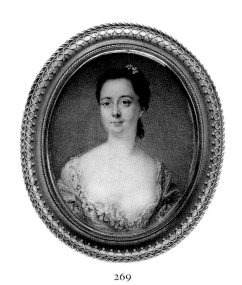

269

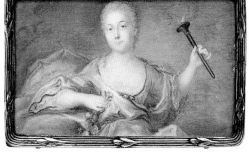

270

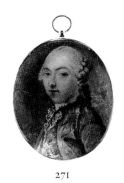

271

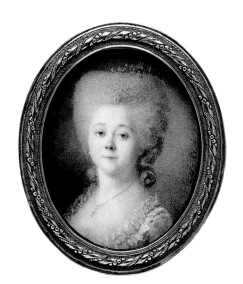

272

Continental (*continued*)

EX COLL.: [Arnold Seligmann, Rey & Co., New York, until 1934]; Mrs. Leopold Fredrick, New York (1934–62).

IN HIS unpublished list of the miniatures in the Fredrick collection (1960), no. 79, E. G. Paine describes this as a portrait of Princess Apraxine by Peter Adolf Hall (nos. 46–50), about 1780. The attribution to Hall cannot be sustained, and it has not been possible to identify the sitter. It may be noted that Maria Johanna (1756–1816), daughter of Franz Joseph zum Rozdalowicz und Haimburg married in 1780 the Russian general and senator Ivan Alexandrovitch, Count Apraxine (died 1818) (Detlev Schwennicke, ed., *Europäische Stammtafeln*, vol. 5 [Marburg, 1988], Tafel 176).

Northern European

about 1770

273
A Man with the Initials CJD

Ivory, 1¾ x 1⅜ in. (45 x 34 mm)
The Moses Lazarus Collection, Gift of Josephine and Sarah Lazarus, in memory of their father, 1888–95 (95.14.54)

Wearing a red uniform jacket, gray waistcoat, and white frilled shirt. Brown eyes; powdered hair. Gray background.

The gilt frame is glazed at the back to reveal plaited brown hair and the monogram CJD in gold.

WHEN THIS miniature was received in the Metropolitan Museum, it was described as a British portrait of an officer. In 1977 Edwin Boucher and Richard Allen suggested that the painter was northern European, rather than British, and this is probably correct.

Continental, possibly Swiss

about 1750

274
Portrait of a Man

Enamel, 1½ x 1⅛ in. (39 x 30 mm)
Gift of Mrs. Louis V. Bell, in memory of her husband, 1925 (25.106.36)

Wearing a black coat and white frilled shirt. Blue eyes; powdered hair tied with a gray bow. Gray background.

The miniature is set in an agate box, the outer bottom of which is carved in a diaper pattern. The gold mounts are twice marked ET, the mark used in France after 1838 for gold articles of foreign manufacture.

THE IMPORTATION marks on the box show that it is not of French origin. The miniature was tentatively ascribed to the German school, but in view of the greater prevalence of enameling in Switzerland, it may have been painted by a Swiss artist.

Continental, possibly Swiss

about 1710(?) or about 1777(?)

275
Portrait of a Woman

Enamel, 1¼ x 1⅛ in. (33 x 30 mm)
Gift of J. Pierpont Morgan, 1917 (17.190.1133) ESDA

Wearing a blue dress with red piping and white shift. Brown eyes; brown hair. Brown background.

The miniature is set in a gold-and-enamel box made by Joseph Étienne Blerzy (apprenticed 1750, master 1768, working 1806) in Paris in 1776–77. The box bears five marks, among them the maker's mark JEB and the Paris marks for 1775–81.

Inside the box are a label printed *2377* and a stock label inscribed *P.M./3532*.

THE SITTER'S costume dates about 1710. The portrait, which is in the style of Charles Boit (1663–1727) or Christian Friedrich Zincke (nos. 117–21), may have been done at that time and would therefore be earlier than the box. But, given the curious disproportion between the head and the bust, it may be a later pastiche which was made for setting in the box.

Swiss

about 1780

276
Portrait of a Woman

Enamel, 1¾ x 1⅜ in. (44 x 35 mm)
Gift of Mrs. Louis V. Bell, in memory of her husband, 1925 (25.106.34)

Wearing a violet dress trimmed with white, light green scarf, and white cap trimmed with light green ribbon. Dark eyes; fair powdered hair. Gray background.

The enamel is set in the lid of a yellow tortoiseshell snuffbox with gold mounts. Inside the box is a blue-edged stock label inscribed in ink *118 / Email sf / boite ecaille / blonde*.

VARIOUS opinions have been expressed about this enamel portrait of about 1780. In 1977 Richard Allen attributed it to the French artist Jean Baptiste Weyler (1747–1791). Hermione Waterfield considered it to be a product of the Swiss school. The handling, which is sfumato and without strong accents, appears to have more affinity with the style of the followers of Jean Étienne Liotard (1702–1789) in Switzerland than with the French artist Weyler. Most recently, Fabienne Sturm of the Musée de l'horlogerie, Geneva, and Hans Boeckh have suggested that it is an early work of the Geneva enameler Louis Ami Arlaud, called Arlaud-Jurine (1751–1829). And Haydn Williams notes similarity to the style of Jean Théodore Perrache (born 1744, died after 1789).

German

about 1790–1800

277
Set of Eight Portraits Arranged as Two Bracelets

Ivory, each 1⅛ x ¾ in. (29 x 19 mm)
Bequest of Collis P. Huntington, 1900 (26.168.63–70)

Each miniature is eight-sided with a gray background, and the two bracelets are arranged and numbered following the same formula. A man (26.168.63), wearing a blue-and-black-striped coat, white frilled shirt, and badge of an unidentified order; gray(?) eyes; powdered hair with a black ribbon. A woman (26.168.64), wearing a white shift and transparent white veil over powdered hair; blue eyes. A boy (26.168.65), wearing a blue dress over white shift; light brown hair. A boy (26.168.66), wearing a gray jacket and white frilled collar; blue eyes; blond hair. A man (26.168.67), wearing a green jacket with white trim, white frilled shirt, and blue ribbon of an unidentified order; blue eyes; powdered hair with a black ribbon. A woman (26.168.68), wearing a white dress trimmed with white lace, diamond pin and diamond tiara with white veil over powdered hair; brown eyes. A boy (26.168.69), wearing a brown jacket and white frilled collar; blue eyes; blond hair. A child (26.168.70), wearing a white shift; brown eyes; light brown hair.

The catch of one bracelet is marked ET once; that of the other is marked ET twice. This mark was used in France after 1838 for gold articles of foreign manufacture.

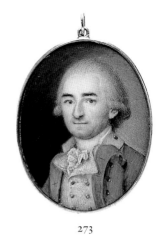

273

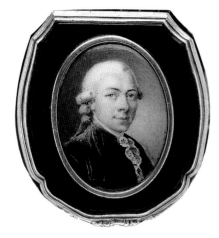

274

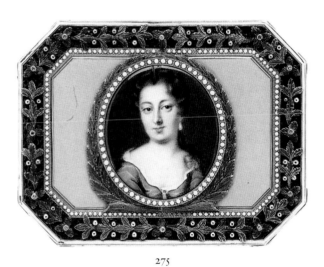

275

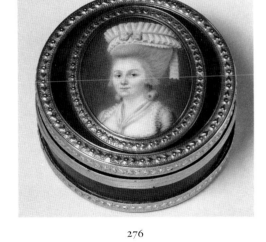

276

277

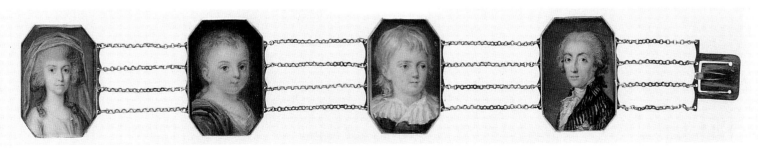

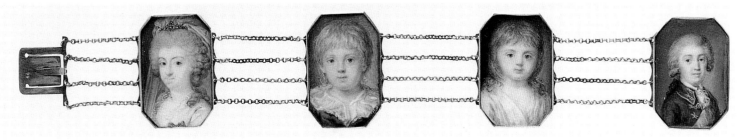

German (*continued*)

LITERATURE: *A Catalogue of Miniatures in the Collection of Collis P. Huntington* (New York, 1897), all reproduced on title page.

THE BRACELETS were received in the Museum as works of the French school of the eighteenth century. It was reasonable to suppose that the miniatures represent members of the same family and on the basis of costume they were thought likely to date between 1785 and 1800. The arrangement was not the original one, since the French mounts were made some forty years later. Richard Allen first proposed that the miniatures might be German, which is very likely given Bodo Hofstetter's recent identification of two of the sitters as Anton (1755–1836) and Maximilian (1759–1838), younger brothers of Frederick Augustus (1750–1827), elector and from 1806 king of Saxony.

Anton is probably represented with his second wife Maria Therese of Hapsburg (1767–1827), whom he married in 1787 (26.168.64). Between 1795 and 1799 the couple's four children died at birth or in early childhood. Maximilian married in 1792 as his first wife Caroline Maria Therese of Parma (1770–1804). Their three sons and four daughters were born between 1794 and 1803; among these seven children are probably the four (26.168.65,.66,.69,.70) represented here. The identification of Caroline of Parma (26.168.68) is the most certain as the miniature is based on her wedding portrait of 1792 by Anton Graff (Schloss Pilnitz, Dresden), where she has the same brown eyes and wears the same diamond tiara and diamond bowknot pin. For this and other related works by Graff, see Julius Vogel, *Anton Graff* (Leipzig, 1898), pp. 23–25, fig. 9, pls. 5–7, and Richard Muther, *Anton Graff* (Leipzig, 1881), pp. 74, 76, 77.

Given the discrepancy in scale and style between the male portraits and the others, the miniatures may have been painted over several years by more than one artist. It is possible that the couples are not correctly paired, as Anton had blue eyes (26.168.67) and Maximilian (26.168.63) had gray eyes; the two wore the same orders and decorations. The children cannot be specifically identified.

Noah Seaman

British, active about 1724–41

A few enamels signed Noah Seaman are known. They are painted in a coarser version of the style of Christian Friedrich Zincke (nos. 117–21). The following enamel may belong to this group.

Attributed to Noah Seaman

278
Portrait of a Man

Enamel, 1⅞ x 1½ in. (47 x 37 mm)
Bequest of Mary Anna Palmer Draper, 1914
 (15.43.287)

Wearing a lilac coat, lilac waistcoat edged with gold braid, and white frilled shirt. Blue eyes; powdered hair. Dark brown background.

The wooden backing of the frame has fixed to it a paper which is inscribed in ink *From / W.W.Warren Esqʳ / Collection / Jan 25 86*; *HANDAL* [sic] in another hand; and various stock numbers.

CONDITION: Crack in the enamel from top right to bottom left.

EX COLL.: William White Warren (his sale, Christie's, London, January 25, 1886, no. 691, to Philpot).

IN THE Warren sale this enamel was described as a portrait of the composer George Frederick Handel (1685–1759), by an unnamed artist. On receipt in the Metropolitan Museum, it was listed as a portrait of Handel after Thomas Hudson (1701–1779). It does not, however, represent Handel. In 1978 Richard Allen and Edwin Boucher attributed the portrait to Noah Seaman, about 1730. This is a plausible suggestion.

W. W. Warren, from whose collection the enamel comes, was a talented minor artist. After his death he was unjustly accused of having made deliberate fakes of the paintings of John Constable (Graham Reynolds, "'Auctioneers, Dealers, Constables and Crooks': A Vindication of William White Warren," *Apollo* 132 [June 1992], pp. 368, 372, no. 7).

British

about 1750

279
Portrait of a Man

Enamel, 1⅞ x 1½ in. (48 x 38 mm)
Bequest of Millie Bruhl Fredrick, 1962
 (62.122.113)

Wearing a bright blue coat, orange waistcoat with gold braid, and white shirt. Brown eyes; brown hair. Gray background.

The back, of white enamel mottled with blue, is uninscribed.

IN HIS unpublished list of the miniatures in the Fredrick collection (1960), no. 40, E. G. Paine attributes this miniature to Christian

Friedrich Zincke (nos. 117–21), about 1755. Subsequently Daphne Foskett has attributed it to Gervase Spencer (active by 1740, died 1763), and Richard Allen and Hermione Waterfield to William Prewett (active 1735–50). Of these suggestions the attribution to Gervase Spencer seems nearest the mark.

British

about 1740

280
Portrait of a Man

Vellum laid on card, 1⅜ x 1⅛ in. (36 x 28 mm)
Bequest of Millie Bruhl Fredrick, 1962
 (62.122.112)

Wearing a light brown-gray coat with gold froggings and white shirt. Brown eyes; powdered wig. Blue-gray background. The vellum is edged with gold.

IN HIS unpublished list of miniatures in the Fredrick collection (1960), no. 36, E. G. Paine attributes this miniature to Christian Friedrich Zincke (nos. 117–21), about 1740. It was also described on accession as an enamel by C. F. Zincke. However, closer examination shows that it is not an enamel but a work on vellum, at that time a rather old-fashioned material.

This work of good quality is in a manner somewhat reminiscent of Peter Paul Lens (1714?–1750?); in fact a signed work by him of 1740 in the Portland collection is painted on vellum (Daphne Foskett, *A Dictionary of British Miniature Painters* [New York and Washington, D.C., 1972], vol. 2, pl. 208, no. 526). The possibility of a Continental origin cannot, however, be excluded.

British

about 1770

281
Portrait of a Man

Ivory, 1⅜ x 1¼ in. (36 x 30 mm)
The Collection of Giovanni P. Morosini, presented by his daughter Giulia, 1932 (32.75.28)

Wearing a pink coat, blue-green waistcoat, and white shirt. Blue eyes; powdered hair. Gray background.

The miniature is in a gold frame set with brilliants.

CONDITION: Damage, perhaps caused by damp, on upper lip and under chin.

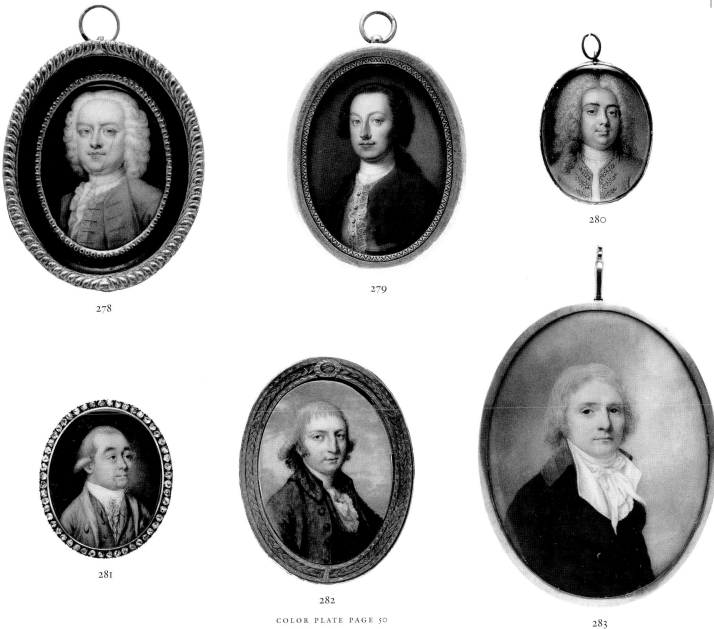

278

279

280

281

282

COLOR PLATE PAGE 50

283

IN 1972 Daphne Foskett suggested that this miniature might be by Edward Vaughan Jr. (1746–1814). She gives an account of this little-known artist, with three reproductions, in *Collecting Miniatures* (Woodbridge, Suffolk, 1979), pp. 296–97, and pls. 77E–G. The attribution is not a convincing one.

British

about 1780

282
A Man with the Initials RH

Card, 2 x 1⅜ in. (51 x 36 mm)

The Moses Lazarus Collection, Gift of Josephine and Sarah Lazarus, in memory of their father, 1888–95 (95.14.96)

Wearing a gray coat and waistcoat and white frilled shirt. Blue eyes; powdered hair. Sky background.

The miniature is circled by a rim of braided brown hair; the frame is glazed at back to reveal the initials RH in seed pearls and a curl of brown hair on a plaited ground of darker brown hair.

CONDITION: The support, which was cockled, responded to humidity and has flattened out. A piece of discolored metal foil at the back was replaced. The convex crystal on the obverse of the locket case was severely deteriorated, with a haze

of moisture on the inner surface. This and the glass at the back were replaced.

THE MINIATURE is by an artist somewhat influenced by the gray sfumato manner of Richard Cosway (nos. 130–32), about 1780.

British

about 1800

283
Portrait of a Man

Ivory, 3 x 2⅜ in. (77 x 60 mm)

Bequest of Millie Bruhl Fredrick, 1962 (62.122.34)

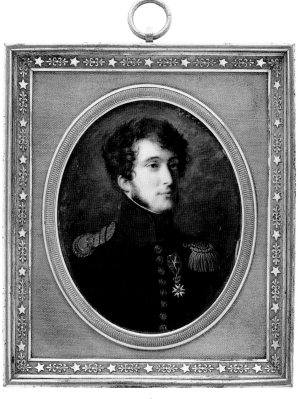

284

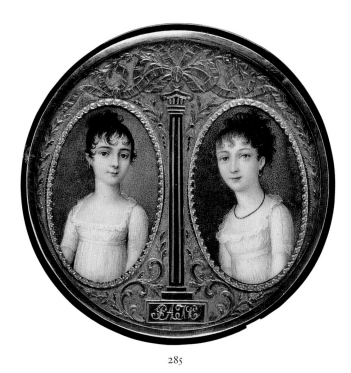

285

Wearing a blue coat with red collar and white waistcoat, shirt, and cravat. Blue eyes; powdered hair. Sky background.

LITERATURE: E. G. Paine, unpublished list of miniatures in the Fredrick collection (1960), no. 49, as by Engleheart, about 1795.

VARIOUS conjectures have been made about the authorship of this miniature. The names of Cosway, Shelley, Engleheart, Mrs. Mee, and Robertson have been suggested without carrying any conviction.

D.B.

French, 1812

284
Portrait of an Officer

Ivory, 2¾ x 2¼ in. (72 x 58 mm)

Signed and dated (left): *D.B. / 1812*
Bequest of Mary Clark Thompson, 1923 (24.80.526)

Wearing a black uniform jacket with blue collar and gold epaulets and the badge of the Légion d'Honneur. Brown eyes; dark brown hair. Dark gray background.

Two labels are fixed to the back of the ormolu frame. One is a stock label numbered 2188/84; the other is inscribed in black ink *un aide-de-Camp / par Boilly / 1812.*

CONDITION: The miniature is damaged around the edges, perhaps by water or from a defective cover glass. It is sealed between a newer glass and a backing card.

WHEN THE miniature was received in the Metropolitan Museum, the signature was read as L.B., and the portrait ascribed to the well-known painter Louis Léopold Boilly (1761–1845) in accordance with the label on the back. According to Leo R. Schidlof, the only miniatures by this artist are grisaille, either in oil on

metal or on porcelain (*The Miniature in Europe* [Graz, 1964], vol. 1, p. 91). The attribution to Boilly was rejected on stylistic grounds in 1977 by Richard Allen and Edwin Boucher.

Continental

about 1800

285
Two Sisters

Ivory, each 2 x 1⅛ in. (49 x 30 mm)
The Collection of Giovanni P. Morosini, presented by his daughter Giulia, 1932 (32.75.47) ESDA

Both wear white dresses. The girl on the left has brown eyes. The girl on the right has blue eyes and lighter brown hair and wears a jet necklace. Gray-blue backgrounds.

THE MINIATURES are set in the lid of an

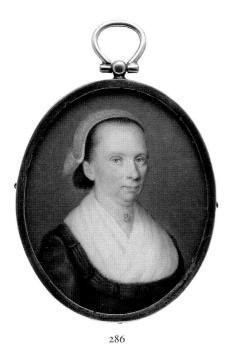

286

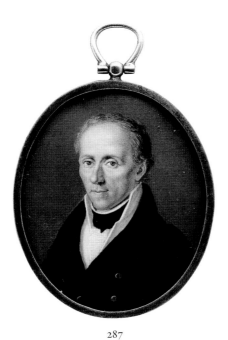

287

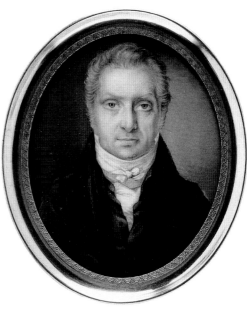

288

unmarked gold-and-tortoiseshell box. The gold plaque fixed to the lid is lettered PAJC.

German

about 1810

286
Portrait of a Woman
 (pendant to 62.122.118)

Ivory, 2¼ x 1⅞ in. (59 x 49 mm)
Signed(?) (right edge, in black): *Ri.p.*
Bequest of Millie Bruhl Fredrick, 1962 (62.122.129)

Wearing a brown dress, white fichu, gold neck chain and jewel, and apricot-colored cap. Blue eyes; brown hair. Gray background.

IN HIS unpublished list of miniatures in the Fredrick collection (1960), no. 134, E. G. Paine states that this miniature is signed *Braun*; he

dates it about 1820. No trace of a signature can now be seen. The miniature is a pair with no. 287. The sitters may be husband and wife.

287
Portrait of a Man
 (pendant to 62.122.129)

Ivory, 2¼ x 1⅞ in. (59 x 49 mm)
Bequest of Millie Bruhl Fredrick, 1962 (62.122.118)

Wearing a blue coat, white waistcoat and shirt, and black tie. Hazel eyes; brown hair. Gray background.

At the back of the miniature is fixed a piece of paper bearing in reverse a truncated inscription in ink, apparently in German script and of no evident relevance.

IN HIS unpublished list of miniatures in the Fredrick collection (1960), no. 133, E. G. Paine

states that this miniature is signed *Braun*; he dates it about 1820. No trace of a signature can now be seen.

The miniature is a pair with no. 286, and both are by the same artist. Bodo Hofstetter suggests that their costumes are Bavarian.

German

about 1815

288
Portrait of a Man, Said to Be
Alexander von Humboldt (1769–1859)

Ivory, 2½ x 2 in. (64 x 52 mm)
Inscribed (reverse of the backing card, in black ink, in an early hand): *Alexander. v. Humboldt.*
Bequest of Mary Anna Palmer Draper, 1914 (15.43.307)

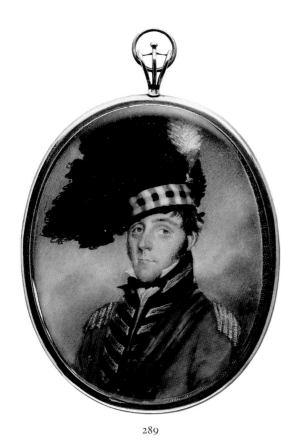

289

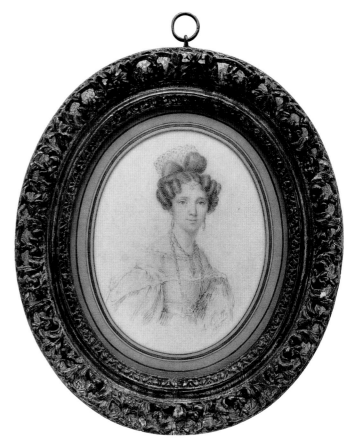

290

Wearing a black coat and waistcoat and white shirt and tie. Fair graying hair and side-whiskers. Gray background.

CONDITION: The miniature is in excellent state. The deteriorated, weeping glass was replaced, and the slightly cockled ivory was released from its backing card.

A NATURALIST, traveler, and statesman, Humboldt was the most eminent German savant of his day. His later years were spent in Berlin at the court of the kings of Prussia. The culmination of his career was *Kosmos* (1845– 62), a serial publication in five volumes which conveyed to the public at large the state of scientific knowledge at the time.

The inscription had been thought reliable, but the resemblance to the many portraits published by Halina Nelken (*Alexander von Humboldt: His Portraits and Their Artists* [Berlin, 1980]) is not compelling.

British

about 1820

289
Portrait of an Officer

Ivory, 3¼ x 2½ in. (78 x 62 mm)

Inscribed (right, in black): *RC*

Bequest of Millie Bruhl Fredrick, 1962 (62.122.46)

Wearing a red uniform jacket with gold-trimmed black revers and black plumed hat with plaid ribbon and white feather. Blue eyes; brown hair. Sky background.

The card backing is inscribed in pencil *Duke of Argyll*.

IN HIS unpublished list of miniatures in the Fredrick collection (1960), no. 8, E. G. Paine attributed this miniature to Richard Collins

(1755–1831), about 1820. However, the inscription RC was probably intended to convey the impression that it is by Richard Cosway (nos. 130–32), which it is not. It is a feeble work of the early nineteenth century.

Continental

1827 or later(?)

290
Portrait of a Woman

Pencil and red chalk on paper, 5⅞ x 4⅝ in. (150 x 117 mm)

Inscribed (lower right, in pencil, falsely): *L. Boilly / 1827*

Bequest of Catherine D. Wentworth, 1948 (48.187.743)

291 (1)

291 (2)

291 (3)

291 (5)

291 (7)

THE DRAWING has nothing to do with Louis Léopold Boilly (1761–1845). It should perhaps be noted that he had a son, Julien Léopold (1796–1874), whose portrait drawings in pencil alone or heightened with chalk or watercolor have an extensive sale record. The elaborate hairstyle and costume are consistent with a date in the first half of the nineteenth century, but closer to 1840. The authenticity of the drawing as a work of the period remains suspect.

British

early 19th century

291
Five Eye Miniatures

Ivory, .1: ½ x ⅞ in. (13 x 22 mm); .2: ¼ x ½ in. (6 x 14 mm); .3: ½ x 1 in. (14 x 27 mm); .5: diam. ¼ in. (6 mm); .7: ¾ x ½ in. (19 x 13 mm)

Inscribed (.7, on back of bezel): *John / Dyer / Ob. 13ᵗʰ / April / 1782 / AE. 29*

Gift of Mr. and Mrs. John W. Starr, 1954 (54.128.1–3,5,7)

No. 54.128.1 is a blue eye, set in a crescent-shaped pin with braided light brown hair at the back; no. 54.128.2 is a hazel eye, set in a pin; no. 54.128.3 is a brown eye, set in a pin; no. 54.128.5 is a blue eye, surrounded by seed pearls and blue-and-white enamel and set in a ring; no. 54.128.7 is an upright oval of a brown eye, mounted in a gold ring. The crystals are scratched, indicating that the jewelry has been worn.

THE VOGUE for eye miniatures took hold during the early years of the nineteenth century. It is supposed to have originated in the days of the French Revolution and to have had erotic and political significance. In 1786 Richard Cosway (nos. 130–32) painted Mrs. Fitzherbert's eye for the Prince of Wales, later George IV (Stephen Lloyd, *Richard and Maria Cosway*, exh. cat. [Edinburgh, 1995], p. 118, no. 60, colorpl. 54). George Engleheart (nos. 146–50) first recorded making a miniature of an eye for a lady in 1796 (G. C. Williamson, "Miniature Paintings of Eyes," *Connoisseur* 10 [1904], pp. 147–49), and William Wood (nos. 165 and 166) painted the eye of Mrs. Oliphant in 1806 (no. 6148 in his ledger). William Pether (no. 123) is known to have made some signed eye miniatures (e.g., no. P.154–1931 in the Victoria and Albert Museum). Although the names of other eminent miniaturists are frequently attached to the British examples, they are usually by lesser hands.

The year 1782 on 54.128.7 is unlikely to be correct; the miniature is an example of this fashion in its maturity.

Le Guay, Étienne Charles, 149–50; 52
Lély, Sir Peter 82, 146
Lens, Bernard, 87, 125–26; 44
Lens, Peter Paul, 196
Liotard, Jean Étienne, 88, 123, 194
Lieder, Friedrich Johann Gottlieb, 166, 168; 60
Lockey, Rowland, 70
Loggan, David, 84
Lombart, Pierre, 80
Longhi, Pietro, 117
Loutherbourg, Annibal Christian, 116
Machera, Ferdinand, 158
Malbone, Edward Greene, 142
Marta, Luigi, 166
Massé, Jean Baptiste, 87–88
 attributed to, 88
Maurice, Louis Joseph, 91–92
Mee, Anne Foldsone, 146–48, 198
Mengs, Anton Raphael, 120; 41
Mengs, Ismaël, 120
Meulen, Adam François van der, 102
Meuret, François, 164
Meyer, Jeremiah, 128, 130
Mignard, Pierre, 76
Miles, Edward, 172–73
Mirbel, Madame de, 154–55
Monogrammist FA, 76
Monogrammist FS (Franciszek Śmiadecki), 82
 attributed to, 82
Monogrammist IS, 76
Monogrammist JG, 76
Monperir, Arnaud Vincent de, 89
 attributed to, 89
Mortier, 114, 116; 39
Mosnier, Jean Laurent, 96–97
 attributed to, 97; 32
Myers, David, 83
Myrtens, Daniel, 78, 79
Nazari, Bartolomeo, 117
Nilson, Johann Esaias, 120
Nixon, James, 130–31, 146
Nogari, Giuseppe, 117
Northern European, 181, 184, 194, 195, 196
Nutter, 142
Oliver, Isaac, 72, 78
Paillou, Peter, 141
Pasquier, Pierre, 89–90; 28

Peat, Thomas, 143; 48
Périn-Salbreux, Louis Lié, 110
Perrache, Jean Théodore, 194
Pesne, Antoine, 119
Pether, William, 128, 201
 attributed to, 128
Petitot, Jean, 74–75, 110
 attributed to, 75
Pietersz, Pieter, the Younger, 68
 attributed to, 68–69
Plimer, Andrew, 144–45
Poly, J. B., 110
Pratt, Matthew, 138
Prévost, Jean, 186
Prewett, William, 127, 128, 196
Prieur, Paul, 76, 184
Provost, Jean J., 186

Quenedey, Edmé, 112; 36

Raeburn, Henry, 178
Ramage, John, 138
Rath, Henriette, 152
Reynolds, Sir Joshua, 128, 138, 143, 145, 146
Richter, Christian, 87
Ritt, Augustin, 97
Robertson, Alexander, 145
Robertson, Andrew, 178
Robertson, Archibald, 145, 178; 48
Robertson, Charles, 176
Robinson, John Henry, 178
Rochard, François-Théodore, 180
Roch, Sampson Towgood, 176
Rokotov, Feodor, 125
Roslin, Alexandre, 97
Ross, Sir William Charles, 178
Rosse, Susan Penelope, 82
Rouquet, Jean André, 124; 128
Rouvier, Pierre, 98
Rubens, Peter Paul, 126, 173–74
Saillant, E. Jean, 74
Sambat, Jean Baptiste, 113
 attributed to, 113
Sartori (Hoffman), Felicita, 192
Sauvage, Piat Joseph, 104, 106–07
 attributed to, 107–08
 style of, 108
Savignac, Edmé Charles de Lioux de, 102, 104; 33
 attributed to, 104
Schalck, Heinrich Franz, 170; 61

Seaman, Noah, attributed to, 196
Seger, Sir William, 72
Senff, Carl August, 166
Shelley, Samuel, 142–43, 201; 47
 style of, 143
Shirreff, Charles, 141
Sicardi, Louis Marie, 97–98, 163; 32
 attributed to, 98
Simonneau, Charles, 102
Smart, John, 130, 132, 134–36, 143; 46
 imitator of, 136
Śmiadecki, Franciszek, 82
 attributed to, 82
Soret, Nicolas, 125
Spanish, 183
Spencer, Gervase, 128, 196
Stein, Theodor Friedrich, 120
 attributed to, 120
Ströber, F., 168
Strecky, Peter Edward, 125
Stump, Samuel John, 178
Swiss, 76, 148, 184, 194
Terebenev, Mikhail Ivanovich, 170
Thiepondt, Carl Friedrich, 119–20; 40

Van Blarenberghe, Hélène, 98
Van Blarenberghe, Henri Joseph, 98, 100–01; 34–35
Van Blarenberghe, Louis Nicolas, 98, 100–01; 34–35
Van Blarenberghe, style of, 102
Vanderbank, John, 127
Van Dyck, Sir Anthony, 78, 79, 176
Vaughan, Edward Jr., 197
Vernet, Claude Joseph, 110, 186
Vestier, Antoine, 95–96, 110, 116, 188, 189
Vien, Joseph Marie, 104, 149
Villers, 112; 37
Villers, L., 112
Villers, Nicolas de, 112
Villers, Maximilien, 112
Vincent, 114, 158; 39
Vincent, Antoine Paul, 114, 115
White, Robert, 84
Weyler, Jean Baptiste, 194
Wood, William, 146, 201; 49
Zincke, Christian Friedrich, 124, 126–27, 128, 194, 196; 45
 attributed to, 128

Index of Collectors